Victorian Thinker

A. L. Le Quesne has lectured in history at the Universities of Tasmania and Sydney, and taught history at Shrewsbury School. He is the author of *After Kilvert* (OUP, 1979).

George P. Landow is Professor of English and Art History at Brown University, Providence, Rhode Island. His other books include *The Aesthetic and Critical Theories of John Ruskin* (1971) and *Hypertext: The Convergence of Contemporary Critical Theory and Technology* (1992).

Stefan Collini is University Lecturer in English and Fellow of Clare Hall, Cambridge. He has published widely on nineteenth-century intellectual and cultural history, including *Liberalism and Sociology* (1979), *That Noble Science of Politics* [with Donald Winch and John Burrow] (1983), and *Public Moralists: Political Thought and Intellectual Life in Britain 1850–1930* (OUP, 1991).

Peter Stansky is Field Professor of History at Stanford University. He has published widely on modern English history and is most recently the author of *Redesigning the World: William Morris, the 1880s, and the Arts and Crafts*.

Victorian Thinkers

Carlyle
A. L. Le Quesne

Ruskin
George P. Landow

Arnold
Stefan Collini

Morris
Peter Stansky

Oxford New York
OXFORD UNIVERSITY PRESS
1993

Oxford University Press, Walton Street, Oxford OX2 6DP

Oxford New York Toronto
Delhi Bombay Calcutta Madras Karachi
Kuala Lumpur Singapore Hong Kong Tokyo
Nairobi Dar es Salaam Cape Town
Melbourne Auckland Madrid

and associated companies in
Berlin Ibadan

Oxford is a trade mark of Oxford University Press

British Library Cataloguing in Publication Data

Data available

Library of Congress Cataloging in Publication Data
Victorian thinkers : Carlyle, Ruskin, Arnold, Morris / A.L. Le Quesne
. . . [et al.].
p. cm. Includes bibliographical references and index.
1. English prose literature—19th century—History and criticism.
2. Carlyle, Thomas, 1795–1881—Criticism and interpretation.
3. Ruskin, John, 1819–1900—Criticism and interpretation.
4. Arnold, Matthew, 1822–1888—Knowledge—Literature. 5. Morris,
William, 1834–1896—Political and social views. 6. Criticism—Great
Britain – History – 19th century. 7. Great Britain – Intellectual
life—19th century. 8. Great Britain—History—Victoria,
1837–1901. I. Le Quesne, A. L. (A. Laurence)
828'.80809 – dc20 PR781.V54 1993 92–30091

ISBN 0–19–283104–6

1 3 5 7 9 10 8 6 4 2

Typeset by Cambridge Composing (UK) Ltd

Printed in Great Britain by
Biddles Ltd.
Guildford and King's Lynn

Foreword

The Victorian age is often regarded as a time when moral and religious values were secure and material progress generated a spirit of satisfaction, even complacency. Yet none of the four Victorian figures whose thought is reappraised in this book was an orthodox Christian and all of them were in open revolt against the prevailing values of the time. They denounced the industrial civilisation in which they lived for its social injustices, its aesthetic shoddiness and its moral and cultural emptiness. Although their prescriptions for reform were different, they agreed in believing that human life ought to be happier, more valuable and more fulfilling than the conditions of nineteenth-century England allowed. Yet in their revolt against the Victorian age they were characteristic of it. They displayed the moral earnestness typical of the period, and they drew on ideas which came from the common cultural inheritance of the time: the Bible, the classics of Greece and Rome and the Romantic movement.

Thomas Carlyle was a product of Scottish Calvinism, incongruously mixed with German Romanticism. He believed strongly in the virtues of hard work, but he was appalled by the social injustices of early industrial society. In his history of *The French Revolution* he exposed the moral failure of the eighteenth-century French aristocracy and in *Chartism* and *Past and Present* he castigated the indifference of the ruling classes of his own day to the hardships of the masses. His impact upon contemporaries both as historian and as social critic was enhanced by his extraordinary prose style, aptly characterised by A. L. Le Quesne as 'rambling, turbulent, ejaculatory, vastly self-indulgent and metaphorical'. Hailed as a prophet in the 1840s, he became increasingly isolated, as his authoritarian belief in the value of 'hero-worship' gradually cut him off from the liberal and democratic tendencies of his day. His posthumous reputation has never equalled the position he occupied in his life-time.

John Ruskin launched an even more fundamental critique of the alienating and dehumanizing nature of industrial work. He began

as a writer on painting and architecture, seeking, in prose which combined vivid word-painting with passionate moral intensity, to educate his contemporaries in the importance of art as the repository of natural truth. By urging the supreme moral value of the Gothic style, he exerted a major influence upon the public taste of the day. His reflections on medieval craftsmanship led him to deplore the modern separation of art from craft and of labour from thought. He rejected *laissez-faire* economics, preferring to believe in abundance rather than scarcity, and co-operation rather than competition. The welfare of the working classes and the cultural health of the nation became his overriding preoccupations. No one has done more to make the position of art so central a criterion of civilization.

Matthew Arnold came to social criticism by way of literature. Having achieved fame as a memorable poet of loss and separation, he turned to the business of literary criticism. His essential achievement was to give the role of literary critic a cultural centrality which it has never lost. He defined culture as 'the best that has been thought and said' and declared that the function of criticism was to learn and propagate that best in a disinterested manner. In his polemical writings he attacked the provincialism, narrow-mindedness and complacency of the Victorian middle classes, blaming what he called their 'philistinism' on the constricting influence of Puritan Nonconformity. It is ironic that in recent times his belief in the supreme value of high culture has been challenged by some of those very literary critics whose profession he did most to legitimate.

William Morris would still be remembered as artist, designer and printer, even if he had never put pen to paper, for Morris wallpaper and the Kelmscott Press have achieved their own immortality. He was also a notable writer of verse and prose romances and, following Ruskin, an exponent of romantic medievalism. He inspired the Arts and Crafts movement and the Society for the Preservation of Ancient Buildings. His overriding passion was to produce and cherish beautiful things. It was this which led him into reflection upon the moral implications of work and the ugliness of mechanical civilisation. Ultimately, he championed revolutionary socialism as the only means of abolishing the

division of labour and arresting the degradation of the arts which he believed to be the fruit of capitalism. But his injunction to 'have nothing in your houses that you do not know to be useful or believe to be beautiful' transcends mere politics.

Their literary gifts and their polemical style ensured that all four thinkers had a high public profile in their own lifetime. Venerated as 'sages' or 'prophets', they were also regarded by many contemporaries as 'unsound' or even mad. Thanks to the four self-contained studies originally written for the Past Masters series and now reprinted in this book, we can now, a century later, see how enduring their influence has been. Ruskin and Morris have profoundly affected the art, design and social thought of the twentieth century. Arnold helped to make the modern literary critic a sort of secular priest. Carlyle has no imitators, but the tensions in his thought between social justice and authoritarianism foreshadow some of the darker sides of twentieth-century politics. It can be said of all of them as Stefan Collini says of Arnold (neatly adapting Arnold's own words): by their heroic and hopeless stand against the inadequate ideals dominant in their time, they kept open their communications with the future.

KEITH THOMAS
General Editor
Past Masters

Contents

Carlyle

A. L. Le Quesne

Preface

This book, I hope, speaks for itself sufficiently clearly for a formal preface to be unnecessary; but there are some debts to be acknowledged. I am grateful to Henry Hardy for inviting me to contribute to this series, to Keith Thomas for his readiness to buy a pig in a poke, and to both of them for allowing themselves to be persuaded that Carlyle is indeed the Past Master that I believe him to be. I am grateful also to the Governors of Shrewsbury School for allowing me not only a sabbatical term but the additional leave required for the completion of this book. But most of all I am indebted to the Governing Body of Christ Church for their election of me to a schoolmaster studentship, without which the essential reading on which the book is based could hardly have been undertaken; and for the friendship and hospitality which they, and the other members of Christ Church Senior Common Room, showed me while I was there. It is to them that this book is dedicated.

Shrewsbury　　　　　　　　　　　　　　　　　　A. L. Le Quesne
5 March 1981

Contents

Abbreviations

References in the text to quotations from Carlyle are given by an abbreviation of the title (sometimes with the addition of a volume number) and a page number. Except where otherwise noted below, the reference is to the most generally available collected edition of Carlyle's works, the Centenary Edition of 1896–9. I use the following abbreviations:

A *Letters of Thomas Carlyle to his Brother Alexander*, ed. E. W. Marrs (Cambridge, Mass., 1968)

C *Chartism*

D *Latter-Day Pamphlets*

E *Critical and Miscellaneous Essays*

FF J. A. Froude, *Thomas Carlyle: A History of the First Forty Years of His Life* (London, 1882)

FL J. A. Froude, *Thomas Carlyle: A History of his Life in London* (London, 1884)

J *Life of John Sterling*

L *Letters and Speeches of Oliver Cromwell*

N *New Letters of Thomas Carlyle*, ed. A. Carlyle (London, 1904)

P *Past and Present*

R *The French Revolution*

S *Sartor Resartus*

T *Collected Letters of Thomas and Jane Welsh Carlyle*, ed. C. R. Sanders and K. H. Fielding (Durham, North Carolina, 1970–)

W D. A. Wilson, *Carlyle Till Marriage* (London, 1923)

There are three quotations from authors other than Carlyle which, following the style of the series, are not referenced in the text. For the sake of completeness I give the references here. The quotations from Emerson on pp. 00 and 00 are to be found in *The Correspond-*

ence of Emerson and Carlyle, ed. J. Slater (New York, 1964), pp. 36 and 38; and George Eliot's judgement on p. 00 in *Carlyle and his Contemporaries: Essays in Honor of Charles Richard Sanders*, ed. John Clubbe (Durham, North Carolina, 1986), p. 182.

1 Early years

Thomas Carlyle was born on 4 December 1795 in the small market town of Ecclefechan in the Scottish county of Dumfriesshire, not far from the north shore of the Solway Firth – the eldest of James Carlyle's second family of nine children. James Carlyle was a skilled stonemason, but Dumfriesshire was a farming community, and all its trades were more or less closely related to the land. Both James Carlyle and his second wife, Margaret, were the children of farmers, and in the hard times after the end of the Napoleonic Wars he went back to farming, a trade in which two of his younger sons were to follow him. In 1827 the Carlyles finally settled at the farm of Scotsbrig – a few miles from Ecclefechan, in the same district of Annandale – where James and Margaret lived till they died, in 1832 and 1853 respectively. The roots of the Carlyles in the soil of Annandale were deep and tenacious. Thomas was to spend more than half his life in the literary world of London, but never saw himself as anything but an exile there. Up to the last years of his life he visited Annandale frequently, and its landscape came to be burdened for him with an almost overwhelming weight of associations of childhood, of bereavement, and of home. It was wholly in keeping that he chose to be buried beside the graves of his parents in Ecclefechan churchyard.

This brief account of his background already reveals three major influences on Carlyle's life. He was a Scot, a working man's son, and a man with a profound sense of family piety. His relations with his mother and with two of his younger brothers, Alexander and John, were particularly close and affectionate, as the voluminous correspondence between them testifies. The rock-like stability of his family, to which he returned for strength and refreshment throughout his life, was one of the chief formative influences upon his character, balancing an unstable and nerve-ridden temperament, prone to bouts of melancholia and prey to a chronic dyspepsia of which he was a lifelong and anything but uncomplaining

9

victim. His national and social origin had a different influence on his career. Both, especially the latter, contributed to making him a maverick and an outsider in the English literary world, in which he became one of the most renowned figures by the middle of the century – a role of which both he and his public were highly conscious, and one which he exploited with brilliant success in becoming the leading prophetic figure of his age, the Jeremiah of nineteenth-century Britain.

Equally important for Carlyle's development was the religious background of his youth. His family were members of the Burgher Secession Church, one of the numerous splinter groups that had rebelled against the laxity of the established Church of Scotland in the course of the eighteenth century, and both his childhood and his whole personality were coloured by the sternly disciplined . piety of Scottish Calvinism, a tradition which he outgrew intellectually but never spiritually. All his later references to his religious upbringing are nostalgic: the unquestioning faith of his parents' generation came to be for him one of the hallmarks of the healthy condition of a man or a society, and the absence of faith in Victorian Britain only reinforced the vehemence of his insistence on the need for it.

James Carlyle was a figure of formidable authority. His whole life was based on an unbending ethic of hard work and austerity, an ethic which harmonised readily with the teachings of his Church. His children inherited these values from him, Thomas perhaps more than any: he never found it easy to communicate with his father, though the devotion he felt to his memory and example came out most poignantly in the memoir that he wrote after James Carlyle's death in 1832, which was later published in his *Reminiscences*. The circumstances of the family were always straitened, although never poverty-stricken. In England at this time a child from such a background could hardly have aspired to any education that took him beyond the three Rs. But Scotland was peculiar in its tradition of popular education reaching back to the Reformation. Carlyle went not merely to the village school at Ecclefechan, but on to the neighbouring grammar school at Annan, and thence to Edinburgh University in 1809, at the (not in fact unusually young) age of thirteen. Like many other poor men's

sons, he walked there – a distance, in his case, of nearly a hundred miles. He found his own lodgings, sent his washing back to Ecclefechan by the local carrier, and received in return a supply of oatmeal which formed the main item of his diet.

Edinburgh, like the other Scottish universities, but unlike the English ones of the time, saw it as its primary teaching function to provide a basic general education, at approximately what we would now regard as secondary level, for a body of unprivileged and often very poor students, most of whom would then hope to go on to careers in the Church, the law, medicine or, at worst, teaching. This education was not free, but it was very cheap – two to three guineas a year. It is hardly surprising that students received little in return for this beyond the right to attend lectures and to use the library. The curriculum was perceptibly wider than those of Oxford and Cambridge – Carlyle attended courses in natural philosophy (in effect, physical science) as well as Latin, Greek, logic and mathematics – but not very demanding in its standards. Although Carlyle in later life could read both Latin and Greek with appreciation, he never possessed the easy fluency in them with which his ablest contemporaries in England emerged from Oxford and Cambridge.

If Carlyle had not been recognised early as a boy of unusual promise, it is very unlikely that he would have got to university at all, for low though the fees were, they were still a heavy burden on a household like James Carlyle's. Only one of his three younger brothers was to follow him to university – the other two remained on the farm. His parents' hope, like that of many similar poor families with one able son at the university, was that he would go into the ministry of his Church, and it was toward this end that his studies at Edinburgh were directed. Like many other students similarly situated, he did not take a degree, but instead, when his four years' course at Edinburgh ended in 1813, went on to a further part-time course in divinity, designed to enable him to earn his living during the day and to study in the evenings. This course would have taken seven years to complete. For a poor student like Carlyle, the natural recourse for a living in the interim was to schoolteaching, and Carlyle accordingly became a teacher, at first at his own old school in Annan, later in Kirkcaldy in Fife. But

11

rebellion had been rising in him for years, and he hated teaching. Finally he took two decisive steps: in 1817 he abandoned all ideas of the Church as a career, and in 1818 he resigned from his post at Kirkcaldy.

To understand this change of course, it is necessary to understand the impact that Edinburgh had had upon him. The world of early nineteenth-century Edinburgh was immensely wider and more sophisticated than the Annandale of Carlyle's childhood, and the education that it had to offer had in it the stiffening backbone of a systematic philosophy that exposed the inherited values of Carlyle's childhood to strenuous challenge. Edinburgh had been the citadel of the eighteenth-century Scottish Enlightenment. The European Enlightenment had struck deeper root in Scotland, and thrown up a more vigorous crop of native thinkers – Hume in philosophy, Adam Smith in economics, Robertson in history – than anywhere else in Britain. The values they advocated were the characteristic values of the Enlightenment – empiricism in philosophy, scepticism toward all revealed religion, a primarily utilitarian account of morals, a coolly objective rationalism that queried tradition, deprecated emotion and enthusiasm, and in seeking explanations of the world about it required above all that they should be compatible with common sense and observed facts. As Carlyle was later to write in *Sartor Resartus*, in satirical retrospect on his student days at Edinburgh,

We boasted ourselves a Rational University; in the highest degree hostile to Mysticism; thus was the young vacant mind furnished with much talk about Progress of the Species, Dark Ages, Prejudice, and the like; so that all were quickly enough blown out into a state of windy argumentativeness; whereby the better sort had soon to end in sick, impotent Scepticism; the worser sort explode in finished Self-conceit, and to all spiritual intents become dead. (S 90)

No doubt there were plenty of Carlyle's contemporaries in Edinburgh who passed placidly through the university without ever noticing the values it stood for – as is true of all universities at all times – or at least without ever troubling their heads about them. This option was not available to Carlyle. He had an acutely receptive and sensitive mind, which reacted immediately and

sharply to the intellectual environment, and from the first he had an avid thirst for knowledge, reading insatiably now that for the first time he found a good library at his disposal. Poverty, a pride in his extraordinary ability, and a formidable capacity for sarcasm (these last two were to be strongly marked features of his character all his life) made him something of a solitary among his fellows, and further intensified his inner life and conflicts. He could not but be aware of the crucial challenge posed by the intellectual assumptions of his Edinburgh world to the values of his Annandale upbringing, its piety, its other-worldliness, its unquestioning religious faith.

This challenge, and Carlyle's response to it, can be seen as the central feature of his entire intellectual and moral life. The conflict took a form which, in similar cases, is familiar enough. The immediate impact of Edinburgh University and all it stood for on the thirteen-year-old boy was overwhelming. The religious faith in which he had been brought up disintegrated before the challenge of the newer and, it seemed, more sophisticated creed. Carlyle himself told the story of how at the age of fourteen he shocked his mother by enquiring sceptically, 'Did God Almighty come down and make wheelbarrows in a shop?' (W 78). The disintegration was gradual, but it was final. Carlyle was never to regain the faith of his childhood, and it is this that explains his eventual decision, in 1817, to abandon the idea of entering the ministry. But while destroying his faith in the creed in which he had been brought up, the new creed never succeeded in making a true convert of Carlyle; what it did was to create in him an agonising sense of alienation and desolation. A sense of betrayal towards his parents was clearly one factor in this, but only a minor one: the central factor was that he was a man for whom a religious creed and a sense of transcendental purpose were in the strictest sense of the word vital. It was Miguel de Unamuno, a Spanish admirer of Carlyle in this century, who said, 'It is not rational necessity, but vital anguish that impels us to believe in God'; but the words might very well have been Carlyle's own.

The immediate aftermath of Carlyle's university years was, therefore, a decade of intense intellectual and moral conflict, as he attempted to find some way of reconciling his desperate spiritual

needs with what seemed to be the irresistible demands of intellectual integrity. But before we go further into this period, there are two final points which need to be made about his university years. One is that the Edinburgh of Carlyle's youth was in its silver, not its golden, age; the intellectual fires which had glowed so bright there in the eighteenth century were dying down. Most of the very great men were dead; arguably the last of them, the moral philosopher Dugald Stewart, retired from his chair in 1810, the year after Carlyle's arrival, and by the standards of the great the men who taught Carlyle were second-rate. Did Carlyle's inability to find satisfaction in the intellectual tradition of the Scottish Enlightenment owe something to the fact that that tradition was already on the decline, already too far worked out to have enough to offer a student of outstanding ability?

The second, very striking point is that the parts of the syllabus which made the strongest appeal to Carlyle at the time were mathematics and the natural sciences, and he seems to have had outstanding abilities in these fields. They were recognised by the professor of mathematics, Leslie, and were sufficient for him to be a credible candidate for the chair of mathematics at Sandhurst in 1822, and a somewhat less credible one for the chair of astronomy at St Andrew's in 1834. His later career followed so different a course that it could almost be taken as a case study supporting his own frequently expressed belief that genius is non-specific, and can be turned to any use. Clearly this early taste for mathematics and science is hard to discern in his public writings, some of which might well have benefited from a larger infusion of these disciplines. It is relevant, though, that it seems above all to have been the pure logic of mathematics, especially geometry, rather than the empiricism of the physical sciences, that appealed to him; and it is fair to add that even in the last years of Carlyle's life his friend John Tyndall, the great physicist, bore witness to his remarkable ability to grasp scientific concepts.

After throwing up his post at Kirkcaldy in 1818, Carlyle withdrew into an inner wilderness from which he emerged only gradually in the course of the 1820s. Economically, morally and intellectually the early years after 1818 in particular were a period of agonising disorientation and instability, a crisis which was

reflected by a partial breakdown in health, in the form of a chronic and crippling dyspepsia from which he was never afterwards wholly free, and an increasingly morbid sensitivity to noise which also never left him. Carlyle was endowed with a nervous system of pathological sensitivity. This was, no doubt, the reverse side of the brilliant powers of description and total recall that make his letters and his *Reminiscences* such vivid documents. But at this time almost every letter is punctuated with complaints of nights rendered sleepless by street and house noises, and of days made unproductive by agonies of indigestion; and, equally typically, with expressions of furious determination to overcome these afflictions, the sense of Puritan purpose working through. He did not know in what direction his life was going or how he should earn a living, and he was appalled by the prospect of a world which seemed now to have lost its spiritual dimension. In words which he later put into the mouth of Teufelsdrockh, the central figure of *Sartor Resartus*:

To me the Universe was all void of Life, of Purpose, of Volition, even of Hostility: it was one huge, dead, immeasurable Steam-engine, rolling on, in its dead indifference, to grind me limb from limb. O, the vast, gloomy, solitary Golgotha, and Mill of Death! Why was the Living banished thither companionless, conscious? (S 133)

Amid this desolation, the one point of security and comfort that remained was the unswerving support of his family. In Annandale, in the simple farm-house in which by now the family was living, he was always sure of love and acceptance. Without the continual flow of their gifts of farm produce it is difficult to see how in these years he could have survived at all in Edinburgh, where for most of the time he eked out a life in cheap lodgings. He toyed with the idea of a career in law, only to throw it up as he rapidly discovered that he had no taste for it. He made a little money in odd tutoring jobs, most of which he disliked, and a little more by writing articles for an encyclopaedia – important as his first published writings, but otherwise the merest journalistic hackwork. But he continued to read omnivorously, accumulating the vast arsenal of literary knowledge and reference which he was later to put to splendid use in his mature writing. He also did two other

15

extremely important things. In 1819 or thereabouts he learned German; and in 1821 he met Jane Welsh. These two encounters were to do much to shape the rest of his life.

Carlyle was a more than competent linguist. He already knew French, Latin and Greek, and was later to acquire Italian, Spanish and Danish. But German was to him far more than a language; it was the revelation of a new attitude to life which held out the prospect of a solution to the torments of intellectual scepticism and spiritual emptiness. And indeed in 1819 German was a very exciting language for an Englishman to learn, since it gave him access to a literary and philosophical renaissance that was still, unlike the tradition of the Enlightenment, in its most vital and creative phase, and still ranks as one of the major milestones of modern European intellectual history. This German Renaissance was itself part of the broader European movement of Romanticism, which in the last third of the eighteenth century was felt to different degrees throughout Western Europe. In the names of instinct, emotion, introspection, tradition, history, the nation, it everywhere mounted a challenge to the values of the Enlightenment: reason, scepticism, universalism, objectivity, the appeal to first principles. To the castaways of the Enlightenment, like Carlyle or, later, John Stuart Mill, it came like the discovery of a spring of fresh water at the moment of death from thirst. Romanticism had struck vigorous root in England too, most notably in the school of the Lake Poets, Coleridge, Wordsworth and Southey; and it is worth asking why Carlyle could not have found his salvation nearer home in them, and why he had to go to Germany for it. But such questions can never be fully answered. Carlyle's poetic sensibilities were always cramped and narrow, certainly. The Lake Poets may have been simply too much figures of the literary and political establishment by the time Carlyle entered upon his years of travail to hold any attraction for him. But very probably the main explanation is that the German Renaissance was a much broader and more imposing intellectual phenomenon than English Romanticism was ever to become. It had not merely a new poetry to its credit, but a new drama and a new philosophy as well; it had in Kant (arguably also in Hegel) one of the seminal figures in the history of European philosophy, and in Goethe a

writer whose breadth of genius has often prompted comparisons with Dante and Shakespeare.

In the decade after 1819 Carlyle read voluminously in German literature, and his indebtedness to the German writers of the last generation was manifold – to Goethe above all. He grappled vigorously with the work of the philosophers, Kant, Fichte, Schelling and Schlegel, for he recognised that the Enlightenment was principally a philosophical phenomenon, and must be met with its own weapons on its own ground. But Carlyle was never by nature a philosopher, and although he satisfied himself that in Kant and Fichte he had discovered the answer to what was to him the desolating rationalism of the eighteenth century, what he in fact got from them seems to have been limited for the most part to ideas and phrases taken out of context and frequently misunderstood. It was the imaginative writers of the German Renaissance who spoke most strongly to him and who helped him most in his time of greatest need, and among them especially the dramatist Schiller, the humorist and satirist Jean Paul Richter, and of course Goethe – or more correctly, perhaps, some of Goethe: *Faust* to a limited extent, and some of the later works, but especially *Wilhelm Meister*, whose theme of a young man finding his way through intellectual and spiritual perplexities to self-fulfilment had an obvious relevance to his own condition.

For the rest of Carlyle's life, Germany was to stand to him as the exemplar of a healthy society (a view perhaps made easier by the fact that he first visited it in 1852 at the age of fifty-six). For twenty years at least, Goethe (with whom he came to correspond on terms of close discipleship) was to be his spiritual lodestar, the incarnate proof that intellectual integrity and faith could still be reconciled. Carlyle saw in him the teacher of a sternly stoical morality whose watchword was *Entsagen*, renunciation; and, not least, the model of the man of letters as an intermediary between the two worlds of the Ideal and the Real, the Divine and the Human.

In all this there was a good deal of misunderstanding and distortion; but this is of secondary importance. Whether Carlyle misread his German mentors or not, there is no question of the importance of what he *thought* he learned from them, or of its

17

effect on his life. What he emerged with was a fluctuating, sometimes inconsistent intellectual amalgam, deriving from the Puritanism of his family background and the impact of the ideas of the Enlightenment as well as from the German intellectual renaissance; and it was perhaps only because the German influence was the most recent that he saw it as dominant. But in a mind as powerful as Carlyle's the amalgam, however mongrel its origins and imprecise its intellectual formulations, became something highly original and of compelling force – above all imaginative force – to the generation to which he proclaimed it. What were its main elements?

Carlyle commonly described the central feature either as 'Mysticism' or as 'Natural Supernaturalism'; the latter description seems to come nearer to his meaning, with its implication of a universe of two separate, but intimately related, orders, but the former has the advantage of making clear Carlyle's primary emphasis upon the supernatural order. More than anything, Carlyle's encounter with the German Renaissance restored his faith in the existence of a transcendent spiritual order which underlay the apparent world and gave it whatever reality it might possess. Throughout the middle period of Carlyle's life, nothing is more typical of him than the quality of stereoscopic vision, his habit of translating this world in terms of values derived from a different and invisible one. This characteristic could obviously be traced to the religious beliefs of his childhood, but rested more immediately on the philosophic idealism of his German mentors – and, one is bound to add, it had in him all the force of a genuinely native vision. A passage from his journal in 1835 is typical:

The world looks often quite spectral to me; sometimes, as in Regent Street the other night (my nerves being all shattered), quite hideous, discordant, almost infernal. I had been at Mrs Austin's, heard Sydney Smith for the first time guffawing, other persons prating, jargoning. *To me through these thin cobwebs Death and Eternity sate glaring.* (FL I 54, my italics)

'To me', one notes. Implicit in his vision was the realisation that the rest of the world, with the rarest exceptions, did not share it; and with it a sense of separateness and what can only be called a consciousness of mission. Carlyle rationalised this 'double

vision' in terms of the distinction, also German, between 'Reason' and 'Understanding', which he derived from Kant, possibly via Coleridge: Understanding, the calculating capacity which deals with the quantifiable world, with what can be weighed and measured; and the confusingly-named 'Reason', the profounder capacity for insight into the real nature of things and the world of values. But as often with Carlyle, the rationalisation was less important than the experience: the experience of seeing in two dimensions where most people saw only in one. This one-dimensional vision was, to Carlyle, the myopia which the world had contracted from the one-eyed philosophers of the Enlightenment, and to which the transcendentalism of the Germans was the antidote. From another German, Fichte, he derived the idea of the man of letters as the prophet of this transcendent order, whose mission it was to make men aware of that order and of its demands upon them. Goethe was to him the supreme example of how that mission might be performed; and inevitably he came to see himself as sharing the same calling. 'Doubtful it is in the highest degree', he wrote about 1830, 'whether ever I shall make men hear my voice to any purpose or not. Certain only, that I shall be a *failure* if I do not' (FF II 81).

There is a danger that all this may sound very abstract, as indeed, in its philosophical origins, it no doubt is. But Carlyle's gift for metaphysics was limited, and his mind was intensely concrete. His rediscovery of what I have called the transcendent order of things, and his insistence that it alone was the source of all reality and of all true value, was combined with an emphatic insistence that it was only through its reflections in this world that it could be discerned, and only by activity in this world – by practical work – that its demands could be met. It is here, no doubt, that the influence of his childhood Puritanism shows most clearly through the German surface. Life to Carlyle was intensely earnest – 'Ernst ist das Leben' was one of the quotations from Goethe that was most frequently on his lips; dilettantism was one of the mortal sins. The supreme justification of a man's life was honest work, solidly performed. In the stout masonry of a bridge that his father had built he saw the symbol of a life properly lived. For all his harsh criticism of the self-seeking materialism of the

industrialists of the early Industrial Revolution, the disciples of Mammon, they were preferable in his eyes to the landed aristocracy because they worked, they *did* something: asked to justify their existence, they could at least point to Manchester and to uncountable millions of cotton shirts, where the landed aristocrat could point to nothing but a row of dead partridges.

In the early 1820s Carlyle began by degrees to work himself out of the pit of depression and ill health into which he had fallen, and to make out with more certainty the path that lay before him. In retrospect, he himself came to lay particular stress upon a moment of illumination, akin to a religious conversion, that came upon him in Edinburgh in the summer of 1821 or 1822, as the crux of his recovery. In fact, the process seems to have been more gradual; but its reality is not in doubt. Although the ravages of dyspepsia and an excessively sensitive nervous system haunted him throughout his life, at least the intellectual and spiritual agonies were triumphantly overcome; he knew what he believed, and never thereafter doubted it. The discovery of German literature was not the only factor in this recovery, but it was a crucial one. His widening range of personal friendships was also important. Loneliness is one of the penalties of genius, and, given the humbleness of Carlyle's social background, it is not surprising that for years he had to find his friends among his intellectual inferiors – an experience that undoubtedly reinforced the tendencies to pride and contempt which had been apparent since his youth. But in the world of Edinburgh he began to make contact with men who could match him intellectually, and who on their side could recognise in him a young man with capacities far above the ordinary.

By near unanimous testimony, Carlyle was an extremely impressive person: a tall, raw-boned figure of compressed and formidable strength of character, of complete spontaneity, of great originality, and of brilliant and vivid powers of self-expression. As these powers began to approach their full unfolding in the 1820s, recognition of his genius grew. It was greatly aided by the friendship of his Annandale compatriot Edward Irving, who had known Carlyle throughout his blackest years. Irving was a few years Carlyle's senior, and himself a man of considerable intellectual attainment; he sensed the quality of Carlyle's mind very early, and

gave him warm, generous help and encouragement throughout his years of depression. In the early 1820s Irving was starting on the meteoric career in the Church which was to lead him to brief fame and public sensation as a millennialist preacher in London, soon and tragically succeeded by ostracism, mockery and an early death. It was through him that in 1822 Carlyle was introduced to a distinguished Anglo-Indian family, the Bullers, and became tutor to their two sons. This tutorship lasted two years, and marks an important turning-point in Carlyle's career. He was proud, touchy, morbidly sensitive, and very difficult; but the Bullers had the insight to see through this and to recognise his exceptional qualities. They treated him with great consideration, and the two boys became devoted to him, especially the elder, Charles Buller, himself destined for a brief but distinguished career in politics. The Bullers gave Carlyle his first entrée to upper-class English society; they were also responsible for his first visit to London (in 1824) and his first visit to the Continent, a week spent with them in Paris. For all this, Irving was responsible; but he was also responsible for the far more fateful introduction of Carlyle to Jane Welsh.

Jane Welsh was the daughter of a prosperous doctor in Haddington, a country town outside Edinburgh. Irving had been her tutor, and there seems little doubt that they had been in love with each other; but Irving was already pledged to another woman. He introduced Carlyle to the Welsh household in 1821, and it was not long before Carlyle too fell in love with her. By all accounts she must have been enchantingly attractive, if not beautiful, with brilliant qualities of mind — witty, pert, vivacious, mercurial and elusive. She had a passion for education and self-improvement, and sensed at once that in Carlyle she had found a man who could uniquely guide her to what she wanted; but it took him five years of hard wooing to convert this unofficial mentorship into her own and her mother's hard-won consent to their marriage. It was to be one of the most fateful and controversial literary marriages of the nineteenth century, and argument has raged over it ever since. Jane Welsh was a brilliant woman, as the distinguished circle of friends who for so many years frequented the Carlyles' 'at home' evenings in London eagerly testified. It was her misfortune that

21

she was endowed with a nervous sensibility almost as acute as Carlyle's own, and a hypochondria that exceeded his; for the last thirty years of her life she was a martyr to headaches and insomnia. The Carlyles had no children; it was a devoted marriage, but latterly it was also for her a tormented one, and it can be, and has been, read in many ways. It can be said that for two people of such temperaments, life together could never have been easy anyway. Equally, feminists have interpreted the marriage, not altogether implausibly, as a typical example of male tyranny and female subjection. It is certainly true that Carlyle's attentions to Lady Ashburton in the 1840s and 1850s did nothing to make his wife's lot easier, harmless though they appeared in his own eyes. Froude, Carlyle's latter-day friend and biographer, hinted that Carlyle was impotent and that the marriage was never consummated, which, if true, would certainly account for its tensions; but the evidence, such as it is, seems to give him little support. It remains true that the early years of the marriage at least seem to have been idyllically happy, that the element of love on both sides remained strong and genuine, and that after Jane's death in 1866, the whole story of the remaining fifteen years of Carlyle's life goes to prove the truth of the words he put on her tombstone, that the light of his life went out with her.

By the time of their marriage in 1826, Carlyle was modestly but firmly established in the literary world of Edinburgh, and was beginning to make a name for himself further afield as a translator and critic of German literature. His first public appearance in this role was an essay on 'Faust' published in 1822, followed by a much more substantial series of articles (later republished as a book) on Schiller, and a translation of the first part of *Wilhelm Meister*. Public awareness of the significance of the German literary renaissance was just awakening in England, thanks to the spadework of earlier critics and translators and above all of Coleridge (whom Carlyle met in his old age, but to whose achievement he did a good deal less than justice). Carlyle therefore found the ground to some extent prepared, and his work had a ready market; but he nevertheless deserves a large share of the credit for transforming the attitude of the educated English public to German literature (and above all to the work of Goethe) in the second quarter of the

nineteenth century. Between 1822 and 1832 he published some twenty major essays in this field, and although he only fleetingly returned to it afterwards, it is important that it was in this intermediary, rather than creative, role that his name was first made. Editors, aware of the growing public interest in the subject, welcomed his work, and through it he became known to several of the most influential of them, including Francis Jeffrey of the *Edinburgh Review*.

The *Edinburgh*, founded in 1802, was the leading organ of liberal ideas in the country, and had set the example for a number of other 'Reviews', which by the 1820s were the most influential section of the British periodical press. The 'reviews' of which they consisted were often long essays only slimly related to the books they were supposedly reviewing. This was a literary form capable of brilliant exploitation, and in the 1820s there was no better way for a young man of literary aspirations to make himself known to the reading public than through the *Edinburgh* and its great Tory rival, the *Quarterly Review*; the most dazzling example of a reputation made in this way is Macaulay. Carlyle lacked Macaulay's advantages of a brilliant Cambridge career and a footing in the upper classes, and his literary range at this time was much narrower; but it was the Reviews, and especially the generous, though not uncritical, patronage of Jeffrey that enabled Carlyle to support himself and his wife, and gradually to acquire a literary reputation that by 1834 made a move to London feasible. The yoke of working for periodicals, and especially the necessity of subjecting his work to the varying political and literary whims and crotchets of their editors was always irksome to Carlyle, all the more so since his opinions and his style became increasingly idiosyncratic and more and more alarming to editors in the later 1820s; but he had good reason to be grateful to the Reviews, for it is hard indeed to see how else he could have built a literary career.

The first part of the Carlyles' married life was spent in Edinburgh, where their vivid personalities and the quality of their conversation swiftly made their modest house the centre of an extremely lively intellectual coterie, forerunner of their later and much more famous one in London. But Carlyle's income from his writings was both small and precarious. During the 1820s he made

several abortive applications for academic posts; but although his abilities could easily have justified such an appointment, he was probably always too much of an original and too anxious for a wider audience to have fitted comfortably into the Scottish academic world. It was poverty more than anything that drove them to leave Edinburgh in 1828 and move to the very remote farmhouse of Craigenputtock in Dumfriesshire, which had been left to Jane at her father's death. Craigenputtock was within comfortable range of Carlyle's family in Annandale, and for their first two years there they had the company of Carlyle's brother Alexander, who farmed the land. They were completely isolated there from the literary world, if also from the noises and trials of urban life which bore so heavily on Carlyle's nerves. This isolation was broken only twice in six years, by prolonged visits to London in the winter of 1831–2 and to Edinburgh early in 1833, and it became increasingly unendurable as time went by. Visitors to Craigenputtock were few and far between – though they did include Jeffrey and his wife, in 1828, and in 1833 the young American Transcendentalist R. W. Emerson. Emerson had read and greatly admired Carlyle's review articles, and it was he who originated the strong and enduring tradition of American admiration of Carlyle's work.

The stream of Carlyle's thought and writing was flowing broader, deeper, and stronger with the years. The range of his articles widened, at first to British and French authors, with notable essays on Burns in 1828, on Voltaire in 1829, and on Diderot and Johnson in 1833, and then to social and historical subjects, with 'Signs of the Times' in 1829, 'On History' in 1830, 'Characteristics' in 1831 and 'Cagliostro' in 1833. Increasingly, he grew impatient with the limitations of review work, feeling that he could only achieve complete self-expression through a book of his own. He had already, in 1827, attempted a novel (*Wotton Reinfred*), heavily autobiographical in content and owing a good deal to *Wilhelm Meister*; but fiction never suited his talents (or his tastes) and he soon abandoned it. The remarkable span of Carlyle's mind made the finding of a suitable literary form, as of a suitable career, unusually difficult. In 1830 he contemplated the idea of a major historical work on Luther, but had to abandon it since a trip to Germany was beyond the Carlyles' means. Instead,

in the autumn of 1830, he started work on what was to become *Sartor Resartus* and over the winter of 1831–2 he paid a visit to London in the hope of finding a publisher for it. In this he failed, but the visit was extremely important to him (and to Jane, who later joined him in London) for other reasons. He was present in the capital at one of the peaks of the Reform Bill crisis, an experience which gave him an altogether new insight into the problems of English society. He started to build up a richly talented group of friends among the London intelligentsia. He became aware of the extent to which the ideas he had been propagating in his review articles over the last decade had begun to wake an echo in some of the liveliest minds of the new generation. He found himself for the first time with a circle, not merely of admirers, but of disciples, whose allegiance was the more flattering because of their own exceptional abilities. Outstanding among them was the young John Stuart Mill, just then experiencing a strong emotional revulsion against the arid Utilitarianism of his upbringing. Mill hardly knew what to make of Carlyle, but he recognised him at once as the most formidable moral and intellectual force he had yet encountered. Their friendship was close, and until they drifted apart at the end of the 1830s it was one of the most interesting crossroads in the development of nineteenth-century English ideas.

The Carlyles returned to Craigenputtock in the spring of 1832, their departure from London hastened by the death of Carlyle's father. But they were never at ease there again. The experience of the intellectual life of London, and of the easy contact with editors and publishers that could only be found there, made the isolation of Craigenputtock unendurable. *Sartor* was finally accepted for publication in instalments in the newly-founded *Fraser's Magazine* in the autumn of 1833. On the strength of this, in the spring of 1834, the Carlyles made the decision to risk a move to London, in spite of the economic uncertainty it involved. In June they settled into the house in Cheyne Row, Chelsea, then a rural suburb of London, in which they were to spend the rest of their lives; and in July Carlyle started work on what was to become *The French Revolution*.

2 Sartor Resartus

The publication of *Sartor Resartus* in *Fraser's* contributed little to either Carlyle's purse or to his reputation, for such attention as it attracted from the magazine's readers was almost uniformly unfavourable. In England, except among the small circle of Carlyle's admirers, the waters closed over it without a trace. In so far as it found an audience at all, it was, thanks to Emerson's efforts on his friend's behalf, in America, where it was published as a book in 1836. In England it was only in 1838, after the success of *The French Revolution* had established Carlyle's name in 1837, that a similar edition appeared. *Sartor* has long since triumphed over its critics. To a modern judgement it is one of the most unquestionable works of genius written in English in the entire nineteenth century. But it remains a ruggedly difficult book to approach, and it is easy to understand the incomprehension and hostility that greeted its first appearance. In novelty of style, diction and form it posed a challenge to its readers only comparable to that posed by *Ulysses* in the twentieth century.

Sartor Resartus is a weird Romantic masterpiece which defies either classification or summary. It has sometimes been called a novel, but it strains even the highly elastic modern concept of that form, let alone the early nineteenth-century one. It was Carlyle's first full-scale proclamation of 'natural supernaturalism', of the newly-recovered Idealism that he had learned from Germany. This alone still sounded strange enough to most English readers in the early 1830s; but it is the form of the book that is truly extraordinary. It appears at first to be an account, by an admiring but dubious 'Editor', of a work by an outlandish German philosopher, Diogenes Teufelsdrockh ('Devil's Dung'), Professor of Things in General at the University of Weissnichtwo ('Don't Know Where'), on the 'Philosophy of Clothes'. The 'Philosophy of Clothes' turns out to be a brilliantly ingenious and amusing metaphor for Carlyle's Idealism, clothes being the symbol of the real world which at once

disguises and conceals, but also reveals and expresses, the ideal world (the 'body') beneath. The metaphor is twisted and turned and held up to the light successively in innumerable different ways and senses, with the breathtaking swiftness and ingenuity of a conjuror; but, tantalisingly, we are given Teufelsdröckh's work only in quotations and in paraphrases, interspersed with lamentations from the 'Editor' about the outlandishness of Teufelsdröckh's ideas and style. Half-way through, he sets about trying to clarify these by attempting a biography of Teufelsdröckh based on a mass of fragmentary jottings sent to him by a friend in Weissnichtwo – a section which in part clearly reflects Carlyle's autobiography.

All this is weird enough, but the effect is heightened by the extraordinary style. This had been developing by degrees in Carlyle's review essays in the later 1820s, as he acquired more confidence in himself and a greater readiness to break with the canons of Augustan English inherited from the eighteenth century. But it was in *Sartor* that a fully-developed 'Carlylese' first saw the light of day; and it is small wonder that readers were bewildered. They had to cope not only with a cast of characters including such unfamiliar figures as Herr Towgood, the Hofrath Heuschrecke, and an Angelic Smuggler who appears at the North Cape and tries to push Teufelsdröckh over the edge of the cliff, but with an English prose capable of such baroque effects as these:

'In the mean while, is it not beautiful to see five-million quintals of Rags picked annually from the Laystall; and annually, after being macerated, hot-pressed, printed-on, and sold, – returned thither; filling so many hungry mouths by the way? Thus is the Laystall, especially with its Rags or Clothes-rubbish, the grand Electric Battery, and Fountain-of-Motion, from which and to which the Social Activities (like vitreous and resinous Electricities) circulate, in larger or smaller circles, through the mighty, billowy, stormtost Chaos of Life, which they keep alive!' – Such passages fill us, who love the man, and partly esteem him, with a very mixed feeling. (S 34–5)

The Editor's qualifying reservation at the end of this passage is typical; but, though he himself usually writes in a somewhat soberer style, even he is capable of such strange apostrophes as this:

Consider, thou foolish Teufelsdrockh, what benefits unspeakable all ages and sexes derive from Clothes. For example, when thou thyself, a watery, pulpy, slobbery freshman and new-comer in this Planet, sattest muling and puking in thy nurse's arms; sucking thy coral, and looking forth into the world in the blankest manner, what hadst thou been without thy blankets, and bibs, and other nameless hulls? A terror to thyself and mankind! (S 45)

The origins of this rambling, turbulent, ejaculatory, vastly self-indulgent and metaphorical style have been much discussed. Rabelais, Sterne and Jean Paul Richter are the models most often mentioned, and the Germanisms, such as the regular use of the second person singular and the employment of capitals at the beginning of words, are obvious. Carlyle always insisted that the style was not artificial but natural, and derived from the pithy and vehement speech of his elders, especially his father, in Annandale; but this can only be true of its remoter origins. There has likewise been great debate as to whether it is one of the best or one of the worst styles in English, and on this no agreement is possible. What can be said is that, for better or worse, the style is unmistakable, and satisfies to a remarkable degree Carlyle's own criterion for style, that it should fit its author like a skin. This is style in its extreme Romantic form, designed to conform to no established canons, but seen purely as a medium of self-expression. Few would deny that it is capable of moments of great beauty – as in a familiar passage from *Oliver Cromwell* describing the night before the battle of Dunbar:

And so the soldiers stand to their arms, or lie within instant reach of their arms, all night; being upon an engagement very difficult indeed. The night is wild and wet; – 2nd of September means 12th by our calendar: the Harvest Moon wades deep among clouds of sleet and hail. Whoever has a heart for prayer, let him pray now, for the wrestle of death is at hand. Pray, – and withal keep his powder dry! And be ready for extremities, and quit himself like a man! – Thus they pass the night; making that Dunbar Peninsula and Brock Rivulet long memorable to me. We English have some tents; the Scots have none. The hoarse sea moans bodeful, swinging low and heavy against these whinstone bays; the sea and the tempests are abroad, all else asleep but we, – and there is One that rides on the wings of the wind. (L II 205)

But whatever is to be said about Carlyle's style, it was unquestionably not likely to win easy acceptance from the public. The

same was true of *Sartor*'s baffling and elusive form. More than a century after it was written, it is possible to see it in context and to realise that Carlyle is looking back mockingly on his own past as a review writer, from which *Sartor* marks a decisive departure, and in doing so making brilliant imaginative use of the conventions of the review. Even Teufelsdrockh's biography, in Book II, reflects the form which Carlyle had evolved for his major review articles of the late 1820s; this was a combination of a life-history of the writer with an analysis of his writings, the two being inseparable to Carlyle – the essays on Burns and Johnson are excellent examples. *Sartor* is a fictitious review article in which, bafflingly, the author identifies with the reviewed rather than the reviewer. The 'Editor' becomes the voice of the doubting British public, or of the best-inclined portion of it; in so far as Carlyle's voice is heard in the book at all, it is in the words of Teufelsdrockh. The devices by which Carlyle conceals his own position and identity in the book are, among other things, the stratagem of a proud man discounting in advance the incomprehension and the hostility which he anticipated in his readers. But these devices create a strange sense of receding identities which remarkably anticipates some typical forms of twentieth-century consciousness; and they clearly had enduring significance for Carlyle, for throughout his later writings he continued to use the device of inventing imaginary, usually German, professors as mouth-pieces for some of his own rhapsodical and high-flown utterances.

The formal and stylistic originality of *Sartor* are thus not in doubt. The content is another matter. *Sartor* is important because it represents the first connected setting-out of the thematic ideas that run through and dominate all Carlyle's later work. In it, as he himself says of Teufelsdrockh, 'his character has now taken its ultimate bent, and no new revolution, of importance, is to be looked for' (S 162). With one major reservation, which we shall come to, he appraised his own future intellectual development to a nicety in these words. The relative emphasis he laid on the various themes was to shift considerably; but the themes themselves are all there in *Sartor*. There is the central point of the 'Philosophy of Clothes', the Idealism that he had learned from his German reading: the idea that the material order of things repre-

sents only a projection, or, to use Carlyle's own term, a 'bodying-forth', of a spiritual order, the only ultimate reality, which under-lies it. The material order is limited by time and space, but these are themselves illusions, concealing the realities of Eternity and Infinity. Man is essentially a spiritual being, and his affinity is with the spiritual order; but the spiritual can only be approached through the material, and man's function in this world is to bring the material world into greater consonance with the spiritual by the medium of earnest work (like the bridge his father had built), or, to vary the metaphor, to make the material world more transparent so that the spiritual can be discerned through it. This is a mission imposed upon man by his nature. Any attempt to elude it (for example, by pursuing nothing but the satisfaction of one's own appetites and vanities, or by caring purely for the appearance of one's work rather than for its solid worth) is blasphemous and, ultimately, self-destructive. Man, therefore, works in the material world, but it is crucial that his efforts should be guided and illuminated by a sense of the spiritual reality under-lying it, a sense that is all too easily and frequently lacking. In a healthy society, all men will feel it naturally; but already in *Sartor* there is visible the germ of an alternative idea that was to grow out of all proportion in Carlyle's later work, the idea of 'hero-worship'.

This was something that Carlyle had learned in the first place from Fichte, with his idea of the 'learned man' as the interpreter of the Ideal to the mass of men unable to discern it for themselves. For Carlyle similarly the Hero performs the traditional role of the Priest, the interpreter of God's will to man. The Priest himself was no longer available for this role, for Carlyle never recovered his faith in orthodox Christianity, and to him all existing Churches and religions were systems of cant, of organised hypocrisy, profess-ing beliefs which they no longer sincerely held, worshipping symbols which had in their time been valid but which had now become hollow shells. But the Hero in any case was a broader concept than the Priest. In *Sartor Resartus* he is still primarily the writer and teacher, as he had been in Fichte; but he can also be the king, and later Carlyle was to recognise him in still other roles. But his essence is still to be the messenger of the divine to men. He has insight into the ultimate spiritual reality to which most

men are blind, and all good men – in a good society, all men – will sense the fact, following him willingly, because only in conformity to the dictates of that ultimate spiritual reality does freedom lie.

These are the common themes of all Carlyle's writings after *Sartor*; and, looked at in the cold light of day, they may well seem a nebulous and unremarkable lot, affording a poor foundation for any claim to greatness for their author. They are not more than lukewarm German Idealism, crossed with a dash of Carlyle's native Puritanism. The criticism can only be accepted; indeed, it must be taken further. Carlyle's whole bent of mind was antipathetic to precision of argument and to systematic reasoning. That he was *capable* of these things has to be accepted – he had, after all, been a geometer of distinction in his Edinburgh days; but one seeks in vain in his writings for any passage of close reasoning. It is impossible to make any serious claim for him as a philosopher (nor, indeed, did he make it for himself). Already in *Sartor* his tendency to prefer vague metaphysical uplift to analytical rigour is disconcertingly apparent, as may be detected easily enough in the foregoing summary of his ideas. Moreover, as we have seen, he was not even an accurate transmitter of the ideas of his German mentors. He repeatedly distorted and coarsened their distinctions and definitions, usually in the interest of deriving a simpler moral message from them; and it is most unlikely that Kant, Fichte, or perhaps even Goethe, would have recognised the 'Philosophy of Clothes' of *Sartor* as a legitimate deduction from their ideas. Carlyle's habitual method was to seize on isolated ideas and phrases from their work – *Entsagen* (renunciation), *Selbsttodtung* (self-annihilation), *Ernst ist das Leben* ('Life is earnest'), and so on – lift them out of context, and reinterpret them in ways that suited him, which is certainly not a widely approved recipe for constructive academic enquiry.

But *Sartor* cannot be assessed purely in terms of its academic content, and this has been recognised during the century and a half since it was written by the way in which it has been quietly handed over from the realm of philosophy to that of literature. Carlyle habitually thought with his imagination, jumping from one association to another. His genius lies, not in conducting his readers along a carefully-graduated series of argumentative steps

31

towards an irresistible conclusion, but in putting two or more seemingly very different objects or situations unexpectedly next to each other, in sudden and blinding juxtaposition, and forcing the reader, even unwillingly, to recognise likenesses where he had seen none before. It was in the realm of the imagination that his supreme talent lay, and *Sartor Resartus* marks a critical point of his development because it was here that he first fully recognised and published the fact. In his essay of 1827 on the 'State of German Literature' he had been at pains to establish the central, Kantian distinction of German Idealism, between *Vernunft* and *Verstand* – Understanding and Reason, as Coleridge had Englished them. In *Sartor* this distinction nowhere appears (nor does it reappear in later works). It is replaced by a broader distinction between logic on the one hand, and intuition and imagination on the other, to the invariable advantage of the latter. 'Wouldst thou plant for Eternity,' he says, 'then plant into the deep infinite faculties of man, his Fantasy and Heart; wouldst thou plant for Year and Day, then plant into his shallow superficial faculties, his Self-love and Arithmetical Understanding, what will grow there' (S 179).

These claims for the primacy of the imagination are not wholly original. They had been anticipated, in particular, by the first two generations of English Romantic poets, by Wordsworth, Coleridge, Keats and Shelley. But there is no evidence that Carlyle's ideas were derived from them, and although during his residence in London in 1824–5 he was for a time on the fringe of the circle that imbibed Coleridge's Idealism from the lips of the ageing poet at Highgate, he showed little interest in their work. From his own experience, Carlyle derived a conviction of the fundamental importance of the hidden depths in human nature, accessible not to the persuasions of reason and calculation, but only by appeals to the imagination, above all through the use of symbols. In his brilliant essay from the same period, 'Characteristics', the central theme is the superiority of the unconscious element in man to the conscious, a theme crystallised in a series of memorable epigrams: 'In our inward, as in our outward world, what is mechanical lies open to us; not what is dynamical and has vitality'; 'Manufacture is intelligible, but trivial: Creation is great, and cannot be understood' (E III 4,5). At times, in his best work of the 1830s, Carlyle

can be felt groping intuitively for concepts of the subconscious mind and the mass unconscious that have had to wait for the twentieth century for their development. These doctrines, of the primacy of the unconscious and of thinking with the imagination, have come into bad odour in this century, because of their associations with totalitarianism, especially in its Nazi and Fascist forms. In the 1940s Carlyle was not uncommonly put into the dock as one of the intellectual ancestors of Fascism, and for the later Carlyle there may be some truth in the charge; of the Carlyle of *Sartor* and the 1830s, it is true only in so far as he adumbrated some truths about human nature of which Fascism was later to make brilliant and wicked use.

There is another sense also in which *Sartor* heralds a definitive change in the direction of Carlyle's thinking. Mention has already been made of a growing interest in social issues which can be discerned in his choice of topics for his periodical articles. In 'Signs of the Times' in 1829, and then in 'Characteristics' in 1831, he had appeared in the new role of social critic. This is not something he had learned from the Germans, and indeed there is little sign of it in him before 1829. It is true that the subjects of his review articles, imposed upon him by the editors of the periodicals, afforded small opportunity for social criticism; but it is absent even from his correspondence. As the educated son of a poor man, and as one who both felt and resented the difficulty of wringing acceptance for himself and his views out of the literary establishment, he might seem to have the equipment of an angry young man; the example of Cobbett shows the opportunities that existed for social criticism in the years of bitter hardship and social tension between 1815 and 1821. But Carlyle at this time was wrapped in his personal agonies, and apart from one fleeting glimpse in the *Reminiscences* he wrote in his old age, there is nothing to show that he took any part in the conflicts of that time. Carlyle's advocacy of German literature did however lead him to a low estimate of the English society which so grossly underestimated it and at the same time so signally failed (in his eyes) to produce any worthwhile literature of its own. 'Signs of the Times', his first general indictment of contemporary society, already reveals his remarkable ability to identify the characteristics of a society's

moral and intellectual condition — an art all the more difficult when, as here, it is a contemporary society that is being described. In 'Signs of the Times' it is the prevailing emphasis upon mechanism, both literal and metaphorical, that he seizes upon as typical of the age: 'Men are grown mechanical in head and in heart, as well as in hand. They have lost faith in individual endeavour, and in natural force, of any kind. Not for internal perfection, but for external combinations and arrangements, for institutions, constitutions — for Mechanism of one sort or another, do they hope and struggle' (E II 63). This emphasis upon the mechanical to the exclusion of the dynamic, the neglect of the unconscious and instinctive sources from which human creativity springs, was for Carlyle a sure sign of disease. There is also an implication here of an organic notion of society which, although never consistently held, is nevertheless typical of much of Carlyle's social criticism. Society is not a mere collection of individuals, but a living entity which can be healthy or sick as a whole. This mode of thinking, which he had undoubtedly learned from his German reading, is fundamentally opposed to the individualism of the Enlightenment. At this time, though, the criticism of society is confined to its intellectual tendencies; there is nothing as yet about economic hardship or social conditions.

The same is true of the more far-reaching and ambitious essay on 'Characteristics', written in the autumn of 1831; but by this time Carlyle's attitude to social problems was undergoing a change, due chiefly, it seems, to two influences. In the summer of 1830 he had come into contact with the Saint-Simonians, a group of idealistic young reformers in Paris who curiously combined a demand for a new religion with a demand for far-reaching social reform. The combination, though, was attractive to Carlyle. In the winter of 1830–1 he went so far as to translate *Le Nouveau Christianisme*, the key work of Saint-Simon, the group's founder. His translation was never published, and his contact with the group was short-lived. Goethe advised him against it, and Carlyle himself had never been able to swallow their strange synthetic brand of religion; but it does appear that they played some part in directing his attention to poverty as one of the most prominent and menacing problems of contemporary society.

The second influence working in this direction is less question-able: it was the experience of living in London in the winter of 1831–2, a period of severe social distress when the Reform Bill crisis was at its height. His letters are full of the issue, and there is no doubt now where his sympathies lie. Carlyle was always at his best in the presence of suffering; there could be a surface grimness in his manner, but beneath it there was a very tender heart (during the 1830s he was never anything but a poor man, but his corres-pondence often contains references to small private acts of charity, usually anonymous).

The hardships of the poor, as he became aware of them in London that winter, touched him; but they did more than that. He began to see the gratuitous suffering inflicted upon the poor, through no fault of their own, as an injustice for which society, and in particular the ruling classes, would have to answer bitterly. An apocalyptic note begins for the first time to creep into his writings. Already in 'Signs of the Times' he had recognised that 'there is a deep-lying struggle in the whole fabric of society; a boundless grinding collision of the New with the Old' (E II 182). Already in 'Characteristics' he had declared that 'the Physical derangements of Society are but the image and impress of its Spiritual' (E III 22). Now, in *Sartor*, he is never more at one with Teufelsdrockh than in the scene in the Green Goose tavern in Weissnichtwo where the philosopher raises his beer-mug and, to thunderous applause, proclaims 'The Cause of the Poor, in God's name and the Devil's!' (S 11).

In the later chapters of the book he proclaims his admiration for only two human types, the inspired artist and the 'toilworn Craftsman'. He declares the decadence of a society in which the poor perish 'like neglected, foundered Draught-Cattle, of Hunger and Overwork' (S 185); and, with a savagery learnt from Swift, he proposes as a cure for over-population an annual three days' hunting season for the shooting of paupers. 'The expense were trifling: nay the very carcasses would pay it. Have them salted and barrelled; could you not victual therewith, if not Army and Navy, yet richly such infirm Paupers, in workhouses and elsewhere, as enlightened Charity, dreading no evil of them, might see good to keep alive?' (S 183). In his 'Dandies' and 'Drudges' he anticipates

the class divisions which were to form one of the major themes of *Past and Present*. There was a formidable indignation at social injustice rising in *Sartor Resartus*; and in the years that followed it was to become the keynote of the message that Carlyle felt himself called to announce to England.

3 Recognition

The publication of *Sartor Resartus* marked an epoch in Carlyle's own intellectual development. It did not mark the achievement of any widespread public recognition. For the next three years the Carlyles, settled now in their house in Cheyne Row, lived very thriftily; the household was kept afloat by Jane's sharp-eyed housekeeping, while her husband set himself to the history of the French Revolution which for some years now had been looming up in his mind. Carlyle several times looked, always in vain, for some regular employment which might provide a little more financial security while he worked on the book; these were years, too, of recurring afflictions, neurotic or otherwise – biliousness for him, headaches for her, sleeplessness for both. Writing was always as much an agony as a necessity for Carlyle. His correspondence rings with his groans over the difficulty of obtaining books, the dullness and obtuseness of his sources, the sense of an immense burden laid upon him, the mental darkness through which he had to grope his way in trying to shape his material. Yet in many ways they were happy years. The Carlyles picked up again the threads of the friendships they had formed in London in 1831–2, and to both of them the opportunity for companionship with men and women of their own tastes, interests and abilities came like a breath of life after the rustic isolation of Craigenputtock. Carlyle had a genius for friendship; this is perhaps less true of Jane, but she had an immense zest for companionship, and in her own right ranked high among the most brilliant and witty talkers in London. In combination they were irresistible, her wit setting off Carlyle's intense moral earnestness and broad humour; and there rapidly gathered around them a coterie of the best minds and literary talents in London, especially those of the rising generation.

The twin decisions to settle in London and to start work on *The French Revolution* can be seen now to have represented the final point of decision for Carlyle; coming as they did almost at the

mid-point of his life, they determined the direction that the rest of it would take. In the words that Carlyle used to describe a similar crisis in the life of his friend John Sterling, 'a crisis in life had come; when, of innumerable possibilities, one possibility was to be elected king, and swallow all the rest' (J 71). For Carlyle the alternative possibilities were, if not innumerable, at least very numerous: he might have been mathematician, moral philosopher, literary critic, perhaps civil servant. But the decision to write *The French Revolution* confirmed that it was as a historian, a moralist and a social critic that Carlyle was to establish his public reputation; and he and Jane were to live and die in Cheyne Row.

Carlyle's increasing absorption, in the years before 1834, in the problems of British society makes the continued importance of this theme in his work unsurprising. But his appearance as a historian calls for more comment, for of his writings before 1834 only the essay on 'Count Cagliostro', which appeared in 1833, and the two essays on history of 1830 and 1833 could be described as falling within this field. Many of his review essays, certainly, had shown a considerable knowledge of the eighteenth-century background, and an interest in relating the authors he was discussing to the moral and intellectual condition of the society in which they worked; but fundamentally they remained within the field of literary criticism. Nevertheless, Carlyle's interest in history was life-long, and he had read deeply in it since his university days. If he had not published any historical works hitherto, this was mainly because the urgent demands, first of finding a way out of his own spiritual crisis, and then of accommodating himself to the demands of review editors in order to make a living, had diverted him in a different direction. Even so, in 1821 he did considerable reading with a view to writing a history of the English seventeenth-century Civil War and Commonwealth – a theme which was to haunt him until it finally found expression in his *Oliver Cromwell* a quarter of a century later; we have just seen that in 1830 he was contemplating a book on Luther; and in the winter of 1833–4 the rival possibilities of books on either Knox or the French Revolution were jostling each other for priority in his mind. It is clear, therefore, that the decision to devote himself entirely to the writing of a major historical work did not in itself involve any

great change of direction for Carlyle. Nevertheless, we must look very closely at his notion of what history was and how it should be written, for it was a very idiosyncratic notion indeed and was to give rise to a very idiosyncratic book.

Carlyle saw history on an enormously broad canvas: he was capable of claiming, not only that history was 'the most profitable of all studies', but even that 'History is not only the fittest study, but the only study, and includes all others whatsoever' (E III 167, 168). Within these claims, it seems possible to identify two main, and contrasting, reasons why history came to take on this transcendent importance for him. In the first place, he had a quite exceptionally acute private awareness of the mysteriousness of Time as the transparent medium in which all human action is irretrievably stuck. He was haunted by the contrast between the lightning-fast transiency of experience and the utter impossibility of re-entering the past to retrieve it; this vision very strongly conditioned his historical writing. Some of this Time-mysticism he learned from Goethe – he frequently illustrated it by reference to the song of the Earth-Spirit from *Faust* – but it seems impossible to believe that it was not also natural to him, so often does he revert to the theme and so vivid is his expression of it. His regular visits in later life to the scenes of his childhood in Annandale became to him experiences of almost unbearable pathos because of this awareness, and are most movingly described in his letters. One of his main preoccupations in writing history was precisely the attempt to recover the lost past and to make it live again.

But history had another, and perhaps even greater, significance for Carlyle: it was a gospel, the revelation of a just providence working in human affairs. Not, certainly, a gospel that could be read simplistically; in the essay 'On History' he bids the historian 'pause over the mysterious vestiges of Him, whose path is in the great deep of Time, *whom History indeed reveals, but only all History, and in Eternity, will clearly reveal*' (E II 89, my italics); but it is nevertheless perhaps the most clearly-legible gospel for nineteenth-century man. Carlyle never recovered the simple faith in the Bible that his parents' generation had possessed, deeply though he revered it; nor did his recovery of faith through the medium of German Idealism in the 1820s give him any comparable

39

source of revelation. Rather, his faith that the workings of a just providence could be traced in history gave him a creed of his own – though certainly one that had more in common with the Puritanism of his ancestors than with the ideas of any of his German mentors.

It was, all the same, a creed that could be given an acceptably 'Germanic' colouring, by seeing in this revelation of providence in history another case of the Ideal manifesting itself in the Real. In thus replacing a faith in the Bible with a faith in History, Carlyle had good nineteenth-century company – most notably, Hegel and Marx, though he was never aware of the parallel. Nor, indeed, is the parallel by any means complete, since to both Hegel and Marx history was a progressive phenomenon. The theme of progress does sometimes occur in Carlyle's writings (especially the earlier ones), but it is very muted and eventually disappears altogether. To Hegel partially and to Marx wholly, history was an autonomous and self-justifying process; to Carlyle it was something more like a theatre for the workings of a providence which itself remains firmly outside history, and whose main concern is less to steer history as a whole to some satisfactory conclusion than to punish and counter the misdeeds and follies of human beings and human societies. Here too, though, Carlyle is inconsistent, and fluctuates between a providential view of history and a more naturalistic one, gleaned from Goethe and the Saint-Simonians, according to which societies oscillate between ages of faith and ages of unbelief. But on the whole Carlyle was much less concerned with laws of history that could not be broken than with rules of history that must not be. He was a less radical historical thinker than Hegel or Marx, and his view has as much in common with the Book of Kings as it does with a fully naturalistic scheme of history like Marx's. But he does share, if in a somewhat confused way, the typical nineteenth-century perception of time as the most significant dimension of both the natural and the human world – a perception exemplified not only by thinkers like Hegel and Marx, but, perhaps even more significantly, by scientists like the evolutionary geologists of the first half of the century and the evolutionary biologists of the second.

It is the providential view, though, that increasingly comes out

on top from the mid-1830s onward; this, of course imparts a great importance to the study of history, for, from the example of the chastisements that have been visited upon erring societies in the past, existing societies can learn to mend their ways in the present. It was on these grounds that Carlyle proclaimed the identity of history and prophecy: the Church had lost its function as the authentic interpreter of God to men and had become a mere hypocritical sham in which sincere belief was impossible. History was now the true revelation of the divine, and the inspired historian was the prophet. Carlyle went further than this: he claimed that history was not only the prophecy, but the poetry, of the modern age. Poetry for Carlyle had little to do with the writing of verse, an activity of which he had a low estimate (he thought that both Tennyson and Browning, in common with all other contemporary poets, would have done better to write prose). Its function was to take a portion of the Real, and by force of imagination to make the Ideal show through it. This, he held, was the true nature of all creative work; and in so far as history was the supreme epitome of human experience, the writing of history represented the highest form of poetry. This eccentric claim makes more sense if seen in the context of the peculiar qualities of Carlyle's genius. His supreme faculty was the imagination, and it dominated his thinking. Since the imagination is the great Romantic faculty, this justifies us in seeing Carlyle as one of the central figures of English Romanticism; central, but not typical, because the literary forms in which the Romantic imagination found most natural expression were poetry and the novel. Carlyle attempted both in his youth, but found both alien to him. His love of the concrete and the actual, as opposed to the fictional, led him to history; and he found the solution to his problem of self-expression in writing a kind of history based not, as it usually has been, on the reasoning faculty, but on the imagination. In terms of his own experience, at any rate, the claim to have united poetry and history makes sense and can be justified.

Carlyle seems to have held two different underlying theories of the nature of historical writing, which may not be incompatible but certainly have no necessary connection. On the one hand, his own sensibility, reinforced by his German reading, led him to a

mystical view of time and to the idea that the function of the historian is the literal re-creation of the vanished past in the imagination of the reader. He once wrote, 'the great business for me, in which alone I feel any comfort, is recording the *presence*, bodily concrete coloured presence of things' (T IX 15). On the other hand, history was the revelation of providence, and the business of the historian was to interpret this revelation and to bring his readers to apply it to their own time and circumstances. Carlyle himself was not aware of the inconsistency; and, remarkably, in *The French Revolution* he achieved a real fusion of the two. This feat required a very high imaginative temperature, which he never fully achieved in his later historical writings, where the prophetic, admonitory element becomes more and more dominant. Both conceptions of history are far apart from those commonly current either at the time or now. Carlyle did not believe that the historian's function was to provide a smoothly flowing narrative for the entertainment of his readers, nor that history could be treated as an experimental science from which inductive laws of human behaviour could be derived, nor that rigid objectivity and detachment were either possible or desirable qualities in a historian. He defied every established canon of his own day as to how history should be written, and every canon that has been established since; and he wrote a masterpiece.

The choice of the French Revolution as his subject was in no way accidental, though, as we have seen, he had earlier considered writing on other historical subjects. But increasingly in the years before 1834 the French Revolution was shaping itself in his mind as the central fact of modern history. There was of course nothing very unusual in this perception. Fear of the Revolution and of the ideas that it had propagated was widespread among the upper classes of the Continent after 1815, and to a lesser extent this was true of Britain also. But to Carlyle, the Revolution was primarily a cause of hope rather than fear; for it was a sentence of divine justice on a corrupt society. This was an interpretation rooted deep in Carlyle's own values and in his spiritual history. The eighteenth century, to him, was the age of unbelief, of scepticism, of destructive criticism, the monstrous negatives which had inflicted upon him that dark night of the soul during his youth at Edinburgh. The

brilliant intellectual culture of the French Enlightenment was the source from which it all came, or, to use a more appropriate metaphor, the patch of desert which gradually extended itself over the whole Continent; in the Revolution it got what it deserved. 'I would not have known what to make of the world, if it had not been for the French Revolution,' he once said (FF II 18). There is no doubt an element of *Schadenfreude* in this. Carlyle never liked France; the hostility can be seen even in his accounts of his first brief visit to Paris with the Bullers in 1824, and, together with his counterposed admiration for Germany, can be traced right through his life, up to his exultation at the German victory over France in 1871. The dislike was due more than anything to the fact that, in a way very typical of Carlyle, he saw France as a symbol, a symbol of an intellectual and moral tradition that he abhorred.

The French Revolution took three years to write. To Carlyle writing was always an agonising business. *The French Revolution* in fact flowed more easily from him than either of his two later major historical works, *Oliver Cromwell* and *Frederick the Great*, and its superior spontaneity is very apparent; but it still cost an immense effort. Much of this can be traced to its dependence on his imagination, a capricious faculty far less under the control of the will than is the reason, and some of it to the difficulty of coupling the imagination to the materials of history. Carlyle was an extremely diligent and conscientious researcher, who habitually went to immense lengths to check the accuracy of his information. But, rather than coming to his research with a set of questions thought out in advance and arranging and categorising his materials systematically as he read, his method was to digest all the material available, shut it up in his imagination and let it ferment there; then, when the process was complete, it would boil out spontaneously in the form his imagination had given to it. He himself compared the process to the eruption of a volcano; and waiting for the moment of eruption could be long and agonising, all the more so because the book commonly seemed to him worthless while he was writing it. In addition, there were external problems that even a conventional historian might have found daunting. There was a constant struggle to make ends meet. His researches were greatly limited by the fact that he could not afford

a trip to Paris, and hence had to work entirely from printed sources available in England; and on top of that, he was unable to make use of the British Museum's unrivalled collection of French Revolutionary pamphlets, owing to a quarrel with the vain and irritable librarian, Panizzi. To crown everything, when the first (of three) volumes was complete in manuscript, and was lent to John Stuart Mill (who more than anyone had encouraged him to undertake the work) to read, by some accident it was mistaken for waste paper and burnt. Carlyle had destroyed all his notes; but real calamity called out the best in him, as it always did. His immediate reaction was sympathy for the shattered and inconsolable Mill, who insisted on paying Carlyle for the time lost in working on the volume. Then, with a resolution that deserves to be called heroic, he sat down and rewrote it.

The French Revolution was published in 1837. It was preceded by two lengthy narrative essays, 'The Diamond Necklace' and 'Mirabeau', themselves sufficiently remarkable, which can be seen as by-products of his work on the book. 'The Diamond Necklace', in particular, anticipates many of the characteristic narrative devices of *The French Revolution*. But inevitably it was the book itself which attracted most attention. It was not an instantaneous popular success, which is not surprising, for Carlyle had made no concessions to his readers; but the reviews were generally favourable, and some very distinguished literary figures, Thackeray outstanding among them, were outspoken from the first in their verdict that, beneath all its shocking originalities of form and style, the book was a masterpiece. The sales gradually gathered way, and Carlyle's reputation with them. *The French Revolution* certainly did not make Carlyle a rich man (he never was one); but it gave him an established literary reputation and status that he never lost, and to its abler readers it spoke a message that they had, consciously or unconsciously, been long waiting for, and that many of them remembered to the end of their lives.

The French Revolution is a very strange history indeed. It is, to begin with, a work of high Romantic art, which means that, far more than any normal work of history, it cannot be detached from its author. 'The Book is one of the *savagest* written for several centuries', Carlyle himself said; 'it is a book written by a *wild*

man, a man disunited from the fellowship of the world he lives in: looking King and beggar in the face with an indifference of brotherhood, an indifference of contempt' (FL I 96). Contempt always came somewhat too easily to Carlyle, and there is an element of posing here; nevertheless it is not an unfair comment on the book, and its implication that the book is primarily a projection of the author is revealing. Carlyle does not attempt orthodox narrative, which he always distrusted. One of the most penetrating epigrams ever uttered about history is his 'Narrative is *linear*, Action is *solid*!' (E II 89); and his solution to this problem is to break up his account of the Revolution into a series of marvellously vivid scenes of present action separated by great gulfs of darkness, periods which he passes over rapidly with the merest summary of events. This effect of extreme discontinuity reflects his own conviction that large areas of history are best forgotten. The historian's job is to concentrate on those which can still be brought alive for the present. The impression on the reader is one of violent chiaroscuro, ideally suited to reflect the lurid events of the Revolution. Carlyle's old patron Francis Jeffrey very accurately described it as 'like reading history by flashes of lightning'. Few history books, if any, have ever so perfectly matched style and subject, for Carlyle's style is itself a revolution, a deliberate wrenching break with the entire Augustan tradition of English prose writing, and in its exaggerations, its grotesqueries and its violent discontinuities exactly mirrors the events it describes. The style was subjected to strong criticism at the time, by Sterling among others, but Carlyle's reply to him was forceful: 'Do you reckon this really a time for purism of style? I do not. With the structure of our Johnsonian English breaking up from its foundations, revolution *there* is visible as everywhere else' (T VIII 135). Moreover, the effect of the style is reinforced by equally violent contrasts of scale, of close-up and distant landscape. In the midst of a lurid description of the horrors following the storming of the Bastille (one of the most famous descriptions of violence ever written), Carlyle is capable of varying his focus like this:

One other officer is massacred; one other Invalide is hanged on the Lamp-iron; with difficulty, with generous perseverance, the Gardes Francaises

will save the rest. Provost Flesselles, stricken long since with the paleness of death, must descend from his seat, 'to be judged at the Palais Royal': – alas, to be shot dead, by an unknown hand, at the turning of the first street!

O evening sun of July, how, at this hour, thy beams fall slant on reapers amid peaceful woody fields; on old women spinning in cottages; on ships far out in the silent main; on Balls at the Orangerie of Versailles, where high-rouged Dames of the Palace are even now dancing with double-jacketed Hussar-Officers . . . (R I 197)

It is a cinematic effect; abruptly, the camera soars away into the blue, till all France is spread out below it, and the chaos around the Bastille is only one speck of violent action in the landscape deep in the peace of a summer evening. Carlyle never allows the reader's attention to become totally concentrated on one plane. He is forever reminding you that, against the furious scenes of public action that capture the attention of the historian, there have to be set, on the one hand the multitude of private lives going quietly on, unaffected by the storm, on the other the enormous perspectives of past and future time.

The vividness of the descriptions is extraordinary. This was a characteristic of Carlyle's conversation. He always had the caricaturist's gift of dashing off a face, a character, a scene in a single compressed, pithy phrase, and he never made better use of it than in *The French Revolution*. His use of the present tense throughout thrusts both writer and reader into the thick of the action, questioning the actors, admonishing them, reconstructing the moment-by-moment revelations of a new turn of events. To an astonishing extent he actually achieves his aim, not merely to present his readers with 'hearsays of things', that is, conventional narrative, nor to pass easy judgement on them, but to thrust those readers into the 'bodily concrete coloured presence' of events, and to force them to make up their minds for themselves. Russell Lowell commented appositely that Carlyle's figures are so real that 'if you prick them, they bleed'.

A full analysis of the dazzling array of literary techniques that Carlyle deploys in *The French Revolution* would be a major undertaking; but there is one other device so characteristic of his habits of thought that we cannot overlook it. Carlyle lays great

stress on the social importance of symbols. As we have seen, he drew from his acquaintance with German thought the idea that the Ideal can only be mediated to man through the Real – that is, through symbols. Thus, Church and King are both supremely important symbols; and nothing shows better the corruption of French society in the eighteenth century than the fact that both have become hollow, have lost their symbolical force. But symbolism penetrates Carlyle's historical method itself. Book II, 'The Paper Age', is constructed round the symbol of paper: paper money, with no sufficient bullion backing; paper schemes of reform, with no prospects of being put into effect; and, as the climax, ascending from Reveillon's paper-warehouse, the brothers Montgolfiers' paper balloon, the perfect symbol of French society in the 1780s – full of hot air, unable to steer, and liable to explode. It is a dazzling piece of historiographical virtuosity; the symbol works perfectly, and involves no straining of the facts. As a historical method, it may be called arbitrary and subjective; but it shows, as few other historians have ever done, the possibilities of a historiography prepared to make full use of all the resources of a first-rate imagination.

To write a great Romantic masterpiece of the creative imagination without ever straying outside the limits of scrupulously accurate history is a very remarkable achievement indeed. But it was the intellectual content of *The French Revolution* that contemporaries found most important, and the ideas it expressed had much to do with Carlyle's establishment as a social prophet.

Carlyle presented what, to English readers at any rate, was a wholly novel interpretation of the Revolution. In the 1830s, the Revolution was still a thing of horror and unredeemed evil to educated opinion in this country; a mere volcanic upsurge of brutal violence, terrifying as a precedent, and associated with a political creed of radical democracy abhorred by all right-thinking men. Carlyle did not deny the horror and the violence – he takes no sides – and he was never at any stage of his life a democrat. But to him, all the horrors of the Revolution were no more than the natural outcome of all that had gone before. They were judgement visited on a society which had lost touch with the divine realities; a society which had denied its gods, in which all the old symbols

of the transcendent had become transparently hollow shams, in which above all the ruling class had forgotten its divinely-ordained responsibilities to those over whom it was commissioned to rule, remembering only its privileges and its pleasures. This is a theme which stands out strongly and unambiguously in the first volume of *The French Revolution*. The menacing growl of the unfed poor is present as a ground-swell in the background of all the earlier chapters. The point of departue for the book is Louis XV's deathbed – fittingly, since death to Carlyle is the supremest and sternest of all destroyers of illusions – and the king's flattering nickname, 'Louis the Well-Beloved', is ironically counterposed against the state of his kingdom, with its 'lank scarecrows, that prowl hunger-stricken through all highways and byways of French Existence' and 'in the Bicetre Hospital, "eight to a bed", lie waiting their manumission' (R I 5). The theme recurs in Carlyle's narration of Louis XV's encounter, while out hunting, with a peasant with a coffin: '"For whom?" – It was for a poor brother slave, whom Majesty had sometimes noticed slaving in those quarters. "What did he die of?" – "Of hunger": – the King gave his steed the spur' (R I 19). Hunger, bankruptcy and death are the realities that stare more and more visibly through the ragged splendours of the Old Regime in the first three books of the first volume, realities which the regime tries in vain to ignore; they are the machinery through which the divine justice works itself out. The end of them, inevitably, is violent revolution; and when the first appalling lynchings take place in the streets of Paris – the sort of horrors that dominated the English image of the Revolution – Carlyle's comment is 'Horrible, in Lands that had known equal justice! Not so unnatural in Lands that had never known it' (R I 208).

This was strong meat for English readers of the 1830s – too strong for a good many of them, to whom it seemed that Carlyle was abetting violence, at a time when violence was all too conceivable, even within England itself. Indeed, Carlyle's interpretation of the years leading up to 1789 as a time of steadily increasing hardship for the poor has not stood up well to later historical research; but this is hardly the main point. *The French Revolution* was original in that it was the first major attempt in

English both to put the Revolution into an intelligible historical context, rather than representing it as a monstrosity at odds with nature; and, on the moral level, to suggest that the old monarchical and aristocratic regime in France deserved what it got, that the economic and political crises that finally led up to the Revolution were only the symptoms of a fundamental moral failure on the part of the French ruling class. But the suggestion that a ruling class lives, so to speak, under judgement, and a judgement that sooner or later will work itself out, not in the comfortable distance of an afterlife, but here and now on earth, was a radical and dangerous one in the 1830s. It was one to attract daring and radical minds as much as it frightened middle-aged and conservative ones; and all the more when the parallel between eighteenth-century France and nineteenth-century Britain was so clearly intended by the author.

The sympathy with the suffering and neglected poor that runs through the early books of *The French Revolution* is, unmistakably, the result of Carlyle's observations in London during the winter of 1831–2. Throughout the 1830s the consciousness of social distress is one of the most consistent themes of his correspondence – a distress interpreted in the same terms of neglect by the ruling class as he employed in his analysis of events in France, and which he saw as bound to lead in the end to some similar catastrophe. The lesson was driven home to him by the difficulties of his own family, struggling to make a living on the land in Dumfriesshire. One of his brothers, Alexander, was finally forced to emigrate to Canada, and in the late 1830s Carlyle himself also thought very seriously more than once of emigrating to America. The comparison with contemporary England is always present in the background of *The French Revolution*. It is usually tacit, but no acute reader was likely to miss the ominous parallels between the condition of the French working-classes in the eighteenth century as described by Carlyle, and the condition of the English working-classes of the 1830s – the desperate agricultural distress and widespread rioting of 1830–1, the Reform Bill riots of the following year, the persecution of the Tolpuddle Martyrs, the renewed distress caused by the onset of economic depression after 1837 and reflected in the rise of the Chartist movement; nor

between a parasitic French aristocracy clinging to its position of privilege, and an English aristocracy hated for its resistance to the Reform Bill and for its adamant refusal to modify the commercial and hunting privileges conferred upon it by the Corn Laws and the Game Laws. There were a good many intelligent observers in the England of the late 1830s who thought that revolution was a real possibility. *The French Revolution* reflected both that fear and the rising moral disquiet that many of them felt as to the justice of the existing social order. Nor was Carlyle's comparison between old France and present England always tacit. There is a remarkable passage in which he discusses the fate of the boy Dauphin, Louis XVI's heir, who died in prison in obscure circumstances after his father's execution. This was a topic that lent itself easily to sentiment, and over which many easy English tears had been shed. Carlyle himself does not conceal his sympathy for the boy, but he has something to say to the shedders of the tears too:

The poor boy, hidden in a tower of the Temple, from which in his fright and bewilderment and early decrepitude he wishes not to stir out, lies perishing, 'his shirt not changed for six months'; amid squalor and darkness, lamentably, – so as none but poor Factory Children and the like are wont to perish, and *not* be lamented! (R III 263)

The soft-hearted reader has his hypocrisy suddenly thrust brutally under his eyes. Even a century and a half later, it is hard to avoid recoiling at the savagery with which Carlyle turns on him.

To Carlyle, the Revolution was the great standing demonstration that, whatever appearances there might be to the contrary, the world was indeed ruled in the last resort by a just providence. The book was intended, and widely read, as a proclamation of this truth to his own countrymen, that they might learn it and apply it to their own country while there was yet time. In this sense *The French Revolution* is a sermon; but it is a rich and complex book, and cannot be reduced to a single formula. Carlyle himself said that he put more of his life into it than into any of his other books, and it has indeed all the compression to be expected of an imaginative mind of the highest class at last finding full, free and coherent expression after half a lifetime of confinement and frustration. Carlyle was forty-one before *The French Revolution*

finally established his reputation; and there is a curious parallel between his own position at the time and the portrait he draws of the popular leader Mirabeau at the opening of the States-General in 1789. Of all the immense gallery of vividly-drawn characters in *The French Revolution*, Mirabeau is the only one to whom Carlyle accords full heroic status. The choice is curious, for Mirabeau's influence on events was never decisive, and his early death soon removed him from the scene; it is tempting to see the explanation in an awareness on Carlyle's part, whether conscious or subconscious, of the parallel between Mirabeau's career and his own up to that time:

In fiery rough figure, with black Samson-locks under the slouch-hat, he steps along there. A fiery fuliginous mass, which could not be choked and smothered, but would fill all France with smoke. And now it has got *air*; it will burn its whole substance, its whole smoke-atmosphere too, and fill all France with flame. Strange lot! Forty years of that smouldering, with foul fire-damp and vapour enough; then victory over that; – and like a burning mountain he blazes heaven-high; and, for twenty-three resplendent months, pours out, in flame and molten fire-torrents, all that is in him, the Pharos and Wonder-sign of an amazed Europe; – and then lies hollow, cold for ever! (R I 140–1)

Sartor Resartus had been an almost wholly, even self-indulgently, personal document. After 1837, all Carlyle's writings for thirty years were to be almost wholly public ones. *The French Revolution* uniquely combined the two; and this, if it sometimes confuses the themes of the book, gives it an extraordinary resonance, because the public reference so often echoes, and is given urgency by, a private reference within it which the reader can sense; the book is at one and the same time a work of objective history and of Romantic self-expression, as perhaps no other history book has ever been. The passage on Mirabeau just cited is an obvious example of this: another instance, on a much greater scale, may be the treatment of the Terror, the period of arbitrary arrests and mass executions that marked the climax of the Revolution in 1793–4. The third and last volume of *The French Revolution* is shaped entirely round the unifying concept of the Terror, which in Carlyle's hands becomes a living entity with a brutal but wholly irresistible life of its own, quite independent of

the lives of the individuals, the Dantons and Robespierres, whom it first uses and then destroys with equal indifference. It is a vast, horrifying, phantasmagoric, irresistible, awe-inspiring, totally authentic thing; something which defies all moral categories: 'worthy of horror, worthy of worship'. On the rational level, this at least represents a more realistic analysis than the level of easy dismissal and condemnation which had been the current British attitude to the Terror before Carlyle wrote; and it clearly fits adequately into the overriding interpretation of the Revolution as a judgement on a corrupt society. Yet one can feel a deeper level of meaning than this in the intensity of Carlyle's picture of the Terror; it is to be found, I think, in the parallel that he sensed between the elemental nature of the Terror and the release of powerful instinctive forces that the writing of the book represented for him, which were far too native to him to be repudiated, and yet of which he was deeply afraid. No adequate reading of *The French Revolution* can neglect this level of interpretation entirely. Moreover, it casts light on what was to become one of the central issues of Carlyle's later writings – his attitude to democracy.

Carlyle was never a democrat. He sympathised deeply with the poor, but he had no faith in the Chartists' panacea of the ballot box as their remedy; he was equally contemptuous of the relatively liberal French constitution of 1791 and the relatively democratic one of 1793, seeing both as mere paper formulas with no relevance to the social and political realities of France at the time. But if he was no democrat, he had the Romantic's preference for instinct over reason; and the crowd could very easily become the symbol of the blind but irresistible instinct pitted against the conscious but fragile reason of the established order. The symbolism is apparent in his account of the storming of the Bastille:

Hast thou considered how each man's heart is so tremulously responsive to the hearts of all men; hast thou noted how omnipotent is the very sound of many men? How their shriek of indignation palsies the strong soul; their howl of contumely withers with unfelt pangs? The Ritter Gluck confessed that the ground-tone of the noblest passage, in one of his noblest Operas, was the voice of the Populace he had heard at Vienna, crying to their Kaiser: Bread! Bread! Great is the combined voice of men; the utterance of their *instincts*, which are truer than their *thoughts* . . . (R I 194).

In *The French Revolution* Carlyle was still on the side of the instincts, as against the repressive thoughts, though he was not to remain so much longer; the crowd, accordingly is still seen as a creative force, though a blind and frightening one, not merely an object for the repressive will of the Hero. There is a curious passage in which Carlyle laments the decline of spontaneity in battles:

Battles, in these ages, are transacted by mechanism; with the slightest possible development of human individuality or spontaneity: men now even die, and kill one another, in an artificial manner. Battles ever since Homer's time, when they were Fighting Mobs, have mostly ceased to be worth looking at, worth reading of or remembering. (R I 251)

Although it is true that his account of the Revolution ends with Napoleon's famous 'whiff of grapeshot' on the 13th of Vendemiaire in 1795, there is no suggestion that this represents the glorious victory of reason over instinct, or of authority over insurrection: the explanation given is that the instincts have had full expression, and have worked themselves out. In that sense only, the time of order has come again.

It is certainly a mistake to see in *The French Revolution* nothing more than a tract for the times. But the importance of this element was greatly reinforced retrospectively by the fact that it foreshadowed the direction that Carlyle's thinking was to take for the next decade, and the role of social prophet with which he was to be above all associated. We have seen that a degree of concern with the condition of society can be traced at least as far back as his visit to London in 1831–2, and on a more abstract level to his essay on 'Signs of the Times' of 1829. But in the late 1830s this concern became increasingly his chief preoccupation, and remained so throughout the following decade. There is no difficulty in explaining this development, for it did no more than mirror the public mood of the time; it was because his writings articulated that mood so pungently and penetratingly that the 1840s brought Carlyle to the peak of his public prestige and intellectual influence.

In 1837 a sharp downturn in the economy ushered in what has come to be regarded as the most serious social crisis of the nineteenth century in Britain. By this time, the Utopian expectations nurtured by the passing of the Reform Act had long since

foundered in disillusionment. The working class bitterly resented what they regarded as their betrayal by the Whigs and the middle class, who had used the threat of popular violence to extort the Reform Act from the ruling aristocracy and had then recompensed their erstwhile allies with the wholly inadequate Factory Act of 1833, the persecution of the Tolpuddle Martyrs, and above all the repressive New Poor Law of 1834. When the depression of 1837 added industrial unemployment on a huge scale to these grievances, the working class responded with the Chartist movement, based on a demand for universal manhood suffrage to be enforced by the weight of mass petitioning, and rising to its first and probably most explosive crisis in the summer and autumn of 1839.

It was in the atmosphere of rising public alarm engendered by these events that *The French Revolution* made its impact and Carlyle's own attention came to be increasingly taken up with the social crisis. Some indication of this can be seen in the topics of the four successive annual courses of lectures that he delivered in London between 1837 and 1840, for whereas the first two were on the history of literature, and harked back to his work for the Reviews in the 1820s, the last two, on the revolutions of modern Europe and on 'Heroes and Hero-Worship' (the only one of the four series to be published), were both concerned with the real or ideal condition of society. But these lectures were never more to Carlyle than an irksome means of making ends meet. His mood of the time is much better reflected in the long pamphlet with the significant title of *Chartism*, published in December 1839.

Chartism has received much less attention than it deserves. It has some claim to be considered the best piece of social criticism that Carlyle ever wrote (though his characteristic weaknesses are also to be discerned in it), and it anticipates the major themes of all his later writings in the field, as well as coining two famous phrases, 'the Condition of England Question' and 'the cash nexus', which were to become commonplaces of social debate throughout the next decade. In spite of its title, the Chartist movement itself is not the major theme of the pamphlet; it is only the latest and most alarming manifestation of the 'deep-lying struggle in the whole fabric of society' that he had already identified in 'Signs of the Times' ten years before. Nor had Carlyle any sympathy with

the Chartist remedy, universal manhood suffrage. The pursuit of the franchise had always been a pursuit of the will-o'-the-wisp, and the record of the reformed Parliament since 1832 gave him no reason whatever to think that a more representative Parliament would cure the social evils of the time. The importance of Chartism to him was the self-evident fact that it bespoke a depth of human suffering which insistently and irresistibly demanded action. This theme, already emphasised in the first book of *The French Revolution*, emerges in *Chartism* as the central element in the indictment of contemporary British society – that suffering on this scale is the fault of the ruling class of the society which permits it. It is in connection with the appalling poverty of Ireland under English rule (a problem which attracted a great deal of Carlyle's attention over the next ten years) that he makes the point most trenchantly:

Ireland has near seven millions of working people, the third unit of whom, it appears by Statistic Science, has not for thirty weeks each year as many third-rate potatoes as will suffice him. It is a fact perhaps the most eloquent that was ever written down in any language, at any date of the world's history . . . A government and guidance of white European men which has issued in perennial hunger of potatoes to the third man extant, – ought to drop a veil over its face, and walk out of court under conduct of proper officers; saying no word; excepting now of a surety sentence either to change or to die . . . England is guilty towards Ireland; and reaps at last, in full measure, the fruit of fifteen generations of wrong-doing. (E IV 136)

The proclamation of England's guilt at the end of this passage is an excellent example of the sort of trenchant statement of plain but heretical moral truth that many of the keener minds of the younger generation found most attractive in Carlyle's social criticism of this period. Equally interesting is the last sentence, for it illustrates the way in which Carlyle typically saw providential justice working itself out in history. English mis-government had brought starvation in Ireland. The consequence was the arrival in England in the 1830s and 1840s of an accelerating flood of poverty-stricken Irish labourers, unable to survive in their own country, whose competition undercut wages in England and created unemployment, in turn leading to the rise of mass popular discontent in the form of Chartism. In this way, Carlyle argues, the chickens of

aristocratic neglect finally come home to roost. The fiercest denunciations in *Chartism* are reserved for the *laissez-faire* theorists who deny on dogmatic grounds that there is anything the state can do to relieve suffering; an attitude which Carlyle stigmatises as 'Paralytic Radicalism' and dismisses memorably with the aphorism that 'the public highways ought not to be occupied by people demonstrating that motion is impossible'. Twentieth-century developmnts may be thought to give that remark a wry or ominous look; but in the context of Britain in the 1830s it had to contemporaries a keen point, and it clearly looks forward to the more generalised indictment of the 'Dilettante Aristocracy' in *Past and Present* four years later.

Within this indictment of inertia on the part of the ruling class there lies an important implication which was to have great influence on the future development of Carlyle's thinking and of his public reputation – an implication that is already clearly drawn out in *Chartism*, though at far less length than in *Past and Present*. To Carlyle, the ruling class of a society is responsible for the moral and physical well-being of the people over whom it rules; but it is responsible for the people rather than to them. The responsibility is upward, to the divine justice that presides over the social order. It is true that it is part of the machinery of that divine justice that, as in the case of Ireland, an élite that neglects its responsibilities will find itself confronted with a Chartist movement, or, worse, a French Revolution. But this is the last resort; the duty of a ruling class is not to carry out the will of the people, but to rule them. This does not imply a crude despotism or oligarchy, though these possibilities were already latent within Carlyle's ideas, and were to become steadily more prominent in it in later years. The true relation between rulers and ruled is complex and mutually dependent. In a healthy society, the ruler is recognised by the ruled as their natural leader, almost as their emanation; a sense of mutual responsibility binds them together. 'Surely of all "rights of man"', Carlyle says, 'this right of the ignorant man to be guided by the wiser . . . is the indisputablest . . . If Freedom have any meaning, it means enjoyment of this right, wherein all other rights are enjoyed. It is a sacred right and duty, on both sides; and the summation of all social duties whatsoever between the two' (E IV 157–8). The

worst corruption of contemporary British society lies in the denial of this right and duty. In *Chartism* Carlyle sees this denial as the fault of the rulers not the ruled: the Chartist movement is to him the inarticulate protest of the ruled against the failure of guidance from above. He found the origin of this failure in the contemporary domination of the public conscience by the utilitarian frame of mind derived from the teachings of Jeremy Bentham. This was his old bogey, the philosophy of the Englightenment that he had had to fight against so hard in his student days at Edinburgh, in a new form; a form that sought to reduce human emotions to measurable quantities, human relationships to mechanical interactions, human dealings to sheer calculations of profit and loss. The only bond left between men was the 'cash nexus', the mere buying and selling of services for money, all broader responsibilities and loyalties being denied in a reduction ultimately intolerable to human nature. The idea of the cash nexus is only sketched in *Chartism*; but it was to have a brilliant ideological future before it, and has been made the basis of what is perhaps still the most serious moral indictment of capitalism.

By his position on this issue, Carlyle made completely clear for the first time the unbridgeable chasm that separated his ideas from the democratic forms of radicalism. He had widely been regarded as an extreme radical, and almost all his previous writings had appeared in Whig or Radical periodicals. *Chartism* for the first time led some to regard him as a Tory, and indeed Carlyle hesitated long over whether it should appear in the Radical *Westminster Review* or the Tory *Quarterly Review*, and finally decided to publish it separately. Carlyle never regarded himself as anything but a radical: 'The people are beginning to discover that I am not a Tory', he wrote approvingly a few weeks after the book's publication. 'Ah, no! but one of the deepest, though perhaps the quietest, of all the Radicals now extant in the world' (N I 185); and for a decade or more after 1839 he continued to be generally accepted at this valuation, on the strength of his undoubted dedication to social (as distinct from political) reform, and the vehemence of his criticism of existing society. Up to this time, of course, experience seemed to most observers to confirm his view of democracy as a wildly unpractical political system; and Carlyle was a realist who

hated cant and dogmatism and insisted that the first quality required of an idea was that it should be able to stand up to the test of practice. Democracy to him was a Utopian creed which had failed in the French Revolution because of its neglect of the realities of power; its proponents, the Girondins, had gone down before the Jacobins, who knew and respected those realities; and it would always fail for the same reasons.

The essentially mystical feeling for the processes of history that Carlyle shared with Hegel, Marx and other great thinkers of the nineteenth century necessarily involves the thinker in the baffling dialectic of might and right; and in *Chartism* this issue, which was to perplex Carlyle for the rest of his life and to become the ground of many indictments of his work, first comes to the surface. His position is far from clear. Like many others, he shrank from the crudity of saying that might makes right, but found himself driven towards that position by the logic of his thinking. He says at one time that no system and no outcome can last without general acceptance, and that it can only win acceptance if it satisfies men's sense of right, which may be true, and is certainly morally acceptable; but he also says that the pursuit of wholly impracticable rights (which might include democracy) is a misuse of time and effort, which may also be true but is far less morally acceptable, since it amounts to saying that might confines right, even if it does not define it.

It is typical of the weakness of Carlyle as a systematic thinker that he makes no real attempt in *Chartism* to identify the causes of the suffering to which he calls attention, and that the concrete remedies that he suggests are manifestly inadequate for a crisis of the proportions that he has described. For causes, he is content to look no further than to lack of leadership on the part of the governing class, which is obviously too diffuse an explanation to be satisfactory. Carlyle was aware of the Malthusian explanation – over-population – and has some admirably pungent comments on the proposed Malthusian remedies, but he attempts no estimate of the validity of the explanation itself. The most obvious alternative explanation of the crisis was to view it as a consequence of the rapid growth of industrialisation; but this too is a hypothesis that Carlyle hardly considers. Carlyle is simply not an analytical

thinker. A passage from *The French Revolution* is very much to
the point: 'But to gauge and measure this immeasurable Thing,
and what is called *account for it*, and reduce it to a dead logic-
formula, attempt not! ... As an actually existing Son of Time,
look, with unspeakable manifold interest, oftenest in silence, at
what the Time did bring: therewith edify, instruct, nourish thyself
...' (R I 213). Carlyle's concern in *Chartism*, as in *The French
Revolution*, is not to account for the phenomenon he describes,
but to force his reader into the 'bodily, concrete, coloured presence'
of it, and to compel him to a moral response. The assumption is
fundamental to Carlyle that the moral response is everything;
once it is made, intellectual solutions will present themselves.

It is not that Carlyle was unaware of the importance of the
transformation being wrought in British society by the impact of
industrialisation; on the contrary, he probably had a profounder
awareness of it than any other contemporary critic. But, like D. H.
Lawrence's reaction to the same phenomenon almost a century
later, it was an awareness primarily of the imagination rather than
of the intellect; and it was too profound to reduce the Industrial
Revolution to nothing more than a cause of social distress, for
Carlyle had an equally acute apprehension of the grandly creative
aspect of industrialisation. He was aware of the lot of the hand-
loom weavers and the factory children – we have seen how he
twisted his account of the Dauphin's fate in *The French Revolution*
to draw attention to it – and yet at the same time he can write a
finely poetic passage in *Chartism* on the grandeur of the sound of
the Manchester cotton-mills starting up at half-past five in the
morning 'like the boom of an Atlantic tide', and balance the
creativity against the evil: 'Cotton-spinning is the clothing of the
naked in its result; the triumph of man over matter in its means.
Soot and despair are not the essence of it; they are divisible from
it' (E IV 182). There is nothing better in Carlyle's social criticism
than this tension, his ability to see the good and the evil simul-
taneously and with equal vividness, and without attempting any
easy trade-off between them. It was a tension sustained only with
difficulty and at great inner cost, and Carlyle would not sustain it
indefinitely.

As to Carlyle's prescriptions for the crisis, his whole emphasis

falls once more on the necessity of responsible leadership. In a long rhapsodic chapter, he invokes the two thousand years of the nation's past as a record of creative achievement, from the first landing of the Saxons and the clearing of the land for cultivation, to the achievements of Shakespeare and Milton in literature and Arkwright and Watt in industry. The implication is that a similar creative effort is required to deal with the existing social crisis; but at the moment none is forthcoming: 'Where now are the Hengsts and Alarics of our still-glowing, still-expanding Europe? . . . Preserving their game!' (E IV 204). In this passage, repeated from *Sartor Resartus*, Carlyle returns, as he often does, to the Game Laws (which reserved all game, even including rabbits, for the landlord) as the symbol of a ruling class which sacrifices the well-being of its inferiors to its own idle pleasures. He makes only two concrete proposals for dealing with the social crisis – emigration and education. Emigration was much in Carlyle's mind at this time, as we have seen; and among those who saw the social problem as primarily a matter of over-population it was a fashionable nostrum in the 1840s. But, as some critics said at the time, education and emigration could not by themselves possibly be adequate solutions for the crisis. Carlyle would probably not have denied it; indeed in *Chartism* itself he satirises the emigrationists. But it was above all a moral response that he was trying to evoke; and without this, any specific proposals could easily become mere formulas as hollow as franchise reform had proved to be. Nevertheless, the weakness is undoubtedly a real and serious one. One of the strengths of *Chartism* is that in it Carlyle made his most determined attempt to wed the force of his moral vision to the empiricism of counted and measured facts. He does, for instance, argue powerfully and effectively that all estimates of the conditions of the working classes are totally inadequate in the absence of adequate statistical studies. But when it comes to suggesting remedies this empiricism is lacking; and the weakness mars a work which in other respects remains a most powerful and penetrating piece of social criticism, marking the increasing emergence of Carlyle in his new role of social prophet.

4 The prophetic role

By the early 1840s Carlyle was no longer a young man; and though his reputation was only just approaching its zenith, the most creative phase of his writing was already behind him. The main themes had already been stated, and the imaginative fire was beginning to cool. It is unlikely that any serious critic would want to put any of his writings after 1840, except *Past and Present*, into the same category as *Sartor Resartus* and *The French Revolution*; and all the major themes even of *Past and Present* had been anticipated in *Chartism*.

But it was between the publication of *The French Revolution* in 1837 and of *Latter Day Pamphlets* in 1850 that Carlyle's real influence, if not his public reputation, was at its height. With *The French Revolution*, one might say, he won the ear of a generation, and with the *Pamphlets* he lost it. During this span of a dozen years, his influence upon the rising intellectual generation was so extraordinary that it has never been approached in modern British history by any other single intellectual figure, not even by the great systematic thinkers such as Freud in the 1920s and Marx in the 1930s, with whom in their own field Carlyle could not stand serious comparison. The dominance is the more remarkable in that it was above all the young, the intelligent and the original who felt most strongly the impact of Carlyle's personality and the force of his ideas; and the spectrum of opinion that they represented ranged all the way from the utilitarian radical John Stuart Mill to the Coleridgean John Sterling (and even on to Tories like Southey and Lockhart). It was in these years that one of the most remarkable intellectual coteries in British literary history was established around the Carlyles' modest home in Cheyne Row. As Thackeray once said, 'Tom Carlyle lives in perfect dignity in a little house in Chelsea, with a snuffy Scotch maid to open the door, and the best company in England ringing at it.' The roll of his friends and disciples in the early 1840s is astonishing: Mill

(though this remarkable friendship was already past its peak by 1840), his fellow radical Charles Buller, the indefatigable publicist and populariser Harriet Martineau, the brilliant and versatile John Sterling, son of the editor of *The Times*, novelists like Thackeray, Dickens and Elizabeth Gaskell, poets like Browning, Tennyson and Edward Fitzgerald (the translator of *Omar Khayyam*), public figures like Charles Kingsley and Thomas Arnold, prominent political refugees from the Continent like Giuseppe Mazzini and Godefroi Cavaignac – all fell, to varying degrees, under Carlyle's spell. Most of them, moreover, came to him rather than he to them, and they came above all, to judge by most accounts of these visits, to hear him talk. In this sense, 'coterie' is perhaps the wrong word; this was not a club of wits, nor a literary discussion group. It was more like the gatherings at the Mitre to hear Johnson talk; yet Johnson was as much a performer as a teacher, and his listeners came less to learn than for the pleasure of witnessing the 'tossing and goring' of his interlocutors. The style of the visitors to Cheyne Row, and of the increasingly eager and numerous circle of Carlyle's readers in the 1840s, was different: it was the style of disciples about a prophet.

As soon as one tries to define Carlyle's role and the nature of his unique influence in the Britain of the 1840s, this word can never be kept out of the discussion for long: it was repeatedly used by his contemporaries themselves. What are the implications of the term? The prophet is an outsider, a moralist, a proclaimer, a messenger who recalls an erring society to the true path. He is not primarily a thinker, and most certainly not an analytical thinker. His authority is *ex cathedra*, and this is reflected in the tone of his pronouncements. He is also not primarily a predictor (though often incidentally one), for he offers a choice, a chance of repentance and redemption (the use of Biblical language is inevitable, for it is in the Bible that the role is defined); the historical schematists, such as Toynbee and Marx, are not prophets (though admittedly Marx's moral fervour does tend to obscure the distinction). The prophetic role, moreover, is ephemeral, and symbiotic. Because the prophet speaks with great intensity to the particular needs of a single society and a single generation, it is unlikely that his message can retain its relevance and appeal, as a great work of art or a great

system of thought can; and, although the prophet is an outsider to his society and a denouncer of it, in the style of John the Baptist and Elijah, it is also true that without that society as an audience, the role is unimaginable. Unlike the artist or thinker, the prophet wholly unrecognised by his own generation is a contradiction in terms.

Carlyle's background, earlier life, and talents fitted him well for the role. In both national and social terms he was an outsider to respectable English society (he retained his broad Annandale accent, as well as his local Annandale loyalties, all his life), which was a brilliant advantage for the prophetic role. Not that this was a conscious strategy on Carlyle's part, for he was a man of transparent simplicity and integrity of character who would have been incapable of such a thing; rather, he became the great Victorian prophet because that was what his qualities made him. Carlyle never ceased to be the wild man from the hills; and whereas for a purely literary figure like Burns, whose background was very similar to Carlyle's, outsidership was a disaster (as Carlyle himself, obviously very sensible of the parallel to his own position, argues in his essay on Burns), it made Carlyle as a prophet a far more convincing spokesman of the quasi-divine message of condemnation and call to repentance. The nineteenth century was a great age of prophets, but the impact of the message of men like Ruskin and Morris was to some extent blunted by the fact that they were insiders to their society. Carlyle alone, as the wild Scot and working man's son, could speak with the authority of the true prophet.

The prophetic role was of course familiar to Carlyle from the strongly Biblical and Calvinist background of his childhood; and the experience of spiritual isolation at Edinburgh University, and of the long rejection of his writings, gave him the sense of apartness essential to it. What he still needed was the prophetic message; and this first came to him in the form of German Romanticism. After that he had an ample intellectual platform from which to denounce the intellectual sterilities of the eighteenth century. The voice of the prophet is already clearly audible in his review articles of the 1820s announcing the new German gospel to the British public; but so far the message was largely confined to the literary, and wholly

to the intellectual, sphere. It was its translation into social terms, closely linked with his move to London in the early 1830s, that completed Carlyle's emergence by the end of the decade as the prophet of modern British society. It is very noticeable, in this connection, how rapidly Carlyle's mental development in the 1830s led him away from German Romanticism. Certainly he never abjured it; he retained his personal admiration for its heroes, and for all things German, to the end of his life. But already by 1837 he could describe himself as 'far parted now' from Goethe, once the lodestar of his existence. References to German literature are sparse in both his books and his correspondence after 1834, and after his bread-and-butter lectures on the topic in 1837, he turned away from it for good. Though transformed by his encounter with Germany, it was the world of ideas of the Old Testament imbibed in Annandale in his childhood, that increasingly dominated his thinking in the 1830s and 1840s; and this of course was the world of the prophets. As early as 1833 he was writing to Mill 'Not in Poetry, but only if so might be in Prophecy, in stern old-Hebrew denunciation, can one speak of the accursed realities that now, and for generations . . . weigh heavy on us!' (T VI 370).

Carlyle's temperament and the nature of his talents exactly suited him for the prophetic role. He was a man at one and the same time of great warmth and spontaneity and of austere and formidable force of character. Though he was not a systematic thinker, he had a brilliantly imaginative and strikingly original mind. He could talk freely as an equal with his friends. His best friend at this time, John Sterling, disagreed with him often and vehemently, and in a memorable phrase Carlyle described their walks together round Chelsea: 'arguing copiously, but *except* in opinion not disagreeing' (J 106). But open-minded discussion could never be easy for a man who held his opinions as passionately as Carlyle did, and increasingly with the years his tendency was toward an authoritarian habit of speech which would brook no denial – the natural dialect of a prophet, all the more when linked with a vocabulary and a flow of images as vivid and arresting as Carlyle's. This, and the intensity of moral conviction that accompanied it, is well illustrated in an anecdote related by his friend Emerson, who once bravely declared his inability to go all the way

with Carlyle's enthusiasm for Oliver Cromwell: Carlyle 'rose like a great Norse giant from his chair – and, drawing a line with his finger across the table, said, with terrible fierceness: Then, sir, there is a line of separation between you and me as wide as that, and as deep as the pit.' A man of these qualities, together with a completely unpretentious personal life of great simplicity, had all the makings of a prophet.

But the prophetic symbiosis requires a properly endowed audience as well as a properly endowed speaker; and in the early 1840s there existed in England an audience superbly equipped to listen to what Carlyle had to say. It should be said at once that this was an audience predominantly limited to the educated classes. Carlyle never repudiated or disguised his own working-class background, nor lost his reverence for the working man. Some working men read his work; some few even wrote to him, and were answered as readily and as helpfully as any of his many correspondents. Nevertheless all his writings from the beginning were addressed to the educated public; and it was among them that the prophet found his fit audience. Given Carlyle's emphasis on conscientious leadership as the prime necessity for society, it made sense that he should address himself to the ruling classes of his country; and his message spoke directly to the peculiar needs of that single generation of that class.

It was a generation that still sought answers to its problems in religious forms, but which at the same time found the traditional religious formulas unsatisfying. The reasons for this include the rationalist scepticism of the eighteenth century, the development of Biblical criticism and of scientific geology – both throwing doubt on the literal truth of the Bible – and the failure of the Churches to respond adequately to the growing social crisis. The spirited counter-offensives mounted by the Churches in the first half of the century in the face of these challenges – Methodism, Evangelicalism, the Oxford Movement, the Roman Catholic revival – failed to satisfy many of the best minds of the rising generation; and a great many of them found relief in Carlyle's outspoken denunciation of the Churches as mere hollow shells of what had once been authentic symbols of the divine instinct in men. Yet Carlyle did not leave his readers in the scepticism which

for most men of the 1840s was still an intellectually unbreathable atmosphere. He held out to them the prospect of a new kind of faith, to be obtained as the prize of a pilgrimage as rigorous as Teufelsdrockh's in *Sartor Resartus*. It was a faith never very precisely defined, an amalgam of German Idealism and a rigorously moralistic and providential system of values derived from the Old Testament; but in the short run at least the lack of definition was an asset, the one aspect appealing to the generation's typical Romanticism as much as the other appealed to its inherited Christian values. Not only did Carlyle offer a *believable* alternative to traditional Christianity; he offered one with its roots deep in the real world and with its own divinely-inspired Scripture in the supernatural justice that governed the course of history. He also offered a creed which had all the emotional and moral colour and challenge that the most formidable alternative non-Christian intellectual system available in Britain at the time, Utilitarianism, conspicuously lacked, and which the young instinctively demanded. The intellectual foundations, and the precise content, of the Carlylean morality might admit of some doubt; of its overwhelming earnestness there was no doubt whatever. One of the most ardent of Carlyle's disciples, his great biographer James Anthony Froude, who first came before the public as the author of the sceptical *succès de scandale* entitled *The Nemesis of Faith*, summed up Carlyle's influence on his generation thus:

I, for one, was saved by Carlyle's writings from Positivism, or Romanism, or Atheism, or any other of the creeds or no creeds which in those years were whirling us about in Oxford like leaves in an autumn storm. The controversies of the place had unsettled the faith which we had inherited. The alternatives were being thrust upon us of believing nothing, or believing everything which superstition, disguised as Church authority, had been pleased to impose; or, as a third course, and a worse one, of acquiescing, for worldly convenience, in the established order of things, which had been made intellectually incredible. Carlyle taught me a creed which I could then accept as really true; which I have held ever since, with increasing confidence, as the interpretation of my existence and the guide of my conduct, so far as I have been able to act up to it. (F I 295–6)

But this accounts only for the less important part of Carlyle's impact on early Victorian England. The prophet is a messenger to

society, not merely to the individual. <u>Carlyle was a preacher of</u> <u>*social*</u> sin and salvation, and in this respect too the message fell on ears exceptionally well tuned to receive it. The British public conscience was in a peculiarly sensitive condition in the years before 1848. On the one hand there were the recurrent rumbles of revolution from the Continent – principally the French revolutions of 1789 and 1830 – to point the Carlylean moral of what happened to erring societies and frivolous and irresponsible ruling classes; and the social unrest of 1815–20 and the Reform Bill crisis of 1831–2 had done much to make revolution imaginable in Britain also. In addition, there was growing uneasiness about the uncontrolled and traumatic social changes sweeping over Britain as a consequence of industrialisation – urbanisation, poverty in both cities and countryside, and large-scale periodic unemployment among the most serious of them. In the relatively prosperous years of the mid-1830s it had been possible to believe the optimistic pronouncements of *laissez-faire* economists that these were only teething troubles; but the renewed plunge into ever deeper and more frightening depths of depression after 1837, accompanied by the revival of mass working-class discontent, lent support to the view that the new economic system contained insoluble built-in weaknesses, and convinced many that the moment of reckoning might indeed be approaching. There was also th<u>e sheer sense of</u> <u>insecurity bred of living in an age of rapid and quite unparalleled</u> <u>social and economic change</u>.

It was just at this time, in the late 1830s and early 1840s, that the first large-scale objective inquiries into the working and living conditions of the poorer classes were taking place in Britain, with the Report of the Select Committee on the Labour of Children in Factories in 1832 at one end, and Henry Mayhew's famous articles on 'London Labour and the London Poor' in 1849–52 at the other. During these years a succession of Parliamentary Committees and Royal Commissions, backed by the new Poor Law Commission established in 1834, issued a series of massive reports which for the first time made available exact evidence on what life was like for the poor, especially the urban poor, in the new industrial England. Independent inquirers added their own reports of their findings on their tours of the industrial north; the prominence of

what, following Carlyle's cue, came to be widely known as 'The Condition of England Question' was reflected too in the extensive debates of the issues in the pages of the great Reviews, in cartoons, and in the growing vogue of the 'social novel', the model set by Disraeli's *Sybil* in 1845. The campaigns of the Anti-Corn Law League, the three successive crises of the Chartist movement in 1839, 1842 and 1848, and the appalling famine that struck Ireland in the wake of the potato blight of 1845–6 gave immediate and most urgent topical point to the issues.

It was an age when *The Times* was in the forefront of the onslaught on the inhumanities of the New Poor Law, and when even *Punch* could be radical; a period of deep social introversion, when the mind of the educated British public was turned in on the state of British society more profoundly, and with an acuter sense of moral uneasiness, than it has ever been since. At various times there was also widespread fear. But fear was not the dominant emotion in most of the discussions of the problem. In the main the issues were faced with a moral seriousness and an intellectual open-mindedness which did much credit to the British society of that generation, whatever may be thought of the conclusions reached.

An educated society so conscious of social evils, so anxious for guidance in tackling them, and so unusually ready to contemplate novel and unorthodox solutions, was an audience ready-made for a prophet. In Carlyle the man was at hand – the only man with a message whose scale and radicalism seemed to meet the scale of the problem, and about whose personality there hung the genuine prophetic aura; a man who seemed to be able to envisage the kind of total moral regeneration of society which alone seemed adequate to the scale of the crisis. Increasingly in the years after 1837 Carlyle found that the winds of public opinion, which had blown obstinately against him for so long, were shifting in his favour. His books began to sell; his lectures were eagerly attended; he had the ear of the younger generation, with his message of social apocalypse and social regeneration. What use he was to make of this position remained to be seen.

5 The prophetic decade

The direction of Carlyle's thinking in the years after the publication of *The French Revolution* was somewhat confused. We have seen that the publication of *Chartism* in 1839 marked unmistakably the coming of the social issue to the forefront of his mind, in close relationship with the deepening of the economic crisis. There followed the publication of *Heroes and Hero-Worship* in 1840. But this was no more than the fourth of the annual series of lectures that Carlyle had undertaken in London, originally out of pure bread-and-butter motives; the fact that it was the only one of the four to be published by Carlyle may have given it undue prominence, and show only that by 1840 publishers were eager for his custom. Nevertheless, hero-worship was to be an increasingly prominent, and ultimately dominant, theme in all Carlyle's later writing. It was not new in 1840. It can be traced back through all Carlyle's writings to its original source in Fichte; but it is in *Heroes and Hero-Worship* that it comes fully into the open as the central feature of Carlyle's view of society. The 'Hero' is the messenger of the divine to the mass of mankind who cannot hear its injunctions for themselves; he is, in fact, in a broad sense the prophet. The prophet can, however, appear in a variety of roles; in *Heroes and Hero-Worship* Carlyle singles out six: the divinity, the prophet, the poet, the priest, the man of letters, and the king. The Protean nature of the hero here is worth noting. Carlyle had first seen the hero as man of letters (clearly the role that had most relevance to his own condition), and in his later writings he was to be almost exclusively the king. But in 1840 the conception was still fairly plastic; and it is characteristic of most of the heroes Carlyle chooses to illustrate his theme that they rise to heroism from obscurity; they are, so to speak, meritocratic heroes. The spirit blows whither it listeth. A healthy society is defined by its ability to recognise its heroes and its readiness to listen to them; and since they may come from anywhere, a relatively fluid society

is likely to be best adapted for the purpose. The great virtue of revolutions is that they provide this fluidity. They allow the true heroes of a society, the Cromwells, the Mirabeaus, the Napoleons, to rise to the top. It is significant that in his lecture on 'The Hero as King' Carlyle's two chief exemplars are Cromwell and Napoleon, and no hereditary monarchs at all.

In retrospect, *Heroes and Hero-Worship* has no place with Carlyle's best work. It was not directly related to the contemporary crisis in British society, and to Carlyle himself it was something of a distraction from the main task that he had increasingly in mind, a history of the Puritan revolution of the seventeenth century in England. Yet it cannot be neglected, for hero-worship was to be a central theme in all Carlyle's later work, and in the view of most of his critics, a distorting one. *Heroes and Hero-Worship* was to be one of the most popular of Carlyle's books, yet the reiteration of its theme was ultimately to be largely responsible for alienating many of Carlyle's ablest and most ardent disciples of the 1840s. The popularity of the book may be accounted for by the fact that it demanded of its readers a readiness neither to tolerate an aggressive novelty of literary style and form, as *Sartor* had done, nor to master a mass of historical detail, nor to face up to the implications of a searching moral critique of contemporary society. An unkind critic might indeed say that it required little but a susceptibility to vague moral uplift; but this is too harsh. Inexactly formulated though it may be, there is a serious content to Carlyle's idea of hero-worship, and even if one regards it as tangential or irrelevant to what was most valuable in his thinking, it remains to be explained why to Carlyle himself it took on such importance.

Carlyle was never a democrat. Given his social background and talents, this is surprising; his radicalism could have taken a democratic turn, though whether this would have made him more or less effective as a prophet is hard to say. He would have won less upper-class patronage from the early 1840s onward, but he might have retained the more valuable allegiance of the Mills and the Cloughs, and might of course also have made a strong appeal to a working-class readership, and given the Chartist movement the authentic prophetic voice that it never found for itself. But he

had an element of tough realism in him at a time when most contemporaries saw democracy as a wholly unrealistic creed. Moreover the strong strain of élitism in the German Romantic thinkers had had a deep influence on his intellectual development. To Carlyle democracy was the offspring of the Enlightenment, and this alone was enough to condemn it. Carlyle was no political theorist, and if he ever read Burke it is not apparent in his writings. Yet his picture of the good society, as it dimly emerges in *Chartism*, in *Past and Present* and in *Oliver Cromwell*, has much in common with the organic, closely integrated, hierarchical society that Burke envisages in its unforced unity of sentiment, its rejection of the seductive claims of abstract Reason, its religious faith and its willing acceptance of leadership from above. But here the one divergence between them arises. Burke has no theory of hero-worship; for him, leadership comes from the traditional ruling class, the landed aristocracy, and is accepted as natural with an unquestioning serenity which is far remote from the note of high-flown romanticism and even hysteria implicit in such a term as 'hero-worship'. Why the difference?

By 1840, the date of *Heroes and Hero-Worship*, it was no longer possible for any sensitive observer to locate authority in the traditional landed aristocracy with the same composure as Burke. Even so, the explanation of Carlyle's view probably lies more in his personal position in society. As an archetypal 'loner', who had made his own the essentially solitary role of prophet, he had not made his way in life (as Burke did) by associating himself with the efforts of any social class or group to enlarge its powers or its liberties. The image of the working man's son was useful for the outsider's stance it gave him in addressing polite society; but he never worked closely *with* working men, and was essentially a member of that most anarchic of all sects, the literary intellectuals. He had made his way in the face of daunting difficulties purely by his own talents and efforts; and the position he had achieved was not merely a decent footing in English upper-class society, but that of the prophetic proclaimer of truth to peasant and peer alike. This was a heroic role, and required a theory of hero-worship to sustain it; and the form of society in which it might flourish could not be a democratic one, for it assumed the ready recognition of authority

71

originating, not in mandate from below, but in commission from above. Carlyle's cult of the hero and rejection of democracy are likely to strike a twentieth-century reader as unsympathetic; but seen against the background of his time, circumstances and personality, it is possible to understand them.

That Carlyle should turn after 1839 to the Puritan revolution as the subject next demanding his attention is not surprising. This was a theme which had interested him intermittently since the early 1820s, and it was entirely congenial to him, echoing as it did the Puritanism of his own family background and Scottish national history. To him the Puritan revolution ranked with the Reformation and the French Revolution as the grand theodicies of modern history – in the language of Idealism, the breakthrough of the Real into the world of shams; in the language of the Old Testament, the sentence of Providence on a corrupt society. Here was the subject for a book, and in 1840 he set to work on it; but it was never to be written in this form. He could not shape the material as he wished, in spite of months of the agonising labour that literary compositon almost always entailed for him; and in any case his mind was increasingly taken up with the mounting tide of social distress around him. In the grim winter of 1841–2, in a typically sharp piece of social observation, he had noticed for the first time garden palings in Chelsea torn up and stolen for fuel: 'a bitter symptom, for the people in general are very honest' (A 535); and in the autumn of 1842, on a tour of the eastern counties to gather material for his history, he saw in passing the crowd of unemployed in St Ives workhouse in Huntingdonshire, which was to provide him with the opening scene for *Past and Present*. The crisis seemed to call for an utterance from him, and he abandoned work on his history for this more urgent task; this time the book flowed easily, and *Past and Present* was published in April 1843.

This event marks the peak of Carlyle's prophetic career. His correspondence clearly reflects the closeness of the interest that he was taking in the problems of society at this time, and in issues such as the Poor Law, the campaign for the repeal of the Corn Laws (a campaign with which he strongly sympathised, but in which he refused to become personally involved), and the condition of Ireland. *Past and Present* was in some ways the fullest

and weightiest of all Carlyle's social pronouncements; and it came at the moment when the public ear was uniquely well prepared to receive it. It has always been regarded as one of his major works, not least because of the inspiration it gave to later social critics as diverse as Friedrich Engels and John Ruskin. It is, with two exceptions, essentially a fuller, more carefully worked out version of *Chartism*, and one which achieved much wider currency because its audience was much better prepared. Its starting point is the fact of mass hardship, and the moral responsibility that this places upon the ruling classes of the country, who bear the guilt for the suffering; in the same way, in *Chartism*, Carlyle had proclaimed their guilt toward Ireland. The vivid description in the first chapter of the unemployed that Carlyle had seen in the St Ives workhouse a few months before ushers in this theme. In the years since he wrote *Chartism*, the novel and little-understood phenomenon of mass industrial unemployment had increased to a huge extent, and outbreaks of rioting in the industrial north in the summer of 1842 seemed to hold out the threat of revolutionary violence – a scenario straight out of Carlyle's *French Revolution*. Carlyle effectively brings out the irony of the gigantic productive possibilities unleashed by the Industrial Revolution set against the unemployment that had resulted from it, and the moral anomaly of men willing and anxious to work who yet cannot find work. But there is no attempt at any analysis of the economics of the problem. Carlyle never showed any interest in economics, which to him always remained associated with the 'dismal science' and moral irresponsibility of *laissez-faire*; a blind spot on which the immense sophistication of economic thought since Carlyle's day has cast a harsh light, but which went little noticed at the time. His own analysis is again, as in *Chartism*, purely moral: unemployment is, in some way never precisely explained, the consequence of the reduction of what should be personal relationships to merely economic ones, of the denial of responsibility by the ruling classes; and it is only in the re-emergence of a ruling class that accepts its responsibility that a solution can lie. Once again Carlyle emphatically refuses to produce anything like a list of specific prescriptions for the crisis, since to do so would blunt the essentially moral nature of his message. Once again there is

reference to emigration and education, both to be organised and undertaken by the state. There is even brief mention of the possibility of giving employees a financial interest in their firm, the germ of the co-operative principle which attracted a good deal of interest in the 1840s. But the nearest approach to a practical programme is the demand for 'permanence of contract'. Having placed the blame for the crisis upon the shifting and purely economic nature of personal relationships under the new economic system, Carlyle argued with some logic that the solution was to substitute a system under which the relationship between master and man should be permanent. The idea has some interest, and curiously brings to mind one of the features of the Japanese economic system which is often adduced to explain the superiority of the Japanese economic performance in recent years; but Carlyle once more shrinks away from explaining in any detail how such a relationship might work, and indeed the examples he uses are the less attractive ones of European feudalism and West Indian slavery.

Yet for all its weaknesses, *Past and Present* is a tract for its times of compelling power, by reason of the intensity of its moral concern for the future of British society, and the depth and sincerity of the sympathy for human suffering upon which it unmistakably rests. Fear may have been one of the motives which induced Carlyle's contemporaries to listen to his message in the 1840s, but it was a motive from which Carlyle himself was wholly free. Neither in *Past and Present* nor in *Chartism* is there any hint of the rationalising tone, the attempt to defend the privileged position of one's own social group, which infects so much social criticism. The other great distinction of *Past and Present* is its remarkable second book, 'The Ancient Monk', the section which explains the word 'Past' in the title.

Book II is a description of life in the Abbey of Bury St Edmund's in the late twelfth century. The idea for it arose from a recent item of Carlyle's omnivorous historical reading, a newly-published edition of a twelfth-century chronicle of life in the Abbey by one of its monks, Jocelin of Brakelond. His chronicle is, by any standards, a remarkable record of medieval monastic life; but few men would have seen in it a stick with which to beat the nineteenth century, which is what it became in Carlyle's hands.

'The Ancient Monk' is the finest example of the way in which, to Carlyle, history was never a merely academic study, but had a prophetic function to serve. Medievalism itself was of course a widespread intellectual fashion at the time, but to most of its adherents it was no more than a wistful nostalgia, a rejection of the present. To Carlyle it was a great deal more. Twelfth-century England becomes a model of the healthy society, not in its picturesque trappings, which are irretrievably of the past, but in its moral essence, which is capable of being revived in the present. Carlyle's book is remarkable not least for the vividness with which he re-creates the life and imaginative world of this extremely remote society; even the great Lord Acton, a man who in general had little use for Carlyle, called it 'the most remarkable piece of historical thinking in the language'. As always, history is of value in Carlyle's eyes only if the historian can make it alive to the reader in the same sense as the present is alive. But what chiefly concerns him is that twelfth-century Bury St Edmund's is a society not yet infected by individualism, in which men are attached to each other by bonds other than cash, and, above all, men's instinct for recognising their superiors finds easy and natural outlet. The Abbey, at the beginning of the chronicle, is in a sad state of debt and dereliction, under the control of an incompetent abbot. After his death, the mode of electing a new abbot is apparently confused, illogical and arbitrary; but because the true instinct of hero-worship is there, the process produces the right man, the reforming Abbot Samson. As was the case with all Carlyle's heroes, Samson is anything but a Utopian. He is a hard-headed realist, a harsh disciplinarian, a sharp man of business, a man whose religion is for the most part inarticulate and instinctive, though wholly sincere. Implied throughout is the contrast with an England governed by a Parliament elected on approved Reform Bill principles, but which, because a society blinded by crass materialist individualism can no longer recognise its heroes, fails to throw up a government capable of coping with the social crisis of the day.

The other major novelty of *Past and Present* is its sharp categorisation of the upper classes of British society into 'Dilettantes' and 'Mammonists'. 'Dilettantes' are the privileged land-owning aristocracy, who, like the aristocracy of France before

1789, have abandoned the duties of governing and retained only its privileges, symbolised again by the Corn Laws and the Game Laws, becoming a class of idle and unproductive parasites; 'Mammonists' are the industrial middle class, whom Carlyle indeed vastly prefers to the Dilettantes because they do work (to the extent of transforming the entire face of England), but whom he also condemns because they work blindly, with no aim but the accumulation of wealth, lacking both a sense of the sacramental nature of work and an awareness of their moral responsibility for the well-being of their employees. England can be saved only by the emergence of a new, morally responsible, working aristocracy, a phenomenon he sees as much more likely to arise from the new middle classes than from the old aristocracy. His imagination was still fired by the vision of the Industrial Revolution as a grand creative achievement; Arkwright and Brindley are among his heroes. At the lower levels of society, the suffering mass of the working classes demand the relief to which they are fully entitled. But their physical hardships are secondary; what they stand in greatest need of is a sense of purpose and direction, a sense that though life may be hard there is a justice behind it. Above all their demand is for leadership, for heroes to rule them. In the end their demand will be met, for if the existing ruling class cannot mend its ways and show itself capable of heroism, Britain will follow France, and find its heroes through revolution.

This was Carlyle's message to his readers at the peak of his prophetic career. As a prophet must, he was saying what they felt needed to be said, but could not effectively articulate for themselves. What was it in Carlyle that struck the deepest echo in the intelligent and sensitive reader of the 1840s? Certainly not a programme of specific action, but something deeper and more resounding. There were three major elements in his message that were likely to have aroused most response: the assertion of an absolute and transcendent moral order, which made life a matter of urgent and unsparing moral challenge (*Past and Present* bore the Goethean epigraph 'Ernst ist das Leben' – 'Life is earnest' – on its title page); the assertion of social responsibility, and the demand for a line of personal and governmental action which should embody it; and the claim that the truest revelation of the divine

was history, and that history in the long run always works for justice. These assertions supported by far the most complete and balanced response to the phenomenon of the Industrial Revolution and industrial society that had yet been achieved, the first indeed to get it into any kind of proper perspective. This was Carlyle's finest achievement as a social critic, and it still commands respect. It was spontaneous, it was undogmatic, it felt with equal sensitivity and emphasised with equal force both the creative and inhuman . aspects of the Industrial Revolution, it recognised it as a moral phenomenon demanding above all a moral and an active response. In *Chartism* and *Past and Present*, modern industrialism has some of the qualities of 'Sansculottism' in the later books of *The French Revolution* (though Carlyle never characterises it as clearly): it forces itself upon the observer like a monster risen from the deep – vast, morally ambivalent, at once divine and infernal, and demanding from him a response in whose making he passes judgement upon himself.

In expressing this vision of the new industrialised society, Carlyle gave voice to the anxieties and the hopes of the best minds of the generation of the 1840s; and in these authoritative statements, it seemed for a time possible for the religious and social anxieties of the generation to find satisfaction. Orthodox Christianity might no longer be possible, but a solid moral order, and even a sense of a divine transcendence, remained. Life had a purpose, and its fulfilment or non-fulfilment was a matter of critical importance for the eternal well-being of the individual concerned. That purpose could be fulfilled only in socially responsible work, and it demanded heroism. And though the revelation of the Scriptures and the authority of the Church could no longer be taken on faith, history was divine and just, and in such contemporary events as the rise of the Chartist movement, the affairs of Ireland, and the revolutions of 1848, the divine monition could be very clearly heard.

This was a strenuous, if inexact, moral creed. In a way which neither of the major religious movements of the age, Evangelicalism and the Oxford Movement, had contrived to do, it united the call to religious commitment with the call to social action, and in doing so it spoke to the deepest anxieties of that worried, radical,

socially conscientious generation. The clearest evidence of this is the extent to which so much of the best-known and most influential social criticism of the age adopts Carlylean formulations. The brief flowering of the so-called 'social novel' in the late 1840s and early 1850s is a case in point. The mere appearance of the form, and the popular success of the books in question, is evidence enough of the state of the public mind at the time and its concern with social issues. More relevant here, though, is the extent to which almost all its leading examples show clear evidence of Carlyle's influence, whether this is demonstrable, as in the case of Mrs Gaskell's *Mary Barton* and *North and South*, Kingsley's *Yeast* and *Alton Locke*, and Dickens's *Hard Times*, or only presumable as in the case of Disraeli's *Sybil*. All these books proclaim, in Carlylean tones, the intolerable distress of the working man, the neglect of his betters, the necessity for a morally regenerated leadership. Gradgrind in *Hard Times* is exactly Carlyle's 'Mammonist': Mr Carson in *Mary Barton* and Mr Thornton in *North and South* are, by the end of the books, exactly the morally regenerated 'captains of industry' for whom Carlyle had called. Barnakill in *Yeast* and Sandy Mackaye in *Alton Locke* are even Carlyle himself. All these books reject, as Carlyle rejected, any purely political solution of the crisis, including Chartism. And all of them surely owed part of their successful appeal to their middle-class readership precisely to this fact, to their rejection of democracy and their ultimate conservatism. Indeed, Carlyle himself can be classed as a conservative, if the vehement rejection of democracy and a consistent and total lack of interest in the redistribution of wealth constitute conservatism. But the categorisation, if it is to be made, requires so many qualifications that it seems to lose most of its value. The social novelists all represent a watering-down of the more radical elements of Carlyle's thinking. They are all, for example (with the possible exception of Dickens), much concerned to demonstrate the continuing relevance of orthodox Christianity, which Carlyle denied. Not only so, but Carlyle was generally regarded as a radical in his lifetime, both by himself and by others; and certainly conservatives of his own time showed themselves anything but eager to turn for help to this eccentric and dangerous figure.

Carlyle belonged to the world of the literary intelligentsia, and it is no surprise that it is there that it is easiest to trace his influence. His contacts with the political world, other than with the small group of radical MPs such as Charles Buller, were occasional and slight. But even in this field the 1840s witnessed a continuing concern with morally-inspired humanitarian social reform that coincided closely with Carlyle's, if in a less radical key, and that illustrated the aptness of his prophetic message to the decade, even if the extent of Carlyle's contribution to it cannot be precisely defined. Obvious examples are the great public campaign for the repeal of the Corn Laws orchestrated by the Anti-Corn Law League, Ashley's campaigns for factory and mines legislation, the relaxation of the administration of the Poor Law under the continuing pressure of public opinion, the campaign for public health legislation that finally found expression in the Public Health Act of 1848, and the increasing concern for public education. On a smaller scale, the Christian Socialist movement founded by J. M. Ludlow and F. D. Maurice in 1848, with the ready co-operation of Charles Kingsley, represents exactly Carlyle's combination of religious and social concern, albeit in a more orthodox fashion. Humanitarian social reform was as much the characteristic concern of British politics in the 1840s as political reform in the 1830s or foreign policy in the 1850s; and of this state of mind Carlyle, as its prophet, was both producer and product.

Carlyle was keenly concerned, too, with the practical implementation of his ideas at this time, and with finding a leader to undertake the task. His increasing public reputation did bring him into contact at least with the fringe of the aristocratic political world in the later 1840s. He met and admired Cobden; but more significantly, after Peel's repeal of the Corn Laws in 1846, he came increasingly to see in Peel the one man with the conscience, the awareness of the need of the moment, and the ability, to undertake the regeneration of British politics and society. Peel was the only British statesman of Carlyle's lifetime in whom he saw, if only briefly, the hope of heroic status; and indeed some of Peel's thinking of the later 1840s does suggest a conception of social reform not wholly remote from Carlyle's ideas. Carlyle met Peel more than once, and after his fall in 1846 eagerly anticipated his

return to office; he seems even to have hoped for official employment under him. But Peel's death in a riding accident in 1850 ended all these hopes, and Carlyle's never very strong expectations of any good coming out of the existing British political system died with him.

For all these striking points of resemblance between Carlyle's prophetic message and the public concerns of the 1840s, there is at least one striking point of divergence. At no point was Carlyle's insistence on the role of the hero convincingly echoed, even by a public opinion otherwise sympathetic to what he had to say. This difference was to grow wider and not narrower, and in the end was to destroy altogether the close communion between Carlyle and his public on which his role as prophet depended. Even if Carlyle's middle- and upper-class readers were comforted by his repudiation of democracy, the Chartist solution for the crisis, few of them were attracted by the markedly authoritarian strain in his teachings. Moreover, this strain in Carlyle became more emphatic as the decade went by. It was already dominant in 1840 in *Heroes and Hero-Worship*, but so far primarily in the fields of religion and literature. By the time he published *Past and Present* in 1843 the hero has become Samson, the practical reformer, and his hoped-for imitator in nineteenth-century England. In the same year appeared 'Dr Francia', a review article in which Carlyle conferred heroic status on a contemporary dictator of Paraguay; and from now on all Carlyle's heroes would be, not priests, prophets, or poets, but political despots. Increasingly the hero does not so much *enlighten* . men as *compel* them.

The next great milestone along this road was the publication, in 1845, of the long-postponed history of the seventeenth-century Puritan Revolution, in the form, finally, of the Letters and Speeches of Oliver Cromwell. What started as a history of a popular movement, analogous to the French Revolution, ended up as a full-blooded eulogy of the Lord Protector. Carlyle originally conceived the *Letters and Speeches* as a mere preliminary to a biography of Cromwell, but eventually came to see them as a substitute. Cromwell is one of Carlyle's three major works of history, and it is undoubtedly a remarkable work in its own right. By it, as he had done in *The French Revolution*, Carlyle to a very

large extent succeeded in reversing an entire tradition of historiography, and in this case one that had stood for nearly two centuries: the picture of Cromwell as a fanatical, hypocritical and ruthless political adventurer. Carlyle's Cromwell is a religious idealist, a man of wrestling and tormented sincerity; and from his interpretation the whole subsequent tradition of Cromwellian biography down to our own day descends. *Cromwell* is the only one of Carlyle's histories to have retained any strictly historical authority down to our own day, the only one that a modern professional historian would ever dream of consulting; though it owes this to its form, a collection of primary source material, and not at all to the fiercely subjective commentary which Carlyle wove into it. By the standards of the age Carlyle was an extremely conscientious editor, both in tracking down Cromwell's papers and in transcribing them accurately, and it is a tribute to him that in his respect his work has never been replaced. Nevertheless, for all the occasional splendours of Carlyle's own prose, it must be reckoned a dull book beside *The French Revolution*. This is primarily because it has far less imaginative power. The sense of multiple levels of meaning, whether explicit or implicit, which perpetually haunts the reader of that masterpiece, is wholly absent here. There is none of the earlier use of symbols, nothing like the plastic sense of blind unconscious forces working through history and the conscious purposes of men that so informs Carlyle's account of the Terror; and though Carlyle certainly intended *Cromwell* to have contemporary reference and to carry a message of admonition to his readers, this quite fails to carry conviction here. Carlyle envisaged it as a kind of Book II of *Past and Present* on the grand scale, a new example of religiously-inspired heroic action from the past to point the need for it in the present; but even in *Past and Present* the analogy between twelfth-century Bury St Edmund's and nineteenth-century England is too remote to be convincing. In *Cromwell* the analogy is left implicit for the most part, and few of its readers then or since can have taken much notice of it. The book also has its embarrassments for the Carlylean: the fiercely enthusiastic interjections with which Carlyle punctuates Cromwell's speeches and, much more seriously, the overt and emphatic approval which he bestows, not merely on Cromwell's high-

handed methods with Parliaments, but also on the grisly massacres which followed the capture of Drogheda and Wexford, during his suppression of the Irish revolt.

Carlyle presented these as examples of providential chastisement of a wilfully rebellious people, an interpretation which was too strong for the stomachs of many even of his admirers, and which comes strangely from a man who had spoken so forthrightly of English injustice toward Ireland in *Chartism*, and who was indeed a personal friend of some of the leaders of the nationalist 'Young Ireland' movement of his own day. It is another example of how Carlyle's increasing emphasis on the actions of the God-given hero in the role of political despot was beginning to open a gap between him and his disciples in the later 1840s. His old friend Emerson, revisiting England in 1847 for the first time since the Carlyles' Craigenputtock days, saw the difference in him. 'Carlyle', Emerson remarked, 'is no idealist in opinions, but a protectionist in political economy, aristocratic in politics, epicene in diet, goes for murder, money, punishment by death, slavery, and all the pretty abominations, tempering them with epigrams.' The fact that the friendship between the two men remained unbroken only strengthens the judgement.

6 The decline of the prophet

Carlyle's evolving opinions were treading hard on the toes of his former liberal admirers by the late 1840s. In 1850 the publication of *Latter-Day Pamphlets* was to break the connection between them completely. The tone for these was sufficiently set by the appearance in a periodical the previous year of his 'Occasional Discourse on the Nigger Question', a denunciation of the Arcadian idleness in which the emancipated slaves of the British West Indies were reputed to be living, coupled with a demand that the universal moral obligation of work should be reimposed on them by a virtual restoration of slavery and the 'beneficent whip'. Of all Carlyle's writings, the 'Occasional Discourse' is the one that best retains its radicalism, if that can be defined by the capacity to create instant and intransigent hostility in almost all its readers. It stamps as hard on the moral shibboleths of the 1980s as it did, and was meant to do, on those of the age of anti-slavery idealism. It offended every shade of respectable opinion in Britain. It is true that Carlyle makes it clear that his defence of slavery, if such it was, was restricted to a heavily modified slavery with ample protection for the slave, even including his right to buy his own emancipation; but it seems likely that by this he merely forfeited his chance of winning the support of the one group that might have been expected to welcome the 'Discourse', the slave-owners of the American South, without conciliating any sizeable section of opinion at home. It is so hard to be just to the 'Occasional Discourse' that it does need emphasising that it takes its rise, however perversely, from something as seemingly blameless as Carlyle's idealisation of work; its central theme is identical with the proposal for 'permanence of contract' that had appeared in *Past and Present*, and it is not *primarily* a racist document. But racist it is nevertheless. It seems impossible to imagine any grounds on which to defend the contemptuous and brutal sarcasm of such passages as 'Our beautiful Black darlings are at last happy; with

little labour except to the teeth, which surely, in those excellent horse-jaws of theirs, will not fail!' (E IV 350).

The *Latter-Day Pamphlets*, which followed in the first part of the succeeding year, keep the same tone, though they do not return to the same subject. They are a violent repudiation of liberalism and democracy alike in all their forms, an explosion of disgust at what Carlyle identifies as all the leading tendencies of the age: its constitutionalism, its cant, its materialism, its godlessness, its worship of sham heroes (typified by George Hudson, the 'Railway King', an unscrupulous company promoter), and its inability to find or recognise real ones. It is this inability which provides the nearest approach to a unifying theme running throughout the eight pamphlets, and by this time it was of course a familiar Carlylean text. There are constructive aspects to the *Pamphlets*, as in their insistence on the need for the strengthening of the administration at the expense of the legislature, the creation of non-elective seats in Parliament for permanent administrators, and the expansion of the sphere of government action at the expense of the ruling ideology of *laissez-faire*. But the general effect is overwhelmingly, very powerfully, and almost nihilistically negative. It is hard to think of any other equally forceful expression of generalised disgust at society in English except the writings of Swift. Sometimes the *Pamphlets* rise to savagely effective satire, as in the denunciation of utilitarianism in the guise of the 'Pig Philosophy' of the final pamphlet:

Pig Propositions, in a rough form, are somewhat as follows: 1. The Universe, so far as sane conjecture can go, is an immeasurable Swine's-trough, consisting of solid and liquid, and of other contrasts and kinds; — especially consisting of attainable and unattainable, the latter in immensely greater quantity for most pigs. 2. Moral evil is unattainability of Pig's-wash; moral good, attainability of ditto . . . (D 316)

Another example is the endearing suggestion that some public figures might be more fittingly commemorated by a coalshaft than by a statue. But in general the disgust they express is too universal for this. The *Pamphlets* are the work of a man who is turning his back on the world in despair. If the role of the prophet is symbiotic, the man who wrote them was no longer a prophet, for he speaks

from a position of self-conscious isolation. The prophetic parallel that comes to mind is that of Jonah sitting outside the redeemed city of Nineveh and complaining bitterly to the Almighty at the disappointment of his expectation that it would be destroyed. But the parallel does not extend far, for to the Carlyle of the *Latter-Day Pamphlets* the doom-clouds are still gathering blacker and blacker over the society of nineteenth-century Britain. His disgust at everything it stands for is validated by the imminent prospect of its apocalypse.

The appearance of *Latter-Day Pamphlets* marked the point of final alienation between Carlyle and every significant shade of liberal and radical opinion in mid-nineteenth-century Britain. Regarded with alarm by respectable conservatives as a dangerous radical, he was henceforth damned in the eyes of liberals and radicals as a reactionary and an admirer of despotism – a reputation that was only to be strengthened a decade later by the appearance of his last major work, the *History of Frederick the Great*. This is not to say that with the appearance of the *Pamphlets* Carlyle ceased to be a major figure on the British intellectual and literary scene. However violently readers might dissent from the opinions expressed in them, it was impossible to deny their force or the strength and originality of the mind that produced them. Carlyle lived another thirty years as the grand old *enfant terrible* of the English intellectual Establishment. But although his reputation survived, his prophetic function did not: he had lost the ear of the rising generation, and the last thirty years of his life were spent in an intellectual isolation almost as complete as that of his first forty.

Many factors converge in explanation of this growing isolation. A major change in the public mood was taking place in Britain between 1848 and 1851. The introverted doubt and social self-questioning that had characterised the 1840s was giving way to the mood of bellicose national self-confidence that typified the 1850s and was exemplified by Palmerston. One main reason for this change was Britain's successful survival of the period of the 1848 revolutions. Nearly every other state in Europe was shaken, but the established order in Britain, with the middle classes now safely recruited in its defence, rode the waves of the last great

Chartist upsurge with triumphant ease. Another was the revival of trade after 1848, which made the 1850s a period of prosperity and widespread improvement in living standards. The new industrial society in Britain seemed to have survived its teething troubles, and to have emerged as a triumphant success. The mood of euphoria was perfectly mirrored in the success of the Great Exhibition in the summer of 1851, which was widely interpreted as a festival of renewed social harmony as well as of the marvels of the new technology.

This was a new generation, with which Carlyle was wholly out of sympathy. Britain's exemption from revolution in 1848 was no cause of triumph for him. His attitude to the continental revolutions of that year was a mixture of satisfaction at the destruction of what he had long denounced as the rotten shams of the existing political and social order, and of horror at the pit of democratic anarchy into which Europe appeared to be descending – he could detect in the revolutions no trace of the renewed sense of providential order and of recognition of true heroes which any hopeful regeneration of society must in his eyes have entailed. A revolution in Britain would at least have justified the warnings of divine judgement impending that had been a constant theme of all his public utterances since the publication of *The French Revolution*; and for a brief time in the spring there seemed to be a real threat of such a revolution, as alarm spread in London at the prospect of the gigantic Chartist demonstration planned for 10 April on Kennington Common. But Mammonists and Dilettantes alike rose in their might; 150,000 special constables were sworn in, and the demonstration collapsed in fiasco. Carlyle himself, on the morning of 10 April, walked into town to observe events. He got as far as the Burlington Arcade, when it came on to rain, and he returned home in a Chelsea omnibus. Despite its element of farce, there is also an element of symbolism in the incident. From this point onward, the course of current events would cease, at least in the eyes of most contemporary observers, to validate Carlyle's prophecies, and it may have been a recognition of the divergence that underlay the increasing stridency of the prophecies themselves. To most observers of the early 1850s things were not getting worse, they were manifestly getting better, even for the poorest. The

sense of social crisis subsided. The values of the 1830s so mercilessly attacked by Carlyle and exposed to so much radical questioning in the 1840s, such as middle-class parliamentarianism and free trade economics, seemed to be triumphantly justified by the new turn of events. The apotheosis of this frame of mind was the Great Exhibition. Carlyle, logically enough, abominated it as the crowning expression of the crass materialistic optimism that he so abhorred (though he was still capable of responding with excitement to the technical novelty and daring of the Exhibition building, the Crystal Palace, itself).

One cause, then, of the decline in Carlyle's influence after the middle of the century was the abrupt shift in public mood in Britain, and the fact that events apparently ceased to bear him out. But as a complete explanation this is inadequate, because the divergence between Carlyle and his leading disciples can be traced back before 1848 – before events had turned against him, and before the public mood had discernibly changed. It was in 1848 itself that Arthur Hugh Clough, that type-figure of his generation, made one of the most significant comments ever made, both on Carlyle's exercise of the prophetic role, and on his forfeiture of it: 'Carlyle has led us out into the desert – and has left us there.' In accounting for this divergence, the point of departure must be Carlyle's growing emphasis on the role of the hero, which had been a point of difference between him and the bulk of his disciples from the start. The eager, intelligent, idealistic young men who looked to Carlyle as their guide in a time of troubles would probably have accepted democracy if he had demanded it of them. They would not accept despotism as the solution to the problems of the age. But a prophet's function is the memorable utterance of the unformed convictions of his hearers. How, in this instance, did Carlyle come to go so far astray in his interpretation of the role that in the end he forfeited their discipleship altogether?

Carlyle himself would have defined the role differently. Truth to him was a monition from on high, not something intuited from the subconscious minds of his listeners. But there was a progressive coarsening in the fibre of Carlyle's thinking and writing from the early 1840s onward, which has often been recognised by his

critics but never completely analysed or diagnosed. Compare a passage from *Sartor Resartus* with one from *Past and Present*:

What, speaking in quite unofficial language, is the net-purport and upshot of war? To my own knowledge, for example, there dwell and toil, in the British village of Dumdrudge, usually some five-hundred souls. From these ... there are successively selected, during the French war, say thirty able-bodied men: Dumdrudge, at her own expense, has suckled and nursed them: she has, not without difficulty and sorrow, fed them up to manhood, and even trained them to crafts, so that one can weave, another build, another hammer, and the weakest can stand under thirty stone avoirdupois. Nevertheless, amid much weeping and swearing, they are selected; all dressed in red; and shipped away, at the public charges, some two-thousand miles, or say only to the south of Spain; and fed there till wanted. And now to that same spot, in the south of Spain, are thirty similar French artisans, from a French Dumdrudge, in like manner wending: till at length, after infinite effort, the two parties come into actual juxtaposition; and Thirty stands fronting Thirty, each with a gun in his hand. Straightway the word 'Fire!' is given: and they blow the souls out of one another; and in place of sixty brisk useful craftsmen, the world has sixty dead carcasses, which it must bury, and anew shed tears for. Had these men any quarrel? Busy as the Devil is, not the smallest! They lived far enough apart; were the entirest strangers; nay, in so wide a Universe, there was even, unconsciously, by Commerce, some mutual helpfulness between them. How then? Simpleton! their Governors had fallen out; and, instead of shooting one another, had the cunning to make these poor blockheads shoot. (S 139–40)

Who can despair of Governments that passes a Soldiers' Guardhouse, or meets a redcoated man on the streets! That a body of men could be got together to kill other men when you bade them: this, *a priori*, does it not seem one of the impossiblest things? Yet look, behold it: in the stolidest of Donothing Governments, that impossibility is a thing done ... It is incalculable what, by arranging, commanding and regimenting, you can make of men. These thousand straight-standing firmest individuals, who shoulder arms, who march, wheel, advance, retreat; and are, for your behoof, a magazine charged with fiery death, in the most perfect condition of potential activity: few months ago, till the persuasive sergeant came, what were they? Multiform ragged losels, runaway apprentices, starved weavers, thievish valets; an entirely broken population, fast tending towards the treadmill. But the persuasive sergeant came; by tap of drum enlisted, or formed lists of them, took heartily to drilling them; – and he and you have made them this! (P 260, 262)

The loss of humanity between these passages is surely unquestionable. In *Sartor*, he starts with the men, innocent craftsmen and members of a healthy little community, and sees the fate that comes upon them as a brutal injustice. In *Past and Present* they are already soldiers when we meet them, and it is only as soldiers drilled to the mechanical perfection of robots that they are admirable. In their previous lives they have been nothing but 'ragged losels, runaway apprentices, starved weavers, thievish valets'. This may be an accurate observation of the levels of society from which the British Army recruited its rank and file in the 1840s; but the change in attitude to the mass of mankind is sadly typical of the later Carlyle, the Carlyle of the 'Occasional Discourse' who can wax sarcastic about 'our beautiful Black darlings' of the West Indies, and of the *Latter-Day Pamphlets*, with its dismissal of his fellow-countrymen as 'twenty-seven millions mostly fools'. This is a note wholly missing in his work of the 1830s, and only just becoming audible in *Past and Present* in 1843; for beside the passage just quoted, with its message of the worthlessness of undrilled humanity, have to be set passages like the deeply humane description of the paupers in the St Ives workhouse at the beginning of the book. But after *Past and Present* that note is never clearly heard again. Ordinary men and women are no longer the simple, long-suffering, much-abused folk of *The French Revolution* and *Chartism* who require no more than rulers conscious of their responsibility before God whom they can readily follow and admire; instead they are idle, greedy, shiftless wastrels, redeemable only by the serf's collar, the slave-driver's whip, the iron and merciless discipline of Frederick the Great's drill-sergeants. The transition is masked, so effectively that it has often gone unobserved, by the continuity of the theme of hero-worship; but the content of this theme itself undergoes a great change between the 1830s, when the hero is the poet like Burns, the religious reformer like Knox, or the revolutionary leader like Mirabeau – divinely inspired, risen from the depths, charismatic, instinctively recognised – and the 1840s and 1850s, when he is the dictator like Francia, the military despot like Cromwell, even the absolutist hereditary monarch like Frederick the Great, whose heroism is imposed, not spontaneously recognised, and imposed primarily by superior military force.

The paradox of all this is that Carlyle was by nature a deeply humane man, and when he met hardship and poverty in the flesh his reactions, to the end of his life, were instinctively and touchingly generous and sympathetic. But in the change in his attitude to men in the mass, and in his interpretation of the nature of the hero, we are close to the secret of how at the end of the 1840s he came to lose his hold on his disciples; and the origin of these changes must be found in the recesses of his remarkable personality. That personality had always been subject to enormous internal pressures. Carlyle's real greatness, perhaps, lay in the ability to endure greater internal stresses and to hold them in balance for longer than any ordinary man. Some of these stresses may have been sexual. Some were certainly physical, such as the sleeplessness and dyspepsia that tormented him all his life. In addition he had a nervous system pathologically sensitive to the impacts of the outside world, a characteristic which appears equally in his horror of noise, in the marvellous vividness of his powers of description, and in his intensely humane response to the spectacle of human suffering. 'Such *skinless* creatures' was his very apt description of himself and his wife. But this sensitivity could easily become unendurable. Because he felt so powerfully, he dared not feel very often. Because of this, there was a constant urge in Carlyle to cut himself off from the world altogether – to retire to Craigenputtock, to emigrate to America, to build the famous 'soundproof room' for himself in Cheyne Row. The loss of humanity in his later writings is to some extent the sign of a natural tenderness so battered by the pains of the world that in the end it takes refuge in brutality, in refusing to feel at all.

But this is not the whole story. There is also apparent in the later Carlyle an increasing rejection of the spontaneous and the instinctive, even the creative, in favour of the imposed, the authoritarian and the repressive, and this must also have originated in his personality. Carlyle was aware of enormous forces within himself, forces of which he only partly approved, which he partly feared, and which he could only very imperfectly control. It is, surely, from them that the idea of 'Sansculottism' in *The French Revolution* derives its dynamic and deeply ambivalent significance. As this example shows, Carlyle in his prime was able to

allow these forces expression, to admit them at least partially to his conscious mind, and so tap the enormously powerful creativity that appears unforgettably in *Sartor* and *The French Revolution*. But he was like a man on the nozzle of an immensely powerful fire-hose. The strain involved was tremendous, and by the 1840s the temptation to turn it off, to shut down the powerful and destructive forces of instinct once and for all, was becoming irresistible. The elevation of the role of the military despot in his later works is the intellectual reflection of this; and because it was essentially a response to a private need, it awoke no echo in, and finally alienated, most of his disciples. The critic G. C. Le Roy suggested that the mob, in all Carlyle's writings, is the equivalent of his instincts, and this seems to me entirely right. The shifting tensions within his personality are mirrored in his changing attitude to the mass of ordinary men and women. As long as he can accept his instincts, they are at least partly benign. When he felt driven to wall them off, his capacity for sympathy with the many atrophied. It is this that accounts for the apparent loss of creativity in the later writings, and for the disappearance of the sense of overlapping levels of meaning which makes *Sartor* and *The French Revolution* such exciting books to read. A single despotic level of Carlyle's personality has usurped authority over his mind. The fruitful tensions have gone – the tensions which, for instance, had enabled him to see simultaneously and with equal vividness both the creative and the destructive aspects of the Industrial Revolution, or of the New Poor Law in *Chartism*. A single value judgement, and a single point of view, now dominate all.

It was because of these shifts in his personality that Carlyle was unable to see anything more than sheer destructiveness and blank anarchy in the revolutions of 1848, an attitude so strikingly less complex and instructive than his interpretation of the French Revolution of 1789 eleven years earlier; and it was precisely this sort of failure that drove a wedge between him and his disciples, most of whom (like Clough) probably instinctively sympathised with the rebels. They would have accepted a call to revolution from Carlyle, but not a call to despotism, and it is possible now to see why Carlyle's way began to diverge from theirs at this point.

An element of personal frustration on a more superficial level may also have played some part in driving Carlyle into isolation at this time. Humility and self-doubt were qualities that had their place in Carlyle's complex personality; but he was a proud man. He was well aware, as no able man can well fail to be, of his own intellectual superiority to the vast majority of those around him, whose neglect and contempt he had nevertheless had to endure for years. Even more, he was burningly conscious of having a message of the most crucial importance to communicate to them, which most of them refused to hear. It would be naïve to assume that Carlyle's constant recurrence to the theme of hero-worship had no reference to his conception of his own position in society. He cannot have failed to see himself as the heroic prophet sent by heaven to lead the British people back to the sincerity, the sense of duty and divine purpose they had lost since the days of Oliver Cromwell. The identification once made, it stares out at the reader inescapably from passage after passage of *Past and Present* and *Latter-Day Pamphlets*. The point is strengthened by Carlyle's repeatedly expressed yearnings in the 1840s to get away from literature to play a part in the practical work of cleansing the Augean stables, preferably by taking an official post. But the possibility, which had seemed so strong in the earlier part of the decade, that the British public might indeed hear his word and take it to heart receded. After 1848, history itself seemed to turn against him. Events no longer seemed to justify his prognosis of imminent doom for contemporary society (a fact, incidentally, which was causing Karl Marx some not dissimilar problems at the same time). Peel, on whom he had pinned his hopes both for the reform of Britain and Ireland and for his own employment in the work, was killed in a riding accident. It is not so surprising, then, if Carlyle's mind turned increasingly to the idea of finding a shorter way than persuasion and conversion to bend men to his ends, if he was attracted increasingly by the illusion that the despot could succeed where the prophet had failed, and that though the mass of men were too far sunk in beer and balderdash to hear his message, the rod and the whip might yet coerce them into salvation. But this was a road on which few or none of his disciples would follow him. To transform his message in this way was to

lose the vital communion with the young, the eager and the intelligent on which his very role as prophet depended.

The final phase of Carlyle's intellectual development is summed up monumentally in his *History of Frederick the Great*, the last and most laborious of all his books, whose writing occupied him for no less than thirteen years, from 1852 to 1865. Before he started work on it, Carlyle also wrote another, much briefer and much more attractive book, the *Life of John Sterling*. Sterling was not Carlyle's hero but his friend, and the book reveals better than any of his other writings the warmth, the open-heartedness, and the sympathetic insight into character that made so many of his contemporaries value Carlyle's friendship so highly. For once, the prophetic mantle is laid by. The *Life* is also an important document for the moral and intellectual history of Sterling's generation, exactly the generation among whom Carlyle recruited his most enthusiastic disciples. Together with the posthumous *Reminiscences* it is probably the most easily approachable (though certainly not the most easily obtainable) of all Carlyle's books, and placed as it is between the uncompromising harshness of the *Latter-Day Pamphlets* and the *History of Frederick the Great*, it is a timely reminder of the profound humanity that existed in Carlyle beneath all the apparent inhumanity.

Frederick itself adds nothing of importance to the ideas already expressed in *Oliver Cromwell* and the *Latter-Day Pamphlets*. By the time he set about it, Carlyle was already approaching sixty, and by the time it was finished he was nearly seventy. It is therefore a work of his old age, and lacks the creativity and the intellectual suppleness of his early writings. It cost him even more agonies than any of his other works. It involved him, to whom journeys and sleeping away from home were always major ordeals, in two considerable visits to Germany. There were the usual battles with inadequate sources: and, all in all, it is a tribute to his dogged sense of dedication that the book was ever completed. Its tone is both authoritarian and didactic. It is without the many-sidedness and dazzling imaginative force of *The French Revolution*. It is weighed down by an immense mass of narrative detail, and by a hero-figure whom even its author could not completely admire and whose cynical political realism most of its English

readers, at any rate, have found thoroughly unattractive. It is by far the least-read of Carlyle's major works, and there seems small reason to expect any increase in its popularity in the future. Yet *Frederick* has remarkable qualities. The rise of Prussia and the Hohenzollern dynasty is traced not only in great detail, but with great fidelity and great clarity. These, perhaps, are basic qualifications in any historian; more surprising are the gusto and frequent humour with which it is written, which certainly would not suggest an ageing author to any unknowing reader, and the vividness of the character-drawing, the topography, and especially the battle pieces which form the high points of the narrative.

The choice of a foreign subject is always something which requires explanation in a historian, but in Carlyle's case it can be seen as the natural culmination of several tendencies in his life, especially, of course, his long-standing enthusiasm for German literature and German thought, but also his increasingly authoritarian idea of hero-worship, and his abiding interest in the eighteenth century as the origin of the intellectual environment which had shaped his youth and the direction of his own ideas. Frederick the Great is 'the last of the Kings', the last authentically heroic national leader in European history, before the pervasive scepticism, democracy and anarchy of the nineteenth century made any such figure unthinkable. He had to work in an environment already polluted by the rationalism of the Enlightenment, and it is in that fact that Carlyle finds the excuse for his limitations, above all his complete lack of the religious earnestness that Carlyle had previously demanded of his heroes. His heroism lies essentially in his realism and his freedom from the cant that Carlyle saw as so typical of the Enlightenment. This respect for hard fact is the nearest approximation to the sense of the divine working in history that the eighteenth century was capable of; and in Frederick's case it is demonstrated above all by the success of his military coup in seizing Silesia from the ailing Hapsburg Empire, and in retaining it in the face of the united military effort of most of Europe. In *Frederick* the judgement of Providence has become identical with military success: might has indeed become right. It is clear that Carlyle himself is unhappy with this conclusion, from the uncomfortable contortions of his attempts to demonstrate the justice of

Frederick's claims to Silesia; but the concentration of the narrative on the two great wars of Frederick's reign, the War of the Austrian Succession and the Seven Years War, and the dominance of the battle pieces, leave little room for doubt on the issue.

There are other things of interest in the book: the anticipation of later nineteenth-century imperialism in Carlyle's picture of Britain pursuing the imperial mission dictated to it by Providence, blindly except for the brief interlude of clear-sighted leadership under the elder Pitt, and the consistent juxtaposing of a pious, grave, moral, Protestant Prussia against a sceptical, frivolous, immoral, Catholic France – a pair of stereotypes which Carlyle projected into the history of his own time, and which a few years later he exultantly saw justified in the outcome of the Franco-Prussian War. There are plenty of incidental pleasures to be had from a reading of *Frederick the Great*; but the implausibility of the claims it makes on behalf of its central figure, and the one-dimensional quality of its writing as contrasted with Carlyle's earlier books, are flaws which rule out any serious claim to include it among his major achievements.

Nevertheless, it was recognised in its time as the final consolidation of Carlyle's literary achievement. It was strikingly symbolised from Germany itself by the award to him of the Prussian Order of Merit in 1874; and indeed the last thirty years of Carlyle's life were in many respects years of triumph. He was offered the Order of the Bath by Disraeli, but refused it. He was elected Rector of Edinburgh University, and delivered a hugely successful inaugural address. But although his position in the literary establishment was unassailable and unique, it was, as he well knew, the position no longer of the prophet but of the sage. The distinction is vital: the prophet emerges from the desert to speak words of life to his people; the sage dwells remote upon his mountain-top, awe-inspiring but unapproached. He never recovered the ear of the public, and indeed alienated further much of that part of it which had once looked to him as mentor by his contemptuous dismissal of the Northern cause in the American Civil War and his vituperative denunciation of the Second Reform Act in Britain. His alienation from his own times became more and more complete; and in terms of ideas, his writings after 1850, considerable though

95

they were in bulk, added nothing of significance to the position he had reached by the end of the 1840s. After 1865 he published no more books, though he left behind him for posthumous publication the marvellously vivid and wistful *Reminiscences* and the *Letters and Papers* of his wife, whose death in 1866 was a blow from which he never completely recovered. His own death in 1881 came as a long-awaited release. In accordance with his own wishes and his lifelong contempt for all forms of public pomp, the offer of burial in Westminster Abbey was declined, and he was buried beside his family in the churchyard of Ecclefechan.

7 Epilogue

The question whether Carlyle was a great man is both easy and hard to answer. Few men have been more unanimously recognised as great by their contemporaries and by those who knew them. But if one is asked to define the nature of that greatness exactly, the difficulties soon appear. Compared with thinkers like Burke and Marx, Carlyle has added nothing to the permanent stock of the world's ideas. The problem is compounded by the fact that, in the last hundred years, the world has not gone his way. Carlyle's notion of radicalism, which rested on a transformation of human relationships based on a fundamentally religious understanding of man's place in the universe, may be potentially the most fruitful one; but, in twentieth-century terms, it was a radicalism of the right, and that radicalism, disfigured by its own twentieth-century excesses, has lost out in practice to the rival radicalism of the left, based on the pursuit of egalitarianism and the transfer of political power. One is back with the familiar question of whether it is worth arguing with the course of history (especially given Carlyle's own propensity to regard history as the final court of appeal). Maybe the same is true of his historiography: perhaps Carlyle's notion of the function of history, with its emphasis on total imaginative re-creation and the interpretation of the past as a record of the relationship of human societies with the transcendent justice (or is it the transcendent reality?) that overrules them, was a similar blind alley, which all later historiography has resolutely and wisely rejected. But this can be granted only with the major reservation that *The French Revolution*, at least, showed that this kind of history *could* be written, and written wonderfully.

If Carlyle was neither philosopher, political thinker, social theorist or historian of the first order, what was he? He was an important transmitter of the ideas of the late eighteenth-century German intellectual revolution to Britain; but others share this distinction, and it could hardly be made the basis of a claim to

greatness. He was the author of two great masterpieces of the literary imagination, *Sartor Resartus* and *The French Revolution*; recent academic interest in Carlyle has been largely confined to critics and literary scholars, and it is as a literary figure that Carlyle's contemporary reputation stands highest. It is, though, ironic if this is to be the basis of Carlyle's claim to greatness, for there are few roles for himself that Carlyle would have repudiated more vehemently than that of the artist. He abhorred the notion of art, literary or otherwise, as an end in itself. The one acceptable role for the writer of his own luckless generation, he repeatedly insisted, was as prophet. As he said in the passage already quoted from one of his early letters to Mill, 'Not in Poetry, but only if so might be in Prophecy, in stern old-Hebrew denunciation, can one speak of the accursed realities that now, and for generations . . . weigh heavy on us!' (T VI 370). He was not interested in writing for posterity: he wanted to deliver a message to his own generation. Pehaps the most penetrating nineteenth-century judgement of Carlyle's importance was made by George Eliot as early as 1855, and it carries more weight because she could never be classed as one of his disciples, but at most as his detached and discriminating admirer:

> It is an idle question to ask whether his books will be read a century hence; if they were all burnt as the grandest of Suttees on his funeral pile, it would be only like cutting down an oak after its acorns have sown a forest. For there is hardly a superior or active mind of this generation that has not been modified by Carlyle's writings; there has hardly been an English book written for the last ten or twelve years that would not have been different if Carlyle had not lived.

The true nature of Carlyle's greatness is missed if one insists on looking for *enduring* memorials of it, even though those memorials may in fact exist (the books *are* still read; Carlyle *is* often recognised as one of the major originators of a tradition of moral criticism of industrial society that persists vigorously to the present day). Carlyle never saw himself as an artist, or an original thinker. He aspired to be a prophet, a man with a message for his age, and for one brief decade he fulfilled that role. It is not every generation that needs, or deserves, a prophet, and those that need one do not always find one; but the generation of the 1840s was

lucky. In Carlyle they found the greatest example of the type in modern times, a man who could express memorably the anxieties and the aspirations they felt, but were only half aware of, or could not themselves articulate. Carlyle fulfilled this role for a bare decade, in a lifetime of eighty years, and even for this decade his success was incomplete. He never succeeded in producing a programme of practical action in sufficiently concrete terms (a notion which he himself would have dismissed as a mere formula, and hence an illusion; but is this more than an escape?); and before long, the pursuit of his own private compulsions drove him away tangentially from the best minds of the generation that had revered him. There is pathos in recalling the passage on Mirabeau from *The French Revolution* in which the half-conscious identification with Carlyle himself occurs: 'like a burning mountain he blazes heaven-high; and, for twenty-three resplendent months, pours out, in flame and molten fire-torrents, all that is in him, the Pharos and Wonder-sign of an amazed Europe; — and then lies hollow, cold for ever!' Carlyle's time of greatness was longer than Mirabeau's, but still short enough; for prophets are ephemeral creatures by the nature of their calling. Carlyle's achievement is local in both time and place. He is neither a philosopher, nor a major figure of European, as distinct from British, intellectual history. Nevertheless, in the years between 1837 and 1848 his social criticism was characterised by an immensely fruitful tension, between the moral and the practical, between marvel and horror at the achievements and monstrosities of industrialism, that was equalled by no other critic of the nineteenth century, and by an inconsistent but nevertheless profound humanity that enabled him to function as the voice and the conscience of the most open and socially sensitive generation of the nineteenth century.

Further reading

Carlyle's works

The standard edition of Carlyle's collected works is the Centenary Edition (London, 1896–9). It is less than satisfactory, especially because it is incomplete; it omits, notably, the *Reminiscences*. A new and fuller collected edition is at present projected. All the major works, other than the *Life of John Sterling* and the *History of Frederick the Great*, are also available in Everyman Library editions. Two good modern annotated editions (both American, like so much Carlyle scholarship) are C. F. Harrold's *Sartor Resartus* (1937) and Richard Altick's *Past and Present* (1977). A convenient introductory selection is the Penguin *Thomas Carlyle: Selected Writings* of 1971. It would be unthinkable not to refer also to the collected edition of Carlyle's and his wife's letters being published jointly by Duke and Edinburgh Universities, under the editorship of C. R. Sanders and K. J. Fielding (1970) – the eighteen volumes so far published reach to 1844. Thomas and Jane were both letter-writers of genius, and the publication of this meticulous edition is far more than a merely scholarly event.

Biographies

J. A. Froude's four-volume biography of 1882–4 has dominated this field, by attraction or repulsion, ever since it was written, and still stands as one of the great milestones of Victorian official biography, and as a major work of art in its own right; there is a very useful recent annotated one-volume abridgement edited by John Clubbe (London, 1979). Froude's book is a work of strong character, and has been subjected to fierce criticism, much of it justified, ever since it was written; but it has never been superseded. Of numerous one-volume biographies, the most recent and authoritative is Fred Kaplan's *Thomas Carlyle* (Cambridge, 1983); Ian Campbell's *Thomas Carlyle* (London, 1974) also deserves mention, especially for its treatment of the Scottish period of Carlyle's life. Thea Holme's *The Carlyles at Home*

(London, 1965) is a most entertaining account of the Carlyles' idiosyncratic domestic life in London.

Criticism

The bulk of critical writing about Carlyle is enormous. Much of the best of it is American, and on the whole literary in its orientation. Two major landmarks are C. F. Harrold's *Carlyle and German Thought* (Yale, 1934) and G. B. Tennyson's *Sartor Called Resartus* (Princeton, 1965). Invidious though it is to single out items in this vast field, I must also mention A. J. La-Valley's *Carlyle and the Idea of the Modern* (1968) – the most original and illuminating recent interpretation of Carlyle that I have read. Easier of access than these books to most English readers is Raymond Williams's interesting treatment of Carlyle in *Culture and Society, 1780–1950* (London, 1958). Those seeking further guidance should turn to G. B. Tennyson's superb discursive bibliography of Carlyle in *Victorian Prose: a Guide to Research*, edited by David J. DeLaura and published by the Modern Language Association of America (New York, 1973).

Ruskin

George P. Landow

Preface

Like all Ruskin's readers, I owe a great debt of gratitude to E. T. Cook and Alexander Wedderburn, the editors of the Library Edition, who have done so much to advance the cause of Ruskin studies. My own particular study of Ruskin began several decades ago in a seminar taught by Professor E. D. H. Johnson of Princeton University, and only he knows how much I owe to his generous advice and guidance. John L. Bradley, upon whose 'Calendar' from *An Introduction to Ruskin* (Boston, 1971) I have based my 'Ruskin Chronology', has always been wonderfully kind and encouraging, and I am deeply grateful to him and to Paul Sawyer, who kindly provided me with a manuscript copy of his important book on Ruskin before its publication. I would also like to thank John D. Rosenberg, Van Akin Burd, James Dearden, Elizabeth K. Helsinger, and all other Ruskinians whose work has proved so important to the development of the ideas in this volume.

Jay Charles Rosenthal, Shoshana M. Landow, Noah M. Landow, and David Cody helped me read the proofs, and I would like to thank them for their assistance. My wife, Ruth M. Landow, copy-edited the book in manuscript and is responsible for much of the smoothness or clarity it may possess.

For Philip and Shirley Macktez

Contents

Note on references

All quotations from the writings of John Ruskin are taken from the *Works*, Library Edition, edited in thirty-nine volumes by E. T. Cook and Alexander Wedderburn (George Allen, London, 1903–12). The Arabic numerals in parentheses refer to volume and page numbers.

Prologue: Ruskin's life

John Ruskin was born on 8 February 1819 at 54 Hunter Street, London, the only child of Margaret and John James Ruskin. His father, a prosperous, self-made man who was a founding partner of Pedro Domecq sherries, collected art and encouraged his son's literary activities, while his mother, a devout evangelical Protestant, early dedicated her son to the service of God and devoutly wished him to become an Anglican bishop. Ruskin, who received his education at home until the age of twelve, rarely associated with other children and had few toys. During his sixth year he accompanied his parents on the first of many annual tours of the Continent. Encouraged by his father, he published his first poem, 'On Skiddaw and Derwent Water', at the age of eleven, and four years later his first prose work, an article on the waters of the Rhine.

In 1836, the year he matriculated as a gentleman-commoner at Christ Church, Oxford, he wrote a pamphlet defending the painter Turner against the periodical critics, but at the artist's request he did not publish it. While at Oxford (where his mother had accompanied him) Ruskin associated largely with a wealthy and often rowdy set but continued to publish poetry and criticism; and in 1839 he won the Oxford Newdigate Prize for poetry. The next year, however, suspected consumption led him to interrupt his studies and travel, and he did not receive his degree until 1842, when he abandoned the idea of entering the ministry. This same year he began the first volume of *Modern Painters* after reviewers of the annual Royal Academy exhibition had again savagely treated Turner's works, and in 1846, after making his first trip abroad without his parents, he published the second volume, which discussed his theories of beauty and imagination within the context of figural as well as landscape painting.

On 10 April 1848 Ruskin married Euphemia Chalmers Gray, and the next year he published *The Seven Lamps of Architecture*, after which he and Effie set out for Venice. In 1850 he published *The King of the Golden River*, which he had written for Effie nine

109

years before, and a volume of poetry, and in the following year, during which Turner died and Ruskin made the acquaintance of the Pre-Raphaelites, the first volume of *The Stones of Venice*. The final two volumes appeared in 1853, the summer of which saw Millais, Ruskin, and Effie together in Scotland, where the artist painted Ruskin's portrait. The next year his wife left him and had their marriage annulled on grounds of non-consummation, after which she later married Millais. During this difficult year, Ruskin defended the Pre-Raphaelites, became close to Rossetti, and taught at the working Men's College.

In 1855 Ruskin began *Academy Notes*, his reviews of the annual exhibition, and the following year, in the course of which he became acquainted with the man who later became his close friend, the American Charles Eliot Norton, he published the third and fourth volumes of *Modern Painters* and *The Harbours of England*. He continued his immense productivity during the next four years, producing *The Elements of Drawing* and *The Political Economy of Art* in 1857, *The Elements of Perspective* and *The Two Paths* in 1859, and the fifth volume of *Modern Painters* and the periodical version of *Unto This Last* in 1860. During 1858, in the midst of this productive period, Ruskin decisively abandoned the evangelical Protestantism which had so shaped his ideas and attitudes, and he also met Rose La Touche, a young Irish Protestant girl with whom he was later to fall deeply and tragically in love.

Throughout the 1860s Ruskin continued writing and lecturing on social and political economy, art, and myth, and during this decade he produced the *Fraser's Magazine* 'Essays on Political Economy' (1862–3; revised as *Munerva Pulveris*, 1872), *Sesame and Lilies* (1865), *The Crown of Wild Olive* (1866), *The Ethics of the Dust* (1866), *Time and Tide*, and *The Queen of the Air* (1869), his study of Greek myth. The next decade, which begins with his delivery of the inaugural lecture at Oxford as Slade Professor of Fine Art in February 1870, saw the beginning of *Fors Clavigera*, a series of letters to the working men of England, and various works on art and popularized science. His father had died in 1864 and his mother in 1871 at the age of ninety. In 1875 Rose la Touche died insane, and three years later Ruskin suffered his first attack of mental illness and was unable to testify during the Whistler trial

when the artist sued him for libel. In 1880 Ruskin resigned his Oxford Professorship, suffering further attacks of madness in 1881 and 1882; but after his recovery he was re-elected to the Slade Professorship in 1883 and delivered the lectures later published as *The Art of England* (1884). In 1885 he began *Praeterita*, his autobiography, which appeared intermittently in parts until 1889, but he became increasingly ill, and Joanna Severn, his cousin and heir, had to bring him home from an 1888 trip to the Continent. He died on 20 January 1900 at Brantwood, his home near Coniston Water.

Introduction

Ruskin, the great Victorian critic of art and society, had an enormous influence on his age and our own. Like so many Victorians, he had astonishing energy, for while carrying on a voluminous correspondence and painting a large body of superb water-colours, he published poetry, a children's fantasy, and books and essays on geology, botany, church politics, political economy, painting, sculpture, literature, architecture, art education, myth, and aesthetics. He had great influence on both the nineteenth-century Gothic Revival and the twentieth-century functionalist reaction against all such revivalist styles in architecture and design. A great and successful propagandist for the arts, he did much both to popularize high art and to bring it to the masses. Ruskin, who strove to remove the boundaries between fine and applied arts, provided a major inspiration for the Arts and Crafts Movement. A brilliant theorist and practical critic of realism, he also contributed the finest nineteenth-century discussions of fantasy, the grotesque, and pictorial symbolism. A master of myth criticism, traditional iconology, and *explication du texte*, Ruskin also provides one of the few nineteenth-century instances of a writer concerned with compositional analyses and other formal criticism. His extraordinary range of taste, interests, and sympathy allowed him to discuss with perceptive enthusiasm both Turner's more traditional works and his later proto-expressionist ones, and he similarly defended (and created a taste for) painting by the English Pre-Raphaelites, Italian Primitives, and sixteenth-century Venetians. Although he was a great student of the past and past traditions, he also saw the role of the critic as having primary relevance to the present. Unlike Matthew Arnold, who during one of the great ages of English literature assured his contemporaries that they could not create major imaginative work, Ruskin perceived that they had already done so and daringly discussed Tennyson, Browning, Dickens, and others within the context of the great traditions of Western literature and art – traditions that his own writings did so much to define. In an age of great prose

stylists, he was a master of many styles, perhaps the most notable of which appears in his famous passages of word-painting.

Ruskin's writings on the arts influenced not only singularly earnest Victorians, such as William Morris, William Holman Hunt, J. W. Inchbold, and a host of others, but also very different men like Walter Pater, Oscar Wilde, and William Butler Yeats. His writings on design and truth to materials had an immense influence on British, European, and American architecture and industrial design. One finds the impress of his thought in many unexpected places – in, for example, the novels and travel writings of D. H. Lawrence, works that reveal the influence of both Ruskin's art and his social criticism as well as his word-painting.

For all the attention he paid to individual works of art and their traditions, which concentration makes Ruskin the pre-eminent art and literary critic of the Victorian age, he also urged that we must perceive art within its social, economic, and political contexts. Indeed, as Arnold Hauser points out in *The Social History of Art* (1952):

There has never been such a clear awareness of the organic relationship between art and life as since Ruskin. He was indubitably the first to interpret the decline of art and taste as the sign of general cultural crisis, and to express the basic, and even today not sufficiently appreciated, principle that the conditions under which men live must first be changed, if their sense of beauty and their comprehension of art are to be awakened ... Ruskin was also the first person in England to emphasize the fact that art is a public concern and that no nation can neglect it without endangering its social existence. He was, finally, the first to proclaim the gospel that art is not the privilege of artists, connoisseurs and the educated classes, but is part of every man's inheritance and estate ... Ruskin attributed the decay of art to the fact that the modern factory, with its mechanical mode of production and division of labour, prevents a genuine relationship between the worker and his work, that is to say, it crushes out the spiritual element and estranges the producer from the product of his hands ... [He] recalled his contemporaries to the charms of solid, careful craftsmanship as opposed to the spurious materials, senseless forms and crude, cheap execution of Victorian products. His influence was extraordinary, almost beyond description ... The purposefulness and solidity of modern architecture and industrial art are very largely the result of Ruskin's endeavours and doctrines.

113

Ruskin's awareness of the socio-political dimensions of art, architecture, and literature led to his writings on political economy, and reading these works changed the lives of men as different as William Morris and Mahatma Gandhi. Indeed, a survey of the first Parliament in which the British Labour Party gained seats revealed that Ruskin's *Unto This Last* had a greater influence upon its members than *Das Kapital*, and recent historians have credited him with major contributions to modern theories of the Welfare State, consumerism, and economics.

Ruskin arrived on the Victorian scene with his interpretations of art and society at precisely the right time, for he challenged the standards of the art establishment when a large number of newly rich industrialists and members of the middle class began to concern themselves with cultural issues. Because he made claims for art in the language his audience was accustomed to hear the evangelical clergy employ, these claims had particular appeal to evangelicals within and without the Church of England who formed the large majority of believers during most of the Victorian age. Similarly, Ruskin's position outside the artistic establishment, like his polemical tone, evangelical vocabulary, and Scripture citation, struck the right note with members of the rising middle class, who welcomed Ruskin's vision of an alternative form of high culture superior to that possessed by the aristocracy and older artistic establishment.

Ruskin also came forward at a particularly interesting time in the history of critical theory. Like Sir Joshua Reynolds and many other defenders of the art of painting in the West, he tried to gain prestige for visual art by coupling it with her more honoured sister, literature. Unlike most advocates of sister-arts theories, however, Ruskin did not argue that painting and poetry are allied arts because they both imitate reality. Rather, writing as an heir to the Romantic tradition, he urged that both are arts that express the emotions and imaginations of the artist. According to the Romantic conception of the poet which Ruskin learnt from Wordsworth, the poet sensitively experiences the world of man and nature and then expresses this emotional reaction to create his art. When Ruskin thus yoked a Romantic view of peotry with a Neoclassical conception of painting in creating his sister-arts theory, he char-

acteristically refused to relinquish any aspect of the arts. Like the Neoclassical theorist, he concerned himself with the effects of art upon the audience; and like the Romantic theorist, who concentrated upon the artist's emotions and imagination, he emphasized the sincerity, originality, and intensity of great art and literature. Ruskin's Victorian aesthetic thus maintains an equal emphasis upon subjective and objective, Neoclassical and Romantic. Such richness, such eclecticism, and such willingness to confront difficult problems rather than settle for easy, more elegant solutions all characterize Ruskin's thought.

A particularly useful way into the thirty-nine massive volumes that constitute the Library Edition of Ruskin's works is provided by the recognition that throughout his career he wrote as an interpreter, an exegete. For Ruskin the act of interpretation, which leads into many fields of human experience, produces readings not only of paintings, poems, and buildings but also of contemporary phenomena, such as storm clouds and the discontent of the working classes. Whether explaining Turner's art in *Modern Painters*, the significance of an iron pub railing in *The Crown of Wild Olive*, or the nature of true wealth in *Unto This Last*, he interprets the nature and meaning of matters that he believed the British public needed to understand.

Before we look at the way Ruskin's interpretative projects form and inform his entire career, we should glance briefly at a few of his major works, for it is in the context of their varying purposes and procedures that his drive to interpret took shape and gradually evolved. *Modern Painters*, Volume I (1843), the first of these major works, opens with a brief explanation of his conceptions of power, imitation, truth, beauty, and relation in art, after which it proceeds to defend Turner against reviewers' charges that his paintings were 'unlike nature'. Summoning work after work of the old masters, he shows that this modern painter has a wider, as well as a more exact, knowledge of visible fact than any of his predecessors. He takes his opponents on their own ground and therefore demonstrates 'by thorough investigation of actual facts, that Turner *is* like nature, and paints more of nature than any man who ever lived' (3.52). Ruskin discusses general truths, by which he means tone, colour, chiaroscuro, and perspective, and then evinces the

range and accuracy of Turner's representations of plants, trees, sky, earth, and water. Moving beyond its polemical origin, *Modern Painters* thus becomes a tour through nature and art conducted by a man whose eyes see and whose mind understands the phenomena of an infinitely rich natural world.

The second volume of *Modern Painters* (1846) contains both Ruskin's theories of imagination and his theocentric system of aesthetics by which he explains the nature of beauty and demonstrates its importance in human life. He combines a Coleridgean theory of imagination (which he seems to have derived indirectly by way of Leigh Hunt) with evangelical conceptions of biblical prophecy and divine inspiration. Beauty 'is either the record of conscience, written in things external, or it is a symbolizing of Divine attributes in matter, or it is the felicity of living things, or the perfect fulfilment of their duties and functions. In all cases it is something Divine' (4. 210). All beauty, if properly regarded, is theophany, the revelation of God. Contemplating beauty, like contemplating the Bible, God's other revelation, is a moral and religious act.

Like much of his writing on the arts, his theories of the beautiful embody a sister-arts aesthetic and as such draw upon both Neoclassical and Romantic positions. Thus his theories of Typical (or symbolic) Beauty, which emphasize objectively existing qualities in the beautiful object, derive from Neoclassical and earlier notions that beauty is created by unity amid variety, symmetry, proportion, and other forms of chiefly visual order. In creating this Apollonian, classical aesthetic of order, Ruskin draws upon Aristotle's *Nicomachean Ethics* and the writings of Addison, Pope, Johnson, and Reynolds. In contrast, his notion of Vital Beauty, the beauty of living things, emphasizes subjective states and feelings in the spectator and derives from the Romantic poets, chiefly Wordsworth, and those eighteenth-century philosophers whose ideas of sympathy and sympathetic imagination prepared the way for Romanticism; that is, Adam Smith, David Hume, and Dugald Stewart. Ruskin, in other words, creates a Victorian aesthetic by fusing Neoclassical, Romantic, and Christian conceptions of man and his world.

Before completing *Modern Painters*, Ruskin wrote *The Seven*

Lamps of Architecture (1849), another work with a heavily evangelical flavour. Despite Ruskin's turn from painting to what he termed 'the distinctly political art of architecture', *The Seven Lamps* has more in common with the second volume of *Modern Painters* than with any of his other works. Like the first two volumes of *Modern Painters*, to which it directs the reader, *The Seven Lamps of Architecture* urges that beauty and design 'are not beautiful *because* they are copied from nature; only it is out of the power of man to conceive beauty without her aid' (8. 141). Furthermore, he set out to win evangelical approval of the Gothic, which was generally associated with High Church Anglicans and Roman Catholics – with the Camden and Ecclesiological Societies and with Augustus Welby Northmore Pugin. Ruskin draws upon commonplace evangelical typological interpretations of the Book of Leviticus to convince his Protestant audience that God intended man to lavish time, energy, and money upon church architecture. He similarly sounds the note of the evangelical sermon when he pleads for truth to materials in architectural construction. This note has had enormous effect on the modern world. Although Ruskin was not the only Victorian to emphasize truth to materials, he received a far wider hearing for his ideas than contemporaries who addressed their ideas only to the architectural fraternity, and architects and architectural historians alike credit him with providing the initial inspiration of much twentieth-century architecture and design.

Although self-consciously relating his comments on architecture to those expressed in his earlier volumes, Ruskin none the less sounds a new note by emphasizing the importance of communal art and creation. Furthermore, he also wants to grant the individual workman the position, independence, and pleasures of the Romantic artist. Therefore, when one considers the vitality of architecture, 'the right question to ask, respecting all ornament, is simply this: Was it done with enjoyment – was the carver happy while he was about it?' (8. 218) These last two points again have done much to shape our art and design in the twentieth century, for they have influenced our cities, homes, furnishings, and utensils – the things we see and touch in everyday life. This emphasis, which inspired William Morris, the Arts and Crafts Movement,

and the Bauhaus, has, like Ruskin's drawing treatises and other similar writings, also shaped our conceptions of education, leisure activity, and the status of the craftsman.

The Seven Lamps of Architecture has shaped our surroundings in yet another important way. Since Ruskin believed both that architecture is an inheritance one generation passes on to another and also that it is the embodiment of the society that built it, he tried to convince his readers to build solidly for future generations. These beliefs, like his protests throughout his work against the destruction of old buildings, stimulated the founding of English and foreign societies for architectural preservation; similarly, his conviction that those alive today are stewards, rather than owners, of works of art was a major source of the museum movement.

After completing the *The Seven Lamps of Architecture*, Ruskin turned to *The Stones of Venice*, which combines the study of architecture with a cultural history, religious polemic, and political tract. Like *The Seven Lamps*, *The Stones of Venice* discusses (and defends) Gothic architecture, but it moves beyond the earlier work's abstract treatment both because it devotes considerable space to the details of architectural construction and also because it places architecture within its social, political, and moral, as well as its religious context. Indeed, as Ruskin explains in its opening pages, he pays such close attention to this once powerful city because the 'arts of Venice' provide firm evidence 'that the decline of her political prosperity was exactly coincident with that of domestic and individual religion' (9. 23), and it is this lesson he wishes to bring home to his Victorian audience. The first volume opens, therefore, with Ruskin sounding the prophet's note as he underlines the connections between cursed nations of the past and contemporary England:

> Since first the dominion of men was asserted over the ocean, three thrones, of mark beyond all others, have been set upon its sands; the thrones of Tyre, Venice, and England. Of the First of these great powers only the memory remains; of the Second, the ruin; the Third, which inherits their greatness, if it forget their example, may be led through prouder eminence to less pitied destruction . . .
>
> I would endeavour to . . . record, as far as I may, the warning which

seems to me to be uttered by every one of the fast-gaining waves, that beat like passing bells, against the STONES OF VENICE. (9. 17)

He states his goals for the entire work in this first chapter, after which he uses the volume's remaining twenty-nine to set forth a theory of architectural construction with individual chapters on the wall cornice, the capital, the roof, and so on.

Since Ruskin believes that the signs of Venetian spiritual decline appear in the city's movement from Gothic to Renaissance architectural styles, the following two volumes, *The Sea Stories* and *The Fall* (both 1853), examine the growth of the city-state and the significance of its major buildings, particularly St. Mark's and the Ducal palace. 'The Nature of Gothic', which provides the ideological core of *The Stones of Venice*, appears in the second volume and argues that because the Gothic style permits and even demands the freedom, individuality, and spontaneity of its workers, it both represents a finer, more moral society and means of production and also results in greater architecture than does the Renaissance style, which enslaves the working man. These discussions of architectural style thus lead directly to an attack on the class system and its effects. Ruskin, who has already begun to develop his consumerist ethic, focuses upon the dehumanizing conditions of modern work and urges that no one purchase goods, such as glass beads or Renaissance ornament, the production of which dehumanizes men. Ruskin the interpreter of art and Ruskin the interpreter of society here merge – or, rather, appear as one man with the same project – when he points out that his readers never have 'the idea of reading a building as we would read Milton or Dante, and getting the same kind of delight out of the stones as out of the stanzas' (10. 206), because architecture produced in the dehumanizing, unmeaning contemporary way fails the people who use it just as it fails those who build it. In other words, a society that enslaves its workers in demeaning, dehumanizing work finds itself demeaned and dehumanized by the buildings they produce. These buildings, which stand as an emblematic self-indictment of the spiritual poverty at the society's core, further harm its members, rich or poor, by starving their imaginations and sensibility –

faculties that Ruskin believes lie at the heart of a healthy, happy, full human life.

When he resumed *Modern Painters* (1856) with the publication of Volumes III and IV, Ruskin had to solve problems raised by his earlier inclusion of Italian Renaissance art. Volume III, the central volume and probably the richest of the five, again advances a Romantic theory of painting, and all the concerns of Romanticism are here – the nature of the artist, the importance of external nature, and the role of imagination, emotion, and detail in art. The first section defines the nature of great art in order to remove apparent contradictions between the first and the second volumes which he had created by praising Giotto and Fra Angelico in Volume II. In particular, his praise of Italian Primitives seems inconsistent with his earlier demands that paintings should display a detailed knowledge of external nature. Ruskin solves the difficulty by explaining that he divides 'the art of Christian times into two great masses – Symbolic and Imitative' (5. 262), and he explains that his demands for accurate representation of the external world refer only to imitative art.

Ruskin then examines the nature of greatness in art and dismisses Reynolds's Neoclassical theory that a grand style is based on the imitation of *la belle nature*, or nature idealized according to certain rules. Writing with a Romantic distrust of prescriptive rules, he offers a formula for greatness that is essentially a psychological potrait of the artist since it is basd on four elements: noble subject (which the artist must instinctively love), love of beauty, sincerity, and imaginative treatment.

His discussion of the rise of landscape painting, Ruskin's second major concern in this volume, was also demanded by his somewhat unexpected inclusion of Italian art. Having begun a defence of Turner, a master of landscape, he had been diverted to other forms of painting; in order to make his way back to Turner, Ruskin felt obliged to inform his reader why landscape art had arisen at all. Classical, medieval, and modern attitudes towards external nature are considered in order to explain the origin of landscape feeling, which he argues is a peculiarly modern development and one part of a more general 'romantic love of beauty, forced to seek in

history, and in external nature, the satisfaction it cannot find in ordinary life' (5. 326).

In this context Ruskin introduces his famous critical concept of the Pathetic (or emotional) Fallacy, the presence of which separates Romantic and later work from the creations of Homer and Dante. According to Ruskin, the modern poet's expressionistic distortions of reality successfully communicate a subjective or phenomenological view of the world at the expense of that balanced worldview which characterizes writers of the absolute first rank. As he points out, poets and novelists who employ the emotional distortions of the Pathetic Fallacy to dramatize the mental states and experiences of a character or first-person narrator make proper use of this technique, but when an author speaking in his own person presents a distorted view of the world, he produces an essentially unbalanced (and characteristically Romantic) literature.

The fourth volume, published the same year as the third, opens with a discussion of the Turnerian picturesque and of the picturesque in general, which are the aesthetic categories specifically related to the growth of landscape art. After sections on the geology of mountain form, the volume closes with an examination of the influence of a mountain environment on the lives of men.

The fifth volume (1860) begins with sections on the beauty of leaves and clouds that are second journeys through ground covered in the first volume. Next follows a discussion of formal relation, or composition. 'Composition may best be defined as the help of everything in the picture by everything else' (7. 205). This notion of help is central to Ruskin's theory of art, as it was to be in his theories of political economy, and he dwells on it at length, telling the reader that the 'highest and first law of the universe – and the other name of life, is, therefore, "help"' (7. 207). Composition, then, is the creation of an organic interrelationship between the formal elements of a work of art. Ruskin then demonstrates, by brilliant analyses of Turner's pictorial compositions, that this artist was a master of this aspect of pictorial art.

The relation of art to life, one of Ruskin's most important interests throughout *Modern Painters* and his works on architecture, provides the heart of his section 'Invention Spiritual'. He suggests that he has begun to shift his primary attention from the

problems of art to those of society when the following chapters relate art to the lack of human hope that Ruskin belives to be a consequence of the Reformation. According to him, after the Reformation when men first lost their firm belief in an afterlife, they could not attain peace of mind or die hopefully, and he discusses four pairs of major artists to show the effect of belief or its lack upon their art – Salvator and Dürer, Claude and Poussin, Wouverman and Fra Angelico, and Giorgione and Turner. After Ruskin has shown the environment in which Turner's mind took form, he devotes a chapter each to detailed interpretation of two works that represent the faith of the artist and his England. These paintings, *Apollo and Python* and *The Garden of the Hesperides*, reveal Turner's fascination with the destruction of beauty and his consequent lack of hope, the cause of which lies in the nature of the age, an age that believes neither in man nor in God and which lets great men die in isolation and despair.

In his next work, *Unto This Last* (1862), which he completed the same year as this final volume of *Modern Painters*, Ruskin turned to attack the economic system that he believed produced such despairing, inhuman relations of men in society. *Unto This Last*, whose four chapters first appeared in 1860 as articles in the *Cornhill*, of which Thackeray was then editor, consolidates the political position Ruskin had been evolving during the previous decade and sets forth the ideas he would continue to advance in *Munera Pulveris* (1862–3), *The Crown of Wild Olive* (1866), *Time and Tide* (1867), and *Fors Clavigera* (1871–84). Most contemporary readers found both Ruskin's general attitudes and his specific proposals so outrageous that they concluded that he must have been struck mad. Today, his political proposals, like his emphases on communal responsibility, the dignity of labour, and the quality of life, have had such influence that they no longer appear particularly novel. In the beginning of *Unto This Last*, as in *Modern Painters*, Ruskin confronts the so-called experts and denies the relevance of their ideas. Whereas classical economists proceeded on the assumption that men always exist in conditions of scarcity, Ruskin, who realized that a new political economy was demanded by new conditions of production and distribution, argues that his contemporaries in fact exist in conditions of

abundance and that therefore the old notions of Malthus, Ricardo, Mill, and others are simply irrelevant. According to him, then, 'the real science of political economy, which has yet to be distinguishd from the bastard science, as medicine from witchcraft, and astronomy from astrology, is that which teaches nations to desire and labour for the things that lead to life: and which teaches them to scorn and destroy the things that lead to destruction' (17. 85).

In the following pages I propose to look at Ruskin's interpretations of art, society, and his own life. The first kind of interpretation Ruskin undertook focuses on Turner. At first he wished simply to explain Turner's art in the context of the contemporary reviewers' scurrilous attacks and, by taking these reviewers on their own terms, to show his readers how to appreciate the great and insufficiently appreciated artist in their midst. This project quickly clarified itself as a lesson in interpreting perception and then as an exercise in practising the correct, more intense way to see the art and world around one.

Ruskin, who evolved from a clever amateur into a polemical critic and art theorist, from there further developed into a Victorian sage, into, that is, a secular prophet who took all society as his province. Throughout his career he remained polemical and throughout his career he remained equally concerned to make interpretations necessary to his audience's cultural, spiritual, and moral health. These tendentious, polemical interpretations always had a wider purpose, and they almost always included Ruskinian parables of perception that instruct the reader by example how to experience fact and meaning, form and content.

Such a drive to interpret remained a constant in Ruskin's career, despite the many changes that took place as he learned more about art and society, lost his religious faith, and met with adulation and yet incomprehension. One must not, however, overstress the degree of change or the inconsistency in his complex thought, since frequently what is at issue turns out to be more a matter of changed emphasis than an entirely new development. For example, perhaps Ruskin's most obvious and apparently radical shift of interest appears in his evolution from a critic of art to a critic of society. But even this new fervent interest in political economy

turns out to be not such a radical departure as it might first appear. Not only did Ruskin never entirely cease writing about art but he also had earlier always been concerned with the effects of art upon its audience. Similarly, when Ruskin shifts increasingly from visual to visionary art, or from aesthetics to iconographical readings of art, these are shifts of emphasis announced in the opening volume of *Modern Painters*, where he states that he will discuss ideas of truth, beauty, and relation in explaining the art of Turner and his contemporaries. Ruskin does at last fulfil his announced plan, but he makes many detours on the way.

Throughout his complex development, however, his urge to educate his contemporaries in the crucial – and crucially related – projects of seeing and understanding their world remains a constant. Ruskinian interpretation, whether of art or society, takes many subjects for its concern. It merges subtly on the one side with seeing, with raw perception, and on the other it blends with definition, the product (and project) of intellectual analysis. As a Victorian sage, Ruskin is first and foremost an exegete, an interpreter and definer of the real, and in the early volumes of *Modern Painters* such a critical project takes various forms. First of all, he sets out to make us *see* – to see all those beautiful facts of nature which laziness and inadequate artistic conventions have prevented us from perceiving. To enable us to see with his heightened powers, Ruskin relies on his word-paintings, which communicate the experience of his intense encounter with the visual world.

At the same time that Ruskin thus provides his reader with such fables of perception, which interpret raw experience for him, he also formulates a theoretical framework for his contention that art that communicates such heightened experience marks a great advance on the work of the old masters. Here the sage's formulations of the key terms of discourse take the appropriate form of precise explanations of terms basic to the painter's and the critic's art, terms such as 'colour', 'tone', 'beauty', 'imitation', and 'taste'. At the same time, Ruskin, who sets out to explain the superiority of modern landscape painting to that of sixtenth- and seventeenth-century masters, early begins to define and interpret broad movements in art and their relation to broader cultural, political, and religious history. His discussions of the fall of a great culture in

The Stones of Venice, the rise of landscape art in *Modern Painters III*, and the significance of the picturesque in *Modern Painters IV* exemplify such broader cultural interpretation. As he turns to the criticism of society, this joint concern to define key terms and interpret crucial phenomena remains constant. Therefore, from one point of view all that Ruskin does when he turns a large portion of his attention from art to society is simply to employ many of the same interests in a new area.

In the later works, however, his application of this interpretative bent often has a very different tone largely because the subjects of his interpretation appear more emotionally loaded, more dangerous, as subjects of such discussion. Furthermore, when Ruskin discussed the meaning of Gothic or the true significance of the picturesque, most of his contemporary readers did not find such issues threatening. In his early works, particularly in *Modern Painters* and *The Seven Lamps of Architecture*, he engaged himself to create a larger appreciation, understanding, and audience for painting and architecture, and a large part of his intended audience readily gave itself into Ruskin's hands. To them his assertiveness, rhetorical flourishes, and confessed dislike of the opinion of professional critics only appealed the more. In contrast, when he began to discuss political economy, a project clearly forewarned in the 1853 discussion of 'The Nature of Gothic' in *The Stones of Venice*, Ruskin pointedly confronted his audience and its beliefs. He not only wrote expecting a collision, he wrote increasingly to ensure one. Of course, having taken such an explicitly contentious, hostile approach to his audience's key beliefs about economic and political truths, Ruskin then skilfully deployed a wide range of rhetorical strategies that, in the face of this hostility, could win his audience's forebearance and eventual acceptance. The later applications of his exegetic skill appear in the context of subjects or concerns that are both surprising and even outrageous. Whereas the earlier matters for interpretation, individual paintings, broad cultural movements, or abstract concerns, were the obvious subjects for such an enterprise, the exegetical subjects in the later works take the reader more by surprise.

Such contentiousness, however, does not mark his autobiography, *Praeterita*, the last of Ruskin's works and the last that we

shall examine. Although its gentle, markedly unpolemical tone sets *Praeterita* apart from almost all his other prose, his citations of personal experience remain a constant throughout his long career. His comparisons in the first volume of *Modern Painters* of his experience of La Riccia with Claude's painting of it, his experience of Tintoretto's *Annunciation* in the second, and his similar narration of the experience of landscape in *The Seven Lamps of Architecture* (1849) and of Venice and its surrounds in *The Stones of Venice* (1851–3) are matched by his many relations of personal experience in the works on political economy. 'Traffic', for example, draws upon his encounter with an advertisement in a shop window observed while walking, and his other works present his personal experiences of the contemporary world, occasionally in the form of citations from his letters or diaries. *Praeterita*, too, which grew out of autobiographical chapters in *Fors Clavigera*, his letters to the working men of England, draws upon his characteristic word-painting and dramatization of the experience of meaning to create a new form of self-history. At the end, Ruskin, who had proved such a brilliant interpreter of art and society, proves himself one of the greatest, if most unusual, of autobiographers.

1 Ruskin the word-painter

Throughout his works, Ruskin engages himself to make us see and understand better – two operations that he takes to be intimately and even essentially related. When other writers would use the terms 'think' or 'conceive', he employs visual terminology; and when one expects to encounter the words 'understand', 'grasp', or 'think', he finds, instead, 'see'. Ruskin's theoretical statements, letters, and diaries all make abundantly clear that he assumed many psychological processes generally considered abstract to be visual and to proceed by means of visual images. Such assumptions do much to explain Ruskin's somewhat anachronistic adherence to the theory of visual imagination held by Hobbes, Locke, Addison, and Johnson – a view whose popularity Burke's *On the Sublime* (1757) had greatly undermined in the second half of the eighteenth century. These assumptions also suggest how Ruskin could be so perceptive about the nature and meaning of allegorical images. He believed that most abstractions, in fact, are first formulated mythically or symbolically and that only later does the conscious reason play its part.

Therefore, he believes that all truth is comprehended visually, and to this axiom he joins the corollary that to learn anything one must experience it – see it – for oneself. At the heart of Ruskin's aesthetic theories, practical criticism, and instructions to young artists lies a heartfelt conviction that one can only learn things, one can only know them, by experiencing them for oneself. Such an emphasis might appear particularly paradoxical in the work of a critic like Ruskin so committed, particularly in his later career, to allegorical and symbolical art. But even in regard to such symbolic modes Ruskin, who combines visual and visionary epistemologies, sees no conflict. As he makes clear in his discussions of artistic psychology and symbolic imagery, he believes that both visual and visionary truths are matters of direct experience, for, according to him, they are the way one actually encounters

127

such truths. In other words, he believes that the greatest moral and spiritual truths appear, and have always appeared, to mankind in symbolic form, so that whereas visual truths arise in the exterior world and visionary ones in the interior one of the mind, both are matters of personal experience. According to Ruskin, then, the fact that one only truly learns things, particularly ideas, by experiencing them simultaneously explains the human value of symbolic and visionary art, his own word-painting, and painterly realism.

For Ruskin the chief justification of realism as an artistic style thus resides in its forcing the artist to educate his eye and hand. Such a Ruskinian conception of realism as self-education furnishes the ultimate justification of his famous, if much misunderstood, injunction to young artists to 'go to nature in all singleness of heart, and walk with her laboriously and trustingly, having no other thoughts but how best to penetrate her meaning, and remembering her instruction; rejecting nothing, selecting nothing, and scorning nothing . . . and rejoicing always in the truth' (3. 624). Many readers have wondered how Ruskin, who had begun *Modern Painters* to proselytize Turner's late works of haze, swirling rain, and fantastic colours, could have ended his volume with such apparently contradictory instructions to the contemporary artist. Was it that the polemical origins of the work had led him astray? As Ruskin frequently reminds us in the course of this opening volume, he defends Turner's close knowledge of visual fact precisely because the critics of *Blackwood's* and *The Times* had attacked the artist's great works for being 'unlike nature'. The 1844 preface to *Modern Painters I* thus explains: 'For many a year we have heard nothing with respect to the works of Turner but accusations of their want of *truth*. To every observation on their power, sublimity, or beauty, there has been but one reply: They are not like nature. I therefore took my opponents on their own ground, and demonstrated, by thorough investigation of actual facts, that Turner *is* like nature, and paints more of nature than any man who ever lived' (3. 51–2). Has Ruskin's understandable desire to show up the critics who so harshly treated his artistic idol led him so far from his original intentions that he forgets to defend Turner's works of the 1840s at all?

As is usually the case with Ruskin, the solution to an apparent

gross inconsistency is readily seen once we look closely at the context in which it appears. Here Ruskin is most definitely not urging that all great art must take the form of realistic transcriptions of visual fact. He is not even addressing his remarks to mature artists. Rather he addresses the student, the beginner, emphasizing that 'from young artists nothing ought to be tolerated but simple *bonâ fide imitation* of nature. They have no business to ape the execution of masters . . . Their duty is neither to choose, nor compose, nor imagine, nor experimentalize; but to be humble and earnest in following the steps of nature, and tracing the finger of God' (3. 623). Even though Ruskin (and the editors of the Library Edition) caution that he directs his remarks to beginning students, readers have frequently misunderstood his point and thought that Ruskin was here advancing a claim for the artistic superiority of extreme photographic naturalism as a painterly style. In fact, immediately after thus instructing the neophyte, Ruskin adds that when visual experience has nurtured the young artists' hand, eye, and imagination, 'we will follow them wherever they choose to lead . . . They are then our masters, and fit to be so' (3. 624). In other words, to paint like Turner, or even to paint a very different art that could rival his, one first had to begin with training eye and hand. One, however, cannot stop at this training stage.

Ruskin made such recommendations because he firmly believed 'the imagination must be fed constantly by external nature' (4. 288) or, as he put it in somewhat different terms: 'I call the representation of facts the first end; because it is necessary to the other and must be attained before it. It is the foundation of all art; like real foundations, it may be little thought of when a brilliant fabric is raised on it; but it must be there' (3. 136–7). Such a conception of artistic development, in which symbolical or even visionary art is seen as growing forth from the visual, explains how Ruskin could have linked his defence of Turner with that of the Pre-Raphaelites, who were then painting shallow, static compositions in a hard-edge realism. His attitude towards the members of the Pre-Raphaelite Brotherhood is summed up in his statements that even though they had not achieved art of the quality of Turner, they were beginners on the right track. He explains in the Addenda to his lecture 'Pre-Raphaelitism' (1854):

It is true that so long as the Pre-Raphaelites only paint from nature, however carefully selected and grouped, their pictures can never have the character of the highest class of compositions. But, on the other hand, the shallow and conventional arrangements commonly called 'compositions' by the artists of the present day, are infinitely farther from great art than the most patient work of the Pre-Raphaelites. That work is, even in its humblest form, a secure foundation, capable of infinite superstructure; a reality of true value, as far as it reaches, while the common artistic effects and groupings are a vain effort at superstructure without foundation. (12. 161–2)

In defending Turner, Ruskin has looked back to his earlier works to reveal that in them the painter had created the necessary foundation that enabled him later to erect a 'brilliant fabric'; in defending the Pre-Raphaelites, a group of young men at the beginning of their careers, he only urged that they had thus far built the necessary foundation.

Ruskin makes personally achieved knowledge of visual fact the foundation of his art theory because he believes that it is only by trying to capture the external world in form and colour that the painter ever learns to apprehend it. Like E. H. Gombrich, he believes that we are more likely to see what we paint than paint what we see. Ruskin emphasizes that because we behold the world by means of conventions, artists have an especially difficult time in seeing the world anew and for themselves since they must break free from both the conventions of everyday seeing and those of artistic representation. According to him, his Victorian contemporaries 'permit, or even compel, their painters and sculptors to work chiefly by rule, altering their models to fit their preconceived notions of what is right'. The sad result of such rules is that 'when such artists look at a face, they do not give it the attention necessary to discern what beauty is already in its peculiar features; but only to see how best it may be altered into something for which they themselves have laid down the laws. Nature never unveils her beauty to such a gaze' (5. 99). Furthermore, the effects of such intellectually created rules do not stop with the work of art and the artist who produces it, for the effect is no less 'evil on the mind of the general observer. The lover of ideal beauty, with all his conceptions narrowed by rule, never looks carefully enough

upon the features which do not come under his law – to discern the inner beauty in them' (5. 99). Not only do cultural conventions teach the spectator to judge paintings by a false standard that prevents his enjoyment of novel beauties but they also teach him to perceive, or mis-perceive, the world around him, thus lessening both his pleasure and his knowledge. Ruskin, who here anticipates the work of Gombrich, always insists that art provides the visual vocabularies with which people confront the world around them and by which they experience it. He thus points out, for instance, that 'little as people in general are concerned with art, more of their ideas of sky are derived from pictures than from reality; and that if we could examine the conception formed in the minds of most educated persons when we talk of clouds, it would frequently be found composed of fragments of blue and white reminiscences of the old masters' (3. 345–6). For Ruskin, therefore, both artist and audience must learn to perceive with an innocent eye, forgetting what something is supposed to look like and trying to see it without conventional visual vocabularies. Unfortunately, one of the greatest barriers to new knowledge, new experience, of the world is that people see what they think they know to be there rather than what they see before them. As he points out in *A Joy For Ever* (1857), 'one of the worst diseases to which the human creature is liable is its disease of thinking. If it would only just *look* at a thing instead of thinking what it must be like . . . we should all get on far better' (16. 126).

Ruskin, one may point out, is one of the few critics and theoreticians in the history of Western art who have granted due importance to the roles of both visual thinking and the physical act of drawing or painting as a means of knowledge. His aesthetic theories here relate importantly to his political views because his recognition of the essential connection that joins the work or eye, hand, and mind in the artistic process leads to his emphasis on the essential dignity of labour. As he argues in *The Stones of Venice*, 'it is only by labour that thought can be made healthy, and only by thought that labour can be made happy, and the two cannot be separated with impunity' (10. 201). According to him, contemporary painting, like Renaissance architecture and modern factory

work, separated labour from thought and paid a heavy price for doing so.

Ruskin, whose personal experience convinced him that one could only sharpen one's perceptions of the external world by trying to draw it, came as a salutary correction to earlier art theory. In particular, the notion of *ut pictura poesis* – that painting and literature were sister arts possessing many of the same qualities and purposes – had been tried to raise the low status of the visual arts by emphasizing the intellectual nature of the artistic act. Writers, such as Reynolds, who worked with a restricting vocabulary that permitted them to distinguish only between manual and intellectual labour, inevitably gave short shrift to the physical and pre-conscious portions of the artistic process. When Ruskin creates a Romantic version of a sister-arts aesthetic, he replaces the great academician's distinction between intellectual and mechanical art with one that emphasizes a third faculty, the imagination. In this way he can avoid the need to see art as either pure mechanical imitation or intellectualized creation. According to Ruskin, the artist who generalizes by convention fails to make contact with nature and beauty, and as a result his art atrophies. He therefore insists: 'Generalization, *as the word is commonly understood*, is the act of a vulgar, incapable, and unthinking mind. To see in all mountains nothing but similar heaps of earth; in all rocks, nothing but similar concretions of solid matter; in all trees, nothing but similar accumulations of leaves, is no sign of high feeling or extended thought' (3. 37; my italics). Ruskin does not, any more than Reynolds, wish art mechanically to transcribe nature, but he emphasizes that the act of generalization – as it is not commonly understood – must be instinctive, unconscious, and imaginative, and it must be prepared for by years of learning to see with one's hand and in one's art.

In *Pre-Raphaelitism* (1851), which argues that all great art derives from the artist's learning to see for himself, Ruskin makes the charge that his contemporaries stifled and corrupted young artists by forging upon them conventionalized, generalized ideals:

We begin, in all probability, by telling the youth of fifteen or sixteen, that Nature is full of faults, and that he is to improve her; but that Raphael is

perfection, and that the more he copies Raphael the better; that after much copying of Raphael, he is to try what he can do himself in a Raphaelesque, but yet original manner: that is to say, he is to try to do something very clever, all out of his own head, but yet this clever something is to be properly subjected to Raphaelesque rules, is to have a principal light occupying one-seventh of its space, and a principal shadow occupying one third of the same; that no two people's heads in the picture are to be turned the same way, and that all the personages represented are to possess ideal beauty of the hightest order, which ideal beauty consists partly in a Greek outline of nose, partly in proportions expressible in decimal fractions between the lips and chin; but mostly in that degree of improvement which the youth of sixteen is to bestow upon God's work in general. This I say is the kind of teaching which through various channels, Royal Academy lecturings, press criticisms, public enthusiasm, and not the least by solid weight of gold, we give to our young men. And we wonder we have no painters! (12. 353–4)

Ruskin scorns the Neoclassical ideal because, by placing man in a prideful, false relation to nature, it limits instead of enhancing vision. In particular, he believes that such premature reaching after an ideal prevents the young artist from learning to see for himself. And, as Ruskin emphasizs in *Pre-Raphaelitism* (1851), to see for oneself is the foundation of all great art: 'every great man paints what he sees ... And thus Pre-Raphaelitism and Raphaelitism, and Turnerism, are all one and the same, so far as education can influence them'. Although very different men may employ their abilities to create different kinds of art, they are none the less 'all the same in this, that Raphael himself, so far as he was great, and all who preceded or followed him who ever were great, became so by painting the truths around them as they appeared to each man's mind, not as he had been taught to see them, except by the God who made both him and them' (12. 385)

Furthermore, like many Renaissance writers on art, Ruskin believes proportion, design, and artistic composition follow natural laws. But, unlike these earlier art theorists, he does not accept that such laws are reducible to a few central rules or proportions, such as the golden mean. Therefore, Ruskin holds, once again, that the only way the artist can learn either to perceive the beautiful or to compose pictures is by confronting nature in the act of representation. As he explains in *A Joy For Ever* (1857), 'A student who can

fix with precision the cardinal points of a bird's wing, extended in any fixed position, and can then draw the curves of its individual plumes without measurable error, has advanced further towards a power of understanding the design of the great masters than he could by reading many volumes of criticism, or passing many months in undisciplined examination of works of art' (16. 149). By attempting to capture nature's beauties in a drawing or painting, one sharpens one's perceptions of both nature and art.

Ruskin's attempts to teach his contemporaries how to see do not stop with the theoretical pronouncements he makes throughout his writings. These theories, which provide the foundation for his entire critical enterprise, are intended to defeat the opponents of Turner, to convince his other readers that Ruskin defends him in an obviously rational manner, and to urge young artists, professional and amateur alike, to forge a living relation with the world. Ideally, Ruskin wants every reader to test his ideas by trying to draw the infinite variety of nature himself, and in fact he wrote *The Elements of Drawing* (1857) to promote such a desire. However, realizing that most readers would have to be convincd by his verbal arguments, Ruskin employs his great gift of word-painting to provide his readers with the kind of visual relation to the world he would like them to develop.

Ruskin's word-painting, his characteristic educative and satiric technique in the early works, takes three forms, each more complex than the last. First of all, he employs what we may term an additive style, in which he describes a series of visual details one after another. For example, when describing how effectively Turner paints water in the first volume of *Modern Painters*, he proceeds by dividing his analysis into various visual facts. He thus first points out that Turner correctly represents the energy of a raging ocean by utilizing both the extension as well as the height of the waves. 'All the size and sublimity of nature are given, not by the height, but by the breadth, of her masses; and Turner, by following her in her sweeping lines, while he does not lose the elevation of its surges, adds in a tenfold degree to their power' (3. 564). Next, he emphasizs the effect of weight that Turner has managed to create: 'We have not a cutting, springing, elastic line; no jumping or leaping in the waves; *that* is the characteristic of

Chelsea Reach or Hampstead Ponds in a storm. But the surges roll and plunge with such prostration and hurtling of their mass against the shore, that we feel the rocks are shaking under them' (3. 564–5).

At this point, having quietly moved from abstract analysis to general description and then to a description of a specific event, he placs us within the energies he describes. Immediately afterwards, he adds another 'impression' when he instructs us, 'observe how little, comparatively, they are broken by the wind: above the floating wood, and along the shore, we have indication of a line of torn spray; but it is a mere fringe along the ridge of the surge, no interference with its gigantic body. The wind has no power over its tremendous unity of force and weight' (3. 565). Whereas earlier in this passage Ruskin merely mentioned the various visual facts that Turner's art had accurately recorded, he now has subtly moved us into the world of these facts, trying to make his readers see more accurately, see the kind of phenomena they would elsewise have neither confronted nor noticed at all. Ruskin concludes this portion of his description by pointing to yet another fact recorded by Turner's painting, after which he points out its implications. Although this passage has moved from a discussion of abstract qualities to a description of specific embodiments of them, Ruskin has not found it necessary to create a fully imagined space because he follows Turner's work so closely. Although more complex than most other instances of his additive style, this passage characteristically proceeds by adding one set of observed facts to previously mentioned ones.

In contrast, his second form of word-painting proceeds by creating a dramatized scene before us, after which it focuses our attention on a single element that moves through the space he has conjured up with language. For example, when writing about rain clouds, Ruskin explains how they first form and then move in relation to the earth below, and then, like the evangelical preacher and the Romantic poet, he cites his own experience:

I remember once, when in crossing the Tête Noire, I had turned up the valley towards Trient, I noticed a rain-cloud form on the Glacier de Trient. With a west wind, it proceeded towards the Col de Balme, being followed by a prolonged wreath of vapour, always forming exactly at the same spot

over the glacier. This long, serpent-like line of cloud went on at a great rate till it rached the valley leading down from the Col de Balme, under the slate rocks of the Croix de Fer. There it turned sharp round, and came down this valley, at right angles to its former progress, and finally directly contrary to it, till it came down within five hundred feet of the village, where it disappeared; the line behind always advancing, and always disappearing at the same spot. This continued for half an hour, the long line describing the curve of a horse-shoe; always coming into existence and always vanishing at exactly the same places; traversing the space between with enormous swiftness. This cloud, ten miles off, would have looked like a perfectly motionless wreath, in the form of a horse-shoe, hanging over the hills (3. 395)

Ruskin thus sets us before his Alpine scene, permitting us to observe the movement of a single element within it. After he has concluded his examination of the moving cloud, he moves us farther away and tells us what it would look like – how we would experience it – from a different vantage point.

In such a passage of description Ruskin proceeds by placing us before a scene, making us spectators of an event. By permitting (or forcing) the reader to see with his eyes, he simultaneously achieves several goals: first, he furnishes us with a standard by which works of art purporting to convey natural fact can be tested; second, by permitting us access to his perceptions – by permitting us to see with his eyes – he allows (or forces) us to perceive specific natural facts we may never have noticed or understood before; third, by so doing, he makes one of his major points, namely, that the external world contains innumerable beautiful phenomena most people never perceive or even realize exist; finally, by making this demonstration on his own pulses, as it were, Ruskin demonstrates to the reader his dependence upon him, for without Ruskin few readers would encounter these phenomena.

In Ruskin's third and most elaborate form of word-painting, he develops his role of Master of Experience even more fully. Now he sets us within the depicted scene itself, makes us participate in its energies, and here fulfils his own descriptions of imaginative art. Several passages in *Modern Painters* explain that both the novice and the painter without imagination must content themselves with a topographical art of visual fact. 'The aim of the great inventive landscape painter', on the other hand, 'must be to give

the far higher and deeper truth of mental vision, rather than that of the physical facts, and to reach a representation which . . . shall yet be capable of producing on the far-away beholder's mind precisely the impression which the reality would have produced' (6. 35). As the opening volume explains, in this higher form of art 'the artist not only *places* the spectator, but . . . makes him a sharer in his own strong feelings and quick thoughts' (3. 134). The great imaginative artist, in other words, grants us the privilege of momentarily seeing with his eyes and imaginative vision; we experience his phenomenological relation to the world.

Ruskin achieves this goal in language by employing what we may anachronistically term a cinematic prose; that is, he first places himself and his reader firmly in position, after which he generates a complete landscape by moving his centre of perception, or 'camera eye', in one of two ways. He may move us progressively deeper into the landscape in a manner that anticipates cinematic use of the zoom lens, or he may move us laterally across the scene while remaining at a fixed distance from the subject – a technique that similarly anticipates the cinematic technique called panning. By thus first establishing his centre of observation and then directing its attention with patterned movement, Ruskin manages to do what is almost impossible – create a coherent visual space with language. Such a procedure, which he employs when describing both works of art and the natural world they depict, appears, for instance, in his brilliant description of La Riccia in the first volume of *Modern Painters* and in many crucial passages in *The Stones of Venice*, including his magnificent tour of Saint Mark's, his aerial view of the Mediterranean Sea, and his narration of the approach of Torcello.

This narration of the approach to this (then) desolate island exemplifies a particularly pure form of such cinematic word-painting because Ruskin strives to convey the experience of movement towards this lonely, deserted place. He begins by locating us in space:

Seven miles to the north of Venice, the banks of sand, which nearer the city *rise* little above low-water mark, *attain* by degrees a higher level, and *knit* themselves at last into fields of salt morass, raised here and there into shapeless mounds, and intercepted by narrow creeks of sea. One of the

feeblest of these inlets, after *winding* for some time among buried frag-
ments of masonry, and knots of sunburnt weeds whitened with webs of
fucus, *stays* itself in an utterly stagnant pool beside a plot of greener grass
covered with ground ivy and violets. (10. 17; my italics)

As my italicization of several words in this passage reveals, Ruskin
infuses even this quiet, desolate scene with energy by here relying
on active verbs and generally avoiding passives. These verbs
provide a movement that leads the eye into the scene even as it
creates it, and having created before the reader's eye the island of
Torcello, Ruskin then selfconsciously places himself and his reader
in that scene:

On this mound is built a rude brick campanile, of the commonest
Lombardic type, which if we ascend towards evening (and there are none
to hinder us, the door of its ruinous staircase swinging idly on its hinges),
we may command from it one of the most notable scenes in this wide
world of ours. Far as the eye can reach, a waste of wild sea moor, of a lurid
ashen grey; not like our northern moors with their jet-black pools and
purple heath, but lifeless, the colour of sackcloth, with the corrupted sea-
water soaking through the roots of its acrid weeds, and gleaming hither
and thither through its snaky channels. No gathering of fantastic mists,
nor coursing of clouds across it; but melancholy clearness of space in the
warm sunset, oppressive, reaching to the horizon of its level gloom (10. 17)

Having approached this desolate island and then climbed its
abandoned bell tower with Ruskin, we find our gaze directed
successively in each of the directions of the compass, after which
he instructs us to look down at Torcello itself and notice the four
small stone buildings, one of them a church, which 'lie like a little
company of ships becalmed on a far-away sea' (10. 18). After
describing the buildings and the distant view of Venice more fully,
he then guides our emotional reaction to what we have seen when
he remarks that 'the first strong impression which the spectator
receives from the whole scene is, that whatever sin it may have
been which has on this spot been visited with so utter a desolation,
it could not at least have been ambition' (10. 20).

Ruskin's perhaps surprising introduction of the notion that only
punishment for sin could have produced such desolation reminds
the reader that he has taken us to Torcello, as he has taken us to
Venice itself, to explain in the manner of an Old Testament

prophet how to read a warning for England in the fate of an earlier commercial and military power. Ruskin characteristically finds such warnings in the evidence of Venetian architecture and its relation to the workers who created it, for he argues that the movement from Gothic to Renaissance styles embodies Venetian secularization and a consequent turning away from the pious Christianity which, he believes, originally founded its strength. Therefore, when he takes us to Torcello, the first island on which the eventual founders of Venice settled in their flight from the mainland, he wishes both to contrast it in its present desolation with its daughter, Venice, and to emphasize how Torcello's founders, who took literally the notion that the church was their ark of salvation, had a faith tragically long since lost. Therefore the remainder of the chapter concerns itself with examining the cathedral on the island and what it meant to its original builders. But to create this effect, Ruskin first skilfully employs his cinematic style to move us through the Venetian lagoon so that we experience the approach to this desoloate place with some of the same feelings as the original settlers, who had fled mainland wars.

Such effective passages are thus hardly mere embellishments of his main argument, nor are they self-indulgent displays of virtuosity – though in his early works, particularly the first volume of *Modern Painters*, Ruskin certainly enjoyed such virtuosity. His word-painting is not even a tactic that he employs to smooth over the rough spots in an argument. Such writing in fact is central to Ruskin's conception of himself as critic and sage. Since he relies upon this cinematic prose to educate his audience's vision, teaching its members to see shapes, tone, colours, and visible fact they have often confronted but failed to observe, these descriptions are basic to his conception of himself as one who teaches others to see, experience, and understand. Such writing also serves to establish what the older rhetoricians called the speaker's *ethos*. The main problem for the Victorian sage is to convince others that he is worth listening to, that he is a man whose arguments – however strange they may at first appear – are the products of a sincere, honest, and above all reliable, mind. One of the first tasks of any speaker or writer is to establish himself before his audience as a believable, even authoritative, voice; and this Ruskin easily

accomplishes by demonstrating that he has seen and has seen more than the critics who oppose him. His critics are blind, and he has vision.

These passages of highly wrought prose take their place as part of a larger structure of argument. They serve, in fact, as a major part of that complex rhythm of satire and Romantic vision which characterizes the proceedings of the Victorian sage. In the earlier volumes of *Modern Painters*, where Ruskin employs it to defend Turner against the claims of older art, this rhythm takes the form of a satirical word-painting of a work by an old master followed by Ruskin's description of either a similar work by Turner or a scene the older work was supposed to represent. For example, in his chapter 'Of the Truth of Colour' in the first volume of *Modern Painters*, he first looks at Gaspar Poussin's *La Riccia* in the National Gallery, after which he presents his own impressions of the original scene. Writing with heavy sarcasm, Ruskin easily conveys the impression that the painting so prized by the critics who treated Turner's advanced work cruelly does not concern itself with presenting the facts of a particular place:

It is a town on a hill, wooded with two-and-thirty bushes, of very uniform size, and possessing about the same number of leaves each. These bushes are all painted in with one dull opaque brown, becoming very slightly greenish towards the lights, and discover in one place a bit of rock, which of course would in nature have been cool and grey beside the lustrous hues of foliage, and which, therefore, being moreover completely in shade, is consistently and scientifically painted of a very clear, pretty, and positive brick red, the only thing like colour in the picture. The foreground is a piece of road which, in order to make allowance for its greater nearness, for its being completely in light, and, it may be presumed, for the quantity of vegetation usually present on carriage roads, is given in a very cool green grey; and the truth of the picture is completed by a number of dots in the sky on the right, with a stalk to them of a sober and similar brown. (3. 277–8)

Immediately after presenting this harshly sarcastic rendering of the painting attributed to Gaspar Poussin, Ruskin employs his familiar strategy of citing his own experience of a scene ineptly presented in a work of visual art:

Not long ago, I was slowly descending this very bit of carriage-road, the first turn after you leave Albano . . . It had been wild weather when I left Rome, and all across the Campagna the clouds were sweeping in sulphurous blue, with a clap of thunder or two, and breaking gleams of sun along the Claudian aqueduct lighting up the infinity of its arches like the bridge of chaos. But as I climbed the long slope of the Alban Mount, the storm swept finally to the north, and the noble outline of the domes of Albano, and the graceful darkness of its ilex grove, rose against pure streaks of alternate blue and amber, the upper sky gradually flushing through the last fragments of rain-cloud in deep palpitating azure, half aether and half dew. The noonday sun came slanting down the rocky slopes of La Riccia, and their masses of entangled and tall foliage, whose autumnal tints were mixed with the wet verdure of a thousand evergreens, were penetrated with it as with rain. I cannot call it colour, it was conflagration. Purple, and crimson, and scarlet, like the curtains of God's tabernacle, the rejoicing trees sank into the valley in showers of light, every separate leaf quivering with buoyant and burning life; each, as it turned to reflect or to transmit the sunbeam, first a torch and then an emerald. Far up into the recesses of the valley, the green vistas arched like the hollows of mighty waves of some crystalline sea, with the arbutus flowers dashed along their flanks for foam, and silver flakes of orange spray tossed into the air around them, breaking over the grey walls of rock into a thousand separate stars, fading and kindling alternately as the weak wind lifted and let them fall. Every glade of grass burned like the golden floor of heaven, opening in sudden gleams as the foliage broke and closed above it, as sheet-lightning opens in a cloud at sunset. (3. 278–9)

In setting forth his satiric examination of *La Riccia*, Ruskin quickly dismisses the original work because he wishs to concentrate only on the element of colour, a point on which he finds it particularly easy to praise Turner and to attack his predecessors.

Here as elsewhere, Ruskin convinces us of his position by means of a superbly controlled alternation of vision and satire, preparing us for his polemic at each step of the way by allowing us to borrow his ideas and see. His skill at presenting us with his experience of landscape and landscape art continually makes us feel that his critical opponents and the painters he attacks both work from theory, from recipes, rather than from vision.

2 Ruskin the interpreter of the arts

When Ruskin devoted entire chapters in his fifth volume (1860) to detailed interpretations of individual paintings by Turner, he sounded a note that had been well prepared for from his earliest writing. As his autobiography shows, he learned to associate narrative and meaning with pictures at a young age. One of *Praeterita*'s more charming vignettes relates, for example, that each morning while his father shaved, he told his son a story about figures in a water-colour landscape that hung on his bedroom wall.

Margaret Ruskin's teaching her son to read the Scriptures, which provided his knowledge of sacred history and exegetical tradition, had an even more obvious influence on his career as an interpreter of art, for her lesson taught him both basic attitudes towards interpretation and detailed knowledge of traditional Christian symbolism. Like so many other major Victorian authors, including Carlyle, Newman, Browning, Eliot, Tennyson, Rossetti, and Hopkins, Ruskin learned his interpretative approaches from reading the Scriptures for types and anticipations of Christ. He transferred to interpretations of painting and architecture the evangelical's habit of taking apparently trivial portions of the Bible and from them demonstrating that even there matters of major significance are found. Preachers and authors of Bible commentaries emphasized, for example, that although the rules in the Book of Leviticus for worship in the Temple at Jerusalem might appear completely irrelevant to a modern believer, they contain truths essential for Christians. According to the standard readings, Christians, who realize that the blood of animals cannot absolve guilt, should none the less meditate upon Leviticus both as a prefiguration of Christ and also as a record of man's gradual realization that he needs a saviour. When Ruskin was nine years old, he took notes on a sermon that made these points, and the various drafts of these sermon records show how completely he understood this interpretative method even as a young boy. In addition, as *The Seven*

Lamps of Architecture (1849) reveals, he drew upon this evangelical interpretation of Leviticus when he argued that his contemporaries should build elaborate houses of worship.

Like Ruskin's knowledge of interpretative commonplaces, the fundamental attitudes towards interpretation which he first learned as a young child appear throughout his career. The most important of these basic assumptions is that everything has meaning, that the universe exists as a semiotic entity that one can read if one has the key. In other words, transferring the attitudes and methods of Protestant scriptural interpretation to art, literature, and society, he approaches such secular matters as if they were Holy Scripture.

When Ruskin makes a straightforward typological reading of Tintoretto's Scuola di San Rocco *Annunciation* or of one of Giotto's frescoes in the Arena Chapel, Padua, he simply applies his knowledge of the conventional religious significance of certain images to an art-historical problem. He makes a more extreme, if none the less conventional, application of Victorian Protestant commonplaces when he begins *The Stones of Venice* (1851) with a warning that this city-state provides a type – and warning – of his own nation's fate. A more radical transference occurs, on the other hand, when he bases his notions of mythology in Turner and the Western tradition on interpretative attitudes derived from his childhood Bible reading or when he employs the tripartite pattern of Old Testament prophecy in writing about contemporary society.

Although word-painting dominates the first volume of *Modern Painters*, even its elaborately pictorial set pieces contain elements of interpretation. Already at this early stage in his career, Ruskin believed that confronting a work of art requires that one encounter it both visually and intellectually. For example, as his satirical description of Claude's *Il Mulino* in *Modern Painters I* demonstrates, his satirical attacks often necessarily contained rudimentary iconographical analyses, for when describing what takes place in the picture to his reader, he interprets and comments upon the action depicted.

When Ruskin turns increasingly towards iconological analysis in the second volume, he clearly does not believe he is turning away from experience of a painting by confronting its symbolism.

Rather, for Ruskin, one experiences meaning, just as one does light, colour, and form. To provide a full experience of a painting for the reader, therefore, he has to dramatize the process of perceiving both. Such an approach to art appears with particular clarity in his section on the penetrative imagination in the second volume of *Modern Painters*. Describing Tintoretto's *Annunciation* in the Scuola di San Rocco, Venice, Ruskin begins with the spectator's experience of its realism. He starts therefore by pointing out that one first notices the Virgin sitting 'houseless, under the shelter of a palace vestibule ruined and abandoned', surrounded by desolation. The spectator, says Ruskin, 'turns away at first, revolted, from the central object of the picture forced painfully and coarsely forward, a mass of shattered brickwork, with the plaster mildewed away from it'. Such genre details, he suggests, might strike one as little more than a study of the kind of scene the artist 'could but too easily obtain among the ruins of his own Venice, chosen to give a coarse explanation of the calling and the condition of the husband of Mary'. Ruskin, in other words, begins his presentation of this painting by dramatizing the paths the spectator's eye takes as it comprehends first major and then minor visual details. But because he believes that visible form inextricably relates to meaning, he then immediately presents us with an imagined spectator's first conclusions about the meaning of these details: they appear, it seems, to reflect both the painter's contemporary surroundings in a ruined Venice and his modern fascination with the picturesque, that aesthetic mode which delights in ruin.

At this point, Ruskin takes us deeper into the picture's meaning, and he does so by first intensifying our visual experience of it. According to him, if the spectator examines the 'composition of the picture, he will find the whole symmetry of it depending on a narrow line of light, the edge of a carpenter's square, which connects these unused tools with the object at the top of the brickwork, a white stone, four square, the corner-stone of the old edifice, the base of its supporting column'. Citing Psalm 118, Ruskin explains that these details reveal that the entire painting – and all its coarsely realistic details – bear a typological meaning, for, according to standard readings of this psalm, it prefigures Christ. In Tintoretto's *Annunciation*, therefore, the 'ruined house

is the Jewish dispensation: that obscurely arising in the dawning of the sky is the Christian; but the corner-stone of the old building remains, though the builder's tools lie idle beside it, and the stone which the builders refused is become the Headstone of the Corner' (2. 264–5)

Ruskin's guide through Tintoretto's *Annunciation* provides his reader with a lesson in perception. Using his gifts for word-painting, iconographical interpretation, and compositional analysis, Ruskin does not simply tell us what the painting in question means. Instead, he provides us with a fable or parable of ideal perception which dramatizes the experience of one who gradually perceives the meaning of a painting and thus fully experiences the work of art. Ruskin, who had a gift for intellectual analysis, understood his role as art critic as necessarily moving beyond it to an imaginative demonstration of the experience of meaning. Just as the first volume of *Modern Painters* teaches his readers how to perceive the worlds of nature and art, his later ones teach them how to interpret those worlds, and in both projects, which Ruskin clearly saw completely intertwined, he concentrates on providing the reader with models of experience.

Ruskin's analytical description of Tintoretto's *Annunciation* had a major effect upon Victorian art. In particular, his description of the way commonplace readings of the Bible could successfully infuse naturalistic detail with an elaborate symbolism significantly influenced the Pre-Raphaelite Brotherhood. Students of this movement long thought that the young William Holman Hunt, John Everett Millais, and Dante Gabriel Rossetti must have been inspired by the first volume of *Modern Painters*, which emphasized that the young student should rely on detailed naturalism to train eye and hand, but Ruskin himself never claimed such influence. Hunt, one of the founding members of the Pre-Raphaelite Brotherhood, related in his memoirs that the critic's second volume came to him as a sublime source of inspiration, precisely because it suggested a means of solving the two major problems that troubled British art – a general weakness of style and technique caused by a reliance on outmoded pictorial convention and the absence of effective pictorial symbolism that could speak to the Victorian audience. Ruskin's presentation of biblical symbolism in his

analyses of Tintoretto encouraged the young men both to test artistic convention and to explore the boundaries of painterly realism. By demonstrating how such imagery could infuse the most minute realistic details of a picture with meaning, Ruskin obviously justified including them. Furthermore, his parable of experience, which dramatizes how the spectator gradually realizes the meaning of Tintoretto's painting, also encouraged these young artists to paint a kind of work which demanded that the spectator pay close attention to all such minute details, and thus Ruskin's descriptions encouraged a kind of nineteenth-century emblematic or meditative art. In addition, Ruskin's description of how typology turned an apparently coarse genre subject into high art also provided a solution to what Hunt felt to be one of the chief needs of Victorian painting – the need for a new iconology to replace outmoded allegories and other forms of symbolism that no longer spoke to the age.

Although Ruskin did not learn of this Pre-Raphaelite debt to his work until after almost three decades had passed, when Hunt thanked him in a letter, he increasingly turned to detailed readings of art after having to defend the Pre-Raphaelites. The need to defend Hunt's paintings, *The Light of the World* (1853) and *The Awakening Conscience* (1853), therefore importantly influenced Ruskin's own career, the student influencing the master, the influenced becoming the influence.

This seeming change of direction in Ruskin's critical enterprise (which none the less was at least partly anticipated by his plan for *Modern Painters*) appears in both *The Stones of Venice* and the volume of *Modern Painters* Ruskin wrote next after sending his famous letters to *The Times* in defence of these young painters. He expanded his notions of artistic symbolism, its relation to the great artist-poet, and its central place in any basic consideration of art. One centre of his new interests appears in his discussions of the entire grotesque mode of imagination, which embodies itself variously in art, architecture, and literature.

Unlike Macaulay, Arnold, and most Victorian critics, Ruskin accepted that allegory and symbolism played an essential role in great art and literature. Indeed, in *Modern Painters III* (1856) he expresses a 'wish that every great allegory which the poets ever

invented were powerfully put on canvas, and easily accessible by all men, and that our artists were perpetually exciting themselves to invent more' (5. 134). He points out that as far as the authority of the past bears on the question, 'allegorical painting has been the delight of the greatest men and of the wisest multitudes, from the beginning of art, and will be till art expires' (5. 134).

Furthermore, while still writing as a believing Christian, he argued that man's love of symbolism, like his instinctive delight in beauty, derives from fundamental laws of human nature that lead man back to the divine. As he explained about the symbolical grotesque in the last volume of *The Stones of Venice* (1853):

It was not an accidental necessity for the conveyance of truth by pictures instead of words, which led to its universal adoption wherever art was on the advance; but the Divine fear which necessarily follows on the understanding that a thing is other and greater than it seems; and which, it appears probable, has been rendered peculiarly attractive to the human heart, because God would have us understand that this is true not of invented symbols merely, but of all things amidst which we live; that there is a deeper meaning within them than eye hath seen, or ear hath heard; and that the whole visible creation is a mere perishable symbol of things eternal and true. (11. 182–3)

Ruskin, whose evangelical religious heritage continued to colour his thought long after he began to lose his childhood faith, always believed that the mind first perceives difficult truths in symbolic form. Symbolism, both pictorial and literary, thus has a basic, essential epistemological role. Whenever we experience anything too great or too difficult for us to grasp fully – and Ruskin holds that most truths are beyond man – we encounter the grotesque, the term that Ruskin applies to all forms of symbolism.

Ruskin's writings on the grotesque, which stand out as some of the finest critical and theoretical work produced in Victorian England, have two main focuses – theoretical descriptions of the artist, essentially psychological profiles of the kind of mind that creates this artistic mode, and analyses of works of art and literature which embody it. According to *Modern Painters III*, the central form or mode of the grotesque arises from the fact that the imagination 'in its mocking or playful moods ... is apt to jest, sometimes bitterly, with under-current of sternest pathos, some-

times waywardly, sometimes slightly and wickedly, with death and sin; hence an enormous mass of grotesque art, some most noble and useful, as Holbein's Dance of Death, and Albert Dürer's Knight and Death, going down gradually through various conditions of less and less seriousness in an art whose only end is that of mere excitement, or amusement by terror' (5. 131). In addition to this darker form of the grotesque, which includes work ranging from traditional religious images of death and the devil to satire and horrific art, there is a comparatively rare form that arises 'from an entirely healthful and open play of the imagination, as in Shakespere's Ariel and Titania, and in Scott's White Lady' (5. 131). This delicate fairy art is so seldom achieved because 'the moment we begin to contemplate sinless beauty we are apt to get serious; and moral fairy tales, and other such innocent work, are hardly ever truly, that is to say, naturally, imaginative; but for the most part laborious inductions and compositions. The moment any real vitality enters them, they are nearly sure to become satirical, or slightly gloomy, and so connect themselves with the evil-enjoying branch' (5. 131–2). In other words, human beings have a natural tendency to discover (or impose) meaning in the facts they encounter.

The third form of the grotesque, which served as the basis for Ruskin's conception of a high art suited to the Victorian age, is the 'thoroughly noble one . . . which arises out of the use or fancy of tangible signs to set forth an otherwise less expressible truth; including nearly the whole range of symbolical and allegorical art and poetry' (5. 132). Ruskin, who valuably perceived that fantastic art and literature form part of a continuum that includes sublime, symbolic, grotesque, and satirical work, makes the individual image the centre of his discussion. As he next explains, 'A fine grotesque is the expression, in a moment, by a series of symbols thrown together in a bold and fearless connection, of truths which it would have taken a long time to express in any verbal way, and of which the connection is left for the beholder to work out for himself; the gaps, left or overleaped by the haste of the imagination, forming the grotesque character' (5.132). Drawing upon Spenser's description of envy in the first book of *The Faerie Queene*, he points out that the poet

desires to tell us, (1) that envy is the most untamable and unappeasable of the passions, not to be soothed by any kindness; (2) that with continual labour it invents evil thoughts out of its own heart; (3) that even in this, its power of doing harm is partly hindered by the decaying and corrupting nature of the evil it lives in; (4) that it looks every way, and that whatever it sees is altered and discoloured by its own nature; (5) which discolouring, however, is to it a veil, or disgraceful dress, in the sight of others; (6) and that it never is free from the most bitter suffering, (7) which cramps all its acts and movements, enfolding and crushing it while it torments. All this has required a somewhat long and languid sentence for me to say in unsymbolical terms, – not, by the way, that they *are* unsymbolical altogether, for I have been forced, whether I would or not, to use *some* figurative words; but even with this help the sentence is long and tiresome, and does not with any vigour represent the truth. (5. 132)

Spenser, on the other hand, puts all of these ideas 'into a grotesque, and it is done shortly and at once, so that we feel it fully, and see it, and never forget it' (5. 133). To demonstrate the power, concision, and sheer memorability of such symbolic statement, Ruskin then quotes the poet's emblematic portrait of envy, to which he attaches numbers referring to his own preliminary interpretation:

	And next to him malicious Envy rode
(1)	Upon a ravenous wolfe, and (2, 3) still did chaw
	Between his cankred teeth and venemous tode,
	That all the poison ran about his jaw.
(4, 5)	All in a kirtle of discoloured say
	He clothed was, y-paynted full of eies;
(6)	And in his bosome secretly there lay
	An hateful snake, the which his taile uptyes
(7)	In many folds, and mortall sting implyes'. (5. 133)

Ruskin concludes that Spenser has compressed all this material in nine lines, 'or, rather in one image, which will hardly occupy any room at all on the mind's shelves, but can be lifted out, whole, whenever we want it. All noble grotesques are concentrations of this kind, and the noblest convey truths which nothing else could convey' (5. 133). Furthermore, the minor examples of this symbolic mode convey truth with a delight 'which no mere utterance of the symbolised truth would have possessed, but which belongs to the effort of the mind to unweave the riddle, or to the sense it has of

there being an infinite power and meaning in the thing seen, beyond all that is apparent' (5. 133).

Ruskin's analysis of Tintoretto's *Annunciation* in the second volume of *Modern Painters*, Spencer's Ate from *The Faerie Queene* in the third, Turner's *Garden of the Hesperides* and *Apollo and Python* in the fifth, and Milton's 'Lycidas' in *Sesame and Lilies* all exemplify this kind of sophisticated interpretative analysis so rare in nineteenth-century criticism.

In the fifth volume of *Modern Painters* (1860), the simple, straightforward interpretation, which characterized his reading of Spenser, is replaced by putting the object of interpretation against the background – or within the context – of a collection of works, all of which together constitute a tradition. During the fourten years that passed between the writing of the second and the fifth volumes of *Modern Painters* major changes took place in the religious faith that had originally founded Ruskin's interpretative methods. Ruskin, who wrote *Modern Painters II* as a fervent evangelical, drew heavily upon his religious heritage in it for argument, authority, and rhetoric, just as he did in *The Seven Lamps of Architecture* (1849). By the time he came to write *The Stones of Venice* (1851–3), his faith, while still relatively firm, had become more tolerant, and for the first time defended Roman Catholicism to his predominantly Protestant audience. By 1856, when he wrote the next two volumes of *Modern Painters*, his faith had gradually weakened under the blows of geology and contemporary approaches to the Bible; and although he still drew upon his religious heritage for evidence and method, he no longer made the Scriptures the centre of any argument. After his decisive loss of belief in 1858, Ruskin spent several decades wavering between agnosticism and outright, if unannounced, atheism. *Modern Painters V* (1860), the first major work written after his abandonment of Christianity in Turin, makes no explicit statement of his changed religious allegiance, but the new attitudes towards man, art, and society which appear reveal that a radical development has taken place. Ruskin's earlier praise of asceticism and Purist Idealism has been replaced by scorn for those who do not emphasize the primacy of life in this world, and his earlier theological emphases have been replaced by something like a concern for a religion of human-

ity. Since Ruskin's loss of belief effectively removed the basis of his earlier defences of beauty and art, he found yet another reason for stressing the capacity of art to convey truth. However, just as he found additional reasons for teaching his readers how to interpret art, the original basis of his interpretative methods vanished, too. Fortunately, he easily replaced it by concentrating on the value of myth and other forms of tradition.

According to Ruskin, myth is a special form of the symbolical grotesque which veils 'a theory of the universe under the grotesque of a fairy tale' (12. 297). Ruskin, who increasingly became attracted to the study of myth when he lost his faith in the Bible as a divinely inspired text, applies to myth interpretative techniques learned in Bible study. He can thus apply these procedures because he still accepts that moral and spiritual truths reside in traditional texts. After he abandons his Protestant faith, however, he no longer takes any one text as divinely ordained, for as he comes increasingly to place his emphasis on human beings rather than upon a divine father, he also places more importance upon received wisdom. No longer accepting any single privileged text, Ruskin thus willingly perceives that of many different ones each contains some portion of necessary truth, and thus finding truth in so many different places, he, like so many moderns, tries to constitute a tradition by assembling its major texts.

Continuing a practice he had begun long before, Ruskin applies habits of mind and methods of reading first learned in Bible study to the interpretation of these texts, including pagan myths. For instance, like the Bible, a myth indicates the presence of meanings by an enigmatic literal or narrative level. As he explains in *The Queen of the Air* (1869), 'A myth, in its simplest definition, is a story with a meaning attached to it, other than it seems to have at first; and the fact that it has such a meaning is generally marked by some of its circumstances being extraordinary, or, in the common use of the word, unnatural' (19. 296). Ruskin further explains that if he informed the reader 'Hercules killed a water-serpent in the lake of Lerna, and if I mean, and you understand, nothing more than that fact, the story, whether true or false, is not a myth' (19. 296). If, however, he intends this story of Hercules' triumph to signify that he purified many streams, the tale, however

151

simple, is a true myth. Since audiences will not pay enough attention to such simple narratives, Ruskin, or any creator of myth, must 'surprise your attention by adding some singular circumstance ... And in proportion to the fulness of intended meaning I shall probably multiply and refine upon these improbabilities' (19. 296). In other words, Ruskin applies to myth the points he made about the symbolical grotesque thirteen years earlier. Myth, like Spenserian allegory, communicates 'truths that nothing else could convey' (5. 133) with a combination of awe and delight that derives from the mind's effort to solve enigmas, 'or to the sense it has of there being an infinite power and meaning in the thing seen, beyond all that is apparent' (5. 133). Furthermore, after Ruskin loses his evangelical religion, he not only considers mythology, like the Bible, a source of spiritual and moral truth, he also interprets it, like the Bible, in terms of multiple meanings.

Ruskin most elaborately applies his conceptions of myth as communally created symbolical grotesques to art criticism in the fifth volume of *Modern Painters* (1860). He begins his reading of Turner's *Garden of the Hesperides* by first explaining the significance of the Hesperid nymphs and the dragon who guards the edenic garden, after which he comments upon the Goddess of Discord and the dark, gloomy atmosphere of the picture, and he explains, 'The fable of the Hesperides had, it seems to me, in the Greek mind two distinct meanings; the first referring to natural phenomena, and the second to moral' (7. 392). Quoting at length from Smith's *Dictionary of Greek and Roman Geography*, he concludes that

nymphs of the west, or Hesperides, are ... natural types, the representatives of the soft western winds and sunshine, which were in this district most favourable to vegetation. In this sense they are called daughters of Atlas and Hesperis, the western winds being cooled by the snow of Atlas. The dragon, on the contrary, is the representative of the Sahara wind, or Simoom, which blew over the garden from above the hills on the south, and forbade all advance of cultivation beyond their ridge. But, both in the Greek mind and in Turner's, this natural meaning of the legend was a completely subordinate one. The moral significance of it lay far deeper. (7. 392–3)

Explaining that in this second sense the Hesperides are connected not 'with the winds of the west, but with its splendour' (7. 393), he draws upon Hesiod to demonstrate that they represent those moral forces and attitudes that reproduce 'household peace and plenty' (7.396). According to him, the names of the individual myths embody moral meanings: 'Their names are, Aeglé, – Brightness; Erytheia, – Blushing; Hestia, – the (spirit of the) Hearth; Arethusa, – the Ministering' (7. 395). He then explains that these four were appropriate guardians of the golden fruit that earth gave to Juno at her marriage:

Not fruit only: fruit on the tree, given by the earth, the great mother, to Juno (female power), at her marriage with Jupiter, or *ruling* manly power (distinguished from the tried and *agonizing* strength of Hercules). I call Juno, briefly, female power. She is, especially, the goddess presiding over marriage, regarding the woman as the mistress of a household. Vesta (the goddess of the hearth), with Ceres, and Venus, are variously dominant over marriage, as the fulfilment of love; but Juno is pre-eminently the housewives' goddess. She therefore represents, in her character, whatever good or evil may result from female ambition, or desire of power; and, as to a housewife, the earth presents its golden fruit to her, which she gives to two kinds of guardians. The wealth of the earth, as the source of household peace and plenty, is watched by the singing nymphs – the Hesperides. But, as the source of household sorrow and desolation, it is watched by the Dragon. (7. 395–6)

This dragon, to whom Ruskin devotes the largest part of his reading, embodies covetousness and the fraud, rage, gloom, melancholy, cunning, and destructiveness associated with it. Turner, as a great artist, takes his place with the ancient creators of myth, for he too accepts the meanings of the past and then recasts them in new ways. For the great English painter thus to add new significance to old myth, he had to have had an imaginative insight into their meaning, and in the course of explicating *The Garden of the Hesperides* Ruskin remarks: 'How far he had really found out for himself the collateral bearings of the Hesperid tradition I know not; but that he had got the main clue of it, and knew who the Dragon was, there can be no doubt', since his conception of the dragon 'fits every one of the circumstances of the Greek traditions' (7. 401–2). This convergence of ancient and modern arises partly

in the fact that Turner perceived the 'natural myth' at the heart of his subject and partly in his knowledge of the Greek tradition. Reading this painting, Ruskin draws upon Homer, Hesiod, Euripides, Virgil, Dante, Spenser, Milton, and the Bible.

Turning to the Goddess of Discord, Ruskin finds that she symbolizes 'the disturber of households' (7. 404), though in fact she is the same power as Homer's spirit of the discord of war. 'I cannot get at the root of her name, Eris', Ruskin admits. 'It seems to me as if it ought to have one in common with Erinnys (Fury); but it means always contention, emulation, or competition, either in mind or words'. The final task of Eris, Ruskin concludes, is essentially that of division, and he cites Homer and Virgil to show that the tradition conceives of her as 'always double-minded; shouts two ways at once (in *Iliad*, xi. 6), and wears a mantle rent in half (*Aeneid*, viii. 702). Homer makes her loud-voiced, and insatiably covetous' (7. 404). Turner combines the conception of discord found in classical literature with Spenser's Ate from *The Faerie Queene* and adds 'one final touch of his own. The nymph who brings the apples to the goddess, offers her one in each hand; and Eris, of the divided mind, cannot choose' (7. 405–6). As Ruskin explains the significance of this figure in the painting, he does not proceed as would one with undoubted authority or one who has access to a privileged, unitary text. Instead, he admits his lack of certainty about certain interpretations, points out potentially contrary readings, and proposes various solutions. The reader sees him groping with the images in Turner's work as they turn out to reveal more and more complex meanings. In other words, Ruskin is again dramatizing the process of interpretation, for we watch him piecing together the meaning of this rich, complex, completely relevant work.

After he has demonstrated how he arrives at meanings of each of the main figures in the painting, Ruskin concludes:

Such then is our English painter's first great religious picture; and exponent of our English faith. A sad-coloured work, not executed in Angelico's white and gold; nor in Perugino's crimson and azure; but in a sulphurous hue, as relating to a paradise of smoke. That power, it appears, in the hill-top, is our British Madonna: whom, reverently, the English devotional painter

must paint . . . Our Madonna – or our Jupiter on Olympus – or, perhaps, more accurately still, our unknown God. (7. 407–8)

In brief, Turner's darkened, dragon-watched garden sets forth in visible form the spiritual condition of England. It testifies that England, having exchanged faith in God for faith in gold, turns away from the path of life, embracing that of death, and longs to enter an earthly paradise that will be, not Eden, the garden of God, but the garden of Mammon in which the head of the serpent, unbruised by Christ, gazes about in icy triumph. Ruskin calls this a religious picture because it expounds the faith by which his contemporaries live and work, the faith, that is, to which their deeds, though not their words, testify.

Ruskin's interpretative *tour de force* in setting forth the meaning of *The Garden of the Hesperides* demonstrates with peculiar clarity how completely entwined criticism of art and society had become by the time he wrote the last volume of *Modern Painters*. In the following chapter we shall observe the way he applied many of the same interpretative methods to read the signs of his own times as he had to both earlier and contemporary arts.

3 Ruskin the interpreter of society

Ruskin's chapter on Turner's *The Garden of the Hesperides*, which displays his interpretations of an individual painting at their most complex, shows that for him any work of art always leads to the society within which it took form. His means of moving from art to society in his analysis of this painting exemplify both his characteristic manner of proceeding as a social critic and his most important ideas about society. Immediately after explaining its mythological or symbolic figures, he offers an interpretation of the entire work which concludes that Turner's representation of ancient Greek myth is in fact a nineteenth-century 'religious picture' because it expounds the faith by which his contemporaries live and work, the faith, that is, to which their deeds, if not their words, testify. 'Here, in England, is our great spiritual fact for ever interpreted to us – the Assumption of the Dragon' (7. 408). Turner, the greatest of British painters, looks about him, observes the triumph of Mammon, and firmly, if sadly, sets down in the guise of a symbolical grotesque the truth he has observed.

According to Ruskin, Turner darkens his palette to 'a sulphurous hue, as relating to a paradise of smoke' (7. 407–8) to show that by choosing to live beneath the watchful glance of the Dragon of Mammon, England entered the true Dark Ages. In the third volume of *Modern Painters* (1856), Ruskin had earlier argued that 'the title "Dark Ages", given to the mediaeval centuries, is, respecting art, wholly inapplicable. They were, on the contrary, the bright ages; ours are the dark ones . . . We build brown brick walls, and wear brown coats . . . There is, however, also some cause for the change in our own tempers. On the whole, these are much *sadder* ages than the early ones; not sadder in a noble and deep way, but in a dim wearied way – the way of ennui, and jaded intellect, and uncomfortableness of soul and body' (5. 321). When he comes to interpret Turner's *Garden of the Hesperides*, Ruskin concludes that the ennui, the sadness, the lack of light and colour arise, as he

believed Turner to have stated, in the worship of what he later termed the Goddess of Getting-on. In taking Turner's *Garden of the Hesperides* as a sign of the times, an index to the spiritual condition of contemporary England, Ruskin sounds a note he will sound with increasing frequency throughout his career as a critic of society.

Ruskin opens the major phase of his career as a social critic, then, by interpreting Turner's painting just as he had opened his career as an art critic by defending its accuracy. Essentially, he proceeds by transforming individual works, as he had earlier transformed individual Venetian buildings, into symbolical grotesques; or, to put it another way, he reads paintings and buildings alike for the meanings they embody. At an early stage of his career – in fact, by the first volume of *The Stones of Venice* (1851) – some of the meanings that compel his attention are social, political, and economic, and by 1860 he applies approaches first used when explaining art to contemporary society.

Throughout his writings on political economy Ruskin depends on a series of aggressive interpretations, and they play a central role in his presentation of himself as a Victorian sage. What makes him a secular prophet in the manner of Carlyle, however, is not his act of interpretation but the fact that he chooses to interpret matters that his audience rarely realizes require interpretation at all. Who, for example, would have expected Turner's *Garden of the Hesperides* to contain such a message for Victorian society, and, similarly, who except a sage would realize that the development of architectural styles in Venice or an industrial accident in England could contain truth essential for England's survival? Indeed, what makes Ruskin, Carlyle, and others like Thoreau or Arnold sages is precisely that they venture to read – interpret – apparently trivial matters such as the colour of contemporary men's clothing, advertisements, and the like, which most members of the audience consider without interest and value. Such is the sage's claim to authority, however, that he can demonstrate that virtually any contemporary phenomenon or incident offers him a direct way into matters of supreme importance – matters such as the cultural health of a nation, its moral nature, and its treatment of the working, producing classes.

This same urge to draw his contemporaries' attention to apparently trivial phenomena that turn out to contain important political and moral truths also informs some of Ruskin's most seemingly quixotic public projects, such as the utopian St George's Guild and the repair of Hinksey Road, Oxford, by a crew of Oxford Undergraduates. Like his interpreting apparently trivial matters, these activities were intended in large part to be exemplary and educational. They were intended to show, for example, the dignity of labour, the necessity of community, and the possibility of non-competitive social organization. Such public gestures were bound to appear quixotic because they forced upon the attention of his contemporaries Ruskin's unfashionable, subversive political economy. Just as his interpretations of perception and symbols have the dual purpose of winning the reader's assent both to the specific interpretation and to the procedure that produces that reading, so, too, these more expansive interpretations have two purposes. First, Ruskin wants to convince us of his interpretations of British society, and second, he wishes us to learn how to make such interpretations ourselves.

Therefore, when he later explains the development of his political views in *Praeterita*, he characteristically presents their evolution in terms of learning to interpret. A visit to the Domecqs, his father's business associates, amid their Parisian elegance presented him with an enigma that demanded interpretation. As a young boy, he wondered why the Andalusians who grew the grapes for the Pedro Domecq sherries 'should virtually get no good of their own beautiful country but the bunch of grapes or stalk of garlic they frugally dined on; that its precious wine was not for them, still less the money it was sold for' (35. 409). Later Ruskin felt himself troubled even more because these gentle, generous people 'spoke of their Spanish labourers and French tenantry, with no idea whatever respecting them but that, except as producers by their labour of money to be spent in Paris, they were cumberers of the ground' (35. 409). These attitudes, says Ruskin, 'gave me the first clue to the real sources of wrong in the social laws of modern Europe; and led me necessarily into the political work which has been the most earnest of my life' (35. 409). When Ruskin explains the development of his political interpretations, he presents him-

self as an outsider and an onlooker, and he suggests that even as a child he found himself asking questions about matters whose obviousness and urgency the adults around him failed to notice.

Following the procedure that informed the previous two chapters, this one will first summarize some of Ruskin's central ideas and then examine those characteristically Ruskinian techniques he developed to present them. First, let us look at the essential emphases of his social criticism. Like his conceptions of the arts, his ideas about political and social economics combine the traditional and the radically new, the expected and the outrageous. As a disciple of Thomas Carlyle, he forces contemporary England to recognize precisely what its actions and ideologies imply. In particular, he makes the individual members of his audience perceive that their basic attitudes towards work, value, wealth and social responsibility contradict the Christian religion that supposedly forms and informs their lives. This part of the Ruskinian enterprise is crucial because, as contemporary observers of the Victorian scene from Engels to the Christian Socialists pointed out, the moneyed classes so effectively segregated the lives of the lower classes – so effectively kept them out of *sight* – that they did not know the sufferings of the industrial, urban poor.

One fundamental portion of Ruskin's task, then, is to thrust such facts into sight and consciousness, thereby creating that awareness which is a necessary precondition of moral and social reform. In 'Traffic' (1865) Ruskin thus mocks his audience's conception of an ideal life by presenting in it the form of what is essentially a dream-vision. Arguing that his listeners' worship of the Goddess of Getting-on implies that they also condemn others to miserable lives, he presents a picture of their ideal that enforces corollaries or implicit points they would willingly leave out of their sight and consciousness.

Your ideal of human life then is, I think, that it should be passed in a pleasant undulating world, with iron and coal everywhere under it. On each pleasant bank of this world is to be a beautiful mansion, with two wings; and stables, and coach-houses; a moderately-sized park; a large garden and hot-houses; and a pleasant carriage drives through the shrubberies. In this mansion are to live the favoured votaries of the Goddess; the English gentleman, with his gracious wife, and his beautiful family; he

159

always able to have the boudoir and the jewels for the wife, and the beautiful ball dresses for the daughters, and hunters for the sons, and a shooting in the Highlands for himself. At the bottom of the bank, is to be the mill; not less than a quarter of a mile long, with one steam engine at each end, and two in the middle, and a chimney three hundred feet high. In this mill are to be in constant employment from eight hundred to a thousand workers, who never drink, never strike, always go to church on Sunday, and always express themselves in respectful language. (18. 453).

As Ruskin points out, this image of human existence might appear 'very pretty indeed, seen from above; not at all so pretty seen from below' (18 453), since for every family to whom the Englishman's deity is the Goddess of Getting-on, one thousand find her the 'Goddess of *not* Getting-on' (18. 453). By making explicit the implications of such a vision of life based upon an ideal of competition, Ruskin's symbolical grotesque serves a powerful satiric purpose. His rich experience and expertise as an art critic here turns out to be particularly helpful, for he carefully explains the sketched-in elements of his supposedly ideal scene with the same techniques that he uses in his descriptions of an Alpine landscape, the city of Venice, or Turner's paintings. In each case he proceeds by presenting visual details and then drawing attention to their meaning. Here he first presents a slightly tongue-in-cheek image of the English capitalist's Earthly Paradise, after which he reveals its dark implications by showing the world of have-nots upon which this kind of paradise rests. By moving through his created word picture from upper to lower, he endows each portion of his visual image with a moral and political value: the upper classes reside literally, spatially, above the industries that provide their wealth and also above the workers who slave to make their lives ones of ease.

As this typical example of Ruskin's polemic makes clear, he applies the stylistic, interpretative, and satiric techniques which characterized his art criticism to his writings on society. Of course, the fundamental reason he can move so easily from writing about Turner and Tintoretto to writing about the labour question and definitions of value, wealth, price, and production lies in the fact that the same attitudes towards co-operation and hierarchy inform both his areas of concern – areas of concern which Ruskin finds

inevitably and inextricably interrelated. For example, when defining composition in the fifth volume of *Modern Painters*, he emphasizes that aesthetic rules and relationships are subcategories of more universal laws of existence. 'Composition may best be defined as the help of everything in the picture by everything else' (7. 205), or, again, it 'signifies an arrangement, in which everything in the work is thus consistent with all things else, and helpful to all else' (7. 208–9), and the artist is therefore a person who 'puts things together, not as a watchmaker steel', but who puts life into them by arranging his materials 'so as to have in it at last the harmony or helpfulness of life' (7. 215). The arts and the work of the artist are therefore images of fundamental laws of life and society, for 'the highest and first law of the universe – and the other name of life is, therefore, "help." The other name of death is "separation." Government and co-operation are in all things and eternally the laws of life. Anarchy and competition, eternally, and in all things, the laws of death' (7. 207). Here we have the centre of Ruskin's social, political, and economic thought: a vision of hierarchical and paternalist (or familial) forms of co-operative social organization, a vision which Paul Sawyer astutely sees as essentially Confucian.

As Ruskin's application of the same techniques and ideas to the criticism of art and society reminds us, he does not shift abruptly from writing about painting to writing about political economy. In fact, as early as the chapter on 'The Nature of Gothic' in *The Stones of Venice* (1853), he had indicted modern society for alienating and dehumanizing its workers by forcing them to perform mechanical, soul-destroying tasks, and in his 1854 pamphlet *On the Opening of the Crystal Palace*, which associated oppressing the poor with the destruction of the past and its beauties, he savagely juxtaposed the self-indulgence of a dinner party to the starving of the poor. In his Manchester lectures published under the title of *The Political Economy of Art* (1857) and later reissued as *A Joy For Ever* (1880), Ruskin introduces his distinction between true and false wealth and argued that a love of true wealth implied a wish to eradicate poverty and unemployment. Attacking advocates of classical *laissez-faire* economics in their own stronghold, Manchester, he instructed its millowners

and merchants that 'the notion of Discipline and Interference lies at the very root of all human progress or power' and that the ' "Let-alone" principle is . . . the principle of death' (16. 26). At this point in his career as a social economist, Ruskin believed that those with political and economic power simply failed to perceive their true responsibilities.

By 1860, when he wrote the individual essays that constitute *Unto This Last* (1862), on the other hand, he had become convinced that they would never perceive these responsibilities until they first realized that their fundamental socio-economic assumptions were pseudo-scientific justifications of selfishness and short-sightedness. The first section of *Unto This Last*, which argues that one cannot formulate a useful economic theory without paying attention to the social affections, therefore attacks the intellectual status of *laissez-faire* economics, particularly in its popularized forms, and the third, which concerns economic justice, attacks its fundamental immorality. The remaining sections advance his own complex humanized conceptions of value, price, production, consumption, and wealth. According to Ruskin, 'THERE IS NO WEALTH BUT LIFE. Life, including all its powers of love, of joy, of admiration' (17. 105), and therefore the measure of a thing's value is the extent to which it aids life and the living.

Ruskin's social criticism eventually had major influence in part because he thus rejected outright the fundamental ideas of classical economics accepted by most of his contemporaries and set out on his own. Drawing upon the Bible, Carlyle, Owen, and the example of the Middle Ages, Ruskin's Tory Radicalism thus opposed Malthusian emphases upon scarcity of resources and instead stressed their abundance and a consequent need for just and efficient distribution. Similarly, he rejected a political economy based upon competition and urged the greater relevance and practicality of one based on co-operation. Working from premises that thus differ radically from those of his contemporaries, Ruskin in *Unto This Last* redefines 'wealth' and transfers emphasis from production to consumption, thus advancing a consumerist ethic:

Economists usually speak as if there were no good in consumption absolute. So far from this being so, consumption absolute is the end, crown,

and perfection of production; and wise consumption is far more difficult than wise production. Twenty people can gain money for one who can use it . . . The final object of political economy, therefore, is to get good method of consumption, and a great quantity of consumption: in other words, to use everything, and to use it nobly; whether it be substance, service, or service perfecting substance. (17. 98, 102)

His assumptions about the nature of wealth and consumption lead him to urge that 'Production does not consist in things laboriously made, but in things serviceably consumable; and the question for the nation is not how much labour it employs, but how much life it produces. For as consumption is the end and aim of production, so life is the end and aim of consumption' (17. 104).

In addition to these general attitudes that horrified many of his contemporaries, Ruskin advanced specific political programmes that they found equally radical and equally disturbing. He urged, for example, that the government should establish 'training schools for youth' and that 'every child born in the country should, at the parent's wish, be permitted (and, in certain cases, be under penalty required) to pass through them' (17. 21). He also proposed that the government not only should take care of all old and indigent but also should establish factories to employ those in need of work. These factories, which would set standards of quality for British manufacturing by example, would also ensure that people on all economic levels could obtain pure, unadulterated food and other necessities.

Of all Ruskin's proposals, however, few struck many contemporaries as more outrageous than the one exhorting them to disregard Malthusian doctrine and pay workers a living wage. To the economists who stated that raising wages would lead the worker either to overproduce his class or to drink himself to death, Ruskin replies: 'Suppose it were your own son of whom you spoke, declaring to me that you dared not take him into your firm, not even give him his just labourer's wages, because if you did he would die of drunkenness, and leave half a score of children to the parish. "Who gave your son these dispositions?" – I should enquire. Has he them by inheritance or by education?' (17. 106). And it is the same, he insists, with the poor. Ruskin, later a proponent of a classless society, points out that either members of the lower

classes have essentially the same nature as the rich and hence are capable of education or they 'are of a race essentially different from ours, and unredeemable (which, however often implied, I have heard none yet openly say)' (17. 106). Ruskin, who applied his skill at biblical and pictorial interpretation to the language of political economy, was particularly astute at finding the claims of self and class interest lurking within supposedly objective explanations.

Indeed, Ruskin particularly embarrassed and outraged many readers – just as he inspired others, such as Morris and Gandhi – when he pointed out that the cruellest treatment of the poor by the rich appears not in poor wages and working conditions but in the way they are kept down by mental and spiritual impoverishment. 'Alas! it is not meat of which the refusal is cruellest, or to which the claim is validest. The life is more than the meat. The rich not only refuse food to the poor; they refuse wisdom; they refuse virtue; they refuse salvation' (17. 106–7). In *Time and Tide* (1867) and *Fors Clavigera* (1871–8, 1880–4) he continues to advance a series of specific proposals based upon his hierarchical, co-operative, familial social vision – namely, that all should work and all do some physical labour, that wages should be fixed by custom, as he believed they were in the professions, and not set by any law of supply and demand; that the nation and not individuals should own natural resources; and that government should take responsibility for education, which he took to be that factor most productive of true wealth.

Like his Tory Radicalism itself, the language in which Ruskin presents his criticism of contemporary society combines old and new, for in attacking crude *laissez-faire* capitalism and its associated social attitudes, he draws upon the rhetoric vocabulary, and tone of both Old Testament prophecy and Victorian preaching. From the beginning Ruskin had a tendency to preach. When he was but three years old, he gathered the family servants around him, climbed on a chair, and urged them, 'People, be good!' The same urge to preach – and the same basic message – colours all his writings. He necessarily exchanges the techniques of the preacher, one whose congregation accepts him as superior, for those of the alienated secular prophet who self-consciously sets himself apart

from his audience when he comes to criticize his society. Ruskin changes his conception of himself as a writer only when he advances essentially unpopular ideas. None the less, whether writing more as preacher or as prophet, Ruskin applies the exegetical methods learned in Bible study.

Of course, when the preacher interpreted even apparently trivial passages, he still dealt with the Bible, a sacred text. Ruskin, in contrast, makes his elaborate interpretations of contemporary phenomena and so emulates the prophets of the Old Testament more than he does contemporary preachers. In so doing, he also follows Carlyle, who developed a variety of strategies to convince an unwilling listener, for the sage writes (or speaks) not only as an interpreter but also as one whose interpretations will be received with hostility. His first task, therefore, must be to win the attention of his audience and then to convince its members that he is worthy of their credence. Ruskin, like Carlyle and other Victorians who wrote in this mode, employs a variety of methods to win his reader's attention and eventual allegiance. The rest of this chapter will examine the literary techniques and rhetorical strategies that characterize his social, economic, and political writings, and as we shall observe, many of Ruskin's techniques as a sage relate so essentially to his ideas that form and content are not easily separated. The examples of Ruskinian technique adduced in the following pages therefore also permit us to examine the major points in his social criticism.

All Ruskin's techniques derive from his need to convince an audience many of whose basic ideas he is attacking. For example, Ruskin makes extensive use of the related techniques of definition, redefinition, and satirical definition to demonstrate that, however little his readers might suspect the fact, they do not know the correct meaning of the words. Their words have lost meaning, which must be restored if these words are to exist in any sort of healthy, correct relation to reality. One may compare Ruskin's definitions in *Modern Painters* with those in his later social criticism. When writing of art, Ruskin defines a host of concepts – imitation, truth (in the visual arts), composition, beauty, sublimity, picturesqueness, tone, colour, form, and grand style. Such definitions provide the usual material of art treatises, of course,

and Ruskin's reader expects him to make them. But when he undertakes more radical and far more disturbing definitions of value, wealth, and religion in his later works, Ruskin thrusts the act of definition into the foreground, thereby demonstrating his audience's complete dependence upon him since only he can provide the true meaning of words crucial to whatever discussion he has embarked upon. For example, *Unto This Last* combines its definitions of key terms with scathing attacks on more conventional ones. According to Ruskin,

Political economy (the economy of the State, of citizens) consists simply in the production, preservation, and distribution, at fittest time and place, of useful or pleasurable things . . . But mercantile economy, the economy of 'merces' or of 'pay', signifies the accumulation in the hands of individuals, or legal and moral claim upon, or power over, the labour of others; every such claim implying precisely as much poverty or debt on one side, as it implies riches or right on the other. (17. 44–5)

Believing that the most basic definitions of classical economists are incorrect because they misconceive their entire subject, he further attacks one economist's definition of his subject as '"the science of getting rich". But there are many sciences, as there are many arts, of getting rich. Poisoning people of large estates, was one employed largely in the Middle Ages; adulteration of food of people of small estates, is one employed largely now' (17. 61). In essence, Ruskin claims by these manœuvres that since his audience has fallen away from the ways of God (or nature), its members find themselves hobbled by a corrupted, misleading, almost useless language and they need him to restore their words. They need him, in other words, to lead them forth from the Tower of Babel. His emphasis upon definition exemplifies the way Ruskinian theme and technique coalesce and become almost indistinguishable, for he believes that the false moral, economic, and political positions that he opposes not only cause unhappiness and obvious societal problems but even have corrupted the language we all use.

As Ruskin's use of definition suggests, his pronouncements frequently take the form of an alternation of satire and vision – satire to destroy opposing ideas and moments of vision to replace them. In addition to redefining the ideas and language of his opponents satirically, Ruskin also employs other forms of satire.

Many of his acts of interpretation themselves take the form of satiric sallies, for as he probes his society's ideas and values, the demeaning conclusions he draws again and again demonstrate that its members have fallen away from their supposed standards of morality and humanity.

By performing elaborate acts of interpretation upon trivial phenomena, which he claims to be windows into a nation's heart, he essentially metamorphoses such matters into elaborate satirical allegories or symbolical grotesques. Ruskin frequently employs two kinds of this formal device, which we may in turn call 'found' and 'invented' versions of the symbolical grotesque. Found or discovered satiric grotesques are those he locates in existing phenomena. For instance, his discussion of wealth and value in *Unto This Last* (1860) includes a newspaper report of a ship-wrecked man who strapped all his gold to himself in an attempt to preserve it, leapt from the sinking vesel, and promptly plunged to the bottom of the sea. Ruskin, who engages himself to examine modern notions of value and ownership, asks the question, Now does the man own the gold or does the gold own the man? In contrast to such discovered satirical grotesques, invented ones, which take the shape both of individual images and parables, do not have a component furnished by contemporary phenomena. These satiric images and parables are exemplified by his image of England's true divinity, Britannia of the Market, in 'Traffic' (1865) or, in the same work, his fable of the two supposedly friendly landowners who spend all their funds on weapons to defend themselves against each other.

These forms of the grotesque contribute to the sage's dominant technique, which is the creation of *ethos* or credibility. According to the older rhetoricians, arguments may take three forms or modes: *logos*, *pathos*, or *ethos*. Arguments that depend upon *logos* employ what we may loosely term 'reason', for they attempt to convince by means of logic, authority, statistics, precedent, testimony, and such like, whereas those that employ *pathos* appeal to the emotions of the listener or reader. In contrast, *ethos* tries to convince the audience that the speaker or writer is a serious, sincere, and, above all, trustworthy person, one whom, when the resolution of an argument lies hanging in the balance, one should

167

follow. Of course, virtually any kind of argumentation draws variously upon all three argumentative modes. But Ruskin proceeds by making all his various arguments and evidence convince the audience that, however much his ideas might seem strange and even outrageous, he deserves their credence. Because he begins from an ideological position that conflicts with that of his audience, he starts with a decided disadvantage; and forced to take grave rhetorical risks, he does so to demonstrate how unusually, how unexpectedly he turns out to be right while received, orthodox opinion turns out to be wrong. All of Ruskin's other techniques – his clear argumentation, his citation of personal experience, his word-painting, his clear sight, and his ability to notice natural phenomena most fail to observe – contribute to creating this appearance of credibility, so that we will pay attention to his most annoying or unexpected ideas, give them some consideration, and allow him the opportunity to convince us both that they are true and that our recognition that they are true is crucial to us personally.

In contrast to 'found' symbolical grotesques which the sage creates from those phenomena he chooses to interpret, the invented form of the symbolical grotesque derives from his own imagination and may take the forms of extended analogies, metaphors, and parables. In his writings on political economy Ruskin makes great use of such invented symbolical grotesques, which there effectively replace the word-painting that characterized his art criticism as his favourite rhetorical device. In 'The Roots of Honour', which opens *Unto This Last*, he uses precisely such a satirical analogy to attack the intellectual stature of nineteenth-century economic theory. Thus, he begins with a corrective introduction that first attacks as delusions these supposedly scientific approaches to society's major problems and then compares them to primitive, outmoded bodies of thought, such as alchemy: 'Among the delusions which at different periods have possessed themselves of the minds of large masses of the human race, perhaps the most curious – certainly the least creditable – is the modern *soi-disant* science of political economy, based on the idea that an advantageous code of social action may be determined irrespectively of the influence of social affection' (17. 25). Granting

that 'as in the instances of alchemy, astrology, witchcraft, and other such popular creeds, political economy has a plausible idea at the root of it' (17. 25), Ruskin argues that the economists err disastrously by 'considering the human being merely as a covetous machine' (17. 25). Although he readily agrees that one should attempt to eliminate inconstant variables when trying to determine guiding laws for any area of knowledge, he points out that economists have failed to perceive that 'the disturbing elements' in the problem they have tried to eliminate from their theories are not the same as the constant elements since 'they alter the essence of the creature under examination the moment they are added; they operate, not mathematically, but chemically, introducing conditions which render all our previous knowledge unavailable' (17. 26). Drawing upon his knowledge of chemistry, a true science, for an analogy, Ruskin then points out how dangerous such false conclusions can be: 'We made learned experiments upon pure nitrogen, and have convinced ourselves that it is a very manageable gas: but, behold! the thing which we have practically to deal with is its chloride; and this, the moment we touch it on our established principles, sends us and our apparatus through the ceiling' (17. 26). Immediately after introducing his satiric analogy, which takes the form of a rudimentary, abbreviated narrative, Ruskin next employs a wonderfully bizarre symbolical grotesque:

Observe, I neither impugn nor doubt the conclusion of the science if its terms are accepted. I am simply uninterested in them, as I should be in those of a science of gymnastics which assumed that men had no skeletons. It might be shown, on that supposition, that it would be advantageous to roll the students up into pellets, flatten them into cakes, or stretch them into cables; and that when these results were effected, the re-insertion of the skeleton would be attended with various inconveniences to their constitution. The reasoning might be admirable, the conclusions true, and the science deficient only in applicability. Modern political economy stands on a precisely similar basis. (17. 26).

According to Ruskin, who is arguing that this supposedly practical science is in fact decidedly impractical and impracticable, modern political economy had the same advantages and disadvantages as does his invented pseudo-science of gymnastics-without-skeletons: its inventors and practitioners have sacrificed usefulness,

relevance, and applicability to theoretical elegance and ease. In making such a charge, Ruskin immediately demonstrates that although he might at first appear the wild-eyed impractical theorist, his ideas have more value than commonly accepted ones.

Ruskin's invented symbolical grotesques are particularly useful in summing up the flaws in opposing positions. These analogies and little satiric narratives of course owe much to Neoclassical satirists, particularly Swift, whose *Tale of a Tub* and *Gulliver's Travels* make extensive use of both to cast an opposing view in a poor light. When Ruskin argues in 'Traffic' against those who claim that they cannot afford to create beautiful surroundings for human life, he employs a characteristic parable to reduce such protests to absurdity. Suppose, he instructs his listeners, that he had been sent for 'by some private gentleman, living in a suburban house, with his garden separated only by a fruit wall from his next door neighbour's' (18. 438) to advise him how to furnish his drawing-room. Finding the walls bare, Ruskin suggests rich furnishings, say, fresco-painted ceilings, elegant wallpaper, and damask curtains, and his client complains of the expense, which he cannot afford. Pointing out that his client is supposed to be a wealthy man, he is told:

'Ah yes,' says my friend, 'but do you know, at present I am obliged to spend it nearly all on steel-traps?' 'Steel-traps! for whom?' 'Why, for that fellow on the other side of the wall, you know: We're very good friends, capital friends; but we are obliged to keep our traps set on both sides of the wall; we could not possibly keep on friendly terms without them, and our spring guns. The worst of it is, we are both clever fellows enough; and there's never a day passes that we don't find out a new trap, or a new gun-barrel, or something.' (18. 438–9)

Fifteen million a year, his client tells Ruskin, the two good neighbours spend on such traps, and he doesn't see how they could do with less and so Ruskin the room decorator must understand why he has so little available capital to beautify his client's environment. Turning to his audience, Ruskin abandons the pose of the naïf and comments in the tones of the Old Testament prophet: 'A highly comic state of life for two private gentlemen! but for two nations, it seems to me, not wholly comic.' Bedlam might be comic, he supposes, if it had only one madman, and

Christmas pantomimes are comic with one clown, 'but when the whole world turns clown, and paints itself red with its own heart's blood instead of vermilion, it is something else than comic, I think' (18. 439). Having first mocked with his satiric parable the intellectual seriousnes of his listeners' self-justifications for failing to spend money on beautifying their environments, Ruskin next moves from mocking to damning them as he reveals, once again, that competition is a law of death and that it destroys art, beauty, and the conditions of healthy, full existence.

In the manner of the Old Testament prophet he demonstrates that the actions of his contemporaries reveal that they have abandoned the ways of God. Ruskin's symbolical grotesques provide a particularly appropriate device for such social criticism, because they emphasize both the symbolical and the grotesque qualities in contemporary life which desperately need correction. These set pieces, which combine Ruskin's gifts for interpretative and satirical virtuosity, replace word-painting as his characteristic stylistic technique in the later writing and prove essential to his enterprise as a sage, for they serve to focus his interpretations of society while providing an attractive, interesting, and often witty means of conveying his ideas.

4 Ruskin interpreting Ruskin

Ruskin, the great master of interpreting art and society, brings his skills to bear on his own life in *Praeterita*, the incomplete autobiography he published in separate numbers between 1881 and 1886, after which year recurrent attacks of madness forced him to stop writing. He wrote *Praeterita* for many reasons. It was, he tells us, 'an old man's recreation in gathering visionary flowers in fields of youth', and it was also a 'dutiful offering at the grave' (35. 11–12) of his parents. He wrote it chiefly, however, as a means of enabling us to see how he learned or developed his main ideas. According to Ruskin, 'How I learned the things I taught is the major, and properly, the only question regarded in this history', and such a statement of purpose makes two important points. First, unlike Rousseau, Ruskin does not conceive his autobiography as a complete self-revelation or confession. It does not therefore include any mention of his ill-fated marriage or, for that matter, of many of his friendships, and neither does it discuss large portions of his career. Attacks of madness that forced him to give up writing before he had covered certain subjects, rather than conscious avoidance of them, explains many, though not all of these major omissions.

Ruskin's statement of purpose also informs us that *Praeterita*, like Mill's autobiography, records largely an intellectual history, and so it does in a peculiarly Ruskinian sense – in the sense that arises in his dual emphases upon the visual sources of knowledge and upon the intrinsic unity of human sensibility. For Ruskin, no such being as economic, aesthetic, or intellectual man exists – even for the sake of argument. According to him, there exists only the human being, all of whose experiences are interconnected, entwined, relevant.

But for Ruskin all his own experiences centre upon acts of perception, and he therefore presents his life history as a series of juxtaposed moments of vision. Ruskin's autobiography thus

weaves together his two concerns with perception and interpretation, and although he occasionally emphasizes either learning to see or learning to understand in individual episodes, he more commonly interweaves the history of both parts of his education because he finds them so essentially related.

Interpretation explicitly enters the tale of his life when he relates the importance of his childhood reading of the Bible: 'It had never entered into my head to doubt a word of the Bible, though I saw well enough already that its words were to be understood otherwise than I had been taught; but the more I believed it, the less it did me any good' (35. 189). He soon learned that even the Bible, which evangelicals took as the literal word of God, could not simply be read. It demanded interpretation.

By the mid-1850s Ruskin found his childhood evangelical belief, which provided the core of his interpretations of art and life, increasingly threatened by geology, the Higher Criticism and his own doubts. These various pressures soon led, he tells us, to 'the inevitable discovery of the falseness of the religious doctrines in which I had been educated' (35. 482). *Praeterita* borrows but recasts the narrative of his decisive break with evangelicalism which had appeared in the April 1877 issue of *Fors Clavigera*. *Fors* tells that the 'crisis' in his thought came one Sunday morning in Turin 'when, from before Paul Veronese's Queen of Sheba, and under quite overwhelmed sense of his God-given power', he went to the Protestant chapel only to hear the preacher there assure his Waldensian congregation that they, and only they, would escape the damnation that awaited all others in the city. 'I came out of the chapel, in sum of twenty years of thought, a conclusively *un*-converted man' (29. 89). According to this earlier version, then the pastor's statements about damnation, which so contradicted Ruskin's own sense of the ways of God, finally enabled him to choose between 'Protestantism or nothing' (29. 89). In contrast, *Praeterita* states that he *first* attended the Waldensian sermon and then encountered the painting by Veronese. Furthermore, according to this second version of his past, Ruskin did not react strongly against the sermon or break sharply with his evangelical belief before he left the chapel. Instead, feeling the sermon irrelevant rather than infuriating, he walked out of the chapel unmoved, and only later

did the music and painting convince him that there were better ways than the evangelical to serve God.

When Ruskin inverted the order of events, placing the sermon before his experience in the gallery, he changed the point of his narrative; for whereas *Fors* explains how a painting convinced him that his evangelical religion preached a false doctrine of damnation, *Praeterita* tells how the arts of painting and music taught him how to serve God better than his earlier belief. *Praeterita* not only fails to mention the crucial fact that his decision was between 'Protestantism or nothing', thereby lessening the sense of crisis, but also emphasizes affirmation rather than denial.

The contradictions that appear when one compares Ruskin's two versions of this turning point in his life reveal how much interpretation dominates the autobiographer's task. The evidence of Ruskin's letters and diaries suggests that the earlier, harsher version of the incident in *Fors* more accurately describes what took place on that balmy afternoon in Turin, but once he returned to some form of Christian belief in 1875, he naturally began to perceive unifying rather than disrupting elements in his past experience.

Ruskin thus organizes his past life chiefly in terms of moments of vision because he conceives himself essentially as a spectator, as one, that is, who lives chiefly by seeing and is fully alive only when engaged in the act of vision. *Praeterita* presents this view of himself by concentrating upon the development of his sense of sight, and the crucial facts in his development stand out as moments when he first saw or learned to see in some new, important way. He lays no claim to artistic imagination, intelligence, or 'any special power or capacity; for, indeed, none such existed, except that patience in looking, and precision in feeling, which afterwards, with due industry, formed my analytic power . . . On the other hand', he tells us, 'I have never known one whose thirst for visible fact was at once so eager and so methodic' (35. 51). His autobiography, which therefore takes the form of showing the ways he developed under the influence of this 'thirst for visible fact', points out that satisfying this thirst provided one of the young Ruskin's chief sources of childhood delight. As a young

child, he had few toys and chiefly amused himself by exploring patterns in the carpets and fabrics in his home.

Such a life of the eye was also encouraged by the way in which the Ruskins made their European tours, neither speaking the language of the countries they visited nor socializing with other British tourists. According to him, such removal has its own benefits, for 'if you have sympathy, the aspect of humanity is more true to the depths of it than its words; and even in my own land, the things in which I have been least deceived are those which I have learned as their Spectator' (35. 119). *Praeterita*, then, is an autobiography of Ruskin the Spectator, the man who sees and understands.

The Spectator, *Praeterita* makes poignantly clear, is also one who stands apart from the flow of life and looks on. *Praeterita*, which relates that his parents' social insecurities largely deprived him of friends his own age, emphasizes his 'perky, contented, conceited, Cock-Robinson-Crusoe sort of life' and his family's social isolation – what Ruskin calls 'our regular and sweetly selfish manner of living'. Thus isolated, he concerned himself largely with the visual and the visionary – studying things close at hand or imagining those far away: 'Under these circumstances, what powers of imagination I possessed, either fastened themselves on inanimate things – the sky, the leaves, and pebbles, observable within the walls of Eden – or caught at any opportunity of flight into regions of romance' (35. 37). Ruskin thus came to love the life of one who sees others without himself being seen: '*My* times of happiness had always been when *nobody* was thinking of me . . . My entire delight was in observing without being myself noticed – if I could have been invisible, all the better' (35. 165–6). According to Ruskin, his childhood love of thus being an almost invisible, seeing eye produced his 'essential love of *Nature*' which was the 'root of all that I have usefully become, and the light of all I have rightly learned' (35. 166). This love, his autobiography tells us, was nurtured by his childhood surroundings, which he continually characterizes in terms of a lost Garden of Eden to which he no longer has access except perhaps in memory.

In addition to characterizing Ruskin's sense of sight and explaining how it developed, *Praeterita* also documents the education of

his eye by relating his various encounters with drawing teachers, specific landscapes, and works of art. It explains, for example, that although his drawing-master, Charles Runciman, did nothing to encourage his gift for 'drawing delicately with the pen point', he none the less taught the young Ruskin 'perspective, at once accurately and simply' and 'a swiftness and facility of hand which I found afterwards extremely useful, though what I have just called the "force", the strong accuracy of my line, was lost' (35. 76–7). Most important, Runciman 'cultivated in me – indeed founded – the habit of looking for the essential points in things drawn, so as to abstract them decisively, and explained to me the meaning and importance of composition' (35. 77).

Ruskin's autobiography also explains that encounters with specific works of art or artistic sites directly influenced his life and career. Sometimes such encounters took place under the guidance of a more experienced eye, such as occurred at a gathering at the home of Samuel Rogers, the banker-poet. Ruskin relates that when he 'was getting talkative' in praise of a Rubens sketch that his host owned, the artist George Richmond asked why he hadn't commented upon the much greater Veronese hanging beneath it. To Ruskin's surprised response that the Venetian seemed quite tame in comparison with the Rubens, Richmond answered that, nevertheless, 'the Veronese is true, the other violently conventional' (35. 337). Comparing Veronese's clear shadows with Ruben's use of ochre, vermilion, and asphalt outline, he thus led the young art critic to a new understanding of Venetian colour and the nature of artistic convention.

Most of the encounters Ruskin describes, in contrast, took place without the assistance of others and were purely individual discoveries. For example, when visiting Genoa in 1840 Ruskin saw 'for the first time the circular Pietà by Michael Angelo, which was my initiation in all Italian art. For at this time I understood no jot of Italian painting, but only Rubens, Vandyke, and Velasquez' (35. 264), and, similarly, his 1845 visit to Lucca first taught him that architecture was more than an excuse for the picturesque. Ruskin, who had a Romantic love of picturesque time-worn structures, suddenly encountered twelfth-century buildings built 'in material so incorruptible, that after six hundred years of

sunshine and rain, a lancet could not now be put between their joints' (35. 350). As a young man he had learned, like all romantically inclined, artistically sensitive people of the time, to seek out the pleasing irregularities and age mark of the picturesque, and for a time he patterned his own drawing style after that of Samuel Prout, who invented a particular kind of urban picturesque. Lucca taught him, however, that great architecture was more than merely an excuse for picturesque seeing. In fact, it had its own rules of form which the seeker of the picturesque inevitably failed to perceive. The picturesque, for all its delights, therefore turned out to be another one of those artistic conventions that ultimately did more harm than good because it masked, rather than aided, seeing what was really there. Having approached this beautiful medieval town to enjoy the delicate pleasures of the picturesque, Ruskin unexpectedly found anti-picturesque buildings, for instead of succumbing to the effects of time, these Gothic structures still retained their strength, firmness, and precise outline.

Venice, one of the centres of his life and thought, also at first appeared to him largely as a stimulus for Romantic imaginings. Like so many eighteenth- and nineteenth-century travellers, he easily fell under its spell. Ruskin, whose autobiography takes form around moments of perception, characteristically describes his love of Venice originating in a single sight, although one less obviously exciting or epiphanic than those he describes occurring in the Alps: 'The beginning of everything was in seeing the gondola-beak come actually inside the door at Danieli's, when the tide was up, and the water two feet deep at the foot of the stairs; and then, all along the canal sides, actual marble walls rising out of the salt sea, with hosts of little brown crabs on them, and Titians inside' (35. 295). Having approached Venice through Byron and Turner, Ruskin immediately fastened the nuances of their art to his own perceptions. According to him, the great moment of revelation about Venice came, not when he encountered the palaces along the Grand Canal or the Ducal Palace, or even Saint Mark's, but when he first saw Tintoretto's great cycle of paintings on the life of Christ. At the urging of his friend and drawing-master J. D. Harding, he visited the Scuola di San Rocco, where his encounter with Tintoretto's masterful cycle forced him, he says,

to study the culture and history of Venice, and thus he came to write *The Stones of Venice*.

The most important discoveries Ruskin reports in *Praeterita* appear in several skilfully narrated parables of perception that explain how he learned to see for himself. His presentation of the famous incidents of the Norwood ivy and the Fontainebleau aspen reveals that an encounter with Turner's work, specifically his sketches of Switzerland, prepared him for these crucial moments of discovery which, in turn, prepared him to understand Turner even better. Ruskin realized that the sketches of Switzerland, which he so coveted 'were straight impressions of nature – not artificial designs, like the Carthages and Romes. And it began to occur to me that perhaps even in the artifices of Turner there might be more truth than I had understood . . . In these later subjects Nature herself was composing with him' (35. 310). Immediately after relating how he came upon this insight into Turner's mode of working, *Praeterita* tells us how Ruskin himself began to see with a cleared vision:

> Considering of these matters, one day on the road to Norwood, I noticed a bit of ivy round a thorn stem, which seemed, even to my critical judgement not ill 'composed'; and proceeded to make a light and shade pencil study of it in my grey paper pocket-book, carefully, as if it had been a bit of sculpture, liking it more and more as I drew. When it was done, I saw that I had virtually lost all my time since I was twelve years old, because no one had told me to draw what was really there! (35. 311)

Ruskin purposively contrasts 'critical judgement' and the act of drawing, sculpture and ivy round a thorn stem, man's art and nature's higher creation. Years of sketching according to the rules followed by the amateur artist in search of the picturesque had left him with a few useful records of place, but not until he forgot himself and casually began to draw this little bit of vegetation did he realize that he had never before 'seen the beauty of anything, not even of a stone – how much less of a leaf!' (35. 311)

The next stage in his progress came at Fontainebleau when, weary from walking, he began to draw a little aspen tree and once again experienced a crucial moment of vision after he had almost casually tried to represent a natural fact without paying attention to any rules.

Languidly, but not idly, I began to draw it; and as I drew, the languor passed away: the beautiful lines insisted on being traced – without weariness. More and more beautiful they became, as each rose out of the rest, and took its place in the air. With wonder increasing every instant, I saw that they 'composed' themselves, by finer laws than any known of men. At last, the tree was there, and everything that I had thought before about trees, nowhere! (35. 314)

Ruskin remarks that his experience of drawing the Norwood ivy had not 'abased' him so completely because he had always assumed that ivy was an ornamental plant. Drawing a randomly selected tree, however, finally convinced him that nature was greater than art.

That all the trees of the wood (for I saw surely that my little aspen was only one of their millions) should be beautiful – more than Gothic tracery, more than Greek vase-imagery, more than the daintiest embroiderers of the East could embroider, or the artfullest painters of the West could limn – this was indeed an end to all former thoughts with me, an insight into a new silvan world.

Not silvan only. The woods, which I had only looked on as wilderness fulfilled I then saw, in their beauty, the same laws which guided the clouds, divided the light, and balanced the wave. (35. 315)

Ruskin believed that his experiences of Turner's Swiss sketches, the Norwood ivy, and the Fontainebleau aspen provided the cornerstone, the foundation, of his future career.

The lessons he learned from the Norwood ivy and the Fontainebleau aspen were continued by his drawing of the Gothic in Rheims. Once again his moment of discovery took him by surprise; for as he drew the tomb of Ilaria de Caretto, he suddenly realized that its beautiful lines followed the same laws that governed the Norwood ivy and the Fontainebleau aspen: The 'harmonies of line ... I saw in an instant were under the same laws as the river wave, and the aspen branch, and the stars' rising and setting' (35. 349). At each state Ruskin found himself taken by surprise as his eyes and hands taught him to recognize something of crucial importance that his mind did not take in. First, he discovered that the ivy embodies laws of beauty far greater than those inventible by the imagination, and then he found out that trees, which are far more majestic creations of nature, also follow such rules. The third stage

in his development arrived when he discovered such laws embodied in the Gothic, a discovery that suggests that the great medieval sculptors and architects had themselves instinctively made this same recognition of the intrinsic beauties of nature which no theorist can encompass or predict.

All of these visual discoveries taught Ruskin the artist that he had to learn to see for himself, and other experiences taught him the same lesson about criticism. Although he occasionally received invaluable guidance, as when Richmond taught him to see Venetian colour, he still had to experience each fact with his own eyes and feelings, and it was for this reason that Ruskin placed such importance upon the act of drawing as a means of the artist's self-education. He traces his independence as a critic to his 1840 visit to Rome when, having been told by parents, friends, and guide-books what to like in Rome, he quickly discovered that he had to decide about these great buildings and painting himself: 'Everybody told me to look at the roof of the Sistine chapel, and I liked it; but everybody also told me to look at Raphael's Transfiguration, and Domenichino's St Jerome' (35. 273), which he did not like, and he thus realized he had to make his own judgements.

Like his encounters with the Norwood ivy and the Fontainebleau aspen, *Praeterita*'s most powerful epiphanies re-enact occasions when he first encountered some beauty of nature. These more dramatic set pieces present Ruskin seeing something, not close at hand, but far away, for they dramatize prospect visions and Pisgah Sights – moments, that is, when he caught sight of a distant, unattainable paradise. For instance, in 1833, when he was fourteen years old, he arrived in Schaffhausen with his family and at sunset saw the Alps for the first time. Looking out upon a landscape that at first glance resembled 'one of our own distances from Malvern of Worcestershire or Dorking of Kent', he suddenly saw mountains in the distance.

There was no thought in any of us for a moment of their being clouds. They were as clear as crystal, sharp on the pure horizon sky, and already tinged with rose by the sinking sun. Infinitely beyond all that we had ever thought or dreamed – the seen walls of lost Eden could not have been more beautiful to us; not more awful, round heaven, the walls of sacred Death.

It is not possible to imagine, in any time of the world, a more blessed

entrance into life, for a child of such temperament as mine. True, the temperament belonged to the age: a very few years – within the hundred – before that, no child could have been born to care for mountains, or for the men that lived among them, in that way. Till Rousseau's time, there had been no 'sentimental' love of nature . . . The sight of the Alps was not only the revelation of the beauty of the earth, but the opening of the first page of its volume – I went down that evening from the garden-terrace of Schaffhausen with my destiny fixed. (35. 115–616)

In relating this and other crucial experiences, Ruskin, like so many Victorians, including Carlyle, Tennyson, and Mill, employed the pattern of a religious-conversion narrative. *Praeterita*, though it does present climactic moments, does not, like most conversion narratives, build towards a single climax or moment of illumination. Rather Ruskin organizes his materials into a series of climactic illuminations, such as that attained by drawing the ivy and the aspen, each of which can stand to some extent by itself. I write 'to some extent' because each moment of vision, each new perception, does join to others in a sequence to form a whole greater than the sum of individual parts. None the less, his primary organization is around centres or moments of personally achieved vision, each of which is accommodated within a segment, a fragment. In other words, *Praeterita*, relies upon the same structural principles that inform *Modern Painters*, *The Stones of Venice*, and his other major works.

Such a recognition helps explain how *Praeterita*, although incomplete, can be one of the greatest of autobiographies. Specifically, it explains how an unfinished work deliberately written in a fragmented manner creates such powerful effects. Such a recognition also leads to a better understanding of a peculiar form of narrative technique – or possibly of an entire genre – which provides a sense of aesthetic completeness and rhetorical effectiveness, even though it apparently lacks the formal completeness of narrative.

Thackeray's daughter thought Ruskin's portraits in language so brilliant that she believed he should have been a novelist – a point that brings to the fore the nature of narrative and Ruskin's structures of interpretation. The problem, at least as Ruskin saw it, was that he could not relate a story effectively, and one way of

looking at *Praeterita* is as an alternative to conventional narrative, to which he did not feel himself particularly suited. This is no confession of major weakness since genuis always builds upon its limitations. Tennyson, for example, did not have much of a gift for conventional narrative structure either, so he developed a poetic form in *In Memoriam* and *The Idylls of the King* which avoided it, relying instead upon complex interweaving of juxtaposed climactic moments, visions, and dreams. In doing so, this supposedly conservative poet managed to create the kind of narrative mode for which Conrad, Faulkner, and Woolf generally receive credit in histories of the novel. *Praeterita*, which had such a major influence on Proust, relies upon a similar, if more diffuse, narrative mode. By organizing his 'visionary flowers', as he called them, into a series of self-sufficient narratives, Ruskin created a literary form that proceeds by juxtaposition and accumulation more than by narrative progressions.

Of course, Ruskin settled upon such a literary structure, to which he was so temperamentally inclined, because he believed conventional narrative falsified the kind of tale he wished to relate. According to him, the complexity of history necessarily conflicts with the simplifying tendencies of narrative: 'Whether in the biography of a nation, or of a single person, it is alike impossible to trace it steadily through successive years. Some forces are failing while others strengthen, and most act irregularly, or else at uncorresponding periods of renewed enthusiasm after intervals of lassitude. For all clearness of exposition, it is necessary to follow first one, then another, without confusing notices of what is happening in other directions' (35. 169).

Essentially, Ruskin's literary structure organizes the work itself and the reader's perception of it into discrete yet individually satisfying segments or episodes. This description of Ruskin's characteristic literary structure strikes a familiar note with readers of his other works. The five volumes of *Modern Painters* and the many numbers of *Fors Clavigera* share the segmented, episodic, and yet strangely satisfying structure of the autobiography. All these works progress by means of a series of illuminations, moments of vision, and epiphanies.

Ruskin saw his own experiences as taking the form of a pattern

of loss and gain. The losses include time lost, but more importantly, people lost, for this gentle memory fugue contains an astonishing number of deaths and death-bed scenes. The gains, the recompense for all this personal loss, occur almost entirely in terms of vision, in learning to see things correctly, whatever the cost, whatever the pain. Another way of putting this point would be to refer to his repeated emphases upon Paradise, earthly edens, and paradises lost which appear throughout this autobiography. Autobiographers frequently organize their experiences, thereby giving them order and meaning, in terms of central metaphors, images, or analogies. Ruskin, one of the most metaphorical of writers, uses many such chains of analogy to interpret his past experience, but the dominant one in *Praeterita* consists of a series of juxtaposed lost edens and Pisgah Sights.

Although Ruskin's autobiography, like the autobiographical elements in his other writings, draws upon the literature of religious conversion for image, rhetorical, and structure, it differs from it in an important way. For it does not attempt merely to testify to the experience of spiritual, aesthetic, or political truth; it tries, instead, to make the reader re-experience something of crucial importance to Ruskin by placing him, as it were, inside Ruskin's consciousness. Ruskin's autobiographical prose, like his art criticism, thus fulfils his own frequently stated requirements for imaginative art. According to him, we recall, great art and literature provided an essential means of enabling the audience to share the emotions and imagination of the artist and poet. To enable the audience to share his past, he relies upon a literature of experience, upon a kind of literature whose primary rhetorical strategy is to make the reader experience his feelings, thoughts, and reasonings. *Praeterita*, like *In Memoriam*, uses its data primarily for an imaginative, emotional effect. Each argument encountered, each person experienced, each landscape confronted is a stage of experience, a rung on the ladder of a developing and liberating vision. The costs of attaining that almost unique vision were great, and one of them was that he became too much a creature of the eye, that is, too much a being who lives isolated and apart and lives only in what he sees.

Therefore, when the world of *Praeterita* appears at Ruskin's

183

bidding, he does not raise a curtain and have us observe a continuing series of happenings. Instead, he takes us by the arm and shows us a gallery of pictures. One picture suggests comparison with another, we move back and forth; and whether or not we arrive at the end of the gallery, we have a sense of being with Ruskin, the spectator of his own life.

Conclusion

The unifying factor in Ruskin's writings, as we have seen, appears in his career-long drive to interpret matters for his contemporaries. The interpretations of painting and architecture with which he began his career met with early and lasting success. Drawing upon the rhetoric and techniques of the Victorian preacher, Wordsworthian conceptions of the poet, and Neoclassical theories of painting and the beautiful, Ruskin offered his Victorian audience convincing arguments for the essential earnestness, the relevance and moral importance, of the visual arts. Arguments of this kind couched in this kind of language were what his contemporaries wanted to hear. As early as 1851, which was only nine years after the publication of *Modern Painters I*, Ruskin began to emphasize the political dimensions of art, and although *The Stones of Venice* was well received, a large part of his audience was disturbed by his touching upon such matters. This was not the kind of argument many wished to hear stated in any kind of language, and the objections to his ideas increased with *Unto This Last* (1862) as reviewers found his eminently sane views of society 'mad' and dangerous.

Although the sense of isolation that Ruskin seems to have felt in varying degrees throughout his life certainly increased after 1860 (which was also the period during which he abandoned his childhood religion), he still retained an audience for his political lectures and publications. Indeed, having disbursed much of the fortune he inherited after his father died in 1864, he earned enough money from his books, including those on political economy, to remain a wealthy man. One of the reasons that Ruskin thus continued to be a popular, if controversial, author lies in the fact that he gradually gained a new audience, one composed of members of the working classes, to supplement and in some cases replace his earlier one.

Ruskin did not, however, concentrate entirely upon political

economy in his mid and late career, for he continued his Oxford lectures and published on subjects ranging from ornithology and botany to painting and air pollution. Beginning in 1878, bouts of mental illness intermittently incapacitated him, but during his calm periods he wrote some of his finest work, including *The Art of England* and *Praeterita*. Ruskin's last acts of interpretation centre upon his own life in *Praeterita*, a quiet, beautiful, lyrical work written during periods when his mind and spirit were calm. After 1888, such moments of peace became ever rarer, and Ruskin remained isolated at Brantwood. Ironically, just at the time when thousands of readers in England and abroad received the words of Ruskin the prophet with adulation, he himself could take no solace from that fact.

As recent histories of literature, art, architecture, design, and political theory make clear, we are just beginning to perceive the degree to which John Ruskin, Interpreter, influenced his own age and continues to affect ours. Ruskin, however, possesses more than historical importance. He remains England's great art critic, and his magnificent prose still teaches us to see and to see better. His social criticism, with its constant emphasis that we can understand our lives, remains immediate and relevant, as does his insistence that the chief test of theories of art, society, and politics is the question, Do they enhance life and spirit, do they make us more fully, more richly, alive?

Further reading

Writings by Ruskin

Students of Ruskin's life and work are indebted to the Library Edition of the *Works*, ed. E. T. Cook and Alexander Wedderburn, 39 vols. (George Allen, London, 1903–12), which contains invaluable background, biographical, and bibliographical information and reproduces as well many of Ruskin's drawings. The *Works* must be supplemented by the poorly edited *Diaries of John Ruskin*, ed. Joan Evans and J. H. Whitehouse, 3 vols. (Clarendon Press, Oxford, 1956), and *Brantwood Diary of John Ruskin*, ed. Helen Gill Viljoen (Yale University Press, New Haven, 1971).

Cook and Wedderburn include a selection of letters in Volumes 36 and 37 and in the introductions to other volumes, but no complete edition of the correspondence exists. The more important published portions include *Ruskin's Letters from Venice, 1851–1852*, ed. John L. Bradley (Yale University Press, New Haven, 1955); *The Winnington Letters*, ed. Van Akin Burd (Harvard University Press, Cambridge, Mass., 1969); *Ruskin in Italy: Letters to His Parents 1845*, ed. Harold I. Shapiro (Clarendon Press, Oxford, 1972); *The Ruskin Family Letters: The Correspondence of John James Ruskin, His Wife, and His Son, 1801–1843*, ed. Van Akin Burd, 2 vols. (Cornell University Press, Ithaca, 1973); and *'Your Good Influence On Me': The Correspondence of John Ruskin and William Holman Hunt*, ed. George P. Landow (Rylands Library, Manchester, 1977).

Writings about Ruskin

The long period during which students of art, literature, and politics generally ignored Ruskin ended more than a decade ago with a flurry of editions, biographies, and critical studies. The chapter on Ruskin by Francis Townsend in *Victorian Non-Fiction: A Guide to Research*, ed. David J. DeLaura (Modern Language Association, New York, 1977), provides valuable summary judgements of both primary and secondary materials, and the annual

bibliographical issue of *Victorian Studies* lists current books and articles and notes reviews of recent books. Readers may also wish to consult *The Ruskin Newsletter*, which contains notices of current sales of Ruskiniana as well as of other matters of interest to students of his life, art, writing, and influence.

Derrick Leon, *Ruskin The Great Victorian* (Routledge & Kegan Paul, London, 1949), remains the best biography although two useful ones have recently appeared: Joan Abse, *John Ruskin the Passionate Moralist* (Knopf, New York, 1982), and J. D. Hunt, *The Wider Sea: A Life of John Ruskin* (Viking, New York, 1982).

John D. Rosenberg, *The Darkening Glass: A Portrait of Ruskin's Genius* (Columbia University Press, New York 1961), a pioneering study that is responsible for much of the current interest in Ruskin, has been superseded by more recent work but still contains many valuable insights, as does Robert Hewison, *John Ruskin or the Argument of the Eye* (Thames and Hudson, London, 1975). Two of the most important studies of Ruskin during the past decade are Elizabeth K. Helsinger's *Ruskin and the Art of the Beholder* (Harvard University Press, Cambridge, Mass., 1982), and Paul Sawyer's *Ruskin's Poetic Argument: the Design of His Major Works* (Cornell University Press, Ithaca, 1985). George P. Landow, *The Aesthetic and Critical Theories of John Ruskin* (Princeton University Press, Princeton, 1971), and Paul H. Walton, *The Drawings of John Ruskin* (Clarendon Press, Oxford, 1972), provide specialized discussions of his thought within the context of Victorian and earlier ideas. Walton's volume, which contains many reproductions of Ruskin's drawings and water-colours, sets his pictures against the background of eighteenth- and nineteenth-century drawing treatises. Landow, who examines the sources and development of Ruskin's conceptions of beauty and the arts, shows how he formulated a Victorian aesthetic by drawing upon Neo-classical conceptions of painting, beauty, sublimity, and picturesqueness and combining them with Romantic conceptions of poetry and evangelical attitudes towards interpretation. James Clarke Sherburne, *John Ruskin, or the Ambiguities of Abundance: A Study in Social and Economic Criticism* (Harvard University Press, Cambridge, Mass., 1972), an essential book, examines the sources, evolution, and influence of his political economy. Ray-

mond E. Fitch, *The Poison Sky: Myth and Apocalypse in Ruskin* (Ohio University Press, Athens, Ohio, 1982) provides a massive study of the subjects covered in its title. *New Approaches to Ruskin*, ed. Robert Hewison (Routledge & Kegan Paul, London, 1982), which contains important essays on individual works, provides a valuable survey of the state of current Ruskin criticism and scholarship.

The study of Ruskin's influence on the arts has produced some interesting results, but much more work needs to be done in this area. Roger B. Stein, *Ruskin and Aesthetic Thought in America, 1840–1900* (Harvard University Press, Cambridge, Mass., 1967) offers a pioneering survey of its broad subject, while Kristine O. Garrigan, *Ruskin on Architecture: His Thought and Influence* (University of Wisconsin Press, Madison, 1973); Eve Blau, *Ruskinian Gothic* (Princeton University Press, Princeton, 1982), and George L. Hersey, *High Victorian Gothic: A Study in Associationism* (Johns Hopkins University Press, Baltimore, 1972), contain much valuable information about his influence on architecture. Allen Staley, *The Pre-Raphaelite Landscape* (Clarendon Press, Oxford, 1973), and George P. Landow, *William Holman Hunt and Typological Symbolism* (Yale University Press, New Haven and London, 1979), examine his influence upon different aspects of Pre-Raphaelitism, as does Robert Secor, *John Ruskin and Alfred Hunt: New Letters and the Record of a Friendship*, English Literary Studies Monograph Studies No. 25 (University of Victoria Press, Victoria, B. C., 1982).

A Ruskin chronology

1819 John Ruskin is born in London on 8 February to John James and Margaret Cox Ruskin.

1836 Resides in Oxford, accompanied by his mother, until 1840. Publishes a series of articles entitled 'The Poetry of Architecture' in the *Architectural Magazine* (1837–8).

1839 Wins the Newdigate Prize for poetry at Oxford with *Salsette and Elephanta*. Meets Wordsworth.

1840 First meets Turner. Falls ill, possibly with consumption, and leaves Oxford for a foreign tour with parents which lasts from September until June. Meets Georgianna Tollemache, later Lady Mount-Temple, who remains one of his closest friends.

1841 Writes *The King of the Golden River* for Euphemia Chalmers Gray, whom he marries in 1848.

1842 Takes BA at Oxford and abandons idea of taking holy orders. Begins *Modern Painters*.

1843 Publishes first volume of *Modern Painters* anonymously in May.

1844 Revises *Modern Painters I*, deleting much of its polemics. Reads A. F. Rio's *La Poésie de l'art chrétienne* and continues studies of botany and geology. Purchases Turner's *The Slave Ship*.

1846 Publishes *Modern Painters*, Volume II, which marks a new departure in his thought.

1847 Reviews Lord Lindsay's *Sketches of the History of Christian Art* in the June *Quarterly Review*. Unknown to Ruskin, *Modern Painters II* inspires William Holman Hunt, John Everett Millais, and Dante Gabriel Rossetti to emulate Tintoretto's fusions of visual realism and elaborate symbolism.

1848 Marries Euphemia Chalmers Gray, a distant cousin, on 10 April, after which he and his wife tour Normandy. Studies Gothic architecture.

1849 Publishes *The Seven Lamps of Architecture*. Works in Venice studying the city's architecture and history from November until March 1850.

1850 Publishes collected *Poems* and *The King of the Golden River*, which is, however, dated the following year.

190

1851 Publishes the first volume of *The Stones of Venice*, 'Notes on the Construction of Sheepfolds', and *Pre-Raphaelitism*. Defends Hunt and Millais in letters to *The Times* after Coventry Patmore points out their works to him. Meets Millais, Rossetti, Hunt, and other members of the Pre-Raphaelite circle. Works in Venice from September until June 1852 on *The Stones of Venice*. Turner dies, having made Ruskin a trustee of his will.

1853 The second and third volumes of *The Stones of Venice* are published. Travels with wife, Millais, and Millais's brother in Scottish Highlands.

1854 Marriage annulled on grounds of non-consummation. (The following year Effie marries Millais.) Begins lecturing on art at the newly founded Working Men's College and becomes friendly with D. G. Rossetti and Elizabeth Siddall. Writes letters to *The Times* defending Pre-Raphaelite painting. Publishes *Lectures on Art and Architecture* delivered in Edinburgh the previous year.

1855 Begins *Academy Notes*, annual reviews of the June Royal Academy exhibition which continue until 1859 (with a single issue in 1875). Meets Tennyson.

1856 Publishes the third and fourth volumes of *Modern Painters*, which concern the rise of Romantic art and attitudes towards landscape. Meets Charles Eliot Norton, his American friend, disciple, and popularizer.

1857 Publishes *The Elements of Drawing* and *The Political Economy of Art*. Lectures extensively and studies works in Turner bequest.

1858 Meets and falls in love with Rose La Touche. Decisively abandons his Protestant religious faith in Turin.

1860 Completes the final volume of *Modern Painters* and publishes political and social criticism in the *Cornhill Magazine*, but protests by readers prompt Thackeray, the editor, to limit Ruskin to four articles later published as *Unto This Last* (1862).

1862 Publishes 'Essays on Political Economy' in *Fraser's Magazine* (1862–3); these are published in book form as *Munera Pulveris* in 1872.

1864 Ruskin's father dies on 2 March and leaves him considerable wealth. Writes and delivers 'Traffic' and 'Of King's Treasuries'.

1865 Publishes *Sesame and Lilies*.

1866 Publishes *The Crown of Wild Olive* and *The Ethics of the Dust*, this last work a series of dialogues with children explaining geology based upon his occasional teaching at the Winnington School.

191

Ruskin's proposal of marriage to Rose La Touche begins a decade of frustration and emotional turmoil.

1867 Publishes *Time and Tide*, letters to a British labourer about social and political issues. Becomes friendly with the social worker Octavia Hill.

1869 Publishes *The Queen of the Air*, a study of Greek myth which expands ideas found in the closing volumes of *Modern Painters*. Appointed the first Slade Professor of Fine Art at Oxford.

1871 Purchases Brantwood near Coniston in the Lake District from the radical W. J. Linton. Undertakes social experiments including street sweeping in London and road mending in Oxford. Begins publication of *Fors Clavigera*, which continues in monthly parts until 1878, after which it appears intermittently. Is seriously ill, with mental and physical illnesses, at Matlock. Mother dies 5 December.

1875 Rose dies, insane, at age twenty-seven.

1878 Founds the Guild of St George. Suspends *Fors* after an attack of madness in the spring and is unable to testify in *Whistler v. Ruskin* in November.

1879 Resigns Slade Professorship at Oxford, in large part because of *Whistler v. Ruskin*.

1880 Recovering from attacks of madness, he resumes *Fors* and begins 'Fiction, Fair and Foul', a series that appears intermittently in the *Nineteenth Century* until October 1881. Publishes *A Joy For Ever*, an expanded version of *The Political Economy of Art* (1857).

1883 Resumes Professorship at Oxford after re-election and lectures on *The Art of England*, which contains extensive comments on Hunt, Rossetti, Burne-Jones, and other Victorian artists.

1884 Delivers 'The Storm-Cloud of the Nineteenth Century' as a lecture at the London Institution and begins to publish the Oxford lectures entitled *The Pleasures of England*. Publishes *The Art of England* in book form. Frequently experiences mental turmoil.

1885 Continues publication of *The Pleasures of England* and publishes *Praeterita*, his autobiography, which appeared intermittently in part until July 1889. Mental illness forces temporary cessation of writing.

1886 Suffers attacks of mental illness.

1900 Dies of influenza on 20 January and is buried in Coniston churchyard.

Arnold

Stefan Collini

To Ruth

Preface

A short book on a writer as rich and diverse as Matthew Arnold must, more than most books, be highly selective. It therefore seems only fair to alert the reader to the chief idiosyncrasies of the portrait of Arnold I have chosen to offer here. Although I have naturally tried to do justice to the range of his achievement, I have judged (not very controversially) that it is as a literary and social critic that he chiefly commands attention today, and that it is his work in these areas written in the 1860s, above all *Essays in Criticism* and *Culture and Anarchy*, which best exhibits his special gifts. I recognize that others might wish to give greater prominence to his books on religion than I do, and that a stronger case could be made for the importance of the critical essays he wrote in the last decade of his life. More contentiously, where some assessments of Arnold might decide to give pride of place to his poetry, I have felt inclined not only to follow the rough proportions of his *œuvre*, in which the prose bulks far larger than the poetry, but also to let the distribution of the chapters reflect my conviction that, for reasons to do with our own cultural preoccupations as much as with the merits of his writing, the best of his prose has a claim on us today that cannot be matched by his poetry.

If the result of giving greater prominence to his writings of the 1860s has been to create a more winning and cheerful Arnold than might naturally issue from concentrating on the poetry or the writings on religion, I trust that those already familiar with his work will not find the likeness unrecognizable, and that potential readers are unlikely to be deterred by it. More generally, my assessment of Arnold may seem a generous one, even culpably indulgent by some standards. This is partly because in a book of this type there is something to be said for trying to bring out what is interesting, attractive, and valuable in the author concerned, but also because there has in recent years, for reasons I touch on in Chapter 7, been no shortage of hostile or unsympathetic judgements of his work. Since 'supplying what the age most lacks' was

one of the animating purposes of Arnold's own critical writings, it seems only right that he in his turn should be the beneficiary of a similar concern.

I should explain, finally, that rather than providing a comprehensive summary of Arnold's 'views', I have throughout concentrated on characterizing the tone and temper of his mind and the distinctive style in which it expressed itself. As I suggest in the first chapter, it is on account of the qualities embodied in his elusive but recognizable literary 'voice', rather than of any body of 'doctrine', that he continues to be such rewarding company for us. Accordingly, I have attempted in the first chapter to characterize this 'voice', to identify its preferred register and habitual strategies, and thus to bring out what is so seductive but also sometimes so irritating about the experience of reading Arnold. To this end, I have allowed myself some longer quotations than may be common in a work of this kind, partly in the spirit of Arnold's injunction that 'the great art of criticism is to get oneself out of the way', but partly also as the best way of coping with the truth of Dr Johnson's observation about the impossibility of doing justice to Shakespeare by means of brief passages: 'He that tries to recommend him by select quotations will succeed like the pedant in Hierocles, who, when he offered his house to sale, carried a brick in his pocket as a specimen.' Thereafter, although Chapters 3 to 6 are thematic rather than strictly chronological in conception, the divisions do very roughly correspond to the four main phases of Arnold's writing life, and this has enabled the biographical account in Chapter 2 to be kept to a minimum.

This book is the expression of an unashamedly personal encounter with Arnold, but I am very conscious of my debts to those far more learned than I am in the byways of Arnoldian scholarship. The sources on which I have drawn most freely are cited in the note on further reading, but I should particularly like to record how much I, in common with all students of Arnold, have profited from the erudition and judgement of R. H. Super and Kenneth Allott in their editions of the prose and poetry respectively. In addition, I am extremely grateful for the generous help and advice of Jane Adamson, John Drury, and Sam Goldberg. I have also greatly appreciated the editorial encouragement of Keith Thomas

and the helpfulness of Thomas Webster and his colleagues at Oxford University Press. R. H. Super's careful scrutiny of the completed script enabled me to make several last-minute corrections, though that should not be taken to suggest that he would endorse all that remains.

Arnold once confided to his sister: 'You and Clough are, I believe, the two people I in my heart care most to please by what I write.' I count myself more fortunate in the slightly larger number of those I 'care most to please', since it is the attempt to give them pleasure and earn their commendation which provides the chief (sometimes, it seems, the only) incentive for enduring the agonies of writing. Prefaces conventionally end with the author exempting others from the responsibility for any errors, but since the following friends have not only read the entire manuscript with characteristic attentiveness, but have also done more than they know to shape its author, they must each partly be held to blame for whatever infelicities and misjudgements this book contains: John Burrow, Peter Clarke, Geoffrey Hawthorn, Ruth Morse, John Thompson, Donald Winch.

Contents

Abbreviations

The following abbreviations are used for references from Arnold's writings cited in the text:

The Complete Prose Works of Matthew Arnold, edited by R. H. Super, 11 volumes (Ann Arbor: The University of Michigan Press, 1960–77), cited by volume and page number, e.g. (vi. 264).

The Poems of Matthew Arnold, edited by Kenneth Allott, 2nd edition revised by Miriam Allott (London: Longman, 1979), cited by page number alone, e.g. (283).

L *The Letters of Matthew Arnold 1848–1888*, collected and arranged by George W. E. Russell, 2 volumes (London: Macmillan, 2nd edn., 1901 [1st edn., 1895]).

UL *Unpublished Letters of Matthew Arnold*, edited by Arnold Whitridge (New Haven, Conn.: Yale University Press, 1923).

C *The Letters of Matthew Arnold to Arthur Hugh Clough*, edited by Howard Foster Lowry (London: Oxford University Press, 1932).

N *The Note-Books of Matthew Arnold*, edited by Howard Foster Lowry, Karl Young, and Waldo Hilary Dunn (London: Oxford University Press, 1952).

1 The Arnoldian voice

With most candidates for 'past masterdom', the claim they now have on our attention rests upon their having originated an influential system of thought or created an enduring literary masterpiece or written some other incontestably great, single work. Honesty might compel us to own up to never having read *The Critique of Pure Reason* or the *Divina Commedia* or *The Decline and Fall of the Roman Empire*, but we readily let the existence of those awesome cultural monuments license an interest in reading about Kant or Dante or Gibbon. The case for Matthew Arnold has to be made in other terms. It is true that in addition to several fine lyric poems and elegies, he wrote at least two minor prose classics which are still widely read, *Essays in Criticism* (1865) and *Culture and Anarchy* (1869). But his achievement did not take the form of one or two great works, and even these two books were collections of essays, most of which had already been published in the periodicals of general culture that were in their heyday in mid-Victorian England. Nearly all his work, in fact, was first published in this way: it is occasional, topical, controversial.

In general, such writing tends to wear badly. The smoke clears, the noise dies down, and all we see is a lone actor on an empty stage still declaiming his now pointless lines. But a remarkable amount of Arnold's writing, especially that dating from the 1860s when he was, in my view, in particularly good voice, soars about the circumstances that prompted it, and moves, instructs, and amuses us still. To read Arnold at his best is to find oneself in the company of a mind of such balance and sympathy that we come, without really noticing, to see experience in his terms, and, unusually, to think the better of ourselves for it. Less original than Coleridge, less prophetic than Carlyle, less profound than Newman, less anaytical than Mill, less passionate than Ruskin, less disturbing than Morris—Arnold is more persuasive, more

perceptive, more attractive, and more readable than any of his peers.

His writing ranges across several areas that have, in the century since his death, set out their stalls as separate specialisms or disciplines. For want of any better single category, we could call him a 'cultural critic', though both terms might need to be freed from inappropriately narrowing connotations. In the more spacious and accommodating language of his day he was a 'man of letters'. He wrote about politics, he wrote about religion, he wrote, above all, about literature; but he did not write as a political theorist a theologian, or even, in any restricted sense, a literary critic. He engaged, in an exceptionally alert and responsive way, with most of the important developments in the cultural and intellectual life of Victorian England, yet did so as one who constantly had in mind the standards established by the larger European tradition of thought and letters. For somebody who was drawn into, or in some cases provoked, so many of the now-forgotten controversies of the period, he remained a remarkably consistent and effective critic of the parochial, the self-important, and the merely fashionable. It is because he embodied, as well as recommended, the virtues of a certain cast of mind, a certain way of inhabiting one's identity, that we can, even when he is in full polemical flow, still find him compelling.

Arnold is also frequently ranked alongside Browning and Tennyson as one of the three pinnacles of Victorian verse. He left a far smaller corpus of poetry than either of those copious, at time garrulous, poets, and in fact nearly all of his best work was written in one relatively brief period in his mid- and late twenties. Moreover, his poetry encompasses only a limited range. He does not belong with those poets who stun us with the sheer inventiveness of their imaginations, nor is his work marked by lush imagery or verbal exuberance. As he realized very early, he was never likely to know the kind of popular success as a poet that was enjoyed by leading contemporaries. He is an intellectual poet, even, it might be said with only a little unfairness, an intellectuals' poet. He writes above all of the melancholy that attends reflection, especially reflection on our inevitable loss of comforting certainties and the capacity for doubt-banishing action. But from

this unpromising clay he fashioned some exquisitely poignant verses, several of which, such as 'Dover Beach' or 'The Scholar-Gypsy', will always press their claims on anthologists the world over.

Beyond this, Arnold has become an inescapable, if also oddly nebulous, presence in modern intellectual life. Indisputably, he has exercised an immense, perhaps decisive, influence over our whole way of talking about 'culture' and its role as a possible antidote or corrective to the cramping hold of the narrowly practical and mundane. He, more than any other single writer (including T. S. Eliot, his nearest rival in this respect), endowed the role of the critic with the cultural centrality it now enjoys, particularly in Britain and the United States. The study and teaching, at all levels, of a certain conception and canon of English literature has claimed descent from him, albeit in ways he might not have recognized and would surely not altogether have welcomed. And Arnold's ideas have been invoked in justification of so many of those institutions which have contributed a distinctive, and often distinctively high, tone to the cultural life of modern Britain, such as the BBC, the British Council, and university departments of English. More generally still, the assumptions that have helped to sustain that whole business of the cultivation and diffusion of the literature and cultural legacy of England, which has been such a marked feature of twentieth-century world history, owe much to the inspiration derived from Arnold's writings and example. In recent decades these assumptions have come under fierce attack from several quarters, and Arnold, or a convenient parody of what he is supposed to have stood for, has been the target of some unusually violent criticism. But such abuse has only served to underline how much he, or someone quite like him, has now become an unavoidable cultural reference-point.

In considering the nature of Arnold's claim on our attention, it is important to reiterate that he was not the creator of a theoretical system or body of abstract doctrines (this is one of the reasons he is so badly served by paraphrase). He had too lively an awareness of the pitfalls of systematic abstraction to be pulled very strongly in that direction. 'If all wisdom were come at by hard reasoning' logic would have no rival. But how much

of the blundering to be found in the world comes from people fancying that some idea is a definite and ascertained thing, like the idea of a triangle, when it is not; and proceeding to deduce properties from it, and to do battle about them, when their first start was a mistake! And how liable are people with a talent for hard, abstruse reasoning to be tempted to this mistake! And what can clear up such a mistake except a wide and familiar acquaintance with the human spirit and its productions, showing how ideas and terms arose, and what is their character? and this is letters and history, not logic. (vi. 168)

What, in the end, we must fall back on, he suggested in the various passages in which he urged this point, is 'the judgement which forms itself insensibly in a fair mind along with fresh knowledge'. This quality of 'judgement' is one of the things we value Arnold for, but by its nature it is a quality that does not easily lend itself to the neatly packaged summary (that, of course, may be not the least of its value). Instead, we need to spend some time in his company and to become familiar with his distinctive literary voice. The remainder of this chapter is intended to provide a few suggestions on what to listen for.

We may stay for a moment with this matter of Arnold's lack of a 'system', because, when put as a reproach, it elicited from him some interesting self-descriptions, often expressed in the light, bantering tone which itself carried the main weight of his reply. Here he is in 1865 having his sport with this complaint:

I am very sensible that [my] way of thinking leaves me under great disadvantages in addressing a public composed from a people 'the most logical', says the *Saturday Review*, 'in the whole world'. But the truth is, I have never been able to hit it off happily with the logicians, and it would be mere affectation in me to give myself the airs of doing so. They imagine truth something to be proved, I something to be seen; they something to be manufactured, I as something to be found. I have a profound respect for intuitions, and a very lukewarm respect for the elaborate machine-work of my friends the logicians. I have always thought that all which was worth much in this elaborate machine-work of theirs came from an intuition, to which they gave a grand name of their own. How did they come by this intuition? Ah! if they could tell us that. But no; they set their machine in motion, and build up a fine showy edifice, glittering and unsubstantial like a pyramid of eggs; and then they say: 'Come and look at our pyramid.' And what does one find it? Of all that heap of eggs, the one poor little fresh egg,

the original intuition, has got hidden away far out of sight and forgotten. And all the other eggs are addled. (iii. 535)

This is a characteristic passage, not only because what starts out as mock-humble soon turns into high-derisory, but also because it is only likely to persuade those who have already half-felt something similar. Still, even those who find it treads too sharply on their convictions thereby register its weight, though the passage may also suggest that if we are to spend any time in Arnold's company, and enjoy it, we must not be too intolerant of irony and occasional facetiousness.

To attempt to focus on 'doctrine' would, in Arnold's case, also be to go astray in another way. One of the reasons why Arnold can still speak to us more directly than most of his contemporaries is that he did not make the prime object of attention the content of a writer's beliefs so much as the spirit in which they were held. 'What the English public cannot understand is that a man is a just and fruitful object of contemplation much more by virtue of what spirit he is of than by virtue of what system of doctrine he elaborates' (L i. 208). Written shortly after his fortieth birthday, when Arnold was in his pomp, this sentence takes us to the heart of the kind of cultural criticism he was attempting. The reference to 'the English public' calls up his highly-developed sense of audience, while addressing what they 'cannot understand' points towards the animating purpose of his writing life. And then 'a fruitful object of contemplation' is such a characteristic Arnoldian phrase, suggesting an appreciative, open-ended, pondering response, rather than conscripting or subordinating what we read to a partisan programme or single use. With the phrase 'what spirit he is of' we meet, in appropriately informal dress, the core of Arnold's concern: it suggests a cast of mind, but of more than mind – a temper, a way, at once emotional, intellectual, and psychological, of possessing one's experience and conducting one's life. And finally the disparaged 'system of doctrine', something that is, in a telling verb, 'elaborated': it is hard to say whether it is the suggestion of abstraction in 'system' or the hint of the demands of orthodoxy in 'doctrine' that is asking to be swept aside first here.

This sentence, which thus condenses so many of Arnold's

concerns, comes from a letter in which he was describing an essay he had just published dealing with the seventeenth-century Dutch philosopher, Spinoza. Spinoza was a Jew; he had a reputation for being an atheist; he had written complex treatises which were thought to encourage immorality. To write about such a figure in a respectable magazine in the religion-drenched England of the mid-nineteenth century was unusual, to write at all favourably was greatly daring. In fact, Arnold was not trying to propagate Spinoza's ideas ('as far as I understand them'), but to indicate the superiority of his generosity of spirit in interpreting the Scriptures, even when allied to what orthodox opinion abhored as his godlessness, over the narrow but doctrinally impeccable literalism of the approved English exegetes. Spinoza may now seem an odd medium for the message, but in its deliberate attempt to provoke the English public into throwing off its prejudices, especially its religious and political prejudices, sufficiently to benefit from a wider world of ideas, this essay is representative of the task that Arnold set himself as a cultural critic.

There is an important general question here about the degree of distance from one's society required by such a task. A certain reflective detachment is obviously indispensable, but the effective cultural critic needs to be sufficiently intimate with the assumptions and traditions of his society to criticize with the requisite discrimination, and he has to share enough of its values to be able to bring them to bear in inducing that kind of self-criticism which is the condition of persuasion. The complete outsider, by contrast, can only denounce; he may disturb those within the walls who hear his curses, but he will not lead them to reform their ways. Arnold was in no sense an outsider: he belonged, by upbringing and style of life, to the most comfortable stratum of the Victorian professional class, mixing easily with the more sympathetic members of the politial and social élite. In intellectual style he was, in Carlyle's adaptation of a Biblical phrase that Arnold was fond of quoting, 'terribly at ease in Zion' (e.g. v. 168). Moreover, he took for granted much that men of his rank and time took for granted. Inevitably, this has left him vulnerable to the reproaches of an age more alert to some of the injustices of class, gender, and race. But it also gave him an insider's ear for significance and nuance, and it

meant that he very rarely indulged in that deceptive form of self-flattery which consists in dramatizing oneself as locked in heroically lonely combat with forces that are both alien and overwhelming.

Implicit in Arnold's conception of his task was an ideal of a certain kind of mental and emotional balance. Words like 'partial', 'exclusive', and 'impetuous' recur in his negative characterizations: 'poise' is a favoured positive term. There can be, as we shall see, weakness as well as strength in this. Balance can seem bland and anaemic as an ideal. We may, for example, feel that without a certain kind of one-sided intensity or obsessive pursuit of one idea or one talent, nothing really original or fine is ever done; perhaps, in other words, creativity, originality, and the capacity for intense experience require a *lack* of balance. There are also some intriguing biographical questions about how far such a balance came naturally to Arnold, and how far the 'imperious serenity' which at least one contemporary critic claimed to find in his early poetry was just that. The author of lines like 'Calm is not life's crown, but calm is well' had certainly known tempestuous times, but he also knew their place in a larger scheme. In any event, the mature Arnold took stock of the options in a characteristically even tone:

No-one has a stronger and more abiding sense than I have of the 'daemonic' element – as Goethe called it – which underlies and encompasses our life; but I think, as Goethe thought, that the right thing is, while conscious of this element, and of all that there is inexplicable round one, to keep pushing on one's posts into the darkness and to establish no post that is not perfectly in light and firm. One gains nothing on the darkness by being . . . as incoherent as the darkness itself. (L i. 289)

In translating this general attitude into a charter for criticism, Arnold famously propounded the ideal of 'disinterestedness', that endeavour, as he frequently glossed it, 'to see the object as in itself it really is' (e.g. i. 140). This apparently artless and naïve recipe has come in for more than its share of scorn and even derision in our intellectually suspicious century, but, as so often, our condescension may be misplaced. Arnold did not intend this as an epistemological claim; an empty victory is secured by demonstrating that, according to the latest findings of philosophy and critical theory, objective knowledge is not so easily come by. Arnold's was a more

practical, if also more elusive, point about a frame of mind, a state of intention. This frame of mind may in fact be uncommon at any time, for all the lip-service paid to it; certainly Arnold thought it was less than abundant in the intellectual life of Victorian England. Criticism shows its disinterestedness, as he put it in his famous essay on 'The Function of Criticism at the Present Time' first published in 1864:

> by steadily refusing to lend itself to any of those ulterior, political, practical considerations about ideas which plenty of people will be sure to attach to them, which perhaps ought often to be attached to them, which in this country at any rate are certain to be attached to them quite sufficiently, but which criticism has really nothing to do with. (iii. 270)

In responding to the political and intellectual life of his own society, the natural movement of Arnold's mind was away from exaggeration and one-sidedness. 'I hate all over-preponderance of single elements', he exclaimed in a letter of 1865 (L i. 287), declaring an aversion that was at once aesthetic, moral, and intellectual. This meant that there was sometimes a hint of the Higher Counter-Suggestibility about his polemical writing. 'It is delusion . . . which is fatal', and the antidote, the telling of unpopular truths, was always in short supply.

> It is not fatal to the Nonconformists to remain with their separated churches; but it is fatal to them to be told by their flatterers, and to believe, that theirs is the one true way of worshipping God, that provincialism and loss of totality have not come to them from following it, or that provincialism and loss of totality are not evils. (v. 254)

There was certainly no danger that Arnold would be cast among the flatterers of the prejudices of his age.

But no less repugnant to him was that partisan habit of mind which he saw constantly at work in the sectarian antagonisms of mid-Victorian England. Nothing is more damaging to the 'free play of the mind on all subjects which it touches' (iii. 270) than the spirit of binary exclusiveness embodied in the tag 'he who is not with us is against us'. Politically, Arnold had broadly Liberal sympathies (a just characterization of his politics is no easy matter, and will be discussed more fully in Chapter 5), but, true to his role and his temperament, he spent far more time undermining the

dogmas and curbing the excesses of party-political Liberalism than in showing up the defects of the more obviously unacceptable Tories. His tendency was not at all, as was maliciously said of the nineteenth-century *Times*, 'to be strong on the stronger side'. He was scornful of, for example, those English newspapers which constantly denounced the evils of over-centralized state power, or those French journalists who were always sneering at the weaknesses of autonomous local government: 'It seems to me that they lose their labour, because they are hardening themselves against dangers to which they are neither of them liable' (ii. 17).

By its nature, this urge to correct imbalance will be bound to take different forms in different historical circumstances (as that last example clearly suggests), something that Arnold accepted and worked with in a way that makes him seem surprisingly modern. With some justice, he identified the besetting sins of the public life of Victorian England as parochialism, complacency, and (in a term, borrowed from Heine, which he did much to put into general circulation) philistinism. His response was to try to open up English consciousness to European ideas and perspectives, and to provoke his readers into an uneasy awareness of the limitations of their established mental habits. He did not, therefore, occupy a position that can easily be characterized as 'radical' or 'conservative', in either intellectual or political terms. He was, like most of his educated contemporaries, apprehensive about the possible levelling involved in the as yet untried experiments of democracy and greater social equality, but he had no illusions about the merits of the established order. In any case, it was the inadequacies of the mind that can only think in terms of 'positions' that he pounced upon, and not only the most obvious inadequacies: he knew that radicalism, too, can have its unthinking prejudice and blind loyalty, just as there can be impatience and over-simplification in conservatism. He wrote to enlarge the horizons and expand the sympathies of all 'sides', optimistic that a mind with access to the standards established by 'the best that has been thought and said' could never rest content with partisan simplicities.

In all of this, Arnold's tone of voice was at once his chief weapon and his most distinctive quality. It was not a matter of forcing the reader to abandon one position in favour of another, but of putting

him in the way of the experience which, when reflected upon, would bring home to him the defects of the frame of mind that had found expression in the erroneous 'position' in the first place. It is not that Arnold proposes a series of definitive answers to the great questions of human life, but rather that, by spending time in his company, we begin to be drawn to the habit of mind that emerges from the way in which he handles these questions. When reading his prose, the sense of the engaging conversational presence of the author is exceptionally vivid.

Arnold, as one might expect of such a self-conscious writer could be knowingly aware of this effect (indeed, a sense of this awareness is sometimes allowed to edge into the prose itself, thereby drawing the reader further into complicity). As his essays began to attract attention, he took the measure of his powers with a frank confidence:

It is very animating to think that one at last has a chance of *getting* at the English public. Such a public as it is, and such a work as one wants to do with it! Partly nature, partly time and study, have also by this time taught me thoroughly the precious truth that everything turns upon one's exercising the power of *persuasion*, of *charm*; that without this all fury, energy, reasoning power, acquirement, are thrown away and only render their owner more miserable. Even in one's ridicule one must preserve a sweetness and good-humour. (L i. 233–4)

Notoriously, the good-humour could seem at best an affectation, at worst a cover. Leslie Stephen turned Arnold's weapon against him when he remarked: 'I often wished . . . that I too had a little sweetness and light that I might be able to say such nasty things of my enemies.' The attempt to charm, in literature as in life, runs a special risk. Argument, when it fails, leaves the reader unconverted; charm, when it fails, leaves him antagonistic, distrustful. More readers have been *irritated* by Arnold than by almost any writer of comparable distinction. G. K. Chesterton registered this exasperation and put his finger near, though not quite on, something crucial when he remarked that 'Arnold kept a smile of heartbroken forbearance, as of a teacher in a idiot-school, that was enormously insulting'. A modern critic, Geoffrey Tillotson, complained representatively that it is Arnold's egotism, clothed in a self-effacing pose, that 'accounts for the high-pitched conversa-

tional tone, the ripple of inspired temporisation, the French grace, the lizard slickness'.

What is it about Arnold's writing that has provoked such reactions? It is something so pervasive, and so much a matter of the chemistry of reader and author, that the reader must read on to see it at work in later chapters, must in fact read Arnold. But one or two extended examples may at least suggest what is at issue. Arnold's playful mockery of his countrymen's philistinism, his criticisms of their educational arrangements, his observations on the signficance of England's lack of a body comparable to the *Académie française*, all provoked some understandably snappish responses, as well as some vigorous re-affirmations of the incomparable achievements of the English nation. From a reply first published in 1866, here is Arnold up and going well.

Of course if Philistinism is characteristic of the British nation just now, it must in a special way be characteristic of the respresentative part of the British nation, the part by which the British nation is what it is, and does all its best things, the middle class. And the newspapers, who have so many more means than I of knowing the truth, and who have that trenchant authoritative style for communicating it which makes so great an impression, say that the British middle class is characterised, not by Philistinism, but by enlightenment; by a passion for penetrating through sophisms, ignoring commonplaces, and giving to conventional illusions their true value. Evidently it is nonsense, as the *Daily News* says, to think that this great middle class which supplies the mind, the will, and the power for all the great and good things that have to be done should want its schools, the nurseries of its admirable intelligence, meddled with. It may easily be imagined that all this, coming on top of the *Saturday Review*'s rebuke of me for indecency, was enough to set me meditating; and after a long and painful self-examination, I saw that I had been making a great mistake. Instead of confining myself to what alone I had any business with, – the slow and obscure work of trying to understand things, to see them as they are, – I had been meddling with practice, proposing this and that, saying how it might be if we established this or that. So I was suffering deservedly in being taunted with hawking about my nostrums of State schools for a class much too wise to want them, and of an Academy for a people who have an inimitable style already. To be sure, I had said that schools ought to be things of local, not State, institution and management, and that we ought not to have an Academy; but that makes no difference. I saw what danger I had been running by thus intruding into

213

a sphere where I have no business, and I resolved to offend in this way no more. (v. 6)

Even at a first reading, we notice several of the qualities that contribute to the distinctive tone here – the light play of irony over the whole passage, the arch references, the self-deprecating mannerisms. What may not at first be so apparent is the way the whole effect depends upon creating a sense of intimacy with the reader, who is drawn to collude in the playfulness. The very fact that some of Arnold's stratagems are so transparent has the effect of flattering us: we are being trusted not to bridle at these flourishes but to appreciate the daring of an author who places himself in our hands in this way. If it works, we are willing to indulge what could otherwise so easily strike us as mere affectation. Sometimes it doesn't work, and with some readers it never works.

Or, to catch him in a quite different mood, here he is in 1878 disposing of some bad writing about Goethe; on the surface, the style could hardly be more direct and baldly classificatory, yet cumulatively it is a passage of great rhetorical forcefulness.

Many and diverse must be the judgments passed on every great poet, upon every considerable writer. There is the judgment of enthusiasm and admiration, which proceeds from ardent youth, easily fired, eager to find a hero and to worship him. There is the judgment of gratitude and sympathy, which proceeds from those who find in an author what helps them, what they want, and who rate him at a very high value accordingly. There is the judgment of ignorance, the judgment of incompatibility, the judgment of envy and jealousy. Finally, there is the systematic judgment, and this judgment is the most worthless of all. The sharp scrutiny of envy and jealousy may bring faults to light. The judgments of incompatibility and ignorance are instructive, whether they reveal necessary clefts of separation between the experiences of different sorts of people, or reveal simply the narrowness and bounded view of those who judge. But the systematic judgment is altogether unprofitable. Its author has not really his eye upon the professed object of criticism at all, but upon something else which he wants to prove by means of that object. He neither really tells us, therefore, anything about the object, nor anything about his own ignorance of the object. He never fairly looks at it, he is looking at something else. Perhaps if he looked at it straight and full, looked at it simply, he might be able to pass a good judgment on it. As it is, all he tells us is that he is no genuine critic, but a man with a system, an advocate. (viii. 254)

Here, self-assurance rather than playfulness is the dangerous element that may misfire. The almost Augustan cadences of this passage, with its self-consciously balanced syntax and lapidary juxtaposition of declarative clauses, give an air of judicial finality. But if we are prone to feel that our own views are implicity being slighted by such conclusiveness, and especially if we were already out of sympathy with the point of substance, then the tone merely arouses impatience and resentment.

These passages represent two extremes of Arnold's writing, the same voice speaking in very different tones for different occasions. In between, he was master of a range of effects which were not so purely instrumental as to deserve to be called devices, but which were expressions of his literary personality that can, when confronted with an unsympathetic reader, prove to be two-edged. In replying to the complaint of another contemporary critic, Henry Sidgwick, that sweetness and light were not the world's great need, Arnold could allow a sequence of rhetorical questions to carry his argument for him:

When Mr Sidgwick says so broadly that the world wants fire and strength even more than sweetness and light, is he not carried away by a turn for broad generalisation? does he not forget that the world is not all of one piece, and every piece with the same needs at the same time? It may be true that the Roman world at the beginning of our era, or Leo the Tenth's court at the time of the Reformation, or French society in the eighteenth century, needed fire and strength even more than sweetness and light. But can it be said that the Barbarians who overran the empire needed fire and strength even more than sweetness and light; or that the Puritans needed them more; or that Mr Murphy, the Birmingham lecturer, and his friends, need them more? (v. 180)

The bathos of putting 'Mr Murphy, the Birmingham lecturer' at the climax of this passage is playing for high stakes stylistically, and is not surprising if some readers have thought that Arnold cheapens his points by being too self-indulgent in his use of such effects.

Nor was he above exploiting the comic potential of inflated titles and funny names. Here he is giving a somewhat rough handling to a sympathetic account of the Mormons.

215

If he was summing up an account of the doctrine of Plato, or of St Paul, and of its followers, Mr Hepworth Dixon could not be more reverential. But the question is, Have personages like Judge Edmonds, and Newman Weekes, and Elderess Polly, and Elderess Antoinette, and the rest of Mr Dixon's heroes and heroines, anything of the weight and significance for the best reason and spirit of man that Plato and St Paul have? (v. 149)

By the time we get as far as 'Elderess Polly and Elderess Antoinette' the game is clearly up; the mere juxtaposition of such names with those of Plato and St Paul is a crushing reminder of a lack of perspective in Hepworth Dixon. But it is also, of course, unfair, and the danger is that Arnold's too evident delight in the kill will turn the reader against him. As ever, there can, on Arnold's part, be an element of simple intellectual snobbery in all this; indeed, sometimes, it has to be said, of snobbery *pur*.

Just as Arnold has a variety of ways of projecting an attractive and persuasive sense of himself and his view of the world, so he has an arsenal of ploys for discrediting his opponents without directly engaging in point-by-point refutation of their claims. Often the mere quotation of a victim's view will be sufficient: since it is the defects of a temper or cast of mind he wishes to expose, the simple exhibition of it, especially given the contrast with the more nuanced sensibility implied in Arnold's surrounding prose, will be lethal; and by mercilessly repeating the least happy phrases over and over again, he drowns his opponent in a sea of comic associations.

Another tactic much favoured by Arnold is that of removing a question to higher ground, thereby undercutting his antagonist. For example, to discredit the assertive brass-tacks politics of Liberal MP J. A. Roebuck, he first cites a few particularly unrestrained sentences. '"I look around me and ask what is the state of England? Is not property safe? Is not every man able to say what he likes? ... I ask you whether, the world over or in past history, there is anything like it? Nothing. I pray that our unrivalled happiness may last."' This was taken from that sort of after-dinner political speech in which some pretty complacent things get themselves said, but, not content with exposing it to the chilly reception of print, Arnold immediately moves to higher ground. 'Now obviously there is peril for poor human nature in words and

thoughts of such exuberant self-satisfaction'; he then quotes Goethe, company which leaves Roebuck looking grotesque, and concludes, with studied mildness, 'Clearly this is a better line of reflection for weak humanity . . .'. The collusive 'obviously' and 'clearly', the ironic understatement, the whole holding of Roebuck's vulgar sentiments out at arm's length, all this is devastating. But to that reader for whom the delicately balanced tone has tipped over into a kind of showy sniffiness, it can also seem needlessly irritating.

One cannot read very far into Arnold's prose, however, without recognizing that much the most important, if also potentially the most troublesome, feature of his style is his irony, and this is closely related to his strategy of taking the higher ground mentioned a moment ago. Irony is a particularly vital resource for a writer who wishes to embody as well as recommend an alternative to stridency, exaggeration, and over-simplification. Skilfully used, irony can conjure up the suggestion of much wisdom and judgement held in reserve, accumulated stocks of experience which are not drawn on directly, but which enable the too-simple or too-loud to be seen for what they are. Such a tone came naturally to Arnold, though he was also fully aware of its effectiveness. 'For my part', he reflected in 1867,

I see more and more whan an effective weapon, in a confused, loud-talking, clap-trappy country like this, where every writer and speaker to the public tends to say rather more than he means, is *irony*, or according to the strict meaning of the original Greek word, the saying rather less than one means. The main effect I have had on the mass of noisy claptrap and inert prejudice which chokes us has been, I can see, by the use of this weapon. (v. 414)

Sometimes, Arnold's irony is broad almost to the point of burlesque:

I was lucky enough to be present when Mr Chambers brought forward in the House of Commons his bill for enabling a man to marry his deceased wife's sister. . . . His first point was that God's law – the name he always gave to the Book of Leviticus – did not really forbid a man to marry his deceased wife's sister. God's law not forbidding it, the Liberal maxim, that a man's prime right and happiness is to do as he likes, ought at once to come into force, and to annul any such check upon the assertion of

personal liberty as the prohibition to marry one's deceased wife's sister. (v. 205)

'Lucky' starts the proceedings with a wink, and thereafter it is downhill all the way for the unfortunate Mr Chambers who spoke so windily of 'God's law'. At other times, the movement of the eyebrow may at first seem barely perceptible: in commenting on the tendency of those of narrow culture to devote themselves exclusively to reading the Bible, Arnold could have written that they 'find a great deal in it'; but instead, with a tiny inflection of the tone, he wrote that they 'make all manner of great discoveries there' (v. 206). We are left in doubt about the real magnitude and worth of these 'discoveries'.

The risk that Arnold runs, of course, is of seeming lofty and sneering, and once that happens, his 'high-hat persiflage', as it has been nicely termed, only compounds the offence. Inevitably, those who are portrayed as being so enamoured of the one great message they have to tell that they compulsively thrust it at us, like a dog with a retrieved stick, will resent being patronized. Irony is a low-temperature medium, and Arnold did not always manage to prevent its having a slightly chilling effect on our sympathies. But at its best, his use of irony constantly suggests what it is like to view a question when we are in reflective possession of great fullness of experience. We are invited to take a step up and to look back at an argument that had seemed so compelling when we were unreflectively meeting it at its own level. In a limited sense, he seems to say, the argument is no doubt true (the 'limited' and 'no doubt' signalling that it is a concession that matters little), but surely we – that collusive, complicitous 'we' – have to recognize that such truths, inherently one-sided and over-blown as they tend to be, can be purchased at too high a price.

Arnold's light touch has misled some readers into thinking him merely flippant. But his 'vivacities' were not only a necessary form of artistic self-assertion on his part: they were in themselves also an essential element in the realization of a purpose which was, at bottom, profoundly serious. He was right to take satisfaction from the thought that 'however much I may be attacked, my manner of writing is certainly one that takes hold of people and proves

effective' (L ii. 5). This is the sort of success of which there can be no objective measurement; indeed, an awareness that the assumptions behind this notion of 'objective measurement' may be quite inappropriate in this sphere is one of the things Arnold is particularly good at helping us to understand. Instead, we may turn to the testimony of a writer who felt sufficient kinship with Arnold but at the same time distance from him, and who was also graced with the necessary delicacy of spirit, to be capable of discerning and rendering his elusive achievement. What Henry James wrote in 1884 has certainly not become less true in the course of the subsequent century:

All criticism is better, lighter, more sympathetic, more informed in consequence of certain things he has said. He has perceived and felt so many shy, disinterested truths that belonged to the office, to the limited speciality, of no one else; he has made them his care, made them his province and responsibility. . . . When there is a question of his efficacy, his influence, it seems to me enough to ask oneself what we should have done without him, to think how much we should have missed him, and how he has salted and seasoned our public conversation. In his absence the whole tone of discussion would have seemed more stupid, more literal. Without his irony to play over its surface, to clip it here and there of its occasional fustiness, the life of our Anglo-Saxon race would present a much greater appearance of insensibility.

2 The life

'I am still far oftener an object of interest as his son than on my own account' (L i. 161). Matthew Arnold may have been exaggerating a little here in order to give pleasure to his mother, to whom he was writing; but the testimony is none the less striking when we remember that the figure now thought of as the leading Victorian man of letters was already 38 when writing this letter, and that his father had been dead for almost twenty years. Carrying the burden of a famous name can warp and cripple, and Arnold's father did not make things easier for his children by dying at the early age of 47, with his powers and reputation still expanding. But in the course of his own lifetime, Arnold *fils* eventually eclipsed even his father's reputation, and posterity has registered a great disparity in stature between them: Matthew Arnold's writings are now studied and enjoyed from China to Peru, whereas his father is remembered, if at all, as the moulder of a style of school whose modern reputation is equivocal, and as the subject of one of Lytton Strachey's feline portraits in *Eminent Victorians*.

When Thomas Arnold, the world's most famous headmaster, died in 1842, his public standing rested on three main achievements. He was one of the leaders of the 'Broad Church' party in England, opposed to the extremism of Tractarians and Evangelicals alike, advocating inclusion of all groups in a national church that was to provide a cultural and political as well as religious centre for English life. In this role, he had engaged in memorable controversies with John Henry Newman, the most brilliant of the Tractarian theologians; Arnold was a combative man, and England in the 1830s enjoyed a sporting match. Secondly, he was an historian of sufficient note to have been appointed Regius Professor of Modern History at Oxford in 1841. The embodiment of Roman vigour and virtue himself, he published a celebrated *History of Rome* which showed that, as a member of the so-called 'liberal Anglican' school of historians, he had profited from the advanced

learning of German scholars like Niebuhr, and owed something to the cyclical theories of Vico. But above all, Thomas Arnold was known as the headmaster of Rugby School, a post to which he had been appointed at the age of 32. He transformed what had been a fair specimen of the debauched and riotous establishments known as public schools into the character-building, God-fearing, scholarship-winning model for the reform in the 1840s and 1850s of other schools of its type. He thereby had an incalculable influence on world history, indirectly staffing an empire, and helping to shape, perhaps to stifle, the emotional development of a governing class for several generations.

Matthew Arnold, second child and eldest son of Thomas and Mary Penrose Arnold, was born on 24 December 1822, at Laleham in the valley of the Thames. An idle and fanciful boy, he survived the experience of being a pupil at his father's school without ever really conforming to its ethos, and in 1841 won a Scholarship to Balliol College, Oxford. Here he could indulge his youthful affections and dandyish tastes: he rose late, drank much, and read little (or so he wished it to seem). In his final year his friends tried to coach him for his exams, but without making much of a dent in his habits: 'Matt has gone out fishing when he ought properly to be working' (C 29). He got a second-class degree. Some said it was fortunate that his father had not lived to see this, but Arnold characteristically recovered by winning a Fellowship at Oriel in 1845, the college where both his father and Newman had been Fellows, and where his great friend, the poet Arthur Hugh Clough, was currently in residence. But such Fellowships were in those days prizes, not the first steps in a scholarly career, and Arnold continued on his debonair way. Already a keen Francophile, he naturally took himself to Paris, largely, it seems, to follow the career of the famous French *tragédienne*, Rachel, all of whose performances of the French classics in the winter of 1846–7 he attended. Clough, a more troubled soul, shook his head:

Matt is full of Parisianism; theatres in general and Rachel in special: he enters the room with a chanson of Béranger's on his lips – for the sake of French words almost conscious of tune; his carriage shows him in fancy parading the Rue de Rivoli; and his hair is guiltless of English scissors: he

breakfasts at 12, and never dines in Hall, and in the week, or 8 days rather (for 2 Sundays must be included), he has been to chapel once. (C 25)

As this last phrase suggests, Arnold no longer even outwardly conformed to the piety of his family. He is unusual among early and mid-Victorians in seeming to have slid out of belief in orthodox Christianity at an early age without experiencing any great emotional turmoil. As we shall see (in Chapter 6), he could be deeply responsive to certain kinds of religious emotion, and became increasingly concerned to rescue what was valuable in Christianity generally and in the cultural inheritance of Anglicanism specifically. But his mind seems never to have been scarred by supernatural theology or Biblical literalism.

In 1847, Arnold became personal secretary to a leading Whig politician, Lord Lansdowne, an undemanding post which brought him into the world of high society and allowed him ample time to cultivate the gifts he was discovering in himself as a poet. In 1849 he brought out his first slim volume, *The Strayed Reveller and Other Poems*; it was published anonymously, for fear, it was said, of bringing his father's name into disrepute. In fact, his family were surprised at the evidence of seriousness, yearning, and grief the poems displayed. His poems, of which there were further volumes in 1852 and 1853, spoke of unhappy searchings for a calm place within himself, for the years 1847 to 1851 were Arnold's *Sturm and Drang* period, vividly recorded in his moody, playful, confessional letters to Clough. Falling in love is notoriously a source of both pain and poetry, and Arnold fell in love twice in these years. The 'Marguerite' of his love poems would appear to be art's tribute to the object of the first of these passions: he writes intriguingly to Clough from Switzerland in 1848 that he intends to 'linger one day at the Hotel Bellevue for the sake of the blue eyes of one of its inmates' (C 91). She may have been a young French woman; the fragmentary evidence has teased and titillated biographers ever since. Then, in 1850, he met Frances Lucy Wightman, daughter of a prominent judge; after enduring some of the common delays, indirectedness, and obstacles of a Victorian courtship, they were married in 1851. It seems to have been a relatively successful marriage: the chief sorrow of their lives was

the death of two sons in 1868, and then of a third, Arnold's favourite, in 1872, a sequence of blows which darkened the spirits of both of them permanently. A son and two daughters survived, and Arnold, an exceptionally affectionate and expressive father, doted on them.

In order to marry, Arnold needed a secure job with an adequate salary. Helped by the patronage of Lord Lansdowne, he was appointed an Inspector of Schools of 1851, thus beginning thirty-five years of what he frequently complained of as 'drudgery', though at other times he acknowledged the benefits of regular work. In the middle of the nineteenth century there were, strictly speaking, no state schools at any level. The limit of public involvement with education was a small annual grant made to various elementary schools, usually denominational in origin and character, which conformed to certain minimal standards. A small group of well-educated gentlemen, often with scholarly or literary inclinations which they continued to pursue, were employed to inspect and report on these schools. Initially, Arnold was responsible for inspecting Nonconformist schools across a broad swathe of central England. He spent many dreary hours during the 1850's in railway waiting-rooms and small-town hotels, and longer hours still in listening to children reciting their lessons and parents reciting their grievances. But this also meant that he, among the first generation of the railway age, travelled across more of England than any man of letters had ever done. Although his duties were later confined to a smaller area, Arnold knew the society of provincial England better than most of the metropolitan authors and politicians of the day.

But drudgery is certainly was. 'I am now at the work I dislike most in the world', he writes to his mother in 1863, 'looking over and marking examination papers. I was stopped last week by my eyes, and the last year or two these sixty papers a day of close handwriting to read have, I am sorry to say, much tried my eyes' (L i. 207). However, the hours and conditions of work were those of the gentlemanly nineteenth-century public service which allowed some time for other pursuits (Peacock and Mill both wrote during office hours at India House, as did Trollope at the Post Office): in the 1860s Arnold would often inspect his schools in the

morning and mark his exercises at night, but spend the afternoon at the Athenaeum writing an article. The monotony was interrupted by several extended tours of the Continent to report on educational arrangments there: a five month visit to France in 1859 was particularly formative for his later social criticism, as well as enabling him to meet Sainte-Beuve, the living critic he most admired. His inspecting duties were also no barrier to his being elected Professor of Poetry at Oxford in 1857, and in the ten years during which he held this largely honorary chair he gave as lectures some of his most enduring essays in literary and social criticism, often sitting up half the night to finish them in time, having already postponed the announced date of a lecture more than once.

In some ways this pattern may have suited Arnold as an author. He could never be one of those writers who chisel and polish a block of prose for years in order to create a few exquisite miniatures in the course of a lifetime. He needed the stimulus of events and controversy. He wrote a good deal – indeed, a remarkable amount for one who was only a part-time writer – and he wrote to cajole, to convince, to controvert, and to pay his bills. While the young poet had sung of the private griefs and yearnings of the solitary, the mature prose-writer moved in a public world whose reference points were the latest number of a periodical, a recent speech in parliament, the season's new books. Nearly all of what we know as Arnold's *books* first appeared in the form of articles in the great monthly journals of general culture, that unrivalled stage upon which so many of the intellectual and literary dramas of mid-Victorian life were acted out. This can, as I have already suggested, sometimes have the result of making his writings a little too full of topical references for the ease of the uninstructed modern reader, but it also means that, since he wrote to be read and not just to be cited in other men's footnotes, his prose is usually lively, often amusing, always accessible.

In the course of the 1860s he acquired a reputation as a critic; by the 1870s he had become a public figure. Of his major work, *Essays in Criticism* had appeared in book form in 1865, *Culture and Anarchy* in 1869, and *Literature and Dogma* in 1873 (these three works will be discussed in Chapters 4, 5, and 6 respectively). He

had continued to write poetry in the 1850s, with, as it has seemed to most later readers, steadily lessening inspiration. The stream became a trickle in the 1860s, and then dried up almost entirely. Commentators ever since have speculated about whether Arnold or the Muse was at fault in their divorce (perhaps Yeats's epigram is relevant: 'We make out the quarrel with others, rhetoric, but of the quarrel with ourselves, poetry.'). Even in his twenties Arnold had even anxious that age increasingly withered the emotions: when he was 30 he described himself to Clough as 'three parts iced over' (C 128). His later poems, and still more his letters, reveal someone all too aware of the fortitude needed for the long trek across the slope of middle age. The deaths of his children and his turn to religious subjects added their own darker hues. His prose of the later 1870s and 1880s, though it contains some memorably powerful writing, most lacked the deftness and light play of irony, including self-irony, that made his earlier work so winning.

His increased fame brought its usual baggage of invitations, honours, and obligations. Fortunately, his taste and talent for sociability never deserted him. As part of his campaign against the assumptions behind English puritanism, Arnold had remarked at one point that 'the wealth of the human spirit is shown in its enjoyments', and his own tastes did not lean towards austerity. He was tall, accounted good-looking, with a charm that owed as much to listening as talking. Even after he had outgrown his dandy phase, he still inclined to high dressing and ran a good deal of fancy waistcoats. He was very responsive to the charms of beautiful women (albeit in his later writings increasingly censorious of sexual misconduct, especially among the 'lubricious' French), and he particularly liked champagne. While in America in 1883, he was reported to have scandalized the elders of the 'dry' college town where he was staying when he was asked what he would like after his lecture and replied 'Whisky'. In characterizing him, some found that the word 'fop' came to mind very easily, and some took his wit as a sign of a lack of seriousness, as some always will. Charlotte Brontë had been more perceptive in finding 'a real modesty beneath the assumed conceit'. Those who knew him well concurred in emphasizing his warmth and gaiety, as well as a

225

sentimentality which, while it could be a blemish in the poet, was lovable in the man.

By the 1880s he was recognized as England's premier man of letters. He capitalized on this with a lecture-tour in America, which earned him a substantial sum (of which he was always more or less urgently in need), but few fresh admirers: he was not a good lecturer, and Americans found him mannered. It did not help his popularity that his assessment of American civilization had always been frankly unflattering. In England he was offered, and after much hesitation accepted, a small civil list pension 'in public recognition of service to the poetry and literature of England'. In 1886 he was, to his great relief, finally able to retire from school-inspecting; although two of his reports on foreign schools had proved to be of such weight as to warrant republication in book form, his official career had been undistinguished, with promotions coming late and seldom. He had long had to contend with warnings from the hereditary heart condition which had carried off both his father and grandfather, and it finally killed him in Liverpool on 15 April 1888. He was buried in Laleham, alongside his three children; a special train brought an impressive body of mourners from London, including Robert Browning and Henry James. Memorial tributes were more than conventionally generous, the most apposite, perhaps, being that of Benjamin Jowett, the Master of Balliol College, Oxford, who was not known for his fulsomeness: 'No-one ever united so much kindness and light-heartedness with so much strength. He was the most sensible man of genius I have ever known.'

3 The poet

The collected prose works of Matthew Arnold occupy eleven fat volumes; the complete poetry, even when fleshed out with notes, variants, and appendices, fits easily into one volume in any of the several modern editions in which it has appeared. Though any rounded account of his achievement must to some extent reflect these proportions, such crude quantities tell us little about the relative value or enduring appeal of his various compositions in the two genres. In fact, the reputation of his poetry has been more stable and more generally favourable over the past hundred years than that of his prose, even though, as I have suggested, I think it is now the latter which has the greater claim on our attention. But certainly there may still be some readers who, vaguely recalling 'Dover Beach' or 'The Scholar-Gypsy' from school anthologies, are suprised to find he 'also' wrote prose.

Arnold's poetry, as we have seen, belongs very largely to the earliest stage of his adult life; most of his best pieces are contained in three slim volumes he published in 1849, 1852, and 1853, all written before his thirtieth birthday. It is true that in the mid- and late 1850s Arnold wrote some of his longest dramatic and narrative poems, but these have never found much favour. In 1867 he published a volume entitled *New Poems*, which contained several fine individual pieces, but even some of these (including 'Dover Beach' and 'Stanzas from the Grande Chartreuse') had almost certainly been largely written before 1853. Much of his poetry recounts an inner struggle to find some equilibrium, but its conclusion, both discursively and in practice, was that balance was only to be found, or only came upon him (since it was not so entirely a matter of will as the poems at times suggest), when he committed himself to the world, to action, to mundane existence – to, in short, prose, with all the overtones that word can carry of the ordinary, the practical, the flat. Part of the poignancy of

Arnold's biography comes from the fact that he never ceased to have the sensibilities and yearnings of a poet, though he largely ceased to write poetry. He lived the greater part of his life knowing that 'the Muse be gone away' (578).

Despite both the limited quantity and, in a sense to be explained in a moment, the restricted range of Arnold's poetry, he has always been regarded as one of the major poets of the nineteenth century, and has indeed usually been accorded a secure place in the second rank of English poetry, no inconsiderable achievement for one who devoted the greater part of his creative energies to other genres. In the best of his lyrics and elegies the experience of reflective sadness is rendered with touching melodic aptness, while even those poems which are uneven wholes sometimes contain lines that make us want to read on and to know more about a poet of such intriguingly erratic gifts.

Moreover, Arnold's poetry continues to have scholarly attention lavished upon it, in part because it seems to furnish such striking evidence for several central aspects of the intellectual history of the nineteenth century, especially the corrosion of 'Faith' by 'Doubt'. No poet, presumably, would wish to be summoned by later ages *merely* as an historical witness, but the sheer intellectual grasp of Arnold's verse renders it peculiarly liable to this treatment. In an exceptionally frank, but not unjust, self-assessment in a letter to his mother in 1869, Arnold himself almost predicted this historical role for his poetry:

My poems respresent, on the whole, the main movement of mind of the last quarter century, and thus they will probably have their day as people become conscious to themselves of what that movement of mind is, and interested in the literary productions which reflect it. It might be fairly urged that I have less poetical sentiment than Tennyson, and less intellectual vigour and abundance than Browning; yet, because I have perhaps more of a fusion of the two than either of them, and have more regularly applied that fusion to the main line of modern development, I am likely enough to have my turn, as they have had theirs. (L ii. 9)

Those who find Arnold's poetry unsympathetic might be inclined to respond that its chief defect lies precisely in the way it arises too exclusively from a movement of *mind*.

'The dialogue of the mind with itself'

Although he wrote in several poetic genres – sonnets, lyrics, elegies, extended narrative poems, verse drama and so on – Arnold's range as a poet was limited in two ways: he largely dealt with a confined set of themes, and to a great extent he wrote in one readily recognizable register or voice. Before considering certain particular aspects of his poetic achievement, it may be well to try to characterize the nature of these themes and this voice in very general terms.

The dominant note of Arnold's best poetry is reflection on loss, frustration, sadness. It is important from the start to draw attention to 'reflection', because his poems nearly always are, even if now explicitly, second-order reflections on the nature or meaning of certain kinds of experience, rather than expressions or records of that experience itself. When Arnold spoke, famously, of modern poetry as 'the dialogue of the mind with itself' (i. 1), he coined a phrase that irresistibly asks to be applied to his own writing. At the same time, and in a spirit with which later generations have become more rather than less familiar, the poetry frequently expresses a desperate, eternally self-defeating desire to escape from this unending round of intellection, from being 'prisoners of our consciousness' (200).

A recurrent symbolic landscape operates both as a backdrop and a load-bearing metaphorical structure in Arnold's chief lyrics and elegies, a landscape which, when reduced to its bare elements, maps the three stages of life's journey. That journey is characteristically represented by a river, which rises in a cool, dark glade, flows out on to the fierce, hot plain, and then finds its way to the wide, calm sea. These are three periods of the individual's life, but also three stages in historical growth more generally: as described in the standard modern commentary on the three phases of this symbolism, 'the first is a period of joyous innocence when one lives in harmony with nature, the second a period of suffering when one is alone in a hostile world, and the third a period of peace in which suffering subsides into calm and then grows up into a new joy, the joy of active service in the world'.

But Arnold's poetry also returns to certain favoured settings

which are symptomatic rather than symbolic in this sense. For example, the implied or explicit location of the persona speaking a particular poem frequently turns out to be on a mountain-top or other lofty place, the natural habitat of reflection and of those searching for the wide comprehending view. 'From some high station he looks down', as he says of 'the poet' in the early 'Resignation' (95), but of course both 'lofty' and 'looking down' also suggests a relation to the world which is not purely a matter of altitude, and Arnold has been accused of viewing suffering humanity a little too much *de haut en bas*. Similarly, his marked taste for ambience of cool, moonlit settings (a staple of Romantic poetry that becomes almost a cliché with Arnold) reveals as well as represents. In Arnold's symbolic economy, such settings are obviously intended to contrast with or provide an escape from the hot, dusty scenes of bustling workaday life, but their coolness and brightness can easily start to seem chill, the light a little too clinical. We are reminded that in this setting the yearned-for transforming emotion which would enable us to escape ourselves can only be reflected upon, not experienced.

Another way to consider the limits of Arnold's range (tastes vary on whether these should also be regarded as limitations) is to observe how much of his poetic diction depends upon a kind of Romantic thesaurus: much use is made of stage-properties like moons and graves, tears flow a little too freely (no less than 68 times, according to one count), and there is embarrassingly frequent resort to the mannered interjection 'Ah!'. It is also noticeable, especially in some of his less successful pieces, how much of the weight of tone and meaning is carried by the adjectives, often in the form of past participles, rather than by the verbs, where he relies a good deal on the blandest or least energizing forms like 'was', 'had', and (an Arnoldian favourite) 'seemed'. These combine with the past participles to reinforce the elegiac sense of a world in which nothing is now happening: it is already all over before the poem starts, whether through death or loss or – not a trivial feature of Arnold's dominant poetical mood – simple belatedness.

Arnold was a self-conscious poet, arguably a learned poet, and thus inevitably preoccupied with his relation to his great predecessors. 'Predecessors', for the young poet of the 1840s, meant,

overwhelmingly, the English Romantics. Needless to say, Arnold's poetic sympathies and, in certain senses, debts were wide: he felt the length of the shadow of the Greeks as much as any Englishman in his Greece-obsessed century; he displayed a responsive affinity to Virgil's gentle pastoral melancholy; he, somewhat exceptionally, was selectively appreciative of Goethe's verse, as well as holding him in something like awe as a cultural hero; and the list could be extended. But the English Romantics, perhaps Byron and Keats even more than Shelley or Coleridge, were his mind's familiar companions and left permanent echoes in his ear. Above all, the inescapable poetic presence for Arnold was Wordsworth. In literary terms, his relationship to Wordsworth bordered on the filial, a connection strengthened by early visits to him from the Arnolds' neighbouring family home in the Lake District, but more significantly intensified by Arnold's implicit association of Wordsworth with the early stage of human innocence, and with the simple, joyful song which that age still allowed. This surfaced most visibly in the 'Memorial Verses' Arnold wrote following Wordsworth's death in 1850, where it is 'The freshness of the early world' which Wordsworth, the poet of childhood recollected in maturity, is credited with restoring to us.

> He laid us as we lay at birth
> On the cool flowery lap of earth. . . .

But the power to re-create the immediacy of this primitive experience is one which Arnold's 'time-ridden consciousness' now regards as irrecoverably lost. Possibly others may arise to do for later generations what Byron and Goethe did for theirs,

> But where will Europe's latter hour
> Again find Wordsworth's healing power?
> Others will teach us how to dare,
> And against fear our breast to steel;
> Others will strengthen us to bear —
> But who, ah! who, will make us feel? (242)

The slight awkwardness of the syntax of 'against fear our breast to steel' is characteristic of Arnold's verse, though for once the interjection 'ah!', complete with its over-insistent exclamation-

mark, manages not to seem affected here, or introduced merely to accommodate the rhythm.

The relation to Wordsworth has an interpretative as well as biographical significance, and it helps us fix the sense in which Arnold should be regarded as a post-Romantic as well as, more straightforwardly, a late-Romantic poet. For example, although he pays homage to some of the same aspects of nature's 'healing power', and even celebrates some of the same associations of the English countryside, the relation to nature revealed in Arnold's poetry is quite different from that characteristic of Wordsworth's. In Arnold's work, nature figures either as a reinforcing backdrop for the dialogue of the mind with itself, or else as a set of symbols on to which man's travails and hopes are transposed. It is never immediately at one with man, nor is it infused with a deeper life of its own. In fact, Arnold tries to make nature, too, into a good Stoic: the nature that 'seems to bear rather than rejoice' has learned to keep a stiff upper lip. For all its recourse to the standard Romantic scenery, Arnold's poetry is pre-eminently that of emotion recollected indoors.

Moreover, where memory, in Wordsworth's poetry, can refresh by bringing back the flavours of a more nourishing or soothing moment, thus easing our passage through an uncongenial world, for Arnold memory itself is usually a painful reminder of the utter unrecoverability of experience: far from refreshing, it merely provides another occasion for self-conscious wistfulness. There are, of course, many possible sources of the feeling that, poetically, one has come too late, but it is particularly characteristic of the post-Romantic sensibility in general and Arnold's in particular to blame the curse of reflectiveness for making certain kinds of pure or unmediated satisfaction permanently unattainable.

Of love and loss

The two poetic forms in which Arnold is commonly held to have excelled are the lyric and the elegy. That traditional division is, however, somewhat misleading in Arnold's case: exaggerating to bring out the point, one could say that most of his lyrics are really elegies too. That is, his characteristic preoccupation as a poet is so

much with transience and loss that he writes in a recognizably elegiac manner even when not formally writing about the dead. But, more suggestively, there is a sense in which many of his finest lyrics are not really about what they seem to be about. The point can be made most tellingly by considering the set of poems Arnold wrote on that most traditional of themes for the lyric – love.

Those short pieces which Arnold later grouped as a sequence under the heading 'Switzerland' ostensibly record successive stages of the love-affair with 'Marguerite'. They do, certainly, contain many of the conventional tropes of the genre, such as the lover's fond inventory of his loved one's attributes:

> The sweet blue eyes – the soft, ash-coloured hair –
> The cheeks that still their gentle paleness wear –
> The lovely lips with their arch smile that tells
> The unconquered joy in which her spirit dwells . . . ('Parting', 125)

But as we reread these poems, the unsettling thought comes over us that they are not really about Marguerite, nor even about the experience of being in love. They are reflections upon how even this kind of experience – it is part of their unsatisfactoriness as love poems that Arnold didactically classifies it as a *kind* of experience, rather than being overwhelmed by its uniqueness – affords no real escape from the self and its oppressive sense of isolation. Although they effectively exploit the lightness and vigour of crisp mountain air and rushing, snow-fed streams, the Switzerland sequence is ultimately dark in tone, a sombre reflection about the inconsolable spiritual isolation which had hoped to find a cure in love, but which, chastened by failure, has now been thrown back upon a deeper self-examination.

Revealingly, several of the poems in this set are doubly retrospective: they are not only, in an obvious sense, reflections on a past experience, but it turns out that that experience itself is already one of rumination prompted by some event subsequent to the experience being ruminated upon. Meeting 'Marguerite' a year later is the most obvious of these reflection-provoking events: the 'still' in the above lines marks both the passage of time and a reflective awareness of the shifting relation of memory and reality. This soon develops into a more comprehensive reflection, in which

the focus retreats from the outer world of the lovers' situation to the inner world of self-knowledge:

> Far, far from each other
> Our spirits have grown;
> And what heart knows another?
> Ah! who knows his own? (126)

Even in these relatively early poems, we can see that love figures as what has been nicely termed 'a sort of mournful cosmic last resort', but one that is, like all earlier possible refuges, ultimately doomed to prove unsatisfactory.

Where, at their best, the 'Marguerite' poems excel is in conveying the poignancy of these sentiments by certain simple yet haunting rhythms rather than by explicit argument. Despite its somewhat mannered title, 'To Marguerite – Continued' constitutes a particularly happy example of this quality. The first stanza states the Arnoldian preoccupation succinctly:

> Yes! in the sea of life enisled
> With echoing straits between us thrown
> Dotting the shoreless watery wild
> We mortal millions live *alone*. (130)

Among the details that contribute to the effect here, we may particularly remark the randomness suggested by 'dotting', the homeless infinity behind 'shoreless', the unnerving transfer of the 'wild', trackless and inhospitable, from land to sea, and the brilliant near-oxymoron of the 'millions' who live 'alone'.

The subtle effect of the rhythms tells to even greater effect in the last stanza, which concludes with one of the most beautiful lines that Arnold every wrote:

> Who ordered that their longing's fire
> Should be, as soon as kindled, cooled?
> Who renders vain their deep desire?
> A God, a God their severance ruled!
> And bade betwixt their shores to be
> The unplumbed, salt, estranging sea. (130–1)

The iambic beat of this is at first regular and almost clipped, with a faintly Augustan flavour to the neat antithesis of 'kindled/

cooled'. But the minor caesura at mid-line following 'salt' is, in both senses, arresting; the effect at first seems angular, but then registers as a lightly-sustained diminuendo. This, together with the fathomless 'unplumbed', the unwelcoming 'salt', the discordant 'estranging', all call up dimensions of loneliness in a line that has a wonderful sense of inevitability to it.

The second, much shorter and generally less successful, sequence of love poems (entitled, banally, 'Faded Leaves') moves even further away from the experience itself in its meditation on the tantalizing power of recalled emotion. The additionally elegiac note here comes from the anguished sense that even memory is only an imperfect reminder that there was, once, an emotion which briefly impinged on our isolation, but that *no* feeling can be preserved or re-created, not even the feeling of love. The most effective of this set is the simple 'Too Late', where larger reflections on transience and the unarrestability of experience do not choke a more directly expressed pain:

> Each on his own strict line we move,
> And some find death ere they find love;
> So far apart their lives are thrown
> From the twin soul which halves their own.
>
> And sometimes, by still harder fate,
> The lovers meet, but meet too late.
> – Thy heart is mine! – *True, true! ah, true!*
> – Then, love, thy hand! – *Ah no! adieu!* (245)

But the immediacy of this last stanza is rare among Arnold's so-called 'love poems', a further indication that they are not essentially *about* love (a point I shall return to at the end of this chapter). Whatever may have been true of Arnold the man, the poet almost seems to treat his ideal of love as a state of *diminished* rather than of heightened emotion:

> How sweet to feel, on the boon air,
> All our unquiet pulses cease!
> To feel that nothing can impair
> The gentleness, the thirst for peace. (134)

In the same poem, in which the speaker imagines being re-united in another life with the woman for whom he has experienced an

unrequited or unsatisfactory love in this life, the deeper sympathy which the lovers might then discover between themselves is referred to as being 'Ennobled by a vast regret'. That 'regret' provides the keynote of these lyrics, and it is revealing of the sensibility that can turn even love-poems into elegies that Arnold should choose to dwell upon its 'ennobling' power.

This sensibility found less problematic expression in the best-known of Arnold's actual elegies, such as the pastoral 'The Scholar-Gipsy' (composed in 1852–3) and its companion piece 'Thyrsis' (probably written 1864–5, in commemoration of Clough, who had died in 1861). Extended discussion of these poems is not possible here, but it is worth remarking that they, too, share with the love-poems the quality of having a deeper preoccupation than their ostensible subjects. What unites them, apart from Arnold's explicit commentary and their use of the same unusual Keats-inspired stanza form, is their celebration of the countryside around Oxford and its association with the untrammelled responsiveness of the young poets who roamed the hills together in the early and mid 1840s. But in fact both poems constantly return to meditating upon the unrecoverability of this youthful aestheticism, and around both poems, but especially 'Thyrsis', there hovers the suggestion of sentimental indulgence in nostalgia and regret for its own sake – 'let me give my grief its hour' (543). In a letter to one of their mutual friends, Arnold acknowledged a little defensively that 'one has the feeling, if one reads the poem as a memorial poem, that not enough is said about Clough in it' (L i. 327). As this suggests, the poem is less an elegy for a dead friend, than a lament for a lost youth, the poet's *own* youth. The meditation soon takes on the stylized pathos of youth-recollected-in-maturity, with

> The heart less bounding at emotion new
> And hope, once crushed, less quick to spring again.
>
> And long the way appears, which seemed so short
> To the less practised eye of sanguine youth; (545)

'Thyrsis' was the last of Arnold's really successful major poems, but its theme, and even to some extent its mood, had been evident in his poetry from the start. Arnold may have written his best

poetry when young, but, given his sustained preoccupation with transience and loss, there is a sense in which he never was a young poet.

'Empedocles on Etna'

A special place in Arnold's poetic *œuvre* is occupied by his long dramatic poem 'Empedocles on Etna'. This is partly because it is such a brilliant dramatization of Arnold's own internal conflicts (though it would be a mistake, of course, simply to reduce the poem to such biographical elements, or to identify the author too closely with any one of its characters); but it is also because he thrust additional significance on the poem by withdrawing it almost immediately after its first publication in 1852. The austere classicism of the Preface to the 1853 collection was in part a justification of his decision to omit 'Empedocles' from that volume; he treated it as the epitome of that modern dwelling upon one's own hesitations and uncertainties whose fruitlessness could only be remedied by returning to the portrayal of great actions. Thereafter, Arnold did not republish the poem until 1867, when he expressly included a note explaining that it now appeared 'at the request of a man of genius . . . Mr Robert Browning' (156). It is a sign of the intensity of Arnold's eddying struggles over his identity in the early 1850s, which found expression in the perversely self-repudiating 1853 Preface, that should omit what has since come to be regarded as a major part of his poetic achievement and one of the most significant long poems of the nineteenth century.

Although Arnold subtitled 'Empedocles' 'a dramatic poem', 'dramatic' is something of a misnomer. Despite being divided into two 'acts' and being put into the mouths of three 'characters', there is really no 'action', but rather an uninterrupted series of discursive monologues. (Actually, something similar could be said of many of Arnold's so-called 'narrative poems' too, which are really extended reflections only very loosely hung on a narrative frame.) In effect, 'Empedocles' takes the usual Arnoldian 'dialogue of the mind with itself' and puts the different sides of the discussion into the mouths of different speakers. Empedocles

himself, who speaks the greater part of the poem, attempts, despite the contrary promptings of his own creative aspirations, to represent in an attractive light the stoicism necessary to confront the increasing burden of joyless life that comes with maturity. He preaches this message to his disciple, Pausanias, who, as a physican and therefore someone who lives in the world of action, is able to confront the prospect fairly cheerfully, which Empedocles himself is notably unable to do. The third character, a young poet named Callicles, expresses the untroubled joy of the creator living entirely in the realm of the aesthetic, a position Empedocles moodily regards as incompatible with increasing maturity.

The three scenes are set at successively higher points on the slopes of Mount Etna, until, in the final scene, Empedocles, unable to resolve the conflicting demands of his sensibilities and his reason into a livable life, throws himself into the crater of the volcano. The meaning of Empedocles' suicide for the interpretation of the poem as a whole has continued to divide commentators, some seeing it as an endorsement of Empedocles' analysis of the irreconcilable conflicts within existence, while others take it as a more robust condemnation of his inability to engage with the world as it is. Perhaps a more detached, philosophic, reading of the outcome is suggested by the obviously important fact that the last lines of the poem are given to Callicles, who sings of the continuing, impersonal, existence of the whole of creation, 'What will be for ever; / What was from of old', concluding with the cosmic closure of

> The day in his hotness,
> The strife with the palm;
> The night in her silence,
> The stars in their calm. (206)

Significantly, the last word of this whole troubled poem is thus 'calm', the quality which Arnold at this point so uncalmly sought and failed to find.

Part of the fascination of the poem lies in the way the verse constantly signals that Empedocles cannot give his real emotional assent to the stoic resignation he ostensibly commends. His official creed is essentially that of the ancient Stoic philosopher

Epictetus (an author whom Arnold had recently been reading with growing sympathy), laced with a dash of the work-ethic of Carlyle. It offers deliberately low-key satisfactions: man must not 'fly to dreams, but moderate desire', and so

> I say: Fear not! Life still
> Leaves human effort scope.
> But, since life teems with ill,
> Nurse no extravagant hope;
> Because thou must not dream, thou need'st not then despair! (182)

Empedocles himself, however, is cursed with a kind of intelletual nostalgia, a yearning for (and reluctance to accept the disappearance of) more animating creeds, held with livelier conviction. He is still tormented by the memory, and sometimes more than the memory, of the struggle between the 'impetuous heart' and the 'contriving head'. Callicles observes that Empedocles' railing is not adequately accounted for by the state of the world:

> There is some root of suffering in himself,
> Some secret and unfollowed vein of woe,
> Which makes the time look black and sad to him. (163)

One source of Empedocles' 'secret and unfollowed vein of woe' is his sense of his 'dwindling faculty of joy'. Suffocated by the inescapable nightmare of consciousness, he fears he is 'a living man no more',

> Nothing but a devouring flame of thought –
> But a naked, eternally restless mind. (200)

He searches for that sense of 'poise' that was, when characterized a little differently, to be such a crucial value in Arnold's critical writings, but in his most anguished moments Empedocles knows that

> . . . only death
> Can cut his oscillations short, and so
> Bring him to poise. (196)

In one of the fiercest passages in the whole poem, Empedocles bitterly ruminates on how, though the body may die and return to the elements whence it came, mind and thought will live on:

> Where will *they* find their parent element?
> What will receive *them*, who will call *them* home?

And so

> . . . we shall unwillingly return
> Back to this meadow of calamity,
> This uncongenial place, this human life;
> And in our individual human state
> Go through the sad probation all again,
> To see if we will poise our life at last,
> To see if we will now at last be true
> To our only true, deep-buried selves,
> Being one with which we are one with the whole world;
> Or whether we will once more fall away
> Into some bondage of the flesh or mind,
> Some slough of sense, or some fantastic maze
> Forged by the imperious lonely thinking power,
> And each succeeding age in which we are born
> Will have no more peril for us than the last; (201–2)

Pausanias, a more robust, active figure, can cheerfully accept the limitations of such a creed and implicitly live by it. Empedocles' own broodings drive him inexorably to a choice between a spirit-numbing, poetry-killing compromise with a drab world – or death, which allows the preservation of at least some kind of integrity of passion. Finally, he works free from the toils of reflection: he knows that he 'breathes free', if only a moment, and to (as it were) commit himself to that moment 'ere the mists of despondency and gloom' begin to choke him once more, he throws himself into the crater (204).

But Arnold, of course, does not. By this I mean not only the rather obvious point that what Arnold 'does' is to write 'Emped-ocles on Etna', thus attempting to shape some whole in which these conflicting choices can be realized and held in a satisfying tension; but also that Arnold *did* 'turn to the world'. His acceptance of the all-too-mundane post of school-inspector in order to get married can be seen, in this light, as something of a 'philosophic act'. Auden famously quipped that Arnold the poet 'thrust his gift in prison till it died'. But it may be nearer the mark to suggest that it was precisely during his poetically creative years that Arnold most

acutely *felt* trapped in 'the hot prison of effortless life', and that the poetry was a kind of protest against the possibility that mind and thought will forever 'keep us prisoners of our consciousness' (200). The poetry and the unresolved unhappiness went together; it was accepting the prison that ultimately provided some release. Arnold did not throw himself into the crater; rather, he turned to writing prose.

'Wandering between two worlds'

After the inner turmoil that accompanied his transition from dandyish young late-Romantic poet to burden-shouldering man of affairs in the early and mid 1850s, Arnold tried various poetic experiments which, it now seems clear, were forced against the grain of his talent. Following the injunction of his 1853 Preface to leave behind the crippling introspection of modern thought, he took his subjects from Norse sagas and Greek history. The first issued in his rather leaden epic 'Balder Dead' (damned for ever by one wag as 'Balder Dash'); the second in his attempt to reproduce th grandeur of ancient tragedy in his verse-drama *Merope*. This last has been universally judged a poetic failure, though an impressive technical achievement: a skilful re-creation of original instruments but a lifeless pastiche of early music. Swinburne long ago set the tone of subsequent response to the piece when he teased, 'The clothes are well enough, but where has the body gone?' *Merope* pays homage to, but only limply embodies, some of the qualities that Arnold most admired in Greek literature (a topic to be discussed more fully in Chapters 4 and 5 below), and it has some of the smooth coolness and clear lines of an alabaster statue; but, as with most things in alabaster, one is constantly aware that one is looking at a reproduction.

Although the 1867 volume *New Poems* is generally thought to include much that fell below the standard of Arnold's earlier volumes, it did contain a few poems that have since become among his best-known pieces, notably 'Dover Beach' (probably written as early as 1851, though the evidence is inconclusive), and the thematically linked but poetically more discursive 'Stanzas from the Grande Chartreuse' (largely composed in 1852). Familiar

as these poems may be, they demand discussion here not only on account of their intrinsic merits, but also because they are such representative expressions of some of Arnold's deepest preoccupations.

It is, of course, hard now to see 'Dover Beach' with anything like fresh eyes, so much a part of our familiar poetic stock has it become. The organizing trope of the poem, the way in which the retreat of the tide-driven sea suggests the withdrawing of 'the Sea of Faith', employs a favoured Arnoldian metaphor. A sequene of monosyllables joined by simple verbs establishes the encompassing peacefulness of the setting.

> The sea is calm tonight.
> The tide is full, the moon lies fair
> Upon the straits; on the French coast the light
> Gleams and is gone; the cliffs of England stand,
> Glimmering and vast, out in the tranquil bay. (254)

The very stillness of the scene invites that mood of reflective sadness at which Arnold excelled. Indeed, the 'grating roar' of the shingle on the beach, and the movement of the waves themselves as they 'Begin, and cease, and then again begin', brings 'The eternal note of sadness in'. It leads the speaker to reflect, as the poem gathers intellectual and rhythmic intensity, how 'The Sea of Faith / Was once, too, at the full'; and then, in a haunting evocation of bleak absence, come the famous lines:

> But now I only hear
> Its melancholy, long, withdrawing roar,
> Retreating, to the breath
> Of the night-wind, down the vast edges drear
> And naked shingles of the world. (256)

Ostensibly, love is then invoked as the only solace, but almost immediately this comes to seem something of a perfunctory gesture, as it is swallowed up by the gathering momentum of the poem's powerfully dark picture of our homelessness in a cold, indifferent world.

> . . . for the world, which seems
> To lie before us like a land of dreams,
> So various, so beautiful, so new.

> Hath really neither joy, nor love, nor light,
> Nor certitude, nor peace, nor help for pain;
> And we are here as on a darkling plain
> Swept with confused alarms of struggle and flight,
> Where ignorant armies clash by night. (257)

Interestingly, though the rhythm and cadence of 'Dover Beach' have cast their spell even over some of the unwillingly-conscripted readers of school anthologies, the poem is unusually hard to analyse in formal terms. It is, as the standard edition describes it, 'a lyric consisting of four unequal verse-paragraphs, irregularly rhymed. Lines vary between two and five stresses, but more than half the lines are five-stressed' (254). This dry, technical description cannot take us very far, but since there is no doubt that Arnold's ear could at times let him down very badly, his command of the emotion-sprung rhythm of 'Dover Beach' is all the more striking precisely for *not* being able to take its structure from one of the established verse-forms. Is it significant or merely curious that it should be Arnold, advocate of an austere classicism and polished cultivator of the most traditional genres, who should thus be credited with the first major 'free-verse' poem in the language?

With 'Stanzas from the Grande Chartreuse', it is hard not to feel that Arnold's relation to 'the Age of Faith' is a little more equivocal than it may at first appear. While the poem laments the impossibility of every again inhabiting an animating faith in the way his imagined monks did, it also condescends a little to the credulity of earlier ages, and thus introduces a slight note of self-congratulation. We may be deprived, but we are not deceived. The monks, 'Last of the people who believe', are no doubt fortunate, but at least those like Arnold, 'Last of the race of them who grieve', can savour the bitter-sweet taste of a yet more exquisite emotion, that special pathos that attaches to being the last of a line. Though the poet famously characterizes himself as

> Wandering between two worlds, one dead,
> The other powerless to be born,' (305)

he surely takes a subtle, if perverse, pleasure in his stranded state, and would not, now, exchange his lot for that of the credulous monk or the indifferent unbeliever. R. H. Hutton, always the most

perceptive of Arnold's contemporary critics, was pointing in the same direction when he unfavourably contrasted 'the true humility of the yearning for faith' with Arnold's 'grand air of tearful Virgilian regret'.

For this as well as other reasons, Arnold may be a more doubtful, or perhaps just a more subtle, witness of the intellectual dilemmas of his age than historians have always allowed. But certainly some of the deepest spirits of his own and the immediately succeeding generation, not least among them George Eliot, found that Arnold's poetry spoke to their anxieties and yearnings with a special power. Hutton again forces his way to the front with the rhetorical excess of the natural spokesman:

When I come to ask what Mr Arnold's poetry has done for this generation, the answer must be that no one has expressed more powerfully and poetically its spiritual weaknesses, its craving for a passion it cannot feel, its admiration for a self-mastery it cannot achieve, its desire for a creed that it fails to accept, its sympathy with a faith it will not share, its aspiration for a peace it does not know.

'Heroic egotism'

We have already seen that the ostensible subject-matter of many of Arnold's lyrics and elegies proves, on closer examination, not really to be the governing preoccupation of the poems. The love poems are not 'about' Marguerite, nor are they actually about love; similarly the elegies are often not about the dead, whether people or faiths, nor even quite about transience and mutability as such. It is rather the poet's own self-conscious melancholy, aroused by reflection on these themes, that determines the emotional force and direction of these pieces. If the experience of love yielded the poet any positive conclusion, it was that at the moments of most intense communion with another, 'A man becomes aware of his life's flow',

> And then he thinks he knows
> The hills where his life rose
> And the sea where it goes. (291)

But even here, in 'The Buried Life', one of his more optimistic poems, the significance of the experience, its beneficiary, as it

were, is a kind of reflective self-centredness. More generously, one might observe how much of Arnold's work, in prose as well as poetry, expresses his sustained, though not showily strenuous, search for self-knowledge. In a revealing letter to Clough, written in 1849 when still roused and disoriented by his love for 'Marguerite', he characterized himself as somebody 'whose one natural craving is not for profound thoughts, mighty spiritual workings etc etc but a distinct seeing of my way as far as my own nature is concerned' (C 110). This should remind us that, although Arnold is often taken as a representative of 'the Victorian crisis of faith' and similar large-scale intellectual shifts, he was not attempting to construct an alternative system or synthesis, in the way in which several nineteenth-century doubters and self-declared 'humanists' were trying to do; rather, more modestly, he was trying to 'see his way'.

But the more immediate conclusion to which the argument of this chapter pushes us is to see that the voice of Arnold's poetry is inherently reflexive: his poems are nearly always fundamentally about himself, not just in the sense in whih any artist's work is the expression of something about himself, but rather in that, by a series of covert mechanisms and sly stratagems, Arnold's poetry so often contrives to make the mood and temperament of the poet the focus of attention. Something of this was caught by Hutton when, in another of his perceptive comments on Arnold's work, he referred to the 'clear, self-contained, thoughtful, heroic egotism' of much of the poetry. There *was* an element of heroism in Arnold's struggle to come to terms with the intensity of his dissatisfaction, but that, too, was egotistical, promoting to centre-stage the poet's sensitivity and visible effort to accommodate himself to a grating world.

This is surely partly accounted for by the deep but neglected truth that melancholy is inescapably self-important, whereas there is a relative impersonality about cheerfulness. Perhaps Arnold arrived at an intuitive recognition of this truth; certainly, much of the 'dialogue of the mind with itself' that took place in the early 1850s suggests an attempt to convince himself of the possibility of rising to the level of cheerfulness, a development, as we shall see in subsequent chapters, that he only really achieved, and then

fitfully, in his prose. In replying to Clough's favourable comments on 'The Scholar-Gypsy', Arnold expressed his own dissatisfaction with the merely self-indulgent aspect of his poetry.

I am glad you like the Gipsy Scholar – but what does it *do* for you? Homer *animates* – Shakespeare *animates* – in its poor way I think Sohrab and Rustum [Arnold's narrative poem of that name, first published in 1853] *animates* – the Gipsy Scholar at best awakens a pleasing melancholy. But this is not what we want.

> The complaining millions of men
> Darken in labour and pain –

[lines from his own 'The Youth of Nature'] what they want is something to *animate* and *ennoble* them – not merely to add zest to their melancholy or grace to their dreams. (C 146)

In the Preface to the 1853 volume of his poems (to be considered further in the next chapter). Arnold's curious repudiation of 'Empedocles on Etna' and the whole mood of anguished self-absorption he took it to represent, was part of his struggle to resist the charms of this 'pleasing melancholy'. That Preface was certainly not a successful way, and its programmatic recommendations stood at odds with Arnold's own best poetic practice. But he could not achieve in poetry what he recommended: it was not a register he commanded. When he tried to escape from himself to impersonal subjects like Nordic myth and Greek drama, he only succeeded in producing the lifeless husks of 'Balder Dead' and *Merope*. They are too willed: his gift did not run so far or so freely. In much of Arnold's poetry we see the disconsolate Romantic trying to turn himself into the resolute Stoic: his partial success has a pathos of its own, though we may wonder whether it is the small element of failure or the large degree of success which is the sadder sight. Yet there is a kind of self-indulgence here, too: genuine stoicism does not keep calling attention to its achievement in this way.

It is not the least of the reasons for which Arnold has been called 'the poet of our modernity' that this consuming self-consciousness was from the start allied to a note of precocious weariness. Although the theme of loss – loss of joy, loss of youth, loss of faith – is, as we have seen, at the heart of Arnold's lyrics and elegies, there is a sense in which what they register is absence rather than

loss. That is, they mourn the fact that the poet – but also we, fellow-victims of history and the corrosion worked by its attendant self-consciousness – have never really known, can never know, the immediacy of real joy, real faith, or even – the precociousness returns in another role here – real youth. In a celebrated phrase, Arnold was later to charge that the Romantic poets were not 'adequate' to their age because, ultimately, they 'did not know enough' (iii. 262), but it could be said that his own poetry movingly expressed the existential plight of those upon whom history has imposed a choking burden of knowledge.

Increasingly, the loss of which he sang was the loss of the power of song itself. The drying-up of 'The fount that shall not flow again' (585) becomes just another of the grey truths to be, more in sorrow than in *angst*, accepted and lived with. The fact that 'the Muse be gone away' (578) was, as I suggested earlier, an enduring source of sadness to Arnold, and it left an undertow of regret and wistfulness occasionally discernible through the urbanity of the later prose. It is possible that he was for once overtly voicing this regret when he wrote of Sainte-Beuve's transition from an early dabbling in verse to his mature critical work:

Like so many who have tried their hand at *œuvres de poésie et d'art*, his preference, his dream, his ideal was there; the rest was comparatively journeyman-work, to be done well and estimably rather than ill and discreditably, and with precious rewards of its own, besides, in exercising the faculties and keeping off ennui; but still work of an inferior order. (v. 305)

But even if Arnold did share this feeling, his own objectivity led him immediately to deny that Sainte-Beuve would have been justified in this self-assessment, given the immense value of his critical *œuvre* set alongside the work of even some of the most creative writers of his time. In the following chapters I shall try to show that, despite the undeniable, if patchy, glories of his poetry, *our* objectivity requires that, whatever sadness it may have brought to Arnold himself, we cannot regret that the greater part of his achievement was to be in prose.

4 The literary critic

It is his work as a critic, more than anything else, that has earned Arnold his pedestal among the immortals. Naturally, there has been a good deal of wailing and lamenting that his emergence as a critic should have been accompanied by – whether as cause or consequence has teased biographers ever since – the drying up of his poetic gift; but he would, without question, cut a smaller figure today had he never turned to criticism, and through his precept and his example he has exercised an enduring and unrivalled influence over the place of criticism in our culture. T. S. Eliot's famous observation that Arnold was 'rather a propagandist for criticism than a critic' was ungenerous on several counts, not least because Eliot's cultural criticism owed much to Arnold: the implied judgement is too dismissive of Arnold's actual criticism, while 'propagandist' is too redolent of a loudspeakerly dogmatism to do justice to the sinuous suggestiveness of Arnold's essays. There was tendentiousness of a different kind in the remark by F. R. Leavis, another critic to feel the length of Arnold's shadow, that Arnold's 'best work is that of a literary critic even when it is not literary criticism'. But we do not have to accede to the restrictive notion of 'literary criticism' underlying Leavis's comment any more than we have to endorse the terms of Eliot's judgement to recognize that, taken together, these two remarks provide a helpful orientation to the true nature of Arnold's achievement. It is on account of what he did *for* criticism as much as what he did *in* it that we value him, while, conversely, we are aware that the qualities he brought to the wide range of subjects he treated were pre-eminently the qualities of an outstanding literary critic.

Modernity and 'the Grand Style'

Every poet is a critic of poetry. The practice of the craft impels an awareness of the possible uses of the resources of form and

language, and where this is combined with an intelligent interest in the work of one's predecessors and contemporaries, there is criticism going on though a line of prose never be written. In this sense, Arnold was a critic from the start. His letters to Clough in the late 1840s constitute a playful, informal seminar on poetic theory. He stands out, with self-conscious sternness, against the Keatsian tradition in early Victorian verse, with its rich abundance of imagery and lush word-pictures but also its lack of large controlling ideas or proper elevation of tone. By way of a corrective, he turns to his favourite classical authors and their English descendants. 'There are', he responds to Clough in a letter of 1849,

> two offices of Poetry – one to add to one's store of thoughts and feelings – another to compose and elevate the mind by a sustained tone, numerous allusions, and a grand style. What other process is Milton's than this last, in Comus for instance? . . . Nay in Sophocles what is valuable is not so much his contributions to psychology and the anatomy of sentiment, as the grand moral effects produced by *style*. For the style is the expression of the nobility of the poet's character, as the matter is the expression of the richness of his mind: but on men character produces as great an effect as mind. (C 100–1)

These precociously grave observations (Arnold was 26) contain the germ of much of his later criticism.

The severe reaction against what he took to be the inhibiting reflectiveness of some of his earlier poetry – the reaction that led him to omit 'Empedocles on Etna' from his *Poems* of 1853 – also provoked his first statement of poetical principles in the Preface to that volume. The somewhat mannered, exaggeratedly olympian tone of the piece was a further expression of that wilful serenity which had already irritated some of his contemporaries ('I admire Matt – to a very great extent,' wrote the future historian J. A. Froude to Clough: 'Only I don't see what business he has to parade his calmness and lecture us on resignation when he has never known what a storm is, and doesn't know what he has to resign himself to . . .'). The Preface calls for a return to the themes of the Ancients: the great primary affections and their expression in noble actions. A young writer's attention (the author of this greybeard advice was now 30) 'should be fixed on excellent models that he may reproduce, at any rate, something of their excellence,

by penetrating himself with their works and by catching their spirit. . . .' (i. 8–9). Their great quality, he ruled, is 'sanity', and therefore (as he restated his point the following year) 'it is impossible to read carefully the great Ancients, without losing something of our caprice and eccentricity' (i. 17). The central insistence of his mature criticism on the need for 'centrality' as a corrective to the provincial and the eccentric is already evident here. He adumbrates another theme of his later criticism, as well as revealing an abiding reservation about Shakespeare, when he remarked that the latter 'has not the severe and scrupulous self-restraint of the Ancients, partly, no doubt, because he had a far less cultivated and exacting audience' (i. 11).

The 1853 Preface has a particular biographical interest, both as a repudiation of aspects of a former poetic self, and as Arnold's first public engagement in those critical controversies that were to be the stimulus to his best work. Implicitly, it was a lofty dismissal of those Keatsian epigoni slightingly referred to as the 'Spasmodic' school of lyric poets. But, as with his own experiments with classical poetic forms and subjects in the 1850s, his prose writings of this decade reveal him trying on certain doctrines and tones, searching for a voice in which to express his prematurely Stoic withdrawal from the empty bustle of modern society.

His inaugural lecture as Professor of Poetry at Oxford, 'On The Modern Element in Literature' (which he delivered in 1857 but did not publish until 1869, and which, significantly, he never republished), saw him adopting a more historical approach. At least, it was ostensibly historical, with much talk of the development of society in different periods, yet in fact the argument of the lecture rests on ahistorical typology and deliberate anachronism. That argument, which perhaps owed something to his father's cyclical view of history, was that the present age needed to be brought to recognize its special affinity with the literature of those other ages which could also be characterized as 'modern', that is, ages which were 'culminating epochs', which exhibited a 'significant spectacle' in themselves and which sought for an 'adequate' literature as a means of comprehending that spectacle. Predictably, especially at this point in Arnold's development, the two candidates for this status which he considers are Greece and Rome.

The latter, however, though a 'highly modern' and 'deeply significant' epoch, did not produce an 'adequate' literature, and so the resounding conclusion of the inaugural lecture by the first holder of the Chair to break with tradition and deliver his lecture in English (rather than in Latin) was to 'establish the absolute, the enduring interest of Greek literature, and, above all, of Greek poetry' (i. 37).

This lecture and the Preface to his verse-drama *Merope*, published in the following year, represent the classicizing tendency in Arnold's aesthetic at its highest pitch. Their cultivated remoteness from the concerns of his own society was regarded as affected antiquarianism, though it in fact expressed, albeit in a displaced form, an absorbing antagonism to some of the features of that society's sensibility. In retrospect, we may discern a close connection between the facts that Arnold had yet to find his own prose voice and that he had still to engage more directly with the cultural preoccupations of his contemporaries. Ironically, he was to do both these things by turning to the most distant point in the Western tradition, the poetry of Homer.

On Translating Homer

Although the three lectures that Arnold published in 1861 under the title *On Translating Homer* are festooned with allusions to long-forgotten controversies about an already arcane subject, this slim volume, together with its pamphlet sequel *Last Words*, remains an impressive and surprisingly accessible statement of the indispensable role of critical judgement and tact even, perhaps especially, in matters where technical scholarship may seem to exercise unchallengeable authority. The middle of the nineteenth century saw an unusual concentration of attempts at that perennially fascinating task of rendering Homer into English. The greatest claim on posterity's attention now exercised by either Ichabod Charles Wright or F. W. Newman (brother of the theologian) is as authors of the translations that furnished the chief butts for Arnold's witty criticisms. Indeed, some readers, both then and since, have judged Arnold too funny by half, and have regretted that his statement of critical principles should have appeared in

251

this polemical form. But it is arguable that this misconstrues Arnold's purpose, as well as perhaps failing to recognize the role of such controversy in setting his mind in motion. No writer can be entirely indifferent to the anticipated verdict of posterity, but the cultural critic, to take only the most relevant category, necessarily has a more immediate audience primarily in mind. Arnold well knew that his 'vivacities' were a calculated risk, but he was convinced that his was a more effective way of gaining the ear and winning the heart of his contemporary English readers than through more solemn and systematic statement. Moreover, the movement of his own mind was – to call upon a still useful sense of an over-used word – dialectical. He needed to have a one-sided or exaggerated view to correct in order to be stirred to articulate his own more complex sense of a truth.

There is far more in these lectures than destructive criticism, but they undeniably contain some destructive criticism of a very high order. He was unsparing on the failings of translators who are deaf to the subtler literary qualities of the original, and he was brilliantly effective in showing how preconceptions derived from historical learning produced misapprehensions of rhythm and poetic effect. High among Arnold's targets was what might be called the pedantry of authenticity, those various ways in which a misplaced fidelity to the assumed conditions of an earlier period can hamstring creative interpretation in the present. For example, he observed of Newman's theory that, because the dialect of Homer was itself archaic, the translator should confine his vocabulary as far as possible to the elements in the language of Anglo-Saxon origin:

Such a theory seems to me both dangerous for a translator and false in itself. Dangerous for a translator, because wherever one finds such a theory announced . . . it is generally followed by an explosion of pedantry, and pedantry is of all things in the world the most un-Homeric. False in itself, because, in fact, we owe to the Latin element in our language most of that very rapidity and clear decisiveness by which it is contradistinguished from the German, and in sympathy with the languages of Greece and Rome; so that to limit an English translator of Homer to words of Saxon origin is to deprive him of one of his special advantages for translating Homer. (i. 101)

There was a similar realism and good sense in his response to the proposal that the familiar, and for Arnold and his readers deeply resonant, forms of Greek names should be changed to correspond with a more 'correct' transliteration in the hope that this would come to seem natural to the next generation:

For my part, I feel no disposition to pass all my own life in the wilderness of pedantry, in order that a posterity which I shall never see may one day enter an orthographical Canaan; and, after all, the real question is this: whether our living apprehension of the Greek world is more checked by meeting in an English book about the Greeks, names not spelt letter for letter as in the original Greek, or by meeting names which make us rub our eyes and call out, 'How exceedingly odd!' (i. 150)

More importantly, Newman and his fellow-offenders were for Arnold symptomatic of something much deeper. 'The eccentricity, ... the arbitrariness of which Mr Newman's conception of Homer offers so signal an example, are not a peculiar failing of Mr Newman's own; in varying degrees they are the great defect of English intellect, the great blemish of English literature' (i. 140). Whereas in Europe 'the main effort, for now many years, has been a *critical* effort; the endeavour, in all branches of knowledge – theology, philosophy, history, art, science – to see the object as in itself it really is', the play of criticism, in this wide sense, has been, he alleged, notably lacking in England. *On Translating Homer* was the first instalment of Arnold's emerging programme to bring some of this critical light to bear on the benighted attitudes of his countrymen. Actually, some of the most telling points were made in the pamphlet which he published in response to Newman's reply to his original criticisms. Newman lodged numerous complaints against both the tone and substance of Arnold's lectures, not all of them unjustified. But his final accusation allowed Arnold a reply in his most provoking manner, in the course of which he gave a marvellously perceptive account of the perennial obstacles to good criticism:

And he ends by saying that my ignorance is great. Alas! that is very true. Much as Mr Newman was mistaken when he talked of my rancour, he is entirely right when he talks of my ignorance. And yet, perverse as it seems to say so, I sometimes find myself wishing, when dealing with these matters to poetical criticism, that my ignorance were even greater than it

is. To handle these matters properly there is needed a poise so perfect that the least overweight in any direction tends to destroy the balance. Temper destroys it, a crotchet destroys it, even erudition may destroy it. To press to the sense of the thing itself with which one is dealing, not to go off on some collateral issue about the thing, is the hardest matter in the world. The 'thing itself' with which one is here dealing, the critical perception of poetic truth – is of all things the most volatile, elusive, and evanescent; by even pressing too impetuously after it, one runs the risk of losing it. The critic of poetry should have the finest tact, the nicest moderation, the most free, flexible, and elastic spirit imaginable.

This passage is a good example of the way Arnold's mind moves from an intuitive perception of the lack of balance in an apparently unexceptionable thought to a widely-ramifying articulation of the basis of that intuition. His tone is initially ironic and personal, but the weight of the argument itself pulls it into a more serious and impersonal register. The unfolding of the implications of that quintessentially Arnoldian term 'poise' has a persuasive momentum. Temper destroys the crucial balance because through the fumes of his own emotion the critic can see nothing as in itself it really is; a crotchet – that is, a pet theory or idiosyncratic preoccupation – destroys it because the critic is inevitably looking for evidence of what he wants to see, he is obsessed with his theory rather than responding to the object of critical attention; then that splendid culminating clause, 'even erudition may destroy it', that is, that the critic may become so absorbed in points of historical or philological detail, that he loses all sense of proportion, and his learning, instead of serving as a helpful auxiliary, obstructs his appreciation of the poem as a whole. And finally the insight, itself an expression of poise, that the 'critical perception of poetic truth' is so 'volatile, elusive, and evanescent' that 'by even pressing too impetuously after it, one runs the risk of losing it'. This surely catches very well that sense, itself elusive and evanescent, that when we press to try to grasp the nature of some complex literary experience, we run the risk of somehow driving it away, or prematurely fixing on a description which is, in fact, inadequate and hence distorting. He is pointing to the way that we have, in some sense, to let the experience come to us a little more, and then to enter and explore its dimensions in a meditative,

noticing sort of way, rather than rushing to try to pin it down. And here again we should feel the force of that deceptively simple Arnoldian injunction to try to see the object as in *itself* it *really* is.

Criticism and its functions

The fact that *Essays in Criticism* (1865) now seems such a coherent book, despite its origin as a collection of lectures and periodical pieces from the preceding two or three years, is testimony to, among other things, the constancy of polemical purpose that animated Arnold in these years. Actually, coherence is not what first strikes the reader on looking at the contents page. The first edition of the book contained nine essays and a specially-written preface: two of the essays are the subsequently famous general statements 'The Function of Criticism at the Present Time' and 'The Literary Influence of Academies'; of the remaining seven, three deal with relatively minor French authors (Maurice de Guérin, Eugénie de Guérin, Joubert) and there is one each of Heine, Spinoza, Marcus Aurelius, and 'Pagan and Mediaeval Religious Sentiment'. In other words, one of the most famous works of literary criticism in the English language appears to contain much that would not now be regarded as 'literature', very little on indisputably significant authors, and nothing at all on any literature in English. But there is a unity to it, and as so often with Arnold one can best grasp this by looking at the way the essays developed in response to the controversies he was engaged in.

The starting-point is an essay that did not appear in this form in the book at all. In 1862, the Anglican Bishop of Natal, J. W. Colenso, published the first instalment of his *The Pentateuch and Book of Joshua Critically Examined*, a work which sparked off one of those now-forgotten storms that shook the Victorian church. Colenso questioned the plausibility of certain passages of the Bible if interpreted literally, as for many their faith still obliged them to do. Arnold might have been sympathetic to this enterprise had it been carried out with more finesse and tact, but these were hardly Colenso's distinguishing qualities. To make the point, Arnold conceived the plan of contrasting Colenso's 'jejune and technical

manner of dealing with Biblical controversy with that of Spinoza in his famous treatise on the *Interpretation of Scripture'* (L i. 204). (Spinoza had long been one of Arnold's favourite authors; some passages from this initial article were to be reused in the one that eventually appeared in *Essays in Criticism* under the title 'Spinoza and the Bible'.) What it was about Colenso's absurdly reductionist calculations that so irked Arnold is easily gleaned from the following specimens of the Higher Knockabout: Colenso's mathematical demonstrations are, as Arnold described them,

a series of problems, the solution of each of which is meant to be the *reductio ad absurdum* of that Book of the Pentateuch which supplied its terms . . . For example, . . . as to the account in Leviticus of the provision made for the priests: *'If three priests have to eat 264 pigeons a day, how many must each priest eat?"* That disposes of Leviticus . . . For Deuteronomy, take the number of lambs slain at the Sanctuary, as compared with the space for slaying them: *'In an area of 1692 square yards, how many lambs per minute can 150,000 persons kill in two hours?'* Certainly not 1250, the number required, and the Book of Deuteronomy, therefore, shares the fate of its predecessors. (iii. 48)

But what really disturbed Arnold and prompted him to ridicule the already ridiculous was the extent to which Colenso was taken seriously by large sections of educated opinion in England. This demonstrated yet again the parochialism of English intellectual life, the want of those standards of critical judgement by which such an eccentric performance could be properly judged. And this meant, Arnold insisted, pursuing his larger purpose, being judged not simply from a theological point of view, but 'before another tribunal', that of what he called 'literary criticism'. But what business, he asks rhetorically, has literary criticism with books on religious matters? His answer is worth quoting *in extenso*, because though he was to refine his statement of the tasks of criticism, no other passage reveals so clearly the ideal animating his larger critical campaigns.

Literary criticism's most important function is to try books as to the influence which they are calculated to have upon the general culture of single nations or of the world at large. Of this culture literary criticism is the appointed guardian, and on this culture all literary works may be conceived as in some way or other operating. All these works have a

special professional criticism to undergo: theological works that of theologians, historical works that of historians, philosophical works that of philosophers, and in this case each kind of work is tried by a separate standard. But they have also a general literary criticism to undergo, and this tries them all, as I have said, by one standard – their effect upon general culture. Everyone is not a theologian, a historian, or a philosopher, but everyone is interested in the advance in the general culture of his nation or of mankind. A criticism, therefore, which abandoning a thousand special questions which may be raised about any book, tries it solely in respect of its influence upon this culture, brings it thereby within the sphere of everyone's interest. (iii. 41)

At first sight, this may appear to be another of those pieces of intellectual imperialism whereby the proponent of one discipline attempts to assert its sovereignty over neighbouring intellectual territories. But it should be clear that Arnold was not writing on behalf of the academic practice we have come to know as 'literary criticism'. He was, to begin with, using 'literary' in a very wide sense: works of theology, history, or philosophy are, in this now somewhat archaic sense, all branches of 'literature'. But an ambitious sense of 'criticism' is involved, too. He does not, after all, say that literary criticism is qualified to discriminate or assess some purely *literary* qualities of these works; he says the 'most important function' of criticism is to 'try books as to the influence which they are calculated to have upon the general culture'. No small task: above all, not a task for the specialist, or even a team of specialists. It requires the exercise of cultivated judgement, formed by responsive engagement with work of the highest standard. 'Literary criticism' is the name Arnold was here giving to this task of general judgement.

These large claims predictably provoked indignation and hostility from several quarters, which may have hardened Arnold in his already exaggerated conviction that genuine criticism was unknown and unwelcome in England. The essays which he wrote between 1862 and 1864, and which were then collected in *Essays in Criticism*, were intended both as a direct response to these objections and as a demonstration of the role of criticism in practice, while the choice of subject-matter was meant to supply another lack by encouraging a more discriminating appreciation of

257

just those writers and cultural traditions likely to be scorned or undervalued in mid-Victorian England.

Arnold generalized his case in the two essays he placed at the head of his collection, which have become two of the most frequently cited pieces he ever wrote. It is in the first, 'The Function of Criticism at the Present Time', that we meet his famous definition of criticism as 'the disinterested endeavour to learn and propagate the best that is known and thought in the world'. His explanation of that crucial Arnoldian word 'disinterested' is worth pondering for a moment, especially since it has come in for more than its share of misunderstanding.

And how is criticism to show disinterestedness? By keeping aloof from what is called 'the practical view of things'; by resolutely following the law of its own nature, which is to be a free play of the mind on all subjects which it touches. By steadily refusing to lend itself to any of those ulterior, political, practical considerations about ideas, which plenty of people will be sure to attach to them, which in this country at any rate are certain to be attached to them quite sufficiently, but which criticism really has nothing to do with. (iii. 270)

It is true that this is one of those passages that collaborate in their own misinterpretation, but in the context of the essay as a whole it should be clear that Arnold is *not* claiming that criticism exists in some transcendental sphere, unconnected with the social and political realities of the world; if he were, his whole programme for the impact of criticism upon that world would be absurd. Nor is he claiming that the critic has no political, religious, or moral values, or that he is uninterested in the relation of the objects of his criticism to those values – 'disinterested' does not, it ought to be unnecessary to say, mean 'uninterested'.

What Arnold is attacking here is any attempt to subordinate criticism to some other purpose. The aim of criticism, as he had already insisted more than once, is 'to see the object as in itself it really is', and that means that immediately and primarily responding to a book or idea in terms of whether its consequences may be acceptable by the criteria of some moral or religious or political view which we are already committed to, but trying first to let it register on our minds and sensibilities in the fullest ways possible, trying to let its own nature manifest itself to us without prema-

turely foreclosing on whether it is or is not acceptable in terms of a standard imported from some other sphere. Arnold's reference in that passage to the situation in England gives the clue to what he was trying to avoid. Those 'ulterior, political, practical considerations about ideas' that he is urging criticism to keep aloof from were precisely the kinds of habits that, in his view, narrowed and stultified the intellectual life of Victorian England. Books and ideas were judged, he was complaining, by whether they were consistent with the true tenets of the Protestant religion, or by whether they supported a Whig or Tory view of the English constitution, or by whether they had an immediate bearing upon the great policy issues of the moment. By urging the critic to practise a kind of 'disinterestedness', he was not encouraging a posture of withdrawal from the world, but rather that kind of openness that is not so blinded by partisan preconceptions that it cannot recognize a new idea or appreciate a new form when it meets it.

It is certainly arguable that Arnold himself did not always live up to this ideal in practice, so committed was he to promoting a particular set of changes in English sensibilities; he could be unfair and tendentious in his own ways, and he sometimes takes that kind of self-conscious pleasure in his own verbal felicity that is itself an obstacle to the truly disinterested treatment of a subject. But to an impressive extent Arnold *did* successfully embody this quality; certainly by the standards of the literary journalism of his day (as exhibited in, for example, the political propagandizing and hanging-judge severity of the *Edinburgh* and *Quarterly* reviews), his criticism was remarkably free from partisan spirit, and it can still communicate a sense of spaciousness and long perspectives. And of course, some of his choices revealed that kind of disinterestedness which is akin to courage, especially when his subjects challenged some of the entrenched prejudices of his society, as, for example, in elevating Marcus Aurelius over his Christian detractors as a model of 'spiritual refinement', or in writing such an enthusiastic appreciation of Joubert, whom he called 'the French Coleridge', when he knew that Joubert, as an enlightened Frenchman, would probably be suspected by the English public of atheism, materialism, levity, and syphilis.

The second essay, 'The Literary Influence of Academies', has

also come in for its share of misinterpretation. It is often described as a lament about the absence in England of an authoritative institution comparable to the French *Académie française*. But this way of putting it then seems to bring us up against the following paradox in Arnold's views about criticism. As we have seen, one of the general terms he uses most frequently to characterize the distinctive qualities of criticism in his sense is 'flexibility'. But it is the essence of the idea of an Academy that it should be authoritative, and indeed, where its pronouncements are made *ex cathedra*, that it should be somewhat authoritarian. 'Rigidity' rather than 'flexibility' might seem to be the quality an Academy would be most likely to foster. How, therefore, was Arnold able to recommend both these things simultaneously?

Although this question does point to an enduring tension in Arnold's mind between two not entirely compatible inclinations, the tension falls some way short of a genuine contradiction in this case. To begin with, we have to recognize that Arnold was *not* in fact recommending the establishment of an Academy in England. Rather, he was trying to highlight the weakness of English intellectual life and literature by contrasting them with the qualities encouraged by, and in fact expressed in, the existence of an authoritative institution like an Academy. The very existence of an Academy along the lines of the *Académie française* expresses a public recognition of the importance of maintaining the highest standards in any sphere of intellectual activity. As Arnold makes clear, he is not talking about works of genius: the English were, he argued, already too prone to compliment themselves on having Shakespeare, Milton, and a string of great poets, and so complacently to conclude that the conditions for literary and intellectual achievement in their country must be in pretty good order. But that is not the point; individuals of genius, especially in a genre like poetry, may appear from time to time, without the general culture of the society being in good order at all. What about what Arnold calls the 'journey-man work of literature' (in the wide sense of that latter term), that is, the work of reviewing and journalism, of translation, reference, and biography? He gives some telling examples of how poorly this was done in England, and then observes:

Ignorance and charlatanism in work of this kind are always trying to pass off their wares as excellent, and to cry down criticism as the voice of an insignificant, over-fastidious minority; they easily persuade the multitude that this is so when the minority is scattered about as it is here; not so easily when it is banded together as it is in the French Academy. (iii. 242)

Again, we see his concern to make criticism effective and to combat that ethos of lax relativism which allows every opinion, no matter how eccentric or ill-grounded, to pass itself off as the equal of any other. Notice, too, his reference to the opposition between the minority and the multitude, in fact the assumption of an antagonistic relation between them. This raises the interesting question (to which I shall return in a slightly different form later) of how Arnold squares his recognition of the fact that the business of culture will in the first instance be carried on by a minority, or as he calls them elsewhere, adopting a biblical phrase, 'the saving remnant', with his claim that disinterested judgement can only proceed from a position of cultural centrality. Can a 'remnant' be 'central'?

In fact, this very notion of 'cultural centrality' itself points toward a deeper resolution of our initial paradox about the conflict between flexibility and authoritativeness. The opposite of an open and flexible mind is, of course, a closed and rigid one, but there are many ways of being closed and rigid. The particular way that Arnold intends is where one is a prisoner of a narrow, partisan, obsessive point of view, where one is confined within the limits of a parochial preoccupation, a provincial standard of judgement, a purely personal range of reference. In this sense, to be brought to participate in the mainstream of European culture is to be emancipated from the constraints of provincial narrowness, and to have access to the highest standards is to be liberated from the despotism of the mediocre and second-rate. In contrasting the eccentric, wayward, opinionated quality of much English prose with the classical lucidity and restraint of the best French writers, Arnold cites a passage from the French writer Bossuet and says: 'There we have prose without the note of provinciality – classical prose, prose of the centre' (iii. 246). That reference to prose of 'the centre' is crucial, and very revealing of the shape of Arnold's concerns in this essay. To be central in this sense is, if you like, to operate

within the largest space; the contrast is the way in which one is cramped if confined just to the margin or periphery. Arnold, then, is not recommending the establishment of an Academy in England: he is trying to bring out how the strengths of a culture that can create and sustain an Academy are precisely the kinds of qualities most lacking in England. He is not so much saying that English intellectual life exhibits such a low level and a lack of standards because it does not have an Academy, but rather that, because of the qualities manifested in its low level and its lack of standards, it could never understand the virtues of having an Academy in the first place.

In 1865 Arnold prefaced his collection with a high-spirited response to some of the criticisms that had accumulated over the previous three or four years. Actually, the Preface which now (since the second edition of 1869) stands at the front of the volume is a considerably toned-down version of the original. In the first edition, he indulged his taste for making his critics look ridiculous while artfully retaining the reader's sympathy for himself. 'It will make you laugh', he told his mother (L i. 286), but it didn't, and he had sadly to recognize that 'from their training and habits of thinking and feeling' his family were unlikely to appreciate some of his immoderate sallies (iii. 482). Nor were many of his other readers very appreciative of the facetious mockery of Arnold's minor Dunciad. *The North British Review* was typical in objecting to what, in a term that was to stick, it called Arnold's 'vivacities' ('but then', as he explained to his mother, 'it is a Scotchman who writes' [L i. 290]). For all his confident swagger, Arnold soon realized that the tone of his raillery could be counter-productive, and thereafter omitted some of the offending passages. Still, it remains one of the least dull Prefaces to a work of criticism ever written, and as a counterpoint to the coarse practicality of some of his Benthamite critics, it concludes with his famous aria to the charms of Oxford, 'steeped in sentiment as she lies, spreading her gardens to the moonlight, and whispering from her towers the last enchantments of the Middle Age' (iii. 290).

Although, as I have suggested, it was controversy that brought Arnold's mind to life at this period, the volume we hold in our hands today as *Essays in Criticism, First Series* (the suffix was

added by the publishers after Arnold's death in 1888 when they collected some of his later pieces, as he had been planning to do, under the title *Essays in Criticism, Second Series*) is remarkably free from disfiguring birth-scars. The volume has idiosyncrasies of its own, to be sure. Arnold's typically nineteenth-century method of reproducing very long extracts from his authors without much comment is apt to seem tiresome (and to raise ungenerous thoughts about reviewers who are paid by length). In fact, this practice makes us aware how little there is in the book of what we now generally regard as the distinctive activity of the literary critic, the close attention to the way in which the language of particular passages works; Arnold, here true to his late-Romantic pedigree, was always better at characterizing *what* effect a work has upon the reader than he was at analysing *how* that effect is achieved. As a result, we are sometimes left wondering why what may seem to us a rather laboured passage is being held up for our admiration: Arnold's method is very vulnerable to changes of taste in this respect. Certainly, the de Guérins, for example, now seem inadequate vehicles for the case he wants to make. This owed something to following the taste of his admired Sainte-Beuve too closely, perhaps, but it also brings out how some of the writing in these essays is less a response to the authors in question, and more a matter of using those authors to illustrate an argument about the nature of criticism.

At times, too, the essays seem to be marked by thumpingly dogmatic judgements (for example, this piece of unfairness to Jeffrey, first editor of *The Edinburgh Review*: 'All his vivacity and accomplishments avail him nothing; of the true critic he had in an eminent degree no quality, except one – curiosity' [iii. 210]). But these dicta are almost invariably a way of establishing a larger, comparative point. In order to show up and correct the eccentricity of English taste, Arnold constantly invokes the wider frame of judgement provided by comparison: his preoccupation with 'ranking' authors, with assigning them their proper place in the league tables of literary greatness, which was later to become a disfiguring tic, here simply takes its place as part of his overall strategy. That strategy, as we have seen, was not a modest one: in Arnold's sense of the term, criticism took all human knowledge as its province,

where 'its best spiritual work', as he put it, was 'to keep man from a self-satisfaction which is retarding and vulgarising' (iii. 271). In the end, what gives *Essays in Criticism* a surprising unity and coherence is the presence in each essay of the idea of criticism itself, embodied in that distinctive Arnoldian voice. 'The great art of criticism is to get oneself out of the way and to let humanity decide' (iii. 227). Arnold could hardly be said always to have lived up to this injunction, so recognizable, so much a personality of its own, was that voice. But it accompanied rather than drowned its subject-matter. Here, he admirably embodied his own ideal: the critic, he observed in a passage which catches the spirit of the book very sweetly, should not always be delivering judgements, but should endeavour rather to be communicating what he sees to the reader 'and letting his own judgment pass along with it – but insensibly, and in the second place not the first, as a sort of companion and clue, not as an abstract lawgiver' (iii. 283).

Later literary essays

Apart from the curious little book of lectures *On The Study of Celtic Literature*, published in 1867, which was more an essay in the comparative analysis of national character than about Celtic literature as such, Arnold published little of note on literary matters for twelve years after *Essays in Criticism*. During that time he was largely absorbed in the social and religious criticism which forms the subject-matter of the next two chapters. When in the last decade of his life he did again return to literary topics, his sense both of the task and the audience had changed somewhat. In the early 1860s he had, with pardonable exaggeration, felt himself to be struggling to obtain for criticism any kind of hearing at all; by the late 1870s he felt the need to distance himself from the 'historical' and 'aesthetic' schools of criticism then growing up. Again, in his earlier criticism he had dealt almost exclusively with classical and European literature, calling the narrowness of English taste before the bar of the highest cosmopolitan standards; in the essays of his last decade he returned more and more to establishing the canon of English classics, self-consciously revising and completing the work of Dr Johnson, impelled above all by the urge to

settle accounts with the great masters of English Romanticism whose literary stepchild he was. And finally, his sense of the relevant audience had changed too: in his earlier work he had been addressing that minority which shared a classical education and read the quarterly and monthly periodicals, whereas from the late 1870s he was aware that the changed educational and social circumstances of Britain in the last quarter of the nineteenth century were creating a far wider market for a certain sort of instruction and moral sustenance.

These changes, acting in conjunction with the darker colours assumed by Arnold's own sorrow-shadowed sensibilities, gave his later work a more didactic and moralistic tone. The easy, conversational intimacy of the earlier work became less marked, though it never entirely disappeared; instead, the greater distance and inequality between author and implied reader produced a more insistent and preachy literary manner. As Arnold himself increasingly required his reading to console rather than to animate, he entrusted literature with the heavy duty of making the truths of religion and morality effective. The essays on Wordsworth, Byron, Keats, and Gray, which all originated as introductions to popular editions of selections of their poetry, still contain some interesting criticism (especially that on Wordsworth), but they are not his best work. It is particularly unfortunate that the most widely anthologized of all of Arnold's prose writings should have been the programmatic essay on 'The Study of Poetry', written as a general introduction to T. H. Ward's popular compilation *The English Poets* (and hence addressed to a relatively unsophisticated audience), since it displays these characteristics of his last period in their most marked form.

It is in this essay that he expounds his famous doctrine of the 'touchstones', those lines of indisputably great poetry (from Homer or Dante, Shakespeare or Milton) that we should bring to the task of helping us discriminate between good and bad poetry, and indeed between great and merely good poetry. This approach has come in for severe, and largely justified, criticism: abstracting single lines from complex poetic wholes is an exercise fraught with pitfalls, just as there are obvious difficulties about comparing these lines with poetry of different genres or written in different

languages, and so on. But Arnold was not in fact proposing this as a complete scholarly method (he was not writing at that level), and his own account of the value of this approach is more modest:

Indeed, there can be no more useful help for discovering what poetry belongs to the class of the truly excellent, and can therefore do us most good, than to have always in one's mind lines and expressions of the great masters, and to apply them as a touchstone to other poetry. Of course we are not to require this other poetry to resemble them; it may be very dissimilar. But if we have any tact we shall find them, when we have lodged them well in our minds, an infallible touchstone for detecting the presence or absence of high poetic quality, and also the degree of this quality, in all other poetry which we may place beside them. (ix. 168)

Once again, 'critical tact' is indispensable; the touchstones can, of course, be applied clumsily and mechanically, but any critical approach can be travestied when it falls into clumsy and mechanical hands. The touchstones are, as this passage says, only a 'help' for discovering the quality of a given piece of poetry, not a sufficient recipe in themselves. But they have the effect of disciplining our taste: in their presence it becomes impossible to be taken in by the fraudulent and second-rate; the contrast jars our sensibilities too much. Arnold had himself deployed essentially this approach at various times in his Homer lectures, as well as in *Essays in Criticism*: in this essay, the touchstones are simply being proffered as the handy pocket-version of the Arnoldian conception of criticism.

But in that passage about the touchstones there was a single word which encapsulated the later Arnold's argument about the high function to be assigned to literature. 'There can be no more useful help for discovering what poetry belongs to the class of the truly excellent, and can *therefore* [my emphasis] do us most good . . .'. This raises several questions – what kind of 'good' does poetry do us? why does the best poetry do us the most good? – but at the heart of the connection Arnold is asserting lies the question of arousing the feelings or sentiments. He is, that is to say, not so much concerned with questions about how we *decide* what is right and wrong – like so many of his contemporaries, he thought the answers to those questions were for the most part not obscure or in doubt – but rather with how we are to become the kind of

person who habitually and spontaneously *does* what is right, how we discipline our will, how we overcome selfishness, laziness, doubt, and despair. In Arnold's view, it is precisely the opposite of these negative states that poetry, above all other agencies, fosters in us. Put very briefly, his view is that poetry (by which he means literature in general, though he always gives pride of place to poetry in the narrow sense) can not only express these convictions, but can give them such beauty or power that they act on our emotions and thus arouse or console us in a way that mere philosophical statement of them cannot do. The better the poetry, the more effectively it engages our emotions and stirs us to action, and the more, therefore, we become the *kinds* of people that it is morally desirable we should become. And a crucial part of this, especially in Arnold's later writings, is the way the most noble or elevated poetry *reconciles* us to the universe, gives us that kind of consolation that can make existence seem bearable.

This is the thought that informs the famous opening sentence of the essay: 'The future of poetry is immense, because in poetry, where it is worthy of its high destinies, our race, as time goes on, will find an ever surer and surer stay' (ix. 161). 'Stay' aptly suggests the propping-up of something otherwise doomed to crumble (and thus also calls up the opening line of his early sonnet 'Who prop, thou ask'st, in these bad days, my mind?' [110], which famously assigns Sophocles this role). Literature is to console and sustain us in hard times, with the strong implication that life is mostly hard times. (The relation with his religious thought will become apparent in Chapter 6 below; here we may simply note that the first paragraph of this essay ends 'The strongest part of our religion today is its unconscious poetry'.) Thus alerted, we notice how the touchstones themselves are nearly all lines that express a melancholy or stoic mood, a certain noble resignation in the face of the universe; and this is the dominant note of his late essays.

Arnold had his limitations as a critic; so many, in fact, especially in his later work, that his inclusion in the pantheon of criticism can sometimes seem puzzling. To begin with his tastes were severely traditional and in some ways surprisingly narrow. The classics cast too long a shadow: no subsequent literature could match them, and this can sometimes give a note of slightly chilly

disdain to his judgements of recent authors, certainly a lack of enthusiasm. He was not above treating experiment and innovation as wilful neglect of 'the best that has been thought and said'; and with the best always in the past, and a pretty distant past at that, he could seem to be inflexibly judging later literature by (as it has nicely been put) 'doomsday standards'. Further, he consistently under-appreciated all the lighter genres. He lauded tragedy, but never did justice to comedy – indeed, scarcely paid attention to it in his major critical manifestos. He prized the epic above all forms of poetry, but undervalued wit and satire. In not regarding the Metaphysical Poets of the seventeenth century as a major movement of English poetry he was, of course, only sharing the received Victorian view, but share it he did; a greater critic might have revised it (as T. S. Eliot was to do). Similarly, he had a late-Romantic aversion to what he regarded as the mere polish and artificiality of the Augustans; he dismissively (but memorably) declared of Dryden and Pope that they 'are not classics of our poetry; they are classic of our prose' (ix. 181). He disparaged Chaucer; and has any English critic of standing written so little or so poorly about Shakespeare?

Then, apart from one very late essay on Tolstoy (which was chiefly an exposition of *Anna Karenina* and an assessment of his moral teaching), Arnold almost entirely neglected prose fiction; writing in one of the most abundantly creative ages of the English novel, he never turned his critical attentions to Dickens, Thackeray, the Brontës, George Eliot, Meredith, or the earlier works of Hardy or James. His letters reveal that in the latter part of his life, at least, he read several of these authors with admiration; but his taste was not formed on them, and he never incorporated any recognition of their achievements into his critical pronouncements. For Arnold, it would seem, poetry still outranked prose, Europe largely outranked England, the past always outranked the present.

Moreover, as with so many critics, his sympathies were most limited with those qualities he least shared. He penned several good lines about Macaulay ('a born rhetorician ... a perpetual semblance of hitting the right nail on the head without the reality' [iii. 210; v. 317]), but his considered conclusion was 'Macaulay is

to me uninteresting, mainly, I think, from a dash of intellectual vulgarity which I find in all his performance' (L ii. 134). The 'intellectual vulgarity' all readers of Macaulay will recognize, but it is surely a limitation of Arnold's own to find him *therefore* 'uninteresting'. The charge of over-fastidiousness has some bite here. Again, his judgement of Charlotte Brontë (admittedly only in an early letter) indicates the limits of his range in another direction. 'Why is *Villette* disagreeable? Because the writer's mind contains nothing but hunger, rebellion, and rage, and therefore that is all she can, in fact, put into her book' (L i. 34). Even if one allowed that there was a grain of truth in this observation (though by the exaggeration of the 'all' it forfeits much respect), it is still a reminder that those who are themselves culturally 'central' can too easily take offence at the tone of such protests and extend too little imaginative sympathy to their sources. And one might extend the list of his defects by including some of the tics I have already mentioned in passing, such as his obsession with 'ranking' authors in the timeless canon, or his increasing tendency to over-value weighty moral utterance.

But despite all this, his most recent biographer is right to declare that Arnold 'is a very great critic: *every* English and American critic since his time has felt his impact'. This is partly because he characterized in unforgettable ways the role that criticism – that kind of literary criticism which is also cultural criticism, and thus, as I shall suggest in the next chapter, a sort of informal political theory – can and must play in modern societies. He introduced a level of self-consciousness about the critic's activities which will never go away. But he also earns the tribute because at his best, as in the last of his Homer lectures or several of the essays in *Essays in Criticism*, he could combine the fine discrimination, the just appraisal, and the telling phrase in a way that has few equals. He could be economical yet devastating: he pounced on F. W. Newman's description of Homer's style as 'quaint, garrulous, prosaic, low': 'Search the English language for a word which does not apply to Homer, and you could not fix on a better than *quaint*, unless perhaps you fixed on one of the other three' (i. 119). He could be mercilessly perceptive: Kinglake's style, he damningly pointed out, was that of 'the good editorial': 'it has glitter without warmth,

rapidity without ease, effectiveness without charm. Its characteristic is, that it has no *soul*; all it exists for, is to get its ends, to make its points, to damage its adversaries, to be admired, to triumph' (iii. 255). He could be discerning and exact: 'the emotion of Marcus Aurelius does not quite light up his morality, but it suffuses it; it has not power to melt the clouds of effort and austerity quite away, but it shines through them and glorifies them; it is a spirit, not so much of gladness and elation, as of gentleness and sweetness; a delicate and tender sentiment, which is less than joy and more than resignation' (iii. 149). And he could be shrewdly realistic: Joubert may have had 'less power and richness than his English parallel, [but] he had more tact and penetration. He was more *possible* than Coleridge; his doctrine was more intelligible than Coleridge's, more receivable' (iii. 193). When these elements combine, as they do in Arnold's best work, we get that sense of the irresistible rightness of the judgements that only comes when we are reading one of the great critics.

5 The social critic

When Arnold left for his tour of French schools in March 1859, he was 36 years old. He had established a reputation as a gifted and decidedly intellectual poet; as a result of a couple of strongly classicizing prefaces and a few lectures as Professor of Poetry at Oxford he had begun to acquire some standing as a critic. But his published work had given little sign of an interest in larger social matters, and, perhaps surprisingly, he had yet to appear as the author of a single periodical article. Yet by the time *Culture and Anarchy* first appeared as a book ten years later, Arnold's name conjured up a particular style and vein of social criticism he had made his own, and with which it has been associated ever since. The apparently apolitical young literary dandy of the 1840s and the austerely classical aesthetic theorist of the 1850s had matured into the formidable social critic with a seldom rivalled capacity to tease, charm, provoke, and irritate his countrymen out of their habitual complacency.

That five-month visit to France was as much the occasion as the catalyst for Arnold to emerge in a new public role. From his private letters, we can see that certain themes had long been maturing in his mind. His Francophilia had, after all, always involved more than a taste for *bons mots* and beautiful actresses: his admiration of French intellectuality, of the 'idea-moved masses' of their democracy, and of the embodiment of these values in a rational, active state were already of long standing in 1859. Moreover, his experience in the dismally provincial society of the Dissenters whose schools he had been inspecting for the last eight years formed the strongest counterpoint to this selectively perceived ideal. The future author of *Culture and Anarchy* was well supplied with preconceptions when he set out for Paris.

Democracy and education

He published his first pamphlet on political matters while still abroad. *England and the Italian Question* was a rather naïvely hopeful attempt to convince the English governing class to take a more sympathetic view of France's intervention in Italy in that year, largely on the improbable grounds that Napoleon III was only acting as the expression of the French people's passion for justice and democratic principles. But woven in with this plea was an adumbration of what was to become a characteristic Arnoldian theme, namely that an hereditary aristocracy, whatever its political achievements in the past, was ill-equipped to understand a modern world that was essentially governed by ideas and inevitably moving towards greater social equality. He expanded this argument in an impressive essay with which he prefaced the published version of his official report on French schools in 1861, and which he subsequently reprinted separately under the title 'Democracy', a title that justly acknowledges the argument's Tocquevillian pedigree.

Characteristically, Arnold focused not upon democracy as a set of political institutions, still less upon the economic arrangements these might presuppose, but upon the question of cultural values and intellectual and aesthetic standards. 'The difficulty for democracy', he wrote in 1861, 'is how to find and keep high ideals' (ii. 17). It was a variant of a problem that preoccupied many nineteenth-century social thinkers: how were increasingly democratic societies to sustain those cultural and political activities that had in the past depended upon the existence of a wealthy and leisured aristocracy? Arnold thought that there were two reasons why the problem assumed a particularly acute form in England. The first was the way in which the sturdy independence which was such a feature of the English national character (Arnold shared his contemporaries' predilection for talking in this vein) had combined with a peculiar political history to produce a very deep antipathy to allowing the state to play a more active part. And secondly, from a rather similar combination of causes, the English middle class, which was thus left to determine the future tone of national life, exhibited a painfully narrow and impoverished conception of what that life might be.

Faced with this diagnosis, Arnold turned in the first instance to education. At that date, there was, in sad contrast to countries like France or Prussia, no national system of education in England. The state did not take even the first steps towards compulsory elementary education until after 1870; secondary education, such as there was, was left entirely to private enterprise. Arnold deplored this neglect of what he took to be one of the most fundamental tasks of the state in a civilized community. In his provocatively-titled *A French Eton* (1864), an attractively informal and concrete account of some of the French schools he had visited, he lauded the virtues of the *lycée* system. But it was not only the practical superiority of the French arrangements he wished to draw attention to; it was also the example they provided of looking to the state to uphold and promote the highest ideals of civilization.

Indeed, at times Arnold seems less concerned with the merits of a state system of education in its own right, and more with the way it instantiated a more expansive conception of the state as the embodiment of the national life more generally. As he put it in 1861, in the introduction to the published version of his official report:

The question is whether ... the nation may not now find advantage in voluntarily allowing to [the government] purposes somewhat ampler, and limits somewhat wider within which to execute them, than formerly; whether the nation may not thus acquire in the State an ideal of high reason and right feeling, representing its best self, commanding general respect, and forming a rallying point for the intelligence and for the worthiest instincts of the community, which will herein find a true bond of union. (ii. 19)

The germ of much of the argument of *Culture and Anarchy* is evident here, as is that elevated vocabulary that was to earn Arnold so much hostility then and since. We may find it hard to discern the expression of 'right reason' and 'best selves' in the grubby buildings erected by local School Boards after 1870, but even if Arnold's language still jars, the principles for which he argued were handsomely realized in the legislation which established the extensive state education system of the twenteith century.

On this question of state action, Arnold was self-consciously (at times perhaps a touch too self-consciously) challenging the estab-

lished pieties of the day. He argued that there was little danger in England of the state exceeding its powers; the safeguards, especially the fierce public antagonism to state action, were too strong for that. Arnold was not indifferent to the dangers an over-mighty state could pose to the liberties of the individual, but he perceived that this case did not want for advocates in mid-nineteenth century England, and concentrated on pressing the claims of the opposite position. This led to a notable difference of view between Arnold and the most obviously comparable social critic among his contemporaries, John Stuart Mill. The question of education crystallized the difference. Mill, fearful of the coercive power of an unchallenged democracy, argued that schools should not actually be run by the state lest that give the state the power to impose its own views and press uniformity upon the next generation (though he accepted the need for the state to set and monitor minimal educational standards); he saw in the variety of different private provision of education the best defence of individuality. Arnold, by contrast, feared that the danger of leaving education in private hands was that it would only be conducted by the narrowest or most eccentric or provincial of criteria. As he put it in 1861:

By giving to schools . . . a public character, the state can bring the instruction in them under a criticism which the stock of knowledge and judgment in our middle class is not at present able to supply. By giving to them a national character, it can confer on them a greatness and a noble spirit which the tone of these classes is not of itself at present able to impart.

In Arnold's mind, the contrast to 'national' or 'public', terms which he always endowed with strong positive connotations, was 'provincial' or 'sectarian'; even in this relatively early essay, the idea that what is 'central' is *in itself* superior to what is marginal or merely local is already evident.

Not long after he wrote these lines, Arnold was faced with a proposed alteration in the relation between state and education in England that was the complete antithesis of his ideals. The grant made by the state to elementary schools of the kind Arnold inspected was minimal, but it both enabled them to escape the worst features of the Dotheboys Hall pattern, and was an expression, however limited, of the nation's interest in the task of

civilizing the next generation. In 1861, the government, prompted on this issue by Robert Lowe, an expenditure-cutting Liberal of Utilitarian descent, proposed to reduce this grant very considerably, and to institute instead a system of examinations for all children in these schools to determine whether the basics of the 'three Rs' were being satisfactorily instilled: a payment would then be made to the school for every pupil who satisfied the examiners. (This was known as 'the Revised Code' or system of 'payment by results'.) To Arnold, this seemed an appalling expression of the mean-mindedness which disfigured the English middle class; it would also reduce the schools to cramming, and would involve the abandonment of any aspiration to shape the young more fully. He criticized the scheme in one of his most carefully-argued articles, 'The Twice-Revised Code' (1862), in the course of which he, with some courage, made several stinging observations about Lowe, who was technically his superior ('a political economist of such force, that had he been by when the Lord of the harvest was besought to "send labourers into his harvest", he would certainly have remarked of that petition that it was "a defiance of the laws of supply and demand"' [ii. 243]). He concluded his article (which seems not to have provoked the official reprisals he had feared) with a fine rhetorical passage, characteristic of his high polemical style. The supporters of the Revised Code were numerous, including

those extreme Dissenters who for the last ten years have seemed bent on proving how little the future of the country is to owe to their intelligence. There are the friends of economy at any price, always ready to check the hundreds of the national expenditure, while they let the millions go. There are the selfish vulgar of the upper classes, saying in their hearts that this educational philanthropy is all rubbish, and that the less a poor man learns except his handicraft the better. There are the clever and fastidious, too far off from its working to see the substantial benefits which a system, at all national, of popular education confers on the lower classes, but offended by its superficial faults. All these will be gratified by the triumph of the Revised Code, and they are many. And there will be only one sufferer: — *the education of the people.* (ii. 243)

As this last quotation indicates, Arnold was broadening the range of his cultural criticism. Previously, it had been 'spasmodic'

poets and leaden-fingered translators of Homer who had felt the lash of his prose; now whole classes – at times, the whole nation – were similarly upbraided. As a result, in the 1860s Arnold was involved in an almost continuous series of overlapping controversies. It was also the decade that saw the composition of his two most enduring works. These two facts were connected, with each at various moments being one of the causes of the other. The seductive style and sheer quality of his social criticism ensured an abundant response, as did its tone of cultivated superiority: it may, after all, be more enraging to be told you are vulgar than to be told you are wicked. But conversely, Arnold thrived on controversy, as he occasionally admitted: it stirred his creativity and aroused him to some of his most imaginative and sustained writing.

With late twentieth-century condescension, we may feel that Victorian society provided Arnold with an altogether too easy target, all earnest humbug and ugly antimacassars. But that was not how it seemed at the time. Arnold was attacking a society that was at the peak of its self-confidence: it was not used to having some of its most cherished beliefs treated with scornful mockery, and still less to having the virtues of other nations held up for emulation. John Bull had shown his superiority over the foreigner at Waterloo, just as he was doing again in every workshop and factory in the land; he could pride himself, and often did, on being heir to a unique tradition of political liberty, sensible religion, and respectable manners. Now, Arnold was not unappreciative of England's fortunate political development, and, as his correspondence reveals, he was responsive to an idea of national greatness: he felt despondent at the prospect of England 'declining into a sort of greater Holland' (L i. 360), and inhabited his own Englishness with ease and some pride, for all that some of his critics charged him with a want of patriotism. But these deep emotional allegiances only made him detest English complacency and parochialism the more, and his diverse essays in social criticism were united by the purpose, much frustrated but resourcefully prosecuted, of teasing, educating, and shaming his countrymen into a greater awareness of these shortcomings.

Among those who did not take kindly to being schooled in this way was that pugnacious Victorian controversialist, James

Fitzjames Stephen. He had no patience with what he took to be Arnold's fastidious nose-holding about the unintellectual English in 'The Function of Criticism', and responded with the delicacy of a wounded rhinoceros in an article entitled 'Mr Arnold and his Countrymen'. Indirectly, but not inappropriately, he thereby provoked what was eventually to become, as *Culture and Anarchy*, the classic indictment of English philistinism. Arnold brooded upon a reply to Stephen's attack while spending several months of 1865 on a tour of the higher education arrangements of the Continent, especially Prussia, which sharpened his sense of England's backwardness in these matters. Upon his return he gave vent to his talent for social satire in a series of pieces later collected under the title *Friendship's Garland*, a work of wit and high spirits that should be required reading for all those who think of Arnold only as an uninvitingly heavy moralist.

Arnold took up and refashioned a familiar device of social criticism, the ostensibly innocent observations of a (fictitious) visiting foreigner, here a young Prussian *savant* called Arminius Von Thunder-ten-Tronckh. The name was taken from that eighteenth-century classic of the genre, Voltaire's *Candide*, though the relation to this character of Arnold as 'editor' is more immediately reminiscent of Carlyle's similar relation to 'Herr Teufelsdröckh' in *Sartor Resartus*. Arminius's unflattering observations on the benighted ways of his hosts were conveyed largely through the medium of a series of letters to the *Pall Mall Gazette* by one 'Matthew Arnold' (who gave 'Grub Street' as his address), a persona which enabled Arnold to play further variations on his habitual vein of ironic self-mockery, as when the 'Matthew Arnold' figure reports himself cut by an English acquaintance and left standing, 'with my hat in my hand, practising all the airs and graces I have learnt on the Continent' (v. 75).

Friendship's Garland also contains elements of extravagant burlesque reminiscent of Dickens's social satires. With exaggerated pride, 'Matthew Arnold' introduces Arminius to the very crown of the cherished English system of local self-government, the magistrates' bench, occupied on this occasion by three representative local worthies: Lord Lumpington, a peer of broad acres and narrow prejudices; the Reverend Esau Hittall, whose 'performance of his

sacred duties never warms up except when he lights on some passage about hunting and fowling'; and the self-made manufacturer, Bottles Esquire. Arminius inquires after the education of these gentlemen, the extent of their professional training in Roman Law, Jurisprudence, and the like. 'Matthew Arnold' replies archly that the squire and the rector were fortunate enough to have 'followed the grand old, fortifying, classical curriculum' (for all his own devotion to the Ancients, Arnold was well aware of the shortcomings of the grind that in practice passed for a classical education in the Public Schools). ' "But did they know anything when they left?" asked Arminius. "I have seen some longs and shorts of Hittall's", said I, "about the Calydonian Boar, which were not bad. . . ." '

However, it is when he turns to the education of Bottles Esquire that the slyly ironic gives way to the exuberantly farcical. The bleak utilitarianism of the world of the commerical classes stirred Arnold's deepest antipathies, and in this case he manages to tar the proponents of a more practical scientific education with the same brush.

'Here we get into another line altogether, but a very good line in its way, too. Mr Bottles was brought up at the Lycurgus House Academy, Peckham. You are not to suppose from the name of Lycurgus that any Latin and Greek was taught in the establishment; the name only indicates the moral discipline, and the strenuous, earnest character, imparted there. As to the instruction, the thoughtful educator who was principal of Lycurgus House Academy – Archimedes Silverpump, Ph.D., you must have heard of him in Germany? – had modern views. "We must be men of our age", he used to say. "Useful knowledge, living languages, and the forming of the mind through observation and experiment, these are the fundamental articles of my educational creed." Or, as I have heard his pupil Bottles put it in his expansive moments after dinner . . . : "Original man, Silverpump! fine mind! fine system! None of your antiquated rubbish – all practical work – latest discoveries in science – mind constantly kept excited – lots of interesting experiments – lights of all colours – fizz! fizz! bang! bang! That's what I call forming a man!" '

Culture and Anarchy

Arnold never wrote a *book* called *Culture and Anarchy* any more than he did one called *Essays in Criticism*. Indeed, the idea of

bringing together several of his articles as a book does not appear in his correspondence until May 1868, when most of the constituent pieces had already been published; the title, which now seems so inevitably right, appears only to have been settled on a month or two before its publication in January 1869. The book, as is so often true of works that later have classic status thrust upon them, was not at first a great commercial success; a second edition was not called for until 1875. But in the course of the twentieth century, and perhaps for some very twentieth-century reasons, the book has joined that select library of works of non-fiction which the educated person feels guilty about not having read. Where *Essays in Criticism* could be seen as Arnold's Epistles to the Philistines, this was the Gospel according to St Matthew, a Gospel which several generations of zealous missionaries have since prached to the dark corners of the earth.

The piecemeal composition of the book over a period of more than a year left its mark in various ways, as generations of puzzled readers have cause to testify. For example, one chapter will make reference to published criticisms of the preceding chapter, and the long Preface, which was written last, is clearly addressing a rather different political and religious situation from that supposed by the first few chapters proper. But the periodical origins of the work are also a source of strengths, such as its conversational, at times almost intimate, discursive tone. Arnold's prose more generally has been characterized as a monologue masquerading as a dialogue, but there is a genuinely responsive rhythm to much of his writing in this book: which of the other great English prose writers, after all, could get away with beginning not just a sentence or a paragraph but a *chapter* with the argumentative conjunction 'But'?

The book is linked to *Essays in Criticism* both by the thread of controversy and by the purpose signalled in its subtitle: 'An Essay in Political and Social Criticism'. No section of English society entirely escaped his critical scrutiny, and among the happy coinages for which the work is remembered was his characterization of the three main classes as Barbarians, Philistines, and Populace. (Interestingly, the first and last of these terms are in effect classical allusions, while the middle one is, of course, biblical: these two sources always remained the chief reference-points of Arnold's

thought and sensibility.) But although the aristocracy and the working class by no means escaped censure (the former perhaps being let off a little more lightly than the latter), the central target of the book, as of Arnold's work in general, was 'the bad civilisation of the English middle class'. *Culture and Anarchy* is a sustained protest against what he saw as the intellectual, aesthetic, and emotional narrowness of English society – against its puritan moralism, its provincialism, its smugness and complacency, its lack of interest in ideas or feeling for style, its pinched and cramped ideals of human excellence; against, in short, its 'philistinism'.

On the strength of this work, or at least of a strongly preconceived and superficial reading of it, Arnold is sometimes recruited to the ranks of those retrospectively canonized figures, the Victorian 'critics of industrialism'. Certainly Arnold, like all his sensitive contemporaries, was dismayed at some of the features of the factory system and its attendant squalors, but, unlike some of the best-known of those contemporaries, he did not take these features to be an emblem of the endemic sickness of modern society, and, exceptionally among the great Victorian social critics, he was almost silent about political economy. Arnold was responding not to the novelty of industrialism, but to the older and broader conception of 'commercial society', of which his criticism might rather be called cultural than sociological. This characterization of Arnold's concern is confirmed when we consider that, in so far as his work had an explicit historical foundation (which was not in fact very far), he dated the malaise of English life not from the Industrial Revolution of the late eighteenth century, but from the linked religious and commercial developments of the early seventeenth. Like several subsequent English critics. T. S. Eliot and F. R. Leavis among them, he tended to idealize what he took to be the vigorous and expressive life of Elizabethan England, the great creative epoch of English history and literature alike, when English culture was not yet divorced from the mainstream of the European tradition. But then, as he had memorably put it in *Essays in Criticism*, 'the great English middle class, the kernel of the nation, the class whose intelligent sympathy had upheld a Shakespeare, entered the prison of Puritanism and had the key turned on its spirit there for two hundred years' (iii. 121).

The 'prison of Puritanism' is a striking phrase, but like many of Arnold's more resonant categories it is not always clear how far 'Puritanism' here is intended to stand for some ideal-typical set of qualities and how far it is supposed to refer to a particular historical embodiment of those qualities (the question will arise again with his famous pairing of 'Hellenism' and 'Hebraism'). Certainly, in this case he was less concerned with the details of seventeenth-century denominational strife than with the way the severer strains of Protestantism – those sects which had refused to acquiesce in the Anglican Settlement and hence were known as Nonconformists or, more commonly, Dissenters – had coloured, in drab and sombre hues, the texture of English life more generally. Ultimately, the importance Arnold assigned to Puritanism in English history was itself a reflection of his preoccupation with the part played by its descendants in Victorian Britain.

It is, I think, almost impossible to overestimate the importance of Arnold's response to Dissent in shaping his social criticism. Some of those modern readers who, on political grounds, find Arnold's feeling for 'centrality' not to their taste have tended to assume that the divisiveness and conflict which he denounced must have been that between social classes. In fact, it was the temper of religious sectarianism that most disturbed Arnold. As we shall see at greater length in the next chapter, religious issues divided Victorian society more deeply, fiercely, and consistently than any other; the obstructive, oppositional activities and sheer noise-making capacities of the Dissenters were formdiable, as several Government ministers could ruefully testify. Arnold, of course, had ample first-hand experience of this sectarian temper from his school-inspecting duties: some of the most stinging sentences in *Culture and Anarchy* may have formed in his mind as he endured the company of stiff-backed Congregational merchants and righteous Baptist farmers while visiting the outlying parts of his territory. As he wrote in a letter in 1869, the year of *Culture and Anarchy*'s publication: 'The feeling of the harm their [the Dissenters'] isolation from the main current of thought and culture does in the nation, a feeling that has been developed in me by going about among them for years, is the source of all that I have written on religious, political and social subjects.'

For many readers coming to *Culture and Anarchy* for the first time, and knowing of its reputation as a classic discussion of large issues about politics and culture, it is disconcerting to find that the long Preface with which the book opens seems to be almost exclusively about the various disadvantages suffered by Dissenters in not belonging to an Established Church. But although the prominence of this issue in the Preface owed something to the eddying currents of contemporary controversies, Arnold's discussion of it tells us much about the shape of his preoccupations and whole cast of mind. It was not only that the Dissenters, with their strictness of conscience, their puritanism, their narrow biblical literalism, their aesthetic poverty and their cultural provincialism, both largely caused and most powerfully embodied all that Arnold found wrong with the life of the English middle class. It was also, and less obviously, that the very fact of being members of a Dissenting sect was, Arnold argued, a cultural handicap for the Nonconformists themselves.

He was not here referring to any legal or educational disadvantages which the Dissenters had historically suffered from, but which had largely, though not entirely, been removed when he was writing. What he was talking about, and what he characterized quite brillitantly, was the kind of deformation suffered by those who define themselves *primarily* in terms of some sectarian opposition to an established order. What he saw was that those whose fundamental identity was given to them by their status as members of a sect could not help but respond to all ideas and values, and judge all issues, from the constraining vantage-point of the person with a grievance. We are perhaps even more preoccupied than were Arnold's contemporaries with the rights of those who are the victims of various kinds of oppression or deprivation. Arnold was certainly not without sympathy for those who suffered from injustice or unfairness, but he also saw the rather less obvious side of the coin, the way in which the person with a grievance can become the prisoner of that grievance, obsessed with a single issue, consumed by resentment and a sense of exclusion. We see again, as in his notion of criticism discussed in the last chapter, his constant search for correctives to all forms of one-sidedness and obsessiveness.

That the Church of England was the ideal corrective in this case, or even an acceptable one, may seem more doubtful. Arnold's own religious views will be discussed more fully in the next chapter, but his conviction of the *cultural* value of sharing in the traditions and rites of an established church was a central feature of his social criticism. Writing as someone temperamentally antipathetic to both biblical literalism and theological abstractions, Arnold arguably failed to show sufficient sympathy with the views of those for whom these matters were literally more important than life or death; the Dissenter could hardly be responsive to the beautiful cadences of *The Book of Common Prayer* when he believed that its use would entail eternal damnation. But in *Culture and Anarchy*, at least, Arnold was concerned rather with ways of bringing whole sections of the population out of the defensive prickliness of their spiritual isolation and into contact with a larger, more enriching experience, and for this purpose it was perhaps forgivable for Dr Arnold's son to think of the church of Cranmer and the Authorised Version as a civilizing agent.

Of course, the wilful, sectarian temper Arnold was criticizing expressed itself in political as well as religious terms. It issued in the doctrine that Arnold pilloried as 'Doing As One Likes'. This represented that central strain in Victorian political attitudes (powerfully expressed in, but not confined to, the Liberal party) which insisted on the right of the individual to go about his business without let or hindrance from his fellow-citizens or from the state. Clearly, this could issue in a policy of extreme *laissez-faire* in social and economic matters, and this is the aspect of Victorian Liberalism that has most engaged the attention of later historians. But Arnold was, as ever, concerned less with particular policies than with the deeper attitudes they expressed. In this exaggerated individualism he detected both a low aspiration, in being content with one's existing wants, and a kind of hubris in assuming that the isolated individual can adequately determine his pattern of life for himself. The ethos of popular Liberalism – on the one hand jealous of its rights and touchy about being patronized, on the other proud of its material achievements and dismissive of cultivation and refinement – had no room for 'high ideals' or notions of a 'best self', and hence was incapable of rising

to 'the notion, so familiar on the Continent and to antiquity, of the *State* – the nation in its collective and corporate character' (v. 117). *Culture and Anarchy* was a bravura attempt to domesticate these alien notions and to make such elevated language part of the common currency of English thought.

Arnold had the shrewd controversialist's eye for ways of gaining attention for his ideas, and a talent for condensing an argument into a catch-phrase. He was delighted to find that his amusing labels for the three great classes of English society caught on almost immediately ('I think *barbarian* will stick', he informed his mother in 1868 [L i. 450]), but these were if anything overshadowed by a yet more lasting coinage, which again owed its origin to Heine, the binary categories of 'Hebraism' and Hellenism'. These terms characterize the two great traditions of thought and feeling that had influenced the Western world, but also stand for the two tendencies which are constantly struggling for dominance within each individual. His various definitions of these two terms prove, as always in Arnold, to be diverse and not always obviously compatible, but the outlines are clear enough. 'The governing idea of Hellenism', as he puts it most pithily, 'is *spontaneity of consciousness*; that of Hebraism, *strictness of conscience*' (v. 165). Hebraism, that is, fixes above all on the idea of duty, of moral rules, of the subjugation of the self: its chief concern is to act rightly, and the emphasis here falls not only on the 'rightly', but also on the 'acting', for Hebraism is an ethic which stresses the exercise of will. Hellenism, by contrast, concerns itself more with knowledge and beauty, with the play of ideas and the charm of form. Hebraism attacks wrongdoing, moral laxness, and weakness of will; Hellenism attacks ignorance, ugliness, and rigidity of mind. Arnold constantly asserts that society needs a balance between these two forces, since both are essential to the full development of the human spirit, but that it must genuinely be a balance. It will already be obvious that, in his view, Victorian England was far too dominated by the ethic of Hebraism, and his work may be seen as a series of attempts to bring some of the resources of the tradition of Hellenism to bear upon the cramped consciousness of his contemporaries. Actually, although Arnold's explicit and, as it were, official view is that both forces are equally

necessary, the attentive reader of *Culture and Anarchy* cannot help but notice that Arnold's characterizations of Hellenism are far more enthusiastic and favourable than those of Hebraism. In part, of course, this is just because it is Hellenism which he believes to be in short supply among his audience, and he needs to obtain a hearing for its virtues and to get its contribution better appreciated. None the less, his prose betrays a limited sympathy for that Augustinian or Calvinist tendency to repress or root out the rebellious urges in the name of obedience and suppression of self that he finds at the root of Hebraism, whereas the passages in which he tries to express the essence of Hellenism have a constant tendency to become lyrical, as in the following example:

> To get rid of one's ignorance, to see things as they are, and by seeing them as they are to see them in their beauty, is the simple and attractive ideal which Hellenism holds out before human nature; and from the simplicity and charm of this ideal, Hellenism and human life in the hands of Hellenism, is invested with a kind of aerial ease, clearness and radiancy; they are kept full of what we call sweetness and light. (v. 167)

Arnold's adjectives in this passage all evoke, perhaps a little over-insistently, visions of lightness, clearness, brilliance, simplicity; it is the sort of language the guide-books use when they want to describe the impression made by a Greek temple in Mediterranean sunlight, and it can, of course, have the same unfortunate effect on the counter-suggestible reader. But these invocations of the clean lines and serene forms of Greek art may have stirred more powerful resonances among Arnold's classically-educated audience, and certainly they express a deep affinity of his own temperament.

The characterization of Hellenism just quoted also includes another famous Arnoldian phrase, 'sweetness and light'. This became one of those tags that he played with over and over again, a kind of code for what he wanted to identify as the peculiar deficiency of 'the bad civilisation of the English middle class'. It is unfortunate, I think, that the words 'sweetness and light' now have a somewhat unctuous, almost genteel, even anaemic air about them; they suggest too much the mild uplift dispensed by that kind of wet do-gooder who never seems to have felt the pull

of any real human appetites. But these were not the connotations Arnold had in mind: indeed, he appropriated the terms (from Swift's fable of the bee and the spider in *The Battle of the Books*) to make a contrast with some of these qualities – he wanted them to stand for gaiety rather than solemnity, for knowledge rather than righteousness, for pure, useless self-exploration rather than corrective, functional, self-improvement. In Arnold's later writings, this strain tends to get overshadowed, even at times displaced, by a more sombre set of preoccupations as he dwells on the need for that 'something not ourselves that makes for righteousness' and for that 'high seriousness' that he looked for in great literature. But in the 1860s he still handled these issues with a lighter touch, and the author of *Culture and Anarchy* manifestly preferred to loll on Parnassus than to crawl up Calvary. Hebraism is, after all, hardly the natural home of the dandy, even the reformed dandy turned cultural critic.

Arnold's Hellenism is not without its problems, however. The Greeks are the unacknowledged heroes of *Culture and Anarchy*, and Arnold has been reproached more than once for adopting a 'Greeker than thou' tone. Although much of his perception of the Greeks was widely shared among their nineteenth-century European admirers – and his work played a significant role in turning these perceptions into the commonplaces of English literary criticism – it is worth remarking how selective, even tendentious, his account was. The language he uses to characterize and celebrate their never-to-be-repeated achievements constantly dwells upon their balance, control, serenity. His famous praise for Sophocles, we recall, was for his ability to 'see life steadily and see it whole', and he endlessly returns to this emphasis on steadiness and balance rather than any unbalancing extremes of passion, displaying always his familiar bias towards unity and wholeness rather than towards any more selective, one-sidedly penetrating and creative play of energy. 'The bent of Hellenism is to follow, with flexible activity, the whole play of the universal order, to be apprehensive of missing any part of it, of sacrificing one part to another' (v. 165).

As an interpretation of the essential qualities of Greek art and thought this could be, and has been, challenged. To contrast with

what Arnold calls 'the Greek quarrel with the body and its desires', it would not be too difficult to assemble a different picture that placed their pagan sensuousness in the foreground, or even to focus upon what Nietzsche was soon to call their 'Dionysiac' qualities. Similarly, one could give an account of the great Greek tragedians which emphasized much more their bleak perception of the savage arbitrariness of life rather than a calm vision of seeing it steadily and seeing it whole. The truth surely is that this characterization expresses a deep yearning of *Arnold's* towards these qualities, at least as much as it provides an objective appraisal of the Greeks. It is he, rather than Sophocles or Thucydides, who is 'apprehensive' of getting things out of proportion.

The term, to come to it finally, which stands for the animating idea of the book, the term with which Arnold's name is now indissolubly linked, is, of course, 'culture'. In one of his many phrases which have subsequently become part of our common language, Arnold said that by culture he meant 'the best that has been thought and said'. In implicitly assigning priority to the literary and philosophical over the visual and musical, the phrase faithfully represents Arnold's own cultural tastes, yet in other ways it expresses rather poorly the richness of the idea behind his use of 'culture'. For he treats culture not just as something that we can acquire or possess, but as something that is an active force in its own right. One indication of this is the frequency with which he uses the word with an active verb: culture '*endeavours* to see and learn, and to *make* what it sees and learns prevail', culture '*conceives* of perfection . . . as a harmonious expansion of all the powers which make the beauty and worth of human nature', 'culture has a rough *task to achieve* in this country', and so on.

This simple stylistic fact alone should suggest that he is not talking about some passive body of art and learning whose natural home is the museum and the library, nor simply a set of high-status social activities encased in an aura of snobbery and pretentiousness. He is talking, rather, about an ideal of human life, a standard of excellence and fullness for the development of our capacities, aesthetic, intellectual, and moral. The ideal which culture holds up before us is that of 'perfection' or the 'harmonious expansion of *all* the powers which make the beauty and worth of

human nature' (v. 94). Of course, the assumption that *all* our capacities could even in principle be compatible with each other is itself doubtful, unless, with a hint of circularity, there is an implicit restriction to our 'positive' capacities. In his other works, Arnold, like several other prominent Victorian moralists, oscillated a little unsteadily between, on the one hand, affirming the possibility of a harmonious development of *all* our impulses, and, on the other, endorsing the view that the self was a battleground where the forces of the higher self of conscience and rationality were perpetually in conflict with those of the lower self of appetite and animality. I have already suggested how, in some of his later writings, which were the work of a more sombre Arnold, sobered by bereavement and prolonged meditation on religion, he most often inclines to the latter view. But in *Culture and Anarchy*, it is the former view which predominates, partly because he defines perfection as 'the growth and predominance of our humanity proper, as distinguished from our animality' (v. 94), but also perhaps because he is, so to speak, rhetorically on the attack, trying to raise both the tone and the stakes rather than to lower them.

He recognized, of course, that even in this active sense culture is not innate: it is something a true understanding of which is only acquired by effort and by exposure to the results of the efforts of previous generations. But it is certainly something that is, in his view, within reach of everybody, given the right opportunities, not something confined to a small class. 'The great men of culture', as he put it in an important passage,

are those who have had a passion for diffusing, for making prevail, for carrying from one end of society to the other, the best knowledge, the best ideas of their time; who have laboured to divest knowledge of all that was harsh, uncouth, difficult, abstract, professional, exclusive; to humanise it, to make it efficient outside the clique of the cultivated and the learned, yet still remaining the best knowledge and thought of the time, and a true source, therefore, of sweetness and light. (v. 113)

This passage also suggests some of the deeper connections between his notion of culture and the ideal of criticism he had explored in his earlier works. In making 'the best thought of their time' available to a wider audience, what is it that the great men

of culture have had to divest it of? The list of adjectives is very striking, and at first sight somewhat heterogeneous: they have divested it of 'all that was harsh, uncouth, difficult, abstract, professional, exclusive'. Now, 'harsh' and 'difficult' are the sort of adjectives we might expect in such a sentence; the best thought may need to be made a little more accessible and attractive. Similarly, perhaps, 'abstract' is not an altogether surprising term here: Arnold means not only abstract in form, as the work of many of the great philosophers may be, but also abstract in the sense of too removed from the realities of life, too much concerned with the intellectual values of system and coherence at the expense of recognizing the disorderly actuality of the world. 'Uncouth' is a bit more surprising, suggestive at first of social rather than intellectual defects, but I think in the context it is clear that it means something more like 'badly expressed', 'jargon-ridden', 'too internal to the preoccupations and language of one individual or group'. These are in fact all ways of being inaccessible, of being something which only the insider can understand; much writing by academics may in this sense rightly be called uncouth. It is at first sight more surprising to find a term like 'professional' in this list, since we may have come to think of it as an entirely positive quality. But by placing it in such company Arnold precisely draws attention to the sense in which it represents a very questionable value. What links all these terms is the idea that knowledge, the best thought of the time, the best that has been thought and said, should not be imprisoned in a form of expression that is specialized, technical, idiosyncratic, or private, but should rather be accessible, shareable, public – part, as we have since come to say, of a common culture.

Analysing his idea of culture in this way also makes clear just how it could be expected to provide what, on Arnold's diagnosis, Victorian England most lacked. In contrast to the cramped and limited models of human excellence provided by the traditions of provincial, Dissenting England, culture would make available a larger, richer sense of human possibilities. In contrast to the parochial, second-rate kinds of art and literature favoured by current middle-class taste, culture would hold up the standard offered by the very greatest achievements of the human spirit in its long history. In contrast to the divisive, sectarian, tiresomely

controversial spirit fostered within the confines of individual religious denominations, political parties, or social classes, culture would act as a unifying force, replacing the parochial with the universal, the sectarian with the national, the exclusive with the inclusive. This idea of the capacity of culture to unify and heal the divisions in society has been (as we shall see in Chapter 7) one of Arnold's most potent legacies.

'A Liberal of the Future'

The question of where the author of *Culture and Anarchy* should be placed in the political spectrum as conventionally understood puzzled some of its first readers, and has continued to vex commentators ever since. The fact that his most vehement critics at the time would all have described themselves as Liberals, and that the work was praised by the Tory leader Disraeli, does not by itself establish the book's conservative identity, though it indicates why the question insists on being asked. Arnold, of course, had already laid it down that criticism remained true to itself by 'keeping aloof from what is called "the practical view of things"', but in practice he was certainly not above using his lofty vantage-point to broadcast judgements on several of the great issues of the day, especially in the last decade of his life when he was a well-known public figure whose utterances were eagerly solicited by the editors of the leading reviews. The political writings of Arnold's last years share the defects of his late literary essays: they can be formulaic and repetitive, indulging a propensity for sententious windiness that the easy availability of recognized pulpits always seems to encourage. But they can also be trenchant and outspoken, and reading them should certainly dispel any lazy notion that Arnold's elevated notion of the state entailed an uncritical endorsement of the conventional wisdom of the governing class of his day.

The difficulty of encompassing Arnold's political thought with any of the conventional labels is acutely illustrated by the juxtaposition of his important essay on 'Equality' (1878) with his later writings on Ireland. 'Equality' expressed a view that was deliberately heterodox and remarkably radical (the more so for the fact that it was first given as an address to the gathering of scientists,

literati, and members of high society who made up the audience at the Royal Institution). It consisted of a sustained denunciation of the extreme inequality of the distribution of property in Britain, and of the impress which that had left on social relations. 'Our inequality materialises our upper class, vulgarises our middle class, brutalises our lower' (viii. 302). He particularly deplored the way in which the laws of bequest and inheritance permitted and even encouraged this excessive concentration of property in a few hands, and, as so often, he made his point by means of a running contrast with France where the law reinforced tradition to prevent such concentration, and where social life was consequently much freer and less deferential. In this essay, Arnold was willing to be entirely pragmatic about what system of property-holding it may be in society's interests to endorse, a view which it is perhaps surprising but certainly creditable to find a hard-pressed man of letters extending, in a companion piece on 'Copyright' (1880), to intellectual property as well. (More predictably, this latter article argued for those two perennial wants of the book-writing class, lower prices and better legal protection against pirated foreign editions.)

Ireland taxed the judgement and tolerance of all English politicians and political thinkers in the late nineteenth century, and brought out a revealing mixture of responses in Arnold. He was sympathetic to Irish grievances and critical of the twin pillars of the Protestant Ascendancy, the Irish (i.e. Anglican) church and the English landowners. He particularly attempted to modify English prejudice against Catholicism (a religion whose aesthetic richness and close ties of the European culture tradition he anyway found more appealing than most forms of Protestantism), and at times one cannot help feeling that his sympathy for the Irish cottier comes as much from a sense that he is a fellow-victim of English puritan bigotry as from any closer understanding of his economic hardships. At the same time, the Arnold who regarded 'anarchy' as the worst of all political conditions, and who upheld the doctrine of 'force till right be ready', condoned the fierce enforcement of the law in Ireland, including the suspension of civil liberties, when faced with the organized campaign of disruption in the 1880s, and he was an unyielding opponent of Gladstone's scheme for Home Rule. Like many mid-century liberal intellectuals, he was in his

last years profoundly alienated from what he perceived as Gladstone's demagogic brand of Liberalism.

Since so much of Arnold's writing was a kind of prolonged family quarrel with the English middle class, he was bound to have intimate but complex relations with that class's chief political expression, the Liberal Party. His many descriptions of himself as a Liberal invariably arrive towing some qualifying phrase behind them – such as 'a Liberal tempered by experience', or, in a phrase he particularly favoured, 'a Liberal of the Future' (e.g. ix. 138). Some of his critics might have preferred to rephrase this in the formula of 'Lord give me Liberalism, but not yet', so fastidiously dissatisfied was he with most incarnations of Liberalism in the present. But he saw it as his role to stand back from the fray and tell the Liberals some unpalatable truths about the narrowness of their views, and conservatives are always ready to seize with delight upon those who presume to criticize radical orthodoxies. But Arnold was no friend to Toryism. The Liberals 'at best . . . are in a very crude state', he wrote to his sister (not altogether tractfully, since she was married to one of their leaders), 'and with little light or help in them at present. But through their failing, and succeeding, and gradual improvement lies our way, our only way; I have no doubt of that.' (ix. 370)

Certainly, some of the presiding spirits who did most to influence his social thought make, when taken together, what might seem to be an odd pedigree for a Liberal: Burke, Newman, Carlyle, to name the most obvious. Actually, he had never been entirely comfortable with the blacker side of Carlyle's reactionary politics, and explicitly repudiated his increasingly unconfined authoritarianism. Similarly, for all his reverence for John Henry Newman, both personally and as the embodiment of the spirit of his beloved Oxford, Arnold was undeniably and unshakeably a liberal in the intellectual and religious senses which Newman had spent his life denouncing, and implicitly he ranged himself on the side of Goethe and Heine and all those whom he described (borrowing yet another phrase of Heine's) as 'soldiers in the Liberation War of humanity' (iii. 107) for their attempts to carry through the best features of the programme of the Enlightenment.

His relation to Burke is more teasing. He fully shared the deep

admiration that was so common in nineteenth-century England, calling him 'our greatest political thinker' (ix. 287), quoting him often, and, suggestively, taking from him the epigraph to both *Essays in Criticism* and *The Popular Education of France*. But as these and the other contexts in which he cites him make clear, Arnold valued Burke as a writer and as one who 'treats politics with . . . thought and imagination', and not, as he has increasingly been treated in the twentieth century, as the chief source for conservative political theory. Arnold noticeably preferred Burke writing about Ireland or America, where he displayed a magnanimity and balance Arnold could identify with, to Burke writing about France, where both Arnold's general Francophilia and his specific enthusiasm for 1789 were sorely taxed ('there is much in his view of France and her destinies which is narrow and erroneous' [L i. 250]). No writer who believed, as Arnold did, that the French Revolution was 'the greatest, the most animating event in history' could be regarded as an unproblematic disciple of Burke, still less could he be anything but an extremely awkward recruit to the ranks of conservatism.

As Arnold himself rightly observed, the notion of the state that he was struggling to introduce into English life was 'familiar to Antiquity and on the Continent'. It has been well said of Arnold that he had a strong, almost Roman, sense of the state, but little feel for the people: in this sense, he was a republican but not a democrat (the influence of his father, the historian of the Roman Republic, was strong here). Even more marked were his affinities with that Idealist tradition of political thought that stretches back from, most notably, Hegel and Rousseau to Aristotle and, above all, Plato. Though he found systematic philosophy uncongenial, Arnold was temperamentally something of a Platonist, with all the Platonist's vulnerability to being dazzled by the beauty of his own ideals to the neglect of their abuse in practice. This surely helps to explain why Arnold has attracted charges of authoritarianism. But this deep intellectual affinity also suggests what might be described as the 'anti-political' character of his thought.

This is well caught in a passage in *Culture and Anarchy* where he is talking about what is involved in coming to recognize ourselves as members of a state in his elevated sense. We come, he

wrote (here very much the residuary legatee of Broad Church historiography and hence, indirectly, of German Idealism), 'to make the state more and more the expression, as we say, of our best self, which is not manifold, and vulgar, and unstable and contentious and every-varying, but one, and noble, and secure, and peaceful, and the same for all mankind' (v. 224). The five negatives in the first part of this sentence all suggest something similar, and their juxtaposition here expresses a deep aversion of Arnold's – an aversion to conflict, cantankerousness, disorder; or, in a word, to anarchy. Arnold's own temperamental affinity for the opposite of these characteristics is evident in the five positive terms in the latter part of the passage, which are all suggestive of rest and order, and, once more, of his deep feeling for centrality and unity.

This helps us to draw several features of his work together. We are reminded of the neoclassical aesthetic of his literary criticism, with its professed desire, not always realized, to get beyond any personal qualities or idiosyncrasies of the critic – or even, in a sense, of the writer – in order to display what is permanent and universal. Similarly, one can see his conception of the state as in some ways the political equivalent of 'the grand style'. It is also another facet of that classicism that leads him to overvalue balance, achieved form, and the perfect proportions of the finished object, and to undervalue the untidy but possibly creative experience of searching and struggling. No one with such a strong aversion to conflict as Arnold came to manifest could be an altogether satisfactory writer on politics, but the fact remains that his deep feeling for order and wholeness, and still more his acuity in discerning the emotional and psychological roots of political attitudes, did enable him to characterize the contentious public life of his time with a sharpness and stylishness which have set something of a standard for social critics ever since.

6 The religious critic

The passions of the Victorian reading public could be stirred by religion as by no other subject. Our own more secular age can easily underestimate the force and pervasiveness of nineteenth-century religion and religiosity: it was a society in which a new work of Biblical exegesis could be a best-seller, and where volumes of sermons and theological tracts far outsold novels and other genres. Many of the great intellectual controversies of the century were either directly about religion, or else were given an extra dimension of intensity by their bearing on religious belief: the debate over Darwin's theory of evolution by natural selection is the most obvious example, but the point can be illustrated by episodes in which the Arnold family was more directly involved, from the Tractarian storms of the 1830s, through the scandal of Bishop Colenso's study of the Pentateuch in the 1860s, to the immense vogue of *Robert Elsmere* (a novel by Arnold's niece, Mrs Humphry Ward, about loss of faith) in the 1880s. Furthermore, many of the major political issues of the period revolved around the endorsement and enforcement of religious beliefs and practices: from the skirmishes over Catholic Emancipation in the 1820s to the protracted haggling over the question of allowing an avowed atheist to take his seat in Parliament in the 1880s, Arnold's lifetime was puncuated by political crises about what it meant to be an officially Christian, indeed Anglican, state.

As we have already seen, Arnold had risked the displeasure of large elements of this Christian audience in his literary and social criticism of the 1860s. Indeed, some of his literary judgements seemed like deliberate provocations to the pious, as, for example in taking a pagan like Marcus Aurelius as a model of spirituality, while his campaign against the narrowness of the Dissenters, culminating in the polemical Preface to *Culture and Anarchy*, had antagonized the most vociferous religious body in the land. But in the 1870s Arnold went further still. He challenged what most of

his contemporaries took to be the central doctrinal tenets of Christianity, and he treated the Bible as a literary text like any other. What is intriguing – and what to some readers at the time and since has seemed baffling and perhaps not entirely credible – is that he followed this path in the hope of rescuing Christianity from the abyss of unbelief, and of securing for the Bible its proper place as the pre-eminent sacred book.

The result was that his religious criticism of the 1870s was at once his most popular and his most unpopular writing. Only when he moved on to directly religious topics did he enjoy immediate and significant commercial success as an author. *St Paul and Protestantism* (1870) was the first of his works to go through more than one edition in the year of publication, while *Literature and Dogma* (1873) sold more than any of his writings in his lifetime: by the early twentieth century, sales of this book (including the shortened popular editions Arnold brought out, and the large number of pirated reprints in the United States) probably exceeded 100,000. At the same time, Arnold became the target of sustained criticism and denunciation by representatives of almost every denomination of Christian: several readers, including one bishop, cancelled their subscription to the periodical in which his articles first appeared, and even in the 1880s Arnold recognized that he could not be considered for a certain public appointment because the outcry from the Dissenters would be too strong. Yet he genuinely believed that he was helping to strengthen rather than weaken the position of the Church, and his mother may not have been so wide of the mark, all allowance being made for her fond wish that the son of Dr Arnold should not stray too far from the fold, when she insisted that 'Matt is a good Christian at bottom'.

Whether, or in what sense, Arnold should be described as a Christian does not now seem a very profitable question (on most orthodox definitions he certainly wasn't, on some more Modernist definitions perhaps he was). In so far as Arnold had any identifiable cosmological or metaphysical ideas – which wasn't in fact all that far – he was some kind of Spinozist, finding very congenial Spinoza's mixture of devotion to virtue and vaguely pantheist belief in a natural order in the universe, 'the stream of tendency', in a phrase Arnold was fond of repeating, 'by which all things seek

to fulfil the law of their being' (e.g. vi. 10). But he recognized that this kind of rarefied intellectual creed was only likely to speak to a small minority, and his writings on religion are largely concerned with the majority whose chief need he identified as being for a source of that 'joyful and bounding emotion' (iii. 134) which would enable them to respond to the demands of morality.

In general, it now seems that it was where he turned to address eternal questions that he has dated most. Yet his writings on religion reveal the continuity of his preoccupations, as well as the qualities and limits of his mind. In this work we see again his constant concern for the spirit in which a belief is held rather than for the letter of dogma, his abiding sense of the narrow limits of intellection, and his emphasis on experience, judgement, and sensitivity rather than theory, doctrine, or literalism. His writings about the Church of England display in another form his desire for inclusiveness and unity, and his antipathy to sectarianism and partisanship. But we also find, perhaps, some insensitivity to the feelings of exclusion among those less central than himself, as well as a culpable lack of rigour with questions that are unavoidably abstract, and traces of an increasingly exigent moralism that constrained the 'flexibility' that he had urged and embodied in his earlier work.

St Paul and Protestantism

In some ways, the long Preface to *Culture and Anarchy*, which was written at the end of 1868, should be considered as the first of Arnold's religious criticisms, since, as we have seen, it was a sustained coloratura on the disadvantages, both to the Dissenters themselves and to the rest of the nation, arising from the continued separation of the Nonconformists from the Church of England. *St Paul and Protestantism* (1870) was a natural extension of the argument of that Preface. It is a work which can best be characterized as an attempt to outflank the Dissenters intellectually.

The bedrock of their position was that they refused to join the national church because it did not teach the true Gospel; they were the Children of the Word, and they took their stand on their text. But what, asked Arnold suavely, if they have misinterpreted

their text? What if the very points of doctrine on which they ground their continued separation prove to be misreadings? The extremer varieties of Protestant made the doctrines of predestination and salvation by faith central, and they claimed the authority of St Paul for so doing. But, argued Arnold, they have made the mistake of turning what was the eloquent expression of emotion in Paul into the elaborate intellectual construction of doctrine. 'What in St Paul is figure and belongs to the sphere of feeling, Puritanism has transported into the sphere of intellect and made thesis and formula' (vi. 8). The whole Calvinist position arises out of inadequately sensitive literary criticism: the mistake has been made by those 'who have not enough tact for style to comprehend his mode of expression' (vi. 22). This has led them further to overlook the fact that Paul was not primarily concerned with such abstract questions as the niceties of different doctrines of salvation, but with 'righteousness'; here we encounter the first of Arnold's many redefinitions of religion when he somewhat tendentiously declares 'Religion is that which binds and holds us to the practice of righteousness' (vi. 33). Calvinism has reared an ingenious system of reasoning, but reasoning is not the essence of religion: St Paul's teachings need to be 'disengaged from the elaborate misconceptions with which Protestantism has overlaid them' (v. 5).

But the Puritans were not only poor literary critics: they were also stiff-necked and self-important in matters of practice. Here, Arnold revised the dominant Whig historiography, which tended to see the Puritans in the late sixteenth and early seventeenth centuries as the victims of persecution, in the face of which the more general rights of free speech and religious toleration had slowly been won. Arnold emphasises rather the way in which it was the Church of England which in the seventeenth century was the more pluralist and open to development and flexibility in theological matters, and the Puritans who had been rigid and uncompromising. Moreover, the Puritans had repeated their mistake of regarding points of 'opinion' as crucial, whereas Arnold again insisted that the Church 'exists not for the sake of opinion but for the sake of moral practice' (vi. 97), thereby tilting the scales of the argument against the Dissenters from the start. The Puritans

had stood out, as their latter-day descendants continued to do, on points of doctrine concerning church organization, which, Arnold insists, is only a secondary issue, not a primary one.

Throughout, his emphasis is on the attitude or cast of mind expressed in and encouraged by the Dissenters' antagonistic relation to the Establishment. Indeed, even when discussing free-thinkers it is this rather than the *content* of their beliefs that he concentrates on, as where he says: 'For instance, what in Mr Mill is but a yielding to a spirit of irritable injustice, goes on and worsens in some of his disciples till it becomes a sort of mere blatancy and truculent hardness in certain of them' (vi. 126). Arnold's fine ear for the nuances of emotional tone and psychological attitude caught the character of much nineteenth-century secularism very well here, and in another telling passage he uncovered the psychological dynamic at the root of much sectarianism, religious and political. What is it, he asks that

the everyday, middle-class Philistine . . . finds so attractive in Dissent? Is it not, as to discipline, that his self-importance is fomented by the fuss, bustle and partisanship of a private sect, instead of being lost in the greatness of a public body? As to worship, is it not that his taste is pleased by usages and words that come down to *him*, instead of drawing him up to *them*; by services which reflect, instead of the culture of great men of religious genius, the crude culture of himself and his fellows? And as to doctrine, is it not that his mind is pleased at hearing no opinion but its own, by having all disputed points taken for granted in its own favour, by being urged to no return upon itself, no development? (vi. 122)

Literature and Dogma

Hardly surprisingly, *St Paul and Protestantism* won Arnold few friends among the Nonconformists, but hasty readers within the Establishment could take comfort and delight from it. However, before long many of them were also to be calling for his blood. St Paul's Epistles were not, after all, the only text which the literary critic might find the theologians had misinterpreted. Moreover, Arnold was broadening the scope of his religious criticism on other counts, too. Where he had previously been disturbed primarily about the consequences of the Dissenters' exclusion from the national church, he now turned to the problem of the threat posed

to all forms of Christianity by the increase of unbelief. This was, of course, a topic that much agitated Victorian intellectuals, and there was a particular fear that the working class was growing increasingly indifferent to religion. But in Arnold's view it was orthodox theology that was at fault here. It tied Christianity to the literal truth of the Bible; as it became less and less possible, in the face of both modern science and modern historical scholarship, to adhere to the Bible as a guide in matters of fact, so belief in Christianity would decline, and the influence of the Bible would be lost. Arnold always accepted that it was useless quixotically to throw oneself across the path of the *Zeitgeist*: it was impossible now for the reasonable person to be a Biblical literalist. But perhaps such a reading of the Bible had been, as he put it, 'an immense literary misapprehension' (vi. 276) in the first place. *Literature and Dogma* was the critic's attempt to repair the damage before it was too late. There is a case for saying it is his most extended single work of literary criticism; certainly no single text engaged his critical energies to anything like the same extent as did the Bible.

As part of his criticism of Hebraism in *Culture and Anarchy*, Arnold had already taken his stand by the maxim 'no man, who knows nothing else, knows even his Bible' (v. 184), and in this respect the later book is an extended demonstration of what culture can do.

To understand that the language of the Bible is fluid, passing, and literary, not rigid, fixed, and scientific, is the first step towards a right understanding of the Bible. But to take this very first step, some experience of how men have thought and expressed themselves, and some flexibility of spirit, are necessary; and this is culture. (vi. 152)

But it is not only the literalist who may misjudge the meaning of the Bible: those scholars who commanded nothing but erudition (his readers hardly needed to be told that this was aimed at the Germans, but he told them anyway) also lacked the necessary 'justness of perception', that 'power to estimate the proportion and relation in what we read' (vi. 153, 158). Here, as elsewhere, Arnold was disparaging about the squint-eyed vision of the specialist.

A sophisticated grasp of the place of metaphor and symbol in religious language is one of the great strengths of *Literature and*

Dogma. Eschewing theology, it repeatedly falls back on 'experience', though in a spirit far removed from that of reductive empiricism. In its dealings with religious belief it talks more of 'feeling' than of 'thinking'. On point after point, Arnold demonstrates the yield from adopting a more imaginative, comparative reading of the Biblical texts, most consequentially in dealing with the very conception of 'God'. In his view, the Jews 'began with experience', and used metaphor and symbol to translate this experience into poetry; it was later theologians who then sophisticated this into an elaborate theory, purporting to have the standing of a scientific explanation, of an omnipotent God. The 'tact' of the critic was, therefore, now required to re-capture the meaning of the original forms of expression, and what this revealed, as he put it in a forceful passage, was that

the word 'God' is used in most cases as by no means a term of science or exact knowledge, but a term of poetry and eloquence, a term *thrown out*, so to speak, at a not fully grasped object of the speaker's consciousness, a *literary* term, in short; and mankind mean different things by it as their consciousness differs. (vi. 171)

What, notoriously, he concluded to have been the essence of the experience which the Old Testament authors had sought to capture with their use of the term 'God' was 'a consciousness of the not ourselves that makes for righteousness' (vi. 196). Many readers at the time and since have felt that this formula strips the traditional notion of God of all that is wonderful and compelling. Certainly, as a way of 'lighting up morality' there might seem doubtful advantage in replacing the bearded patriarch of popular imagination with the impersonal reach of the long arm of the Law.

His treatment of the New Testament has particularly won admiration from later commentators. One of his most radical contributions here was his insight that 'Jesus was over the heads of his reporters' (e.g. vi. 260). The Jews constantly denatured Jesus's novel teachings by assimilating them to their established categories and expectations, yet despite this, the force of Jesus's message had left its mark in the Gospel record. Jesus brought an inwardness to what had been the sternly legalistic public code of Jewish morality; his characteristic tone Arnold aptly characterized as

'sweet reasonableness'. In all this it is noticeable how Arnold responded with particularly keen appreciation to the poet who wrote the Fourth Gospel, partly, perhaps, because the soaring style of his mysticism confounded the literalists at every turn.

Reading *Literature and Dogma* alongside Arnold's earlier works, one sees that just as he called upon criticism to deliver the truth of the Bible from the clutches of the literalists and the pedants, so in return he exploited its success in this task to make a point in his larger campaign on behalf of criticism's cultural role. The Bible yields its full riches only if read 'with the tact which letters, surely, alone can give', and he was not loath to press the point.

For the thing turns upon understanding the manner in which men have thought, their way of using words, and what they mean by them. And by knowing letters, by becoming conversant with the best that has been thought and said in the world, we become acquainted not only with the history, but also with the scope and powers of the instruments which men employ in thinking and speaking. (vi. 196)

Once again we are reminded that Arnold was not talking about 'literary criticism' in any narrow modern sense.

Indeed, much of the book is taken up with a selective intellectual history of the Western Church, showing how successive generations imposed their own constructions on the literary creations of the ancient Jewish authors. Popular Christianity, especially, became weighed down with this *Aberglaube*, the accretion of supernatural and superstitious beliefs that had grown up around the simplicity of the original message, a message that spoke above all of 'righteousness'. Arnold was insistent that 'the antithesis between *ethical* and *religious* is thus quite a false one', and this led him to his famous definition of religion as 'morality touched by emotion' (vi. 176). This high-sounding tag (Arnold's talent, or weakness, for condensing an argument into a formula never deserted him) has come in for severe criticism, most damningly (originally by F. H. Bradley) for being a tautology. The charge is that Arnold could not have meant touched by just *any* emotion (which he surely did not), but, rather, touched by *religious* emotion, and therefore the definition is circular. The case may not be quite so desperate, though precision and consistency of reasoning

in such matters was admittedly not Arnold's forte. But it seems (as we shall see towards the end of this chapter) that Arnold had in mind a more general kind of heightened emotion, a rising above our ordinary selves, the kind of feeling that in his view poetry (we might feel inclined to say art more generally) has a particular capacity to arouse in us. Such emotion inevitably brings with it a hovering awareness of something 'not ourselves'.

But this, of course, is already to begin to divest religion of any particular doctrinal content. There is a telling moment in *Literature and Dogma* when, in discussing what he sees as a false antithesis between natural and revealed religion, he says that 'religion springing out of an experience of the power, the grandeur, the necessity of righteousness is revealed religion, whether we find it in Sophocles or in Isaiah' (vi. 195). But this begs the whole question for the believer for whom the uniqueness of the Bible resides in the fact that it is the word of *God*, by comparison with which a work by some pagan dramatist has no standing, be it no matter how moving and effective in inciting us to righteousness (a highly contestable reading of the effect of a Sophoclean tragedy anyway).

Seen thus, Arnold's whole enterprise was anathema to the orthodox: it was bad enough to treat the Bible as a text like any other, worse still to treat it as a text by several authors. There was already, of course, a very considerable tradition of the so-called Higher Criticism of the Bible in the nineteenth century, though Arnold was irritated when people assimilated his work to that of the German scholars (for whom his esteem was limited), insisting that he was but developing the tendency of English Broad Church theology, with the aid of Spinoza (Arnold's protestations could not altogether hide the fact that his father, whose work he thus claimed to be continuing, had believed in a far more straightforward sense in the *truth* of Biblical revelation). Still, as the storm of controversy that greeted Jowett's contribution to *Essays and Reviews* in 1860 revealed, the application of ordinary standards of textual criticism to the Bible was far from being an accepted part of English intellectual life, and Arnold appeared to go much further than a liberal churchman like Jowett. Indeed, after the first two instalments had appeared as articles in the *Cornhill Magazine*, the

editor decided against continuing the series, presumably for fear of too greatly offending the orthodox among his readers. As a consequence of this loss of his normal periodical outlet, *Literature and Dogma* is the only one of Arnold's major works that was actually written as a book.

But Arnold puzzled his readers, for he protested that he was trying to save 'the natural truth of Christianity', yet seemed to be setting aside all its distinctive doctrines. This, as well as Arnold's occasional preciosity, was wickedly caught in W. H. Mallock's satire, *The New Republic*, where he has the Arnold-figure, 'Mr Luke', say: 'It is true that culture sets aside the larger part of the New Testament as grotesque, barbarous and immoral; but what remains, purged of its apparent meaning, it discerns to be a treasure beyond all price.' There is shrewdness here, as there is in Lionel Trilling's later rhetorical question: 'Will men build Chartres to "a power not ourselves that makes for righteousness"?' Arnold wanted there to be religious emotion, but he wanted it to be stirred by things in which it is reasonable to believe; there may be loss as well as gain in this.

In *God and the Bible*, published two years later in 1875, Arnold responded to criticism of *Literature and Dogma* and elaborated some of its themes further, but restatement only compounded his offence in the eyes of the orthodox. The book did reveal his surprising mastery of the technicalities of Biblical history and textual criticism, but it reiterated that this was all in the service of a practical goal, 'to restore the use of the Bible to those (and they are an increasing number) whom the popular theology with its proof from miracles, and the learned theology with its proof from metaphysics, so dissatisfy and repel that they are tempted to throw aside the Bible altogether' (vii. 143). Arnold took very seriously the task of making the Bible effective at the popular level. The establishment of compulsory elementary education by the Act of 1870 gave him a sense of urgency about the task: the Bible, he observed, is 'for the child in the elementary school almost his only contact with poetry and philosophy' (vii. 412). He therefore prepared a more accessible edition of the last 27 chapters of the Book of Isaiah in the Authorised Version as a Bible-reading for schools in 1872, and in 1883 he published his version of the first

66 chapters. That he should invest so much of the limited time available for his own writing in a project of this kind is itself an indication of the importance he attached to keeping alive some source of religious emotion for the unlearned masses, something that needs to be borne in mind in reading his writings on religion more generally.

A national institution

'A man who has published a good deal which is at variance with the body of theological doctrine commonly received in the Church of England and commonly preached by its ministers, cannot well, it may be thought, stand up before the clergy as a friend to their cause and to that of the Church' (viii. 65). But this is just what Arnold did, though evidently he could not altogether keep a smile out of his prose. In an address to Anglican clergymen, the author of *Literature and Dogma* explained why he valued the Established Church so highly. To be sure, his reasons were not their reasons: he called it 'a great national society for the promotion of goodness' (viii. 67), a playful use of the language of Victorian pressure-groups that no doubt grated on some of his clerical audience. But Arnold did genuinely value the Church of England, and it had a special place in his imaginative sympathies, both because it was a church and not a sect, and because it was the historic church of the English people. To some extent, his attachment was to an idealized Anglican Church rather than to the real thing, just as his reverence for Oxford was, in many ways, for an Oxford of the mind. He was well aware, and deplored, that, as he put it in 1871, Anglicanism's 'Tory, anti-democratic and even squirearchical character is very marked' (UL 57), and as he had drily observed some years earlier: 'It is not easy for a reflecting man, who has studied its origin, to feel any vehement enthusiasm for Anglicanism; Henry the Eighth and his parliaments have taken care of that' (ii. 320). None the less, he was true to his Broad Church, and hence ultimately Coleridgean, lineage in being convinced of the need for an established church as 'a beneficent social and civilising agent' (ii. 321).

Once again, Arnold's feeling for 'centrality' and 'comprehensiveness' manifested itself here. Those who are born within one of 'the

great nationally established forms of religion' can 'get forward on their road, instead of always eyeing the ground on which they stand and disputing about it' (ii. 321);. sharing its traditions and its discipline helps one 'to eschew self-assertion' (viii. 85). As the reference to 'forms' in the plural indicates, Arnold's argument was frankly cultural not theological: different churches were, for reasons of history and national character, suited to the needs of different countries. The Anglican Church did not offer the unique road to salvation; indeed, a too zealous insistence on the exclusive doctrinal correctness of one's preferred religion was the cloven hoof of sectarianism. But in England the Anglican church had provided 'a shelter and basis for culture', and there was still no agency that could rival its moral and aesthetic impact upon the majority of the population.

The shape of Arnold's concern about this last aspect of the Church's role is nicely illustrated in his discussion of an issue that may now seem to be of barely antiquarian interest. Under legislation dating from the Restoration, Dissenters could only be buried in English churchyards if the Anglican incumbent officiated, using the service prescribed in the Book of Common Prayer. Dissenters naturally pressed to be able to conduct their own services using their own liturgy. Although Arnold was willing to make many practical concessions to the Dissenters in an attempt to remove their crippling sense of grievance and perhaps eventually incorporate them in the national church, he objected to Parliament officially endorsing the use of the Dissenters' liturgy at public burial services, because he placed great weight on the civilizing power of the Church of England service on these public occasions. To make his point, he compared the beauty of a passage from Milton with that of a passage from Eliza Cook, a sentimental third-rate poet popular with the Victorian middle-class. He conceded that there was, of course, no sense in trying to compel people to read Milton in private if they preferred Eliza Cook, 'yet Milton remains Milton and Eliza Cook remains Eliza Cook. And a public rite, with a reading of Milton attached to it, is another thing from a public rite with a reading from Eliza Cook' (viii. 345). Now, as Arnold well knew, there was in fact no proposal by the Dissenters to use Eliza Cook, nor, of course, did Milton figure in the Anglican service, but

what is so revealing about his example is that the crucial division, in Arnold's mind, was *not* between the traditional religious services of the two denominations on the one hand and the poetry of the two poets on the other; for him, the important distinction was between the beauties of the Anglican service and Milton on the one hand, and the dreariness of the Dissenters' service and Eliza Cook on the other.

For those disposed to be hostile to Arnold, his commitment to the Church of England seems particularly damning. Born of theological compromise and *raison d'état*, Anglicanism is derided as unspiritual, unsystematic, and irretrievably implicated in England's oligarchic social and political history. But Arnold did not require the condescension of later generations to make him aware that 'actual Anglicanism is certainly not Jerusalem' (ii. 321). However, for him as for the calmly unillusioned eighteenth-century divine, Bishop Butler, whom he so much admired, it was 'a *reasonable* Establishment', the existence of which encouraged that 'largeness of spirit' so lacking in all forms of sectarian self-importance. A 'vehement enthusiasm' was not what the Anglican Church excited in its more reflective members; indeed, 'vehement Anglicanism' may be an oxymoron. But then that, for Arnold, was not the least of its merits.

'Joy whose grounds are true'

In giving the title *Last Essays on Church and Religion* to the collection of pieces he published in 1877, Arnold signalled his intention of quitting the field of religious polemic. But in a sense, what really constituted his 'last essays' on religion, given the way he had re-defined religion, were his articles on literary subjects that he published in his final decade, above all his classic essays on 'Wordsworth', 'Byron', and 'The Study of Poetry'. In his late essays, Arnold comes very near to equating religion and poetry, partly because in both cases he views them pragmatically, in terms of the effect they have on us. Both do more than fortify and console, although, as we have already seen, this somewhat Stoic note tends to predominate in these essays; religion and poetry also animate and ennoble, and here the emphasis is on their effect on

the will, on how they give us that energy and sense of purpose outside ourselves that enables us to meet the demands of morality. But even if the religious believer could accept this description of the psychological effect of his faith, still he would insist that it was consequential upon the *truth* of what he believed; for the believer, religion is not just an efficacious fiction. In what sense, it may be asked, can poetry lay claim to display any such truth? Some light is shed on this by, surprisingly, Arnold's essay on Byron (1881).

In the course of his usual attempt to fix a writer's position in the league tables of Poetic Greatness, Arnold's discussion of Byron requires a comparison between Leopardi and Wordsworth, and the conclusion to his argument for the superiority of the latter is particularly revealing.

It [his superiority] is in the power with which Wordsworth feels the resources of joy offered to us in nature, offered to us in the primary human affections and duties, and in the power with which, in his moments of inspiration, he renders this joy, and makes us, too, feel it; a force greater than himself seeming to lift him and to prompt his tongue, so that he speaks in a style far above any style of which he has the constant command, and with a truth far beyond any philosophic truth of which he has the conscious and assured possession. . . . As compared with Leopardi, Wordsworth, though at many points less lucid, though far less a master of style, far less of an artist, gains so much by his criticism of life being, in certain matters of profound importance, healthful and true, whereas Leopardi's pessimism is not, that the value of Wordsworth's poetry, on the whole, stands higher for us than that of Leopardi's. (ix. 230–1)

Here, Wordsworth's superiority initially seems to rest upon his capacity for positive feeling, his responsiveness to the sources of 'joy'. Whether this excludes any claims on behalf of his cognitive achievement, his clarity of perception about the human condition, depends upon whether we assume, as Arnold surely does, that Wordworth's capacity to feel this joy is *itself* an index of the truth of his perception. Joy, rather than pain, is what a correctly-understood world has to offer. Something like this optimistic assumption seems to be present in the last sentence of the passage, where he asserts that Wordsworth's criticism of life is 'healthful and true, whereas Leopardi's pessimism is not'. The sense in which

Leopardi's criticism of life is less 'true' than Wordsworth's doesn't seem to depend to any great extent upon an examination of what they actually say about the world, so much as upon a comparison of the effects they have upon the reader. The relation between the terms 'healthful' and 'true' in that passage is at least as much that it is true *because* healthful, as that it is healthful because true. To his pragmatic theory of poetry and religion, Arnold almost seems to be adding a pragmatic theory of truth here. As with his phrase 'joy whose grounds are true', it is not that he requires or proposes any very probing theory of the nature of reality to award the label 'true', but simply that what animates, what conduces to a state of mind in which there is a readiness for virtuous action, is what is true, and it is true because it in some way corresponds to our deepest feelings. And it is when these feelings are aroused, when our 'higher self' shakes itself free from the clutches of our appetite-satisfying 'lower self', that we rise to the level of moral conduct.

Despite his repeated assertions that 'conduct is three fourths of life' (conduct must have been index-linked to Arnold's growing earnestness, since it later became 'four fifths' of life), Arnold in the end had very little to say about morality, and he had very little to say about it because he essentially took it for granted. As he had put it, with bland confidence, in *Literature and Dogma*, 'conduct ... is the simplest thing in the world as far as *understanding* is concerned; as regards *doing*, it is the hardest thing in the world' (vi. 172). For all his criticism of the 'prison of Puritanism' from which English life had yet to escape, his work does not really contain much critical engagement with the actual moral code of his day, as opposed to the spirit in which that morality was intruded into all discussion. What he is preoccupied with, instead, is getting people to live up to the moral code, finding a source of emotion, a prompt for strong *feeling*. Ultimately, he, like so many of his contemporaries, appears to be secure in the confidence that those feelings will be harmonious, both with each other and with the feelings and needs of other people.

The note of melancholy characteristic of Arnold's best poetry, the voice of a self observing its need for a faith it cannot believe, and expressing the sadness that this awareness of perpetual frustration must induce, is largely absent from his later writings on

literature and religion. He now seems more confident that the Bible *does* meet our needs, that poetry *is* our 'stay'. This is largely because he is here addressing the needs (the rather limited needs, as he conceives of them) of the mass of the population for emotional sustenance and moral guidance, rather than singing of the plight of the over-reflective individual. But perhaps it is also true that, as in some of his other writing of this period, there is detectable a slight hardening or coarsening of Arnold's thought in the last decade of his life, or at least more of a tendency to paint in the great primary colours and to insist on the preaching of certain large and simple truths. It is noticeable, too, that his religious writings are far less ironical and facetious in tone, and, with the exception of his notorious trope of 'the three Lord Shaftesburys' to illustrate the popular idea of the Trinity (which he later removed), these writings have little of that high-spirited banter that some readers of his earlier works found offensive.

Although a string of Modernist theologians and, more recently, several literary critics of the Bible have paid tribute to Arnold's religious writings, most modern readers have found them the least satisfying part of his work. In his effort to salvage Christianity from the popular theology and Biblical literalism of his day, he now looks like a man who has retreated to a higher sand-castle to escape a wave without realizing that the tide will soon engulf sand-castle and beach as well. And yet, as a suggestion of where future generations might look to find what their less troubled predecessors had found in traditional Christianity, his work may not have fared so badly after all. Arguably, many people, without ever putting it in Arnold's terms, do find a source of moral guidance and sense of 'something not ourselves' in art if they find it anywhere; more, perhaps, in genres like novels and films than in poetry and tragedy in their traditional forms. A passage from the eighteenth-century German writer Herder, which Arnold copied into his notebooks, may stand for much informal twentieth-century belief: 'It is culture [*Bildung*] alone which binds together the generations which live one after another as men who see but one day, and it is in culture that the solidarity of mankind is to be sought, since in it the strivings of all men coincide.'

In his desire to preserve the greatest possible cultural continuity

and his looking to literature for moral authority, as, more obviously, in his responsiveness to the beauties of the King James Bible and his affection for the curious growth that is Anglicanism, Arnold seems a very distinctively English writer. (Certainly, European critics, normally so appreciative of his cosmopolitan range, greeted his religious writings with a kind of baffled respect.) This thought may have been in the mind of his friend, Grant Duff, when in 1889 he recorded in his diary having attended a meeting about a memorial fund for Arnold that had taken place in the Jerusalem Chamber of Westminster Abbey:

How strange amidst all its revolutions is the continuousness of England! Here were we assembled in a room which was historical long before Shakespeare, and made world-famous by him, – to do what? In the very place in which the Westminster divines had set forth in elaborate propositions the curious form of nonsense which was Christianity to them, to do honour to a man who, standing quite outside their dogmas, had seen more deeply into the heart of the matter than all of them put together.

7 The Arnoldian legacy

It is a remarkable fact that Matthew Arnold is more central to the cultural debates of the late twentieth century than he has been at any time in the hundred years since his death. It would seem eccentric, or at least obsessively academic, to attempt to register one's present intellectual or political allegiances by hoisting a flag marked, say, 'Carlyle' or 'Ruskin', for all that one might feel admiration for their achievements or sympathy with their ideas; those names simply do not denominate a readily recognizable identity for current controversial purposes. But 'Arnold', and still more the conveniently unspecific 'Arnoldian', is widely taken to signal a claim to descent and an affirmation of loyalty from which one's response to a variety of still-contested issues could be fairly accurately inferred. This may seem simply to provide further testimony to his continued vitality and readability: for all their constant allusion to the now-forgotten polemics of Victorian England, the best of his writings could be said to have dated less than those of any of his peers, with the possible exception of John Stuart Mill. But for a less naïvely individualistic explanation of his talismanic role, we need to consider the vagaries of his reputation in the past century, and, even more, to recognize how a pattern of cultural change has thrust a certain representative status upon him.

At the time of his death in 1888, Arnold already stood in a slightly uneasy relation to the first members of that diverse and fractious brood who claimed to be his rightful literary descendants. Most notably, there was the doubtful and ambiguous case of the various strands that made up the late nineteenth-century movement commonly called 'aestheticism'; figures as diverse as Walter Pater, Oscar Wilde, and Max Beerbohm could all be seen as having absconded with part of his legacy, and imitation of one aspect of Arnold's style (much diluted and mixed with two parts mannerism to one part talent) coloured the somewhat precious and whimsical literary 'portraits' and 'appreciations' produced by the next gener-

ation of velveteen-jacketed Edwardian bookmen. Of course, in the complex manner of intellectual history, this development can be seen both as a continuation of, but also as the beginning of a reaction against, some of those features least inaccurately described as 'Victorian' (and the complexity is multiplied because Arnold himself was in some ways a Victorian critic of aspects of what came to be known as 'Victorianism').

The generation or two after a writer's death usually sees the trough of his reputation, and in Arnold's case this was intensified by the voguish rejection of all things 'Victorian' in the first three or four decades of the twentieth century. Lytton Strachey, for example, contributed a routinely abusive essay on Arnold just before the First World War, refusing to see anything but the heavy moralism and enlarged social conscience of the later Arnold which Strachey's polemical parody of 'Victorianism' required, wilfully ignoring the urbanity, wit, and taste for French literature which, in altered forms, were so essential to Strachey's sense of his own identity. (The cardinal document of the 'reaction against Victorianism', Strachey's *Eminent Victorians*, with its sinuously insinuating portrait of Arnold's father, followed four years later in 1918.) Only in the 1940s did this kind of cultural Oedipal antagonism cease to dominate responses to the great public figures of the late nineteenth century.

On another plane, the prejudices of literary 'Modernism' were hostile to the spoilt Romanticism of the mainstream of Victorian verse. At the beginning of the century, Arnold had been held in special affection and respect by what one might call 'the Golden Treasury view' of English verse; a selection of his poetry *had* been edited by Sir Arthur Quiller-Couch, after all. When the tide of literary fashion turned against this, the audience for Arnold's poetry, which was anyway never wide, contracted still further. Described as 'after Milton, the most learned of English poets', Arnold has naturally attracted extensive academic annotation and commentary in recent years, and it is this which has largely restored his standing as a poet.

Although the reputation of Arnold's prose was at its nadir in the first few decades of this century, he remained an inescapable presence in both Britain and the United States. But to understand

the nature of the peculiar significance that he has since acquired, it is crucial to recognize that his authority was most loudly invoked in the 1920s and 1930s by those who emphasized the social role of literature as an agent of cultural regeneration in the face of what was stigmatized as 'mass civilization'. In Britain, the very influential 'Newbolt Report' on 'The Teaching of English', which appeared in 1921, was an explicitly Arnoldian document, injecting an upbeat version of his 'message' into the curriculum of the next generation. But far more important for his long-term standing was the fact that the three writers who did most to install literary criticism in its central position in modern British culture all explicitly associated Arnold with the larger moral and political purposes of their enterprise. For all the self-justifyingly distancing tone of some of their remarks about Arnold, and for all the very great differences between each of them as well as between any one of them and Arnold, it remains true that through the writings in the 1920s and 1930s of T. S. Eliot, I. A. Richards, and F. R. Leavis, his name was thenceforth associated with their distinctively twentieth-century programme of cultural renewal.

Although this development was particularly intimately intertwined with the intricacies of English social and intellectual life, the appropriation of Arnold by later social critics who found something superficially congenial in his style and concerns was to some extent a significant episode in American cultural history also. For example, the 'Humanism' of Irving Babbitt and his followers in the first few decades of the twentieth century explicitly traced its descent back to Arnold, thus encouraging an identification of his work with an anxiously reactionary response to the democratization of modern societies. More influential in the long run, however, was the publication in 1939 of Lionel Trilling's *Matthew Arnold*, which not only introduced a more serious and sympathetic appraisal of Arnold's ideas, but also, by the affinity it suggested between its subject and its author – who was to become the outstanding American critic in the three decades after the Second World War, a critic of comparably wide intellectual interests and not dissimilar cultural convictions – helped bring Arnold into prominence in post-war literary-political debates in the United States also.

But from this point, Arnold's increasing significance has to be seen in relation to the wider developments I alluded to earlier. The most important of these have been, first, the enormous growth of higher education since the end of the nineteenth century, which has in turn led to the cultural concerns of modern societies being far more intimately tied to academic fashions and controversies than ever before, and, secondly, a remarkable expansion of the teaching of English literature in universities during the last fifty years. When Arnold died, 'Eng. Lit.' was practically unknown as an academic subject (as, of course, were several others that have since attained that dubious respectability); now, it is often the largest single humanities department in British and American universities. But more important than sheer expansion of numbers has been the fact that literary studies have borne the double burden of aspiring to some recognized disciplinary status, possessing its own techniques and vocabulary, while at the same time providing a forum and an idiom in which larger moral and existential questions can be broached. This has nourished, and has in turn fed on, the large cultural hopes invested in 'English' as the successor-subject to Classics, and even as the successor-religion to Christianity. As one observer has put it: 'True to Arnold's prophecy, literature has become the religion of the twentieth century, with criticism its theology.'

Like so many others, Arnold has thus had academic greatness thrust upon him. Despite his sentimental fondness for an idealized Oxford, he was not in the least an academic critic. Moreover, he was sceptical about some of the proposals for the introduction of literature into the university syllabus that were advanced towards the end of his life, urging, for example, that English literature should certainly not be taught in isolation from its Classical and European sources. But, despite the fact that he never confined his notion of 'criticism' exclusively to *literary* criticism, just as the literature he recommended was not primarily *English* literature, Arnold was the chief of those recruited to preside over and give legitimacy to a new professional specialism. Furthermore, the fact that, for various reasons, literary criticism in Britain continued to use, as to some extent it still does, that informal, conversational register which Arnold recommended and exemplified, has in effect

disguised the extent to which modern literary scholarship has moved away from the assumptions that sustained the judgements of a cultivated and discriminating man of letters in the mid-nineteenth century.

None the less, until about 1960 it continued to be possible to believe that the dominant forms of 'criticism' carried on within university departments of English (whose influence on the wider culture was by this date attracting much comment) still belonged within a tradition that could, without too much violence to the facts, be traced back to Arnold more than to any other single figure. Since then, of course, there has been a quick succession of critical 'new waves' which have promised both to provide a properly scientific methodology for a discipline still troubled by its doubtful standing, and at the same time to entail a set of more unambiguously radical political conclusions. The oddity of the yoking together of these two not obviously compatible aspirations is a reminder of how even the most iconoclastic critical theories have continued to assume the dual burden that the needs of twentieth-century culture have imposed on the study and teaching of literature. Partly for this reason, and partly because of the traditionally close links between literature and 'the higher journalism' in Britain and to a lesser extent the United States, these disputes have attracted a degree of public attention not lavished on the internal squabbles of any other academic discipline.

It is not difficult to see how Arnold has constituted a convenient target for those who pride themselves on being both methodological and political radicals, and in recent decades he has come in for some pretty rough handling. Of course, all earlier critics can, if treated with the right mixture of animosity and high-handedness, be made to look intellectually naïve by their more self-consciously sophisticated successors. Though there might seem to be some intellectual, and certainly some professional, advantage to be gained from exposing the questionable assumptions underlying the work of, say, Dryden, or Johnson, there would seem to be little cultural payoff to 'unmasking' the way these assumptions were rooted in political or moral beliefs that are no longer considered acceptable (this does not, however, mean that no one ever does it). But the sense of greater direct continuity with Arnold's concerns,

and a suspicion that current critical practices still draw authority from, and are to some extent based on, his canonical pronouncements, means that 'unmasking' *his* assumptions in this way can seem a worthwhile victory, the slaying of a father who would otherwise exercise a tyrannical authority.

Arnold has not been without his champions, of course: the founding in the 1950s of a journal with the deliberately Arnoldian title of *Essays in Criticism*, for example, made the assumed line of descent explicit, and as this line has come under increasingly severe attack in recent decades, some of those who have styled themselves its defenders have invoked Arnold as a talisman against the evil demons suspected of lurking down the departmental corridor. All this has not necessarily resulted in any greater or more sympathetic understanding of his work, but it has undeniably kept his name, though sometimes little else, at the centre of those debates in which some of the sharpest divisions in modern intellectual life have been expressed.

But Arnold resonates within a wider field of conflict still, particularly in Britain, and this involves a further aspect of the broader historical developments I mentioned above. The dispute here is ultimately political: the social changes of the mid-twentieth century, the wider recruitment to higher education not least among them, have issued in an assault on the assumptions behind the traditional position of what has come to be called, usually pejoratively, 'high culture'. The gist of the many charges that cluster around this topic is that the prescriptive ideal of 'culture', and especially the limited specification of its content, derives from and reinforces a pattern of relations between classes, sexes, and races that is fundamentally unjust. This charge has appeared in its most uncompromising form as part of the class antagonisms that have set the agenda for much modern British political and, to a lesser extent, intellectual history (and which have therefore given that history some of the intensity, but also opacity to outsiders, that characterizes the family quarrel). Along with this rejection of the value and standing of the traditional conception of culture has gone a dismissal of any notion of 'cultural centrality', which is scorned as the imposition of the limited preoccupations of a privileged élite upon the rival and no less legitimate concerns of

other social groups. An equally hostile treatment, on similar grounds, has been given to the very idea of a 'canon' of particularly valuable or inescapably major works of art and literature, a hostility which in turn has somtimes led to a revision, or more usually an expansion, of the categories of 'art' and 'literature' themselves.

Naturally, Arnold presents himself as a particularly inviting target here, too. Not only did he decisively shape the modern prescriptive notion of 'culture', but he also explicitly promoted its capacity to heal ('suppress', according to the more intransigent) social conflicts, an ideal discernible only just below the surface of much educational thinking and activity in twentieth-century Britain. Moreover, as we saw in Chapter 5, he exhibited a strong attachment to 'order', and urged a more elevated conception of the state; he spoke favourably of the role in diffusing culture to be played by those 'aliens' outside the three classes; and, in more historical detail, he was less than implacably hostile to the established order – he was indulgent to the Anglican Church, for instance, and was known to have hob-nobbed with the titled and landed, all of which has been cited as casting doubt on the value of his ideas. Even so distinguished a critic as Raymond Williams, to take an influential example, felt it important to try to discredit Arnold by showing that his response to the Hyde Park riots of 1866 was not the 'correct' one. As I implied a moment ago, there would surely be something laughable about taking great pains to reveal that Dryden's assumptions were insufficiently 'democratic' or that Johnson's were reprehensibly 'ethnocentric', yet Arnold has had to face several such firing-squads at successive new political dawns.

It is noticeable, too, that Arnold attracts a particular rage of resentment not just because of what he can be accused of 'standing for', but also because of the very poise and grace with which he conducted himself. This, in turn, is partly because these qualities themselves are now frequently subject to the suspicion of being obstructive affectations, but also perhaps because unless guarded against, their seductive appeal may still do some of its work of sapping dogmatism and reducing exaggeration. The rage may be involuntary tribute to his power: the resentment is redoubled by

an irritation that the despised qualities should still be able to exert any pull over us. In any event, for many cultural commentators today he has become, in a telling appropriation of his own term, 'a negative touchstone'.

By this point it will have become obvious that some of the reasons for Arnold's current importance bear only a tenuous relation to any considered understanding of the complexities of his tone and temper. Yet it is by those qualities of balance, perceptiveness, and wit, which he sometimes embodied as well as recommended, that he provides a still-effective antidote to just that cast of mind that insists on denigrating him for its own partisan purposes. One unfortunate outcome of the linked historical developments discussed above is that any attempt at a reasonably dispassionate assessment of his achievement, something which presupposes a measure of imaginative sympathy and sensitivity to the historical constraints of his situation, runs a high risk of having covertly sectarian motives ascribed to it.

Needless to say, not even Arnold's most devoted champions (of whom I am not one) could acquit him of *all* the charges that have been laid against him over the years, and I hope the previous chapters of this book have sufficiently indicated where I think he is most liable to criticism. In general, it would have to be allowed that he did not altogether practise what he preached: disinterestedness too often gave way to self-indulgence or unfairness, for example. Moreover, we need be under no illusion that what he preached, even taken at its best, adds up to an adequate diet. His work, the poetry included, does not really touch the extremes of human life: he can be pessimistic but he does not rise to the tragic; he can be joyful without ever reaching the sublime. It is not that he did not know almost unbearably painful suffering, nor that he underestimated its place in human life; but such matters did not find unforgettable expression in his writing. Viewed from another perspective, of course, one can be grateful that these matters did not monopolize his attention, and that he does not try to force them to monopolize ours; it is hardly a complaint to observe that the characteristic tone of his best prose can have an almost Mozartian gaiety about it.

Some, both among his contemporaries and ours, have been

suspicious of the habitual balance of his tone, and have seen something a little too willed in what Hutton called his 'imperious serenity'. But if a form of composure or equanimity is achieved without undue suppression, it is not obvious that we should value it the less for the fact that it is *achieved* rather than natural. A misplaced cult of authenticity may encourage particular intolerance of a self-conscious stylist like Arnold, in whom we have to recognize a continuity between the stylishness of his writing and the accomplished (in both senses of the word) balance of his character.

This balance may have limited both the range and register of Arnold's writing. To adopt his own favoured comparative way of speaking, we may say that he does not give us the huge canvas and black passions of, say, a Dostoevsky, or the unnerving brilliance and spiky originality of a Nietzsche, or the moral passion and architectonic power of a Marx. In citing such names we are only following his own practice of always placing the writer he is assessing in the company of the indisputably outstanding, to keep our assessments in perspective. There was in Arnold, to repeat that perceptive phrase of Charlotte Brontë's, 'a real modesty beneath the assumed conceit', and he would not have wanted his own standing to be allowed to get out of proportion.

'Perspective' and 'proportion' call to mind the cooler virtues, and that is right. If in the end we are persuaded and buoyed up by reading Arnold's best prose, it is surely because we know that the lightness of touch and the feel for style, no less than his actual convictions on culture and conduct, do embody a deeply pondered response to the place of these things in the larger scheme of life. It is not, of course, a complete response, and not always the response we most want or even need, but it is surely an indispensable element in any adequately receptive view of what the variousness of our literary heritage can offer us. The Mozartian parallel should not be overworked (proportion might even compel us to substitute, let us say, Rossini), but even the mere mention of it can remind us that there has to be cheerfulness and amenity as well as drama and justice if life is to be managed at all.

However, despite Arnold's early commendation of 'the grand style', to end on a note of anything like portentousness would be

the least appropriate way to do justice to his continuing appeal. With a writer who 'perceived so many shy truths . . .', the tone of our leave-taking should have some of the intimacy and informality he so winningly cultivated in the two genres in which he excelled, the meditative lyric and the conversational essay. An occasional piece, composed in a minor key, may suggest a more suitable register. The poet who felt so deeply that 'we mortal millions live *alone*' was also exceptionally responsive to the consolations offered by that sense of kinship, transcending our own isolation and transience, which we can sometimes experience when a writer speaks to us across the chasm of centuries in a voice that we recognize as both like and unlike our own. In 1877 Arnold published his affectionate appreciation of Falkland, the seventeenth-century statesman and man of letters who found himself caught between the insistent simplicities of the two sides in the English Civil War. Arnold, himself more ambivalent Cavalier than ardent Roundhead, obviously felt some sympathy with this sensitive man trapped by the movements of history, with 'the lucidity of mind and largeness of temper' to see that he would be forced to give himself to 'the least bad of two unsound causes' (viii. 204). Occurring as it does in the middle of a fairly slight periodical essay on by no means the most important figure in English seventeenth-century history, his reflection on this fate provides a suitable note on which to take leave of Arnold himself.

Shall we blame him for his lucidity of mind and largeness of temper? Shall we even pity him? By no means. They are his great title to our veneration. They are what make him ours; what link him with the nineteenth century. He . . . by [his] heroic and hopeless stand against the inadequate ideals dominant in [his] time, kept open [his] communications with the future, lived with the future. [His] battle is ours too.

Further reading

The editions of Arnold's prose and poetry by R. H. Super and Kenneth Allott respectively (details of which are given in the note on p. 202) not only establish the authoritative texts of his works and record textual variants, but also provide a great deal of useful historical, critical, and bibliographical information. They are now the indispensable starting-points for the serious study of Arnold, and I have relied upon them heavily. Selections from Arnold's writings are available in various modern editions: three of the most accessible are *Matthew Arnold: Selected Prose*, edited by P. J. Keating in the Penguin English Library (Harmondsworth, 1970; repr. 1982); *Arnold: Poems*, selected by Kenneth Allott in the Penguin Poetry Library (Harmondsworth, 1954; repr. with new Introduction by Jenni Calder, 1971; repr. 1985); and *Matthew Arnold: Selected Works*, edited by Miriam Allott and R. H. Super in the Oxford Authors series (Oxford, 1986). The various editions of his letters and notebooks are also cited on p. 202; the two-volume collection of letters edited in 1895 by G. W. E. Russell remains the most important biographical source, though it is seriously inadequate in several ways, not least in its unacknowledged excisions from some letters. A considerable number of Arnold's letters have come to light in the past century: copies of nearly all of them are now held at the University of Virginia at Charlottesville, where a complete edition is being prepared under the direction of Cecil Lang. Much the fullest biography, which draws extensively on these sources, is now Park Honan, *Matthew Arnold: a Life* (London, 1981).

There is a vast secondary literature on Arnold, and what follows is a very brief selection, containing those works that I have found particularly useful or stimulating. For fuller and more authoritative guides, one should consult David J. DeLaura (ed.), *Victorian Prose: A Guide to Research* (New York, 1973); Frederic E. Faverty (ed.), *The Victorian Poets: A Guide to Research* (Cambridge, Mass.,

1956; 2nd edn. 1968); and the annual bibliographies provided in three periodicals: *Victorian Studies, Victorian Poetry*, and *The Arnoldian*. Some indication of the range of contemporary response to Arnold may be gathered from the relevant volumes in the 'Critical Heritage' series: *Matthew Arnold: the Poetry*, edited by Carl Dawson (London, 1973), and *Matthew Arnold: Prose Writings*, edited by Carl Dawson and John Pfordresher (London, 1979).

The most interesting book-length study of Arnold remains, in my view, Lionel Trilling's *Matthew Arnold* (New York, 1939; repr. Oxford, 1982); the sections on the historical context now seem a little superficial, and the treatment of both the poetry and the religious writings is perhaps rather thin in places, but the book is the expression of a genuine and impressive meeting of minds. Two particularly good collections of essays on Arnold, which deal with both the poetry and the prose, are David J. DeLaura (ed.), *Matthew Arnold: a Collection of Critical Essays* (Englewood Cliffs, N.J., 1973) and Kenneth Allott (ed.), *Matthew Arnold*, 'Writers and their Background', (London, 1975).

On the poetry, the most comprehensive discussion is A. Dwight Culler, *Imaginative Reason: The Poetry of Matthew Arnold* (New Haven, 1966). Also of interest in different ways are Louis Bonnerot, *Matthew Arnold, poéte* (Paris, 1947); G. Robert Stange, *Matthew Arnold: The Poet as Humanist* (Princeton, 1967); and the chapter on Arnold in J. Hillis Miller, *The Disappearance of God: Five Nineteenth-Century Writers* (Cambridge Mass., 1963; 2nd edn. 1975). C. B. Tinker and H. F. Lowry, *The Poetry of Matthew Arnold: a Commentary* (London, 1940) is still useful.

Certain aspects of Arnold's thought and prose have been the subject of some outstandingly good scholarship, others rather less so. Sidney Coulling, *Matthew Arnold and his Critics: A Study of Arnold's Controversies* (Athens, Ohio, 1974) is excellent and immensely useful; David J. DeLaura, *Hebrew and Hellene in Victorian England: Newman, Arnold, Pater* (Austin, Texas, 1969) is a distinguished study; the chapter on Arnold in John Holloway, *The Victorian Sage: Studies in Argument* (London, 1953) is extremely perceptive. Arnold's literary and cultural criticism has been the subject of several classic essays (reprinted in the collections of essays cited above); two books which are interesting and

very learned, but which perhaps ride their particular interpretations a little hard, are William A. Madden, *Matthew Arnold: A Study of the Aesthetic Temperament in Victorian England* (Bloomington, 1967) and Joseph Carroll, *The Cultural Theory of Matthew Arnold* (Berkeley, 1982). His social and political writings have been rather poorly served: F. G. Walcott, *The Origins of 'Culture and Anarchy'* (London, 1970) is useful on Arnold's educational writings in the 1860s, but Patrick J. McCarthy, *Matthew Arnold and the Three Classes* (New York, 1964) is disappointing. Arnold's religious and moral thought has been discussed very thoroughly in William Robbins, *The Ethical Idealism of Matthew Arnold: A Study of the Nature and Sources of his Moral Ideas* (Toronto, 1959), in the chapters on Arnold in Vincent Buckley, *Poetry and Morality* (London, 1959), and in Ruth apRoberts, *Arnold and God* (Berkeley, 1983).

Notes on sources

My chief scholarly debts are acknowledged in the note on Further Reading. The sources of actual quotations given in the text, other than from Arnold's works, are as follows.

209 'imperious serenity'. R. H. Hutton, *Literary Essays* (London, 1888), p. 317.

212 '. . . of my enemies'. Leslie Stephen, quoted in David J. DeLaura, *Victorian Prose: A Guide to Research* (New York, 1973), p. 290.

212 '. . . enormously insulting'. G. K. Chesterton, quoted in DeLaura, *Victorian Prose*, p. 290.

213 '. . . lizard slickness'. Geoffrey Tillotson, *Criticism and the Nineteenth Century* (London, 1951), p. 56.

218 'high-hat persiflage'. Tillotson, *Criticism and the Nineteenth Century*, p. 49.

219 '. . . of insensibility'. Henry James, 'Matthew Arnold' (1884), repr. in Henry James, *Literary Criticism*, Vol. 1 (New York, 1984), pp. 728, 731.

225 '. . . ourselves, poetry'. W. B. Yeats, quoted in Edward Alexander, 'Roles of the Victorian Critic', in P. Damon (ed.), *Literary Criticism and Historical Understanding* (New York, 1967), p. 53.

225 '. . . assumed conceit'. Charlotte Brontë, quoted in Park Honan, *Matthew Arnold, A Life* (London, 1981), p. 220.

226 '. . . ever known'. E. Abbott and L. Campbell, *The Life and Letters of Benjamin Jowett*, Vol. 1 (London, 1897), p. 223.

229 '. . . in the world'. A Dwight Culler, *Imaginative Reason: The Poetry of Matthew Arnold* (New Haven, 1966), p. 4.

231 'time-ridden consciousness'. William A. Madden, *Matthew Arnold: A Study of the Aesthetic Temperament in Victorian England* (Bloomington, 1967), p. 83.

241 '. . . the body gone?'. A. C. Swinburne, quoted in Frederic E. Faverty (ed.), *The Victorian Poets: A Guide to Research* (Cambridge, Mass., 1956; 2nd edn 1968), p. 200.

244 '. . . Virgilian regret', and '. . . does not know', both Hutton, *Literary Essays*, pp. 352, 350.

245 '. . . heroic egotism'. Hutton, *Literary Essays*, p. 313.

248 '. . . than a critic'. T. S. Eliot, *The Sacred Wood* (London, 1920), p. 1.

248 '. . . literary criticism'. F. R. Leavis, 'Arnold as Critic' (1938), repr. in F. R. Leavis, *The Critic as Anti-Philosopher*, ed. G. Singh (London, 1982), p. 57.

249 '. . . resign himself to . . .'. J. A. Froude, quoted in Howard Foster Lowry (ed.), *The Letters of Matthew Arnold to Arthur Hugh Clough* (London, 1932), p. 127.

268 'doomsday standards'. Tillotson, *Criticism and the Nineteenth Century*, p. 80.

269 '. . . felt his impact'. Honan, *Matthew Arnold*, p. viii.

286 'Greeker than thou'. Richard Jenkyns, *The Victorians and Ancient Greece* (Oxford, 1980), p. 265.

296 '. . . Christian at bottom'. Quoted in Basil Willey, 'Arnold and Religion', in Kenneth Allott (ed.), *Matthew Arnold* (London, 1975), p. 236.

304 '. . . beyond all price'. W. H. Mallock, *The New Republic: Culture, Faith and Philosophy in an English Country-House* (London, 1877; repr. Leicester, 1975), p. 31.

304 '". . . makes for righteousness"?'. Lionel Trilling, *Matthew Arnold* (New York, 1939; repr. Oxford, 1982), p. 321.

'. . . all men coincide'. Quoted (and identified) in Ruth apRoberts, *Arnold and God* (Berkeley, 1983), p. 45.

310 '. . . them put together'. Quoted in Sidney M. B. Coulling, *Matthew Arnold and his Critics: A Study of Arnold's Controversies* (Athens, Ohio, 1974), p. 268.

315 '. . . criticism its theology'. David Lodge, 'Literary Criticism in England in the Twentieth Century', in Bernard Bergonzi (ed.), *The Twentieth Century* (The Pelican Guide to English Literature) (Harmondsworth, 1970), p. 372.

318 'correct'. Raymond Williams, *Politics and Letters* (London, 1979), p. 124.

Morris

Peter Stansky

Preface

I am grateful to Keith Thomas and Henry Hardy for asking me to write this essay. My debts are many, particularly to those who are expert on William Morris: Chimen Abramsky, Sanford and Helen Berger, Ron Goldstein, Norman Kelvin, and especially Joseph Dunlap. I also wish to thank William Abrahams as well as Barbara Gaerlan, Ann Halsted, Loraine Sinclair, Vanessa Malcarne and Barbara Wawrzynski.

I should like to thank the Society of Antiquaries, London, for permission to quote from the unpublished writings of William Morris.

Stanford University P.S.

Contents

Abbreviations and note on sources

The following abbreviations are used:

H Philip Henderson, ed., *The Letters of William Morris to His Family and Friends* (1950).

CW May Morris, ed., *Collected Works*, 24 volumes (1910–15).

MS Manuscript, from various manuscript collections including the Beinecke Library, Yale University; the British Library; the Bodleian Library, Oxford; the Berger Collection, Carmel; Columbia University Library; the Huntington Library, San Marino; The National Library of Iceland; the William Morris Gallery, Walthamstow.

The description by Henry James on p. 351 is from his *Letters*, ed. L. Edel, I (1974), 93–4. 'The growth of decorative art . . .' (p. 361) is from P. Henderson, *William Morris* (1967), 66. The interview with Emma Lazarus quoted on p. 363 was published in *The Century Illustrated Monthly Magazine* (July 1886), XXXII, 397. 'As regards colour . . .' on p. 366 is from A. Charles Sewter, *The Stained Glass of William Morris* I (1974), 88–9 (copyright Yale University Press). 'to combine clearness of form . . .' (p. 367) is from B. Fryberger, *Morris & Co* (1971), 29. 'The sources of Morris's manuscripts . . .' (p. 375) is from *William Morris and The Art of the Book* (1976), p. 69. 'To speak quite frankly . . .' (p. 386) and Morris's letter quoted on p. 391 are from J. Bruce Glasier's *William Morris and the Early Days of the Socialist Movement* (1921), 32, 193. The quotation from Morris's diary (p. 390) is from Florence Boos, ed., 'William Morris's Socialist Diary', *History Workshop* 13 (Spring 1982), 44. 'I distinctly . . .' (p. 392) is from R. Page Arnot, *Unpublished Letters of William Morris* (1951), 5. Morris's rediscovered lecture (p. 398) can be found, ed. Paul Meier, in *International Review of Social History* XVI (1971), part 2, 23–4. 'All of the later prose romances . . .' on p. 402 is from Jessie Kocmanová, 'Landscape and Sentiment', *Victorian Poetry* XIII, 3–4 (1975), 117.

to Marina

1 Youth

At the time of William Morris's death in October 1896, his disciple Walter Crane, the artist and illustrator, delivered a short speech about his beloved mentor, in which he mentioned that Morris himself had wondered 'which, of six distinct personalties, he himself really was'. Was he primarily the author, one of the leading poets and prose writers of the day, who might have been Poet Laureate after the death of Tennyson in 1892 – the 'dreamer of dreams' born out of his due time? Or the artist and craftsman who had created designs for wallpaper, stained glass, cloth, tapestries, carpets, which were in his lifetime, and now in ours, amazingly popular? Or the businessman who left an estate of £55,000, quite a hefty sum at the end of the nineteenth century? Or one of the most important printers the world has known, whose Kelmscott Press not only had a considerable influence upon commercial printing, but also fathered the great private press movement of the late nineteenth and early twentieth centuries? Or the ardent socialist, indeed, as he called himself, a communist, who was bent upon a revolutionary transformation of England, and who devoted a great deal of money and energy to that aim? Or was he primarily the private man, full of high spirits and hot temper, married far from happily to a famously beautiful woman, and the father of two daughters?

Of course Morris was all of these individuals, but it is suggestive of the complexity of his life that he could leave his mark in so many areas in a comparatively brief number of years. He had considerable energy and he drove himself relentlessly, doing as many things at once as possible. To him it seemed foolish that anyone shouldn't weave tapestry, compose poetry, and do whatever else at the same time. He appeared to be in robust good health; in fact, his father's side of the family was short-lived and that constitution took its toll upon him. But his doctor is alleged to have said that Morris died from 'being William Morris'.

Morris said on his death-bed that he wished to 'get mumbo-jumbo out of the world'. He wanted to make life simpler and more beautiful, more worth living, and more worthily lived by more people. These ideas tied his life together and solidified his influence.

He was born on 24 March 1834 at Elm House, Clay Hill, Walthamstow, outside London – though the Morrises were originally Welsh – the eldest son and third child of William and Emma Morris. His father was a successful bill broker in the City of London, in effect a banker exchanging money and discounting bills of exchange, at the heart of the burgeoning capitalist system. This might have had an effect on the young Morris: certainly what he was presently to do could not have been more contrary to his father's career. There were numerous younger brothers and sisters, but with the exception of his eldest sister Emma they do not seem to have played much of a role in William's life. He was very close to Emma, who had some of the same drive that he did. She and her husband spent their lives working among the coalminers of Derbyshire. It has been argued that William's deep love for Emma was one cause of his unsatisfactory relations with his wife Jane.

His father died in 1849, when William was eleven, but before that he had made enough to establish the family in grand Victorian comfort. The Morris family might stand for what was happening in England in the nineteenth century in terms of money-making and success. Morris himself would use the organisation and entrepreneurial skills of the Victorian businessman, first to become successful within the bourgeois world and then to turn against it.

His paternal grandfather, the first William Morris, had left Wales for Worcester; the next William Morris moved to London, and when he was sufficiently successful moved out to Elm House in the country. He became even more prosperous through the lucky chance of acquiring 272 Devon Great Consols, shares in a Devonshire copper mine. They came to be worth £200,000 and were the basis of the financial security of the family. When William became twenty-one he acquired an annual income of £900.

The English have a healthy respect for the freedom which money makes possible. Without that secure income Morris probably could

not have waited until he was twenty-five before launching his career firmly. (Before that, there were quite a few false though extremely valuable starts.) Ultimately, Morris's aim became to destroy his own class and the economic barriers which divided people in the world. Yet he recognised that it was his strong financial position that allowed him to pursue his interests. As he wrote in 1883:

If I had not been born rich or well-to-do I should have found my position *un*endurable, should have been a mere rebel against what would have seemed to me a system of robbery and injustice . . . The contrasts of rich and poor are unendurable and ought not to be endured by either rich or poor . . . Such a system can only be destroyed, it seems to me, by the united discontent of numbers; isolated acts of a few persons of the middle and upper classes seeming to me . . . quite powerless against it. (H 176)

The source of the family income remained important to Morris. In 1871 he became one of the directors of the mining company in order to watch over his investment. The reorganisation of his design firm in 1875 was partly a result of the need to be more careful financially at a time when the mine was ceasing to be a source of income. In 1876 he resigned as a director, and as a gesture of release, giving much pleasure to himself, he sat on his top hat.

Ancestry was not of much interest to Morris. Towards the end of his life, he wrote to a correspondent:

I have no ancestors, and don't think I should care if I had; it would be enormous trouble to hunt up photos of myself and this generation of my people. The last generation having [been] recorded (if at all) before the days of photography and after those of art haven't the least interest even to their grandchildren. Besides I don't think I approve of the whole affair. What I offer to the public is my work, I don't want them to know anything else about me. (MS)

He helped one brother out with a job at his factory when he was in financial need, and he kept in very close touch with his mother, writing to her frequently. She died only a few years before he did. He was much involved with his two daughters, the elder of whom, Jenny, had epilepsy, never married and spent most of her life as a recluse. The younger, May, was extremely active in all her father's interests, as a designer, particularly in embroidery, but also very

much a participant in his political activities. (She received a testimonial from her fellow members at the Hammersmith Socialist Society at the time of her brief marriage to Halliday Sparling.) May did not have children, and the direct line died out, although there are descendants of the various brothers and sisters. In every sense, Morris's legacy was to the world, although his more immediate estate went to his wife and daughters, and his firm (Morris & Co.) lasted well into the twentieth century.

When William was six the family moved to Woodford Hall, near the Thames in Essex, the grandest house in which they would live, with fifty acres of park and a hundred acres of farm. It subsequently became Mrs Gladstone's Convalescent Home for the Poor, which she founded in the late 1860s in the wake of the cholera epidemic – a pleasing coincidence, for Morris's eventual involvement with politics came about as the result of Gladstone's concern with the Eastern Question, although he turned upon him later.

There was in Morris, even at this tender age, an intense romanticism which lasted through all his life, and finally united with his political idealism – as E. P. Thompson indicated when he entitled his monumental study *William Morris: Romantic to Revolutionary*. But the former was not lost in the latter. Morris had the exuberance and fantasy of a childhood rich in imagination that had been allowed to thrive freely. What was extraordinary about him was that something of it remained with him all his life, in all his work. It was not an unmixed blessing: at times he acted like a spoilt child, would bang his head against the wall, could not react to others with delicacy and mature concern. But in his childhood all was glory, and he took great pleasure in the multiple activities of the country estate. These years at Woodford Hall were richly fulfilling. There was the extended, almost medieval world of Epping Forest at his doorstep, where William could wander about on his pony, at times dressed in a toy suit of armour which had been made for him. He learned to read early and his exhaustive reading of the novels of Sir Walter Scott fed his romantic imagination.

His religious upbringing was somewhat contradictory. He was influenced by the intense religiosity of his mother and his sister

Emma, but they pulled in opposite directions – his mother towards the evangelical Low Church, his sister towards high Anglicanism. He called his childhood religion 'rich establishmentarian puritanism'. Morris moved in the Anglo-Catholic direction, and even for some time thought he would take up a career in the Church. All through his life he had a sense of religious vocation, a religious dedication to his task to reform the world. It was this emotional and intellectual commitment which gave his life its basic consistency – first to change the world religiously, then secularly. His evolution followed that of many Victorians, most particularly Gladstone, who was so important in the origins of his political activism, and then came to stand for a moderation Morris could not tolerate.

After his father's death, the family moved again – in 1840 – to the somewhat smaller Water House in Walthamstow (now the William Morris Gallery), where they lived until 1856. Though smaller, it was none the less a considerable house, still in a comparatively rural part of the world, 'a suburban village', as Morris later described it, 'on the edge of Epping Forest, and once a pleasant place enough, but now terribly cocknified and choked up by the jerry building' (H 184). What he might say of it in our time is hard to imagine, although Water House itself is now surrounded by a pleasant if urban park, with ponds and an aviary, providing some relief from the endless miles of outer London, and the tube stop for Walthamstow uses a Morris tile as its motif.

Morris's ideas are being re-created in a variety of contradictory images. In 1934, at the centenary of his birth, the Tory Prime Minister Stanley Baldwin (a nephew of Morris's greatest friend, Sir Edward Burne-Jones) gave a speech in Walthamstow celebrating Morris, whom he practically converted into a Tory paternalist: '[He] regarded men and women around him as that raw material which, if life were long enough, he might be able to mould and work into something far happier and better than he saw.' When the Gallery was opened in 1950, the then Prime Minister, Clement Attlee, claimed Morris as an ancestor of *his* party, Labour. This was technically true, of course, but whether Morris would have liked the 'demi-semi Socialism' of the modern Welfare State is another matter. A man who had been virtually a rebel and certainly

339

against authority hence was celebrated by two Prime Ministers, one Tory and the other Labour – and it was the Tory who was practically a relation. In the tradition of the English left, there were backward-looking elements in Morris's thought as well as in his literary and design work. Concerned with the future, he frequently depicted in his poetry and prose a past which provided elements of a better society than that of the present.

A great deal of Morris's education was gained by reading and exploring on his own, but he also had a more formal schooling. At the age of nine he was sent to a preparatory school in Walthamstow as a day boy. Then, at the age of thirteen, he was sent away to a public school. In his case it was Marlborough, one of the up-and-coming new boarding schools founded to serve the ambitions of the middle class to educate their sons appropriately and, it was hoped, in the company of their social superiors. Such schools also catered for the sons of ministers, who generally paid lower fees, and were deemed suitable for those who might be going into the Church. Thomas Arnold had already brought about the reforms designed to educate Christian gentlemen capable of ruling both England and the developing Empire, but Marlborough itself had not yet settled down. It had only been founded in 1843, the school was overcrowded, and was not very well organised. For Morris this was a great boon. He found himself free to wander about the Wiltshire countryside, and fell in love with Savernake Forest, the Downs, and the remains of ancient civilisations, the famous stone circles of Avebury, the Roman villas at Kennet. The area fed his sense of romance more effectively than the school would educate him, but he kept a fond memory of it and of his schoolfellows, whom he had amused by his story-telling. One of them was to read his funeral service.

After Marlborough, he returned to his widowed mother and her many children. The family had been somewhat broken up, not only by the father's death, but also by the marriage of Morris's beloved sister, Emma, to a clergyman, which may have strengthened his own resolve to go into the Church. While at home, he prepared for Oxford and passed the matriculation examination – specifically for Exeter College – in June 1852, although because a place was lacking he did not actually enter until January of the

next year. Sitting beside him at the examination was one Edward Jones, the son of a poor Birmingham craftsman who was to be his closest friend, and become known to history as Burne-Jones, the 'Burne' being added later.

Before Morris went off to Oxford to begin the broader adventure of self-discovery, one important non-event, or 'counter-event', in his life should be mentioned. During 1851 he went with his family, as did millions of Britons, to view the Great Exhibition in Paxton's extraordinary Crystal Palace in Hyde Park. That Exhibition boldly demonstrated England's fulfilment of the promise of the Industrial Revolution, and her victory over France in 1815. It asserted England's position as the most powerful country in the world: Morris's mature life would be dedicated to challenging the basis for that assumption. He could hardly have known that in 1851. Yet it is reported that he refused to go into the Exhibition because he hated what he heard of the ugliness and vanity inside.

The theoretical basis of his ideas was a hatred for the mechanical civilisation so clearly celebrated in the useless machine-made curlicues on many of the objects at the Exhibition. Thus, as a very young man, Morris was already making war against the Victorian age. He was similarly disrespectful of matters of state. The next year, in 1852, he refused to attend Wellington's funeral but instead chose to spend the day riding through Epping Forest to see Waltham Abbey.

2 Oxford

Despite the achievements of the Great Exhibition and what it represented, England was still, at mid-century, very much in transition. Many of its institutions maintained their eighteenth-century character, alongside signs of the changes the new age would bring. Oxford was no exception. The expansion and the aggressiveness of the nineteenth century were about to start taking a terrible architectural toll on the city, much to the distress of Morris, who had an intense love for what was left of the medieval town. The very year that he went up to Exeter, the early seventeenth-century chapel of the college was torn down, to be replaced by an impressive if gloomy structure based on the Sainte-Chapelle in Paris. It was designed by Gilbert Scott, who would become Morris's symbol of all that was wrong with nineteenth-century architectural restoration. The building of the new chapel took place while Morris was at Oxford, mostly in 1855; the Victorian passion for 'improvement' disturbed his sleep.

In other ways too Oxford was losing out to the modern world – over the opposition of many in the University, the railway was extended from Didcot to Oxford, a reality of the present and portent of what lay ahead. Morris and Burne-Jones preferred to explore the countryside on horseback, visiting churches which deepened their feeling for the medieval past.

Oxford was in a state of flux, responding to the intellectual currents and excitements going on in the University. The Oxford Movement – that new seriousness about Anglicanism, its past and its current practices – had officially terminated in 1845 with Newman's conversion to Rome; but its effect was still in the atmosphere, tempting Morris and Burne-Jones to follow his example, and reflected in a growth of intellectual commitment on the part of some of the students and dons at the University.

His years at Oxford were extremely important to Morris. He enjoyed himself there in large part, as is generally the case, because

of the friends he made. Through Burne-Jones he met a group of Pembroke College undergraduates from Birmingham. They too became friends for life; one of them was the mathematician Charles Faulkner, later a partner in Morris's Firm, and a political follower.

The formal education at Oxford in these years was limited, and Morris was only working for a pass degree. Most of what he learned was from contemporaries. The group adored poetry, most particularly Tennyson's, whose 'The Lady of Shalott' made a strong appeal to Morris's sense of the past. He discovered that he himself could write poetry. In 1856 he started a literary magazine:

About that time being very intimate with other young men of enthusiastic ideas, we got up a monthly paper which lasted (to my cost) for a year; it was called the *Oxford and Cambridge Magazine*, and was very *young* indeed. (H 185)

There were twelve issues, and Morris appeared in ten of them with his first published work, poems, tales and essays.

Like many intellectually inclined undergraduates, Morris and his literary friends were enthusiastic and hopeful of the future. They bewailed the present, scorned their philistine fellow-students and acquired a sentimental place in their hearts for Oxford, misguided though they might believe the beloved institution to be from time to time.

There were other pleasures apart from friendship. Morris's reading had always been extensive, but at university it became voracious and more concentrated, and placed him for life squarely in the tradition of his mentors. Carlyle and Ruskin, who are nowadays mentioned in the same category as himself as critics of nineteenth-century English society, were then of course still comparatively young. Many of Morris's attitudes at that time can be attributed to them, and he continued to revere them both throughout his life – Ruskin more so than Carlyle – even though he came increasingly to differ from the conservative, indeed reactionary, tendencies of their thought. Theirs was another influence which reinforced his medievalism, his conviction that aspects of the world of the past were better than what had replaced them in the world of the present. Eventually, Morris's socialism would

lead him to believe that it was possible for the values of the past to come to fruition in a democratic way in the future, but he was not yet politically inclined. Only the premiss for such a conversion was there in his dislike of contemporary civilisation. It was around this time that he and Burne-Jones came to the conclusion that the world of the present was unsatisfactory, that shoddy was king, and that they must engage in a holy war against the age. In Morris's case, the form of that warfare changed over the years, but the objective continued the same.

In Exeter College library there is a miscellany of Morris possessions – spectacles, callipers, pipes, pens, and his copy of Carlyle's *Past and Present*, published in 1855, which argued the virtues of the past over the vices of the present. An even more decisive literary event for him was his reading of John Ruskin's works, which – as he wrote – 'were at the time a sort of revelation to me' (H 185). He had read the two published volumes of Ruskin's *Modern Painters*, but much more significant for Morris was the publication in 1853 of the second volume of *The Stones of Venice*, of which the most important chapter was 'The Nature of Gothic'. As early as 1854 this chapter was printed separately, and perhaps its most famous reprinting was in 1892 by Morris himself, with a preface by him, as the fourth publication of the Kelmscott Press, his great 'typographical adventure' toward the end of his life. Morris remarked of the chapter in the preface that 'in future days it will be considered as one of the very few necessary and inevitable utterances of this century'. In that chapter (and elsewhere) Ruskin advanced the idea which became crucial to Morris's thinking: there was virtue in the lack of perfection or roughness in the Gothic craftsman or sculptor, for it reflected the humanity of the art and the pleasure the maker took in the work. It is easy to sympathise with this protest of Ruskin's against the soulless perfectionism of the machine, but it ultimately led to a difficulty in Morris's own thought, in that many of his repeating designs could in fact be as well or better done through the regularity of machines. Morris, one should emphasise, was never adamantly against machines, but he certainly thought of them as second best. That position can lead, obviously, to archaic and bull-headed attitudes, yet it keeps squarely in mind that it is the human being

who counts, both the maker of the object, whether a work of art or anything else, and the user. Just at the moment when the Industrial Revolution appeared to be all-triumphant it was important to these young men, and the many others who read Ruskin, that the price to be paid, and the values that might be endangered, be kept in mind. Ruskin reinforced Morris's belief that medieval society 'allowed the workmen freedom of individual expression' because the 'art of any epoch must of necessity be the expression of its social life.' In Morris's mind, there was in the earlier age the right interplay between the individual and the community. The basic premisses of the ideas he would hold throughout his life were taken from Ruskin and Carlyle. Though ultimately he would become far more a figure of the left than these two sages, he never questioned their indictment of the shoddiness of contemporary civilisation, or their insistence upon the importance of joy in labour.

To Ruskin and to Pugin, Morris owed his conception of workmanship, sharing with them a concern with the moral implications of work – that work in and of itself could be either debasing or noble.

Pugin and Ruskin were prophets of the Gothic revival, that belief in Gothic as the only truly Christian architecture, dominant throughout the nineteenth century, not only for churches but for an increasing number of public buildings – indeed for some private buildings as well. For Pugin, and particularly for Ruskin, the Gothic style suggested a philosophy of workmanship. Whether or not the philosophy was an accurate understanding of the Middle Ages is another matter, and not necessarily crucial to its significance for the nineteenth century. Pugin, Ruskin and Morris saw in the style an important statement about workmen in the fourteenth century: their labour was undivided, they were skilled as stonemasons, carvers and so forth rather than specialists on a small aspect of the job who were thereby prevented from having a sense of the total endeavour. These workmen were not mere mechanics, reduced to the level of the modern factory, trapped in an invariable deadening routine.

In 1854, in his first summer vacation Morris visited France. The Gothic cathedrals of Amiens, Beauvais, Chartres and Rouen were

revelations to him. The next summer he went to France again, and prepared himself by reading *The Dictionary of French Architecture from the Eleventh to the Sixteenth Centuries* by Viollet-le-Duc, the celebrated restorer, whose most notable achievement, attacked by some, was the rebuilding of Carcassonne. But could this revelation of the Gothic be put to practical use? The problem of what to do with his life beset him.

In 1855 Morris achieved his majority and now had an income of £900 a year. He, Burne-Jones and their friends were talking more and m⌐.e of a brotherhood, or a monastery, but less and less did they think of it in religious terms. In 1855, he and Burne-Jones decided that they definitely would not enter the priesthood, but rather dedicate themselves to art. His mother was distressed that Morris had decided to abandon the Church.

He took his pass degree examination in the autumn of 1855. But he remained in Oxford, articling himself in 1856 to one of the most promising architects of the day, the 'great Goth', G. E. Street (whose most famous building, started in 1866, would be the Law Courts in the Strand). Street was ten years older than Morris and had just set up his practice in Oxford in 1852. Morris eventually would have doubts about his master's great work: he realised that Gothic had its limitations as a style of the past used for the present and he was uneasy about building in a historical style. But these thoughts were far in the future. Most of Street's practice was ecclesiastical, building churches, among them some of the finest of the nineteenth century. Most important in terms of Morris's training was Street's belief that the architect must not only design the building but have a practical knowledge of everything that went inside it – ironwork, painting, fabric, stained glass. His influence was incalculable in establishing Morris's future conception of his role.

It was in Street's office that Morris met Philip Webb, the son of an Oxford doctor, three years older than himself. Webb and Burne-Jones were throughout their lives Morris's closest friends, and were deeply involved in all Morris's artistic adventures. Webb who, unlike Burne-Jones, would also follow Morris in his politics was, Morris felt, the best man he had ever known. Both these

friends were somewhat less emotional than Morris, less given to sudden rages and impulses. Burne-Jones was the more aesthetic figure, and his painting tended towards the ethereal. Webb was more solid, and although the number of buildings he designed was small, he became a great influence in the architectural community as the century progressed. Morris's actual experience in the nine months that he spent in Street's office was rather limited, most of it devoted to copying a drawing of the doorway of St Augustine's, Canterbury. More important was the visit he paid with Street to the Low Countries in the summer of 1856. These tours abroad each summer while he lived in Oxford broadened his conception of art and architecture, particularly as this was before the days of widespread reproduction of paintings and pictures of buildings.

Working for Street served as an important and thorough introduction to architecture. Dante Gabriel Rossetti and the Pre-Raphaelite circle introduced Morris to the world of painting and London bohemia, along with complications of living and sexuality considerably more intricate than in those jolly youthful times the congenial group of Oxford undergraduates had enjoyed over the past three years. Morris was already on his way to becoming a multiple artist – plunging into poetry and prose, illumination and embroidery – but the question was where he was to put his greatest emphasis. He was living out the motto he now adopted as his own from the painter Van Eyck's 'Als ich kanne', which Morris rendered in French 'Si je puis' (If I can).

He was also becoming a patron of his new acquaintances. His early purchases included Arthur Hughes's painting *April Love* and, for £40, a small study of a hay field by the Pre-Raphaelites' master, Ford Madox Brown. His interests were turning towards painting under the influence of Rossetti, to study with whom Burne-Jones had come to London in the spring of 1856, without taking his degree from Oxford.

Rossetti was only six years older than Morris, but in the decade 1850–60 he was at the height of his powers, both as painter and poet. The Pre-Raphaelite Brotherhood, of which he was a founder, had been formed in 1848, that year of revolutions, with Holman Hunt and Millais as its other most prominent members. It was

dedicated to the return to an earlier form of Italian painting, truer to nature. Its publication, *The Germ*, issued from January to April 1850, served as a model for the *Oxford and Cambridge Magazine*.

Rossetti and his friends were a heady influence upon Morris during the many weekends he spent down from Oxford in London at this time. In 1856 Rossetti did a sketch of Morris as a model for the head of King David for the Llandaff Cathedral triptych. It reveals a rather beautiful young man, caught in a quiet moment. Rossetti, with his interest in medievalism, and in a brotherhood, was bound to be deeply congenial to Morris and Burne-Jones. He also moved them in an art-for-art's-sake direction. Yet the emphasis on the decorative in his paintings also ultimately acted as an inspiration for Morris to make good design more widely available, through objects rather than through paintings. Aestheticism had a negative political impetus – it was an act of rebellion against an ugly age. It was a comparatively simple matter – although Rossetti himself was quite apolitical – to extend the artistic revolt to encompass political elements. As well as the importance of decoration for its own sake, the Brotherhood had emphasised a belief in the relevance of art to all parts of life. This was a crucial influence upon an impressionable young man. Morris was becoming more and more convinced that being an architect was not the career for him. He gave up his apprenticeship with Street at the end of 1856, and moved to London, first taking rooms with Burne-Jones in Upper Gordon Street in Bloomsbury. Later the two of them moved to Red Lion Square nearby.

Although he was now spending much of his time in London, it is appropriate to consider this period as still part of Morris's student years. His complete independence of the great university city was not assured until his marriage and the building of Red House in 1859. Meanwhile, his primary activity was trying to make himself a painter, under the tutelage of Rossetti. Feeling that no furniture was worthy of the Red Lion flat, he embarked upon the design of a settle. When constructed, it was so mammoth that it had to be hoisted into the building through the windows. This object, in all its magnificence and power, is still to be seen in Red House in Bexleyheath, outside London, although it no longer has Rossetti's painted panels.

These years were also a time of boisterous living. Morris gave up shaving, and developed the bearded look by which he is now remembered. They were young men released from the restraints of university life, and allowed to do what they wished in the metropolis: there were frolics, heavy eating and drinking, noise and enjoyment. There is no indication that Morris took advantage of the *vie de Bohème* for sexual adventures; although he regarded himself as a pagan, there was probably enough residual evangelicalism in his system to prevent that. But he believed in the pleasures of food and drink, and his figure began to fill out. While working on his painting he continued his work and experimentation in embroidery and woodcarving.

Ruskin, who had committed himself as a defender of the Pre-Raphaelites, was a frequent visitor. It was in this year, 1857, that Ruskin moved into politics, with his lecture in Manchester on 'The Political Economy of Art'. These ideas planted seeds in Morris's mind that were to flower twenty years later. Ruskin, as Rossetti and Street had done, reinforced his conception of the artist as necessarily concerned with every part of the arts. Though critical of the age, these men, like Morris himself, were true Victorians with an almost boundless confidence in their ability to master all aspects of their areas of interest.

But despite their omnivorous energy and interests, it was necessary to have a focus, and that had not yet appeared in Morris's thought. He still seemed something of a lightweight (though increasingly corpulent!), swept up in the latest enthusiasm of the moment. This, in 1857, was a project to paint murals in the just completed new Debating Chamber of the Oxford Union, for which the architect was Benjamin Woodward, also the architect of Ruskin's admired Natural History Museum at Oxford. It was Rossetti's idea, and he persuaded Morris, Burne-Jones and other friends to participate in the project. They had a wonderful time, particularly as the Union was paying for their food, lodging and equipment, although they were donating their labour. As Burne-Jones wrote, 'It was blue summer then and always morning and the air sweet and full of bells.' The project was misconceived, first of all because windows in the middle of the areas to be painted meant that glare made everything very difficult to see. The ground

for the paintings had not been prepared properly, so that the pictures began to fade almost as soon as done. They can in fact still just be seen in the room, now the Library of the Union. Infrared photographs make it possible to know what the original paintings looked like. They were taken from legends of King Arthur and the Knights of the Round Table based on Malory's *Morte Darthur*. Seven murals were completed out of the ten proposed; Morris's was 'How Sir Palomydes loved La Belle Iseult with exceeding great love out of measure, and how she loved not him but rather Sir Tristram.' This theme of unrequited love had already figured in his writings and would continue to do so. It was, as we shall see, also a theme in his personal life.

Morris finished his painting early and was able to embark upon a scheme of decoration for the ceiling area above the painting. Ruskin found it too ornate, and Morris's Firm renewed it in 1875 in a more restrained manner; it is now perhaps the most impressive part of the design scheme. He also helped in providing a model for a suit of armour, in having it made, and modelling it for his colleagues; one of the most memorable moments in the whole enterprise was when Morris roared and yelled because he could not open the visor. The helmet and sword are still preserved, and may be seen in the William Morris Gallery in Walthamstow. The spirit of the whole enterprise was high, and did not quite have the solemnity that Max Beerbohm mockingly suggested in his depiction of the event in *Rossetti and His Circle* (1922), in which he had Benjamin Jowett, the famous Master of Balliol, ask of Rossetti 'And what were they going to do with the Grail when they found it, Mr Rossetti?'

Rossetti was central to Morris's life in another way. In an Oxford theatre during this perfect summer – it must have rained sometime – he spotted a 'stunner', as they called beautiful women who caught their fancy. She was Jane Burden, an Oxford girl who, two years later, would become Morris's wife. That she was discovered by Rossetti was crucial – it was almost as if Morris wished to be involved with someone who had the Master's approval. In many ways she was more Rossetti's than Morris's: it now seems certain that they had a long affair while she was married to Morris. Jane Burden sat for Guinevere in Rossetti's contribution to the fiasco of

the Oxford murals, and from then on she would be one of his most important models. She was the archetypal Pre-Raphaelite woman, as suggested some twelve years later in a description of her in a letter by Henry James:

she haunts me still. A figure cut out of a missal – out of one of Rossetti's or Hunt's pictures – to say this gives but a faint idea of her, because when such an image puts on flesh and blood, it is an apparition of fearful and wonderful intensity. It's hard to say [whether] she's a grand synthesis of all the pre-Raphaelite pictures ever made – or they a 'keen analysis' of her – whether she's an original or a copy. In either case she is a wonder. Imagine a tall lean woman in a long dress of some dead purple stuff, guiltless of hoops (or of anything else, I should say,) with a mass of crisp black hair heaped into great wavy projections on each of her temples, a thin pale face, a pair of strange sad, deep, dark Swinburnish eyes, with great thick black oblique brows, joined in the middle and tucking themselves away under her hair . . . a long neck, without any collar, and in lieu thereof some dozen strings of outlandish beads – in fine Complete. On the wall was a large nearly full-length portrait of her by Rossetti, so strange and unreal that if you hadn't seen her, you'd pronounce it a distempered vision, but in fact an extremely good likeness. After dinner . . . Morris read us one of his unpublished poems, from the second series of his un-'Earthly Paradise,' and his wife having a bad toothache, lay on the sofa, with her handkerchief to her face . . . this dark silent medieval woman with her medieval toothache. Morris himself is extremely pleasant and quite different from his wife. He impressed me most agreeably. He is short, burly and corpulent, very careless and unfinished in his dress . . . He has a very loud voice and a nervous restless manner and a perfectly unaffected and business-like address.

Even after the happy summer of painting had passed, Morris lingered in Oxford, going down to Red Lion Square frequently, but staying on in the well-known fashion of former students who find it hard to leave their university. But he was also there because of the presence of Jane Burden, who lived in Holywell Street. Practically nothing is known about her background, other than that she was the daughter of a groom. She was, as Henry James and many others have noted, of great beauty, and exactly the sort of beauty desired by the Pre-Raphaelites. On the surface it was certainly a highly unsuitable match for a member of the upper middle classes. Morris's mother was already in quite a state of despair about her eldest son, who had brusquely announced to her his change of

career from architect to painter; but he had achieved his majority, his father was long dead, and he had a sizeable personal income which allowed him to do pretty much what he pleased.

Jane became famous for her silences, as Morris did for his noisiness, so that it was hard to estimate her. It appears that she was not much involved in his work, although she was active as an embroiderer in the Firm. She would take little interest in her husband's political activities; on the other hand she did not try to curb him. She was remembered for having tricked George Bernard Shaw, a dedicated vegetarian, into eating a suet pudding, and for suggesting to Cobden-Sanderson, who became the most famous bookbinder of the period, that he take up that skill as no one else did it in the Morris circle. She certainly participated in the life of the family, in bringing up their two daughters, and she spent a great deal of time stretched out on the sofa, not feeling well – in the manner of the time. They would take trips to Italy and Germany with a view to improving her health. In fact, she was probably much stronger physically than Morris, and lived on to 1914. They came greatly to depend upon one another, but it was not a happy marriage: it was a continuing sadness, even tragedy, for one who believed so deeply in human love and the importance and goodness of the animal parts of human life. The difference in social class might have been a source of friction; it is perfectly possible for those of the upper classes who are on the left, particularly in England, to be unable to mix with those from the lower classes, despite their intense desire to do so. Perhaps in this sense the English class system defeated Morris in the end: there may not have been enough mutual interests to sustain the marriage. It wasn't that Jane was stupid. Her letters suggest an intelligent and pleasant woman. But their contrasting temperaments, which might have complemented one another, in fact tended to grate. Jane was calm, and emanated the essence of silence, the passionate quietness caught in Rossetti's many pictures of her, whereas Morris was continually active, and undoubtedly drove her to distraction, although he was certainly as considerate as he could be. His style was hardly gentle, but he devoted much time to worrying about her health, going with her to places where she might feel better, and his letters are marked

with this continual concern. For her it was a brilliant match, and she seems to have been happy in its early years. It is not clear exactly what happened to her between their meeting in the summer of 1857, when she was seventeen, and their marriage at the little church of St Michael in the centre of Oxford on 26 April 1859. One wonders if perhaps the time was used for her to receive some further education.

Morris's attitude towards women has come under attack in Anthea Callen's *The Angel in the Studio* (American title: *Women in the Arts and Crafts Movement*), where it is claimed that he was guilty of 'pedestalisation' (the word seems a crime against the English language). He once remarked that women were rather feeble on the artistic side, although excellent in business and mathematics. Women workers did endless and boring tasks of embroidery to produce Morris's designs. But then the men in the shop did boring work as well – though perhaps they were paid better for it. In the context of the time, Morris was certainly far more enlightened than most, and in this perspective it seems harsh to judge him negatively. In *News from Nowhere*, his utopian novel, women perform traditional tasks, but do so from choice. He was not necessarily imaginative in visualising the range of what women might do.

The affair between Rossetti and Jane clearly disturbed Morris. But he does not appear ever to have contemplated divorce or any other drastic action. Rather, when Rossetti and Jane were closest, in the early 1870s, he kept out of their way, and did most of his travelling to Iceland. Morris did have a small circle of women friends, most notably Georgiana Burne-Jones, the wife of his greatest friend. There was no indication that they ever had an affair. He preached the importance of joy and happiness in life and work, yet he in fact failed to have a happy personal life. Rossetti, an Italian, was accustomed to associating with artists' models, women of beauty whom, presumably, he did not expect to be also intellectually stimulating. Jane's other known affair was with Wilfred Scawen Blunt, the eccentric poet, political gadfly and womaniser, who was not looking for women with whom to have permanent relationships. His wife, Lady Anne Blunt, Byron's granddaughter, provided quite enough fire for the married state.

In the mid-1880s Morris wrote an interesting letter to one of his oldest friends, which gives a vivid sense of his attitude to sex.

Copulation is worse than beastly unless it takes place as the outcome of natural desires and kindliness on both sides! So taking place there is even something sacred about it in spite of the grotesquery of the act ... mere animal on one side, inexplicably mysterious on the other: The decent animalism plus the human kindliness: that would be infinitely better than the present system of venal prostitution which is the meaning of our marriage system on its legal side; though as in other matters, in order to prevent us sinking out of existence, real society asserts itself in the teeth of authority by forming genuine unions of passion and affection ... The economical freedom of the family would clear away the false sentiment with which we have gilded the chain; but to my mind there would still remain abundance of real sentiment which man has evolved from the mere animal arrangements, and that this would prevent indecencies: though as to the outward form or symbol that it would take I can make no prophecies ... The couple would be *free* ... We must not forget that the present iniquity like all iniquities weighs much heavier on the working classes than on us because they are cooped together like fowls going to market. (MS)

The year before his marriage, 1858, saw the publication of Morris's first book of poems, *The Defence of Guenevere and Other Poems*. It was dedicated to Rossetti – 'friend and painter'. Although Rossetti had not yet published much poetry, the Pre-Raphaelites' controversial reputation as painters and, to a degree, as literary figures, may have helped bring about the unenthusiastic reaction to Morris's book of poems. Morris was young and unknown; the book received very few reviews, some favourable, some not, but the unfavourable ones tended to be the more vehement, as in one damning paragraph in the *Spectator* (February 1858):

The Poems of Mr. William Morris chiefly relate to the knights and ladies of King Arthur's time, and nearly all the rest of the pieces belong to the vaguely fabulous age of chivalry; though the author has introduced into his poems touches of what modern research or judgment has shown to be its real coarseness and immorality. To our taste, the style is as bad as bad can be. Mr. Morris imitates little save faults. He combines the mawkish simplicity of the Cockney school with the prosaic baldness of the worst passages of Tennyson, and the occasional obscurity and affectation of plainness that characterise Browning and his followers. Some of the smaller

poems are less unpleasing in their manner than the bulk of the book, and a poetical spirit runs through the whole, save where it is unskilfully overlaid. We do not, however, augur much promise from this power; the faults of affectation and bad taste seem too deeply seated.

Although the worst received of all the poetry that Morris wrote, *The Defence of Guenevere* contained his best poems and about half its contents are probably the most reprinted of his verse. That may in part be due to a change of taste. The long narratives of his later poems, which served as novels for Victorian readers, are no longer in fashion. Few modern readers have the patience to read them. The later poems also lack the intensity of vision of the early ones, of the young man waiting impatiently to be married, as suggested in a few stanzas of 'Praise of My Lady'

> My lady seems of ivory
> Forehead, straight nose, and cheeks that be
> Hollow'd a little mournfully.
>
> *Beata mea Domina!*
>
> Her full lips made to kiss,
> Curl'd up and pensive each one is;
> This makes me faint to stand and see.
>
> *Beata mea Domina!*

The poems are marked by their interest in medieval scenes, their sense of decorativeness, their facing the grimness of medieval life rather than endlessly romanticising it. They surge with erotic energy. This is unusual, for one expects to find Victorian sublimation in poems published in the mid-century, but it is not surprising, considering Morris's youth and his exposure to the bohemianism of Rossetti's life. The story of Guenevere and her adulterous love for Sir Lancelot had a continual fascination for the Victorians, and so did its suggestion that private immorality could bring down the Kingdom, as Guenevere's betrayal of her husband King Arthur contributed to the end of Camelot. Yet Morris presents a sympathetic picture of the Queen.

Undoubtedly, *The Defence* contains the best and most vivid of Morris's shorter poems. But the lack of an enthusiastic response at

the time of their publication, and his involvement in a variety of other interests, put a long halt to his poetical career. He returned to writing poetry in 1861, but did not publish any verse again until *The Life and Death of Jason* in 1867.

3 Red House and the Firm

Morris married in Oxford, but his marriage in 1859 brought firmly to an end his Oxford years. From then on he would visit the city only sporadically, most notably in 1883, when he declared himself a socialist in those hallowed halls, much to the indignation of the residents.

He had done a lot for one so young: received his degree, had a brief career in the office of one of the leading architects of the period, become a disciple of one of its most prominent and controversial painters, and completed his one easel painting, 'La Belle Iseult', also known as 'Guinevere', a picture of his wife. (He had difficulty handling the human figure – a metaphor, it might be said, for his personal relations, and it is also ironic that by whatever name the picture is called, it is of an unfaithful wife. It can be seen now in the Tate Gallery.) He had sponsored and financed a literary magazine and published quite a bit of his own work in its pages. He had brought out a book of poems. He had married. The multiplicity of his activities was apparent, but his life as yet had no obvious focus. What was clear was that the cheerful bachelor life of Red Lion Square could not continue: that grander quarters were necessary for the married couple.

The ultimate result was one of the most important buildings of the nineteenth century. The construction of the house was the prelude to what were probably the happiest five years in Morris's life. There were not yet clouds in the relationship between his wife and himself. In 1861 and in 1863 his two daughters, Jane and Mary – commonly called Jenny and May – were born. But where to live? The Morrises had taken up temporary residence in Great Ormond Street. Nearby Morris's friend Philip Webb had his office, and the two dedicated themselves to finding a place to build Morris's dream house. They selected an orchard in Upton, now Bexleyheath, in Kent just outside London. It was there that a house

357

in brick, called Red House because of its colour, was built. The Morrises moved into it at the end of the summer of 1860.

The house has been seen by certain critics as the beginning of modern architecture because of its comparative plainness, and it does have the quality of austerity one associates with Webb, suggesting the start of the attempt to achieve an ahistorical style in his later architecture. It was a two-storey building, L-shaped, with the faint feeling of a monastery about it, almost as if it were part of a cloister. Morris in fact saw it as potentially part of a non-celibate commune which might be expanded. The Burne-Joneses – Edward had married Georgiana MacDonald in 1860 – might come to live with them there. That plan never came to anything. It had been seriously discussed in 1864 but decided against, and Morris's thinking about the house, his attachment to it, is reflected in his reaction to the news: 'As to our palace of Art, I confess your letter was a blow to me at first, but hardly an unexpected one: in short I cried, but I have got over it now' (H 22). Friends came to visit continually, and there were festive times, a continuation of the jolly life of Oxford and Red Lion Square. It was a wonderful place for entertaining and pranks, and the remaining orchard and the imitation medieval garden made the outside attractive as well. The building was not as new in conception as it was sometimes claimed to be. Its elements were based on Webb's experience with Street, the vicarages Street had built, and on Webb's sketches of the work of another prominent Victorian architect, William Butterfield. It was similar to the brick Gothic-style schools that both established architects had built. The building had, however, distinctive touches of pure Webb, removing itself from the fanciness and ornamentation that were hallmarks of Victorian styles of architecture. It also reflected loyalty to local material – brick was much easier to come by in the area than stone.

The house was thought of in a romantic way, appropriately as the first residence of a newly married couple. The interior was not in the light and airy modern style, but was rather dark and medieval, with heavy furnishings. The settle and wardrobe were brought from Red Lion Square, and Webb designed other objects as well – in a plain Gothic style – beds, chairs, candlesticks, glass and so forth. The important point was not that these designs were

necessarily revolutionary, but that Morris, Webb and their friends felt that the goods available to be purchased were not satisfactory. One needed to design for oneself. There were murals and hangings on some walls, but most of the walls and ceilings were covered by colourful patterns devised by Morris. Not much notice was paid to the house in the architectural press until towards the end of the century, when Morris and Webb were obviously names to be reckoned with. Yet it will not do to go too far in denying the house its importance. It may not have attracted a great deal of attention at the time that it was built, but its comparative practicality and plainness do suggest what future buildings might aim for: the importance of designing domestic architecture less concerned with impressing others than providing comfort for those who lived there. The ceremonial aspects of an 'important' private residence were dispensed with. The house was not designed for vulgar display of England's riches, but to show that life might be both simple and comfortable (it was, in fact, to Morris's taste, under-heated). The ordinary person could not afford to build such a house, but it suggested a direction that domestic architecture might take. It partook of the past in its architectural traditions, but it also had implications for the future of design. Rossetti wrote about the house that 'it is most noble in every way, and more a poem than a house ... but an admirable place to live in too.' Despite its similarities to other architectural developments, Red House pinpoints the attempt to make the smaller house an artistic work of architecture.

It also represented the spirit of Morris's early endeavours – that of a group of friends embarked upon improving the world. With the ingenuousness and arrogance of youth, they now felt they might be able to transform the look of everything about them. What is amazing is how successful they were, despite their many limitations and failures. They showed that serious artists were able to devote their energies to tasks which they might have previously considered beneath them. In this sense, their activities were also part of the professionalisation that was such a hallmark of the later nineteenth century. The issue was tied in with class, whether this was consciously recognised or not. If undoubted gentlemen, bohemian though some of them might be, were

involved in matters of manufacture and design, then the pursuits themselves were considered to be at a somewhat higher level. The class aspects of his activities were not of deep concern to Morris for some years. But from his reading of Ruskin he was aware of the implications of what he was doing.

At Red House, Morris was faced on a much larger scale with a problem he had first confronted in Red Lion Square. In order to find anything with which he was willing to live, he would have to design his own furnishings, or have them designed by Webb and others. With his experience of architecture and painting, and his hobbies of woodcarving and embroidery, he was well equipped to become a designer. But it required the building of Red House – and no doubt the many discussions concerning its planning, and the long wine-soaked evenings spent there by Morris and his friends, to bring about the existence, in April 1861, of Morris, Marshall, Faulkner & Company.

Such design firms had existed before, most notably that formed by Henry Cole, the organiser of the Great Exhibition of 1851 and the inspirer of the Victoria and Albert Museum. There had been a long history of discontent, both unofficially and on the government level, about the state of English design. There was, after all, a great tradition of good eighteenth-century English design. But it had seemed to come apart under the impetus of industrialisation and the development of more modern forms of production. Red House had demonstrated that it was possible for artists to create designs for living; not only unique items, like the murals and individually executed pieces of furniture, but also other objects – table glass, for instance – which might be produced in greater number. Why not embark on such a venture commercially? Related to this idea was the problem that Morris had still not found a specific career for himself. He was now a husband and father, and the Devon Great Consols were showing signs of declining in value. Burne-Jones was launched as a painter, Webb as an architect, but Morris's occupation was still undefined, particularly as his book of poems had not been a notable success.

Those who were to participate in the Firm were Ford Madox Brown, Burne-Jones, Charles Faulkner, Morris, Rossetti, and P. P. Marshall, a surveyor and friend of Madox Brown's. Morris was to

receive a salary of £150 as the principal partner, and Faulkner the same sum as bookkeeper. Perhaps Faulker and Marshall shared the title of the Firm with Morris because their names would convey the practical aspect of the enterprise better than those of the artists Burne-Jones, Rossetti and Madox Brown. They were all partners with a nominal investment of £1, while the real financial backing, to the tune of £100, came from Morris's mother.

As became a business prospectus, theirs was firmly assertive, and emphasised that these were artists who now condescended to participate in activities such as decoration.

The growth of Decorative Art in this country, owing to the efforts of English Architects, has now reached a point at which it seems desirable that Artists of reputation should devote their time to it. Although no doubt particular instances of success may be cited, still it must be generally felt that attempts of this kind hitherto have been crude and fragmentary. Up to this time, the want of that artistic supervision, which can alone bring about harmony between the various parts of a successful work, has been increased by the necessarily excessive outlay, consequent on taking one individual artist from his pictorial labours. The Artists ... hope by association to do away with this difficulty. Having among their number men of varied qualifications, they will be able to undertake any species of decoration, mural or otherwise, from pictures, properly so-called, down to the consideration of the smallest work susceptible of art beauty.

The Firm put itself forward to execute mural decoration, carving, stained glass (Burne-Jones was to be the leading designer in this area), metalwork, and furniture. The prospectus also claimed that its work would be 'much less expensive than is generally supposed'. In an autobiographical letter that Morris wrote to Andreas Scheu in 1883, he stated much more succinctly that 'all the minor arts were in a state of complete degradation especially in England, and accordingly in 1861 with the conceited courage of a young man I set myself to reforming all that: and started a sort of firm for producing decorative articles' (H 186). Offices were taken in Red Lion Square, near the old flat. Until 1865 Morris remained in Red House. When the commuting became too difficult, and after a serious illness, he moved, as did the firm, to Queen Square, near Red Lion Square.

The high tone of the prospectus, common enough in such

publications, turned out in this case to be justified by events. Not that the enterprise had a completely smooth history. Morris was a careless businessman, and it was only because there were good business managers that profits were made. Morris was the dominant figure throughout his life, and the Firm continued until 1940, when it went into voluntary liquidation. In 1875 it was reorganised as Morris & Co.; the temperamental painters Rossetti and Madox Brown felt that they had not received adequate compensation, and Morris was estranged from Brown for fifteen years. From 1861 on the Firm was a constant in his life, although undoubtedly he was most involved in it from its founding until he began to become politically active in 1876. During the 1870s he still created more than 600 designs.

Morris as designer had an extremely important practical and intellectual influence. He had a lasting effect upon the look and thought of the contemporary world. Nikolaus Pevsner in *Pioneers of Modern Design* (1936) has argued the crucial influence of Morris for the modern movement, unmodern though much of his work looks to our eyes. He worked in the context of his time; but ever since adolescence, in his refusal to enter the Crystal Palace, in his declaration of holy warfare against the age, he had opposed the fanciness and ostentation of the man-made world – not that all of his own work was totally free of such characteristics. He tried to maintain the Pugin–Ruskin credo of truth to nature and to material and the importance of the quality of workmanship. And he came to advocate a certain proto-functionalism, expressed in his famous dictum: 'Have nothing in your house that you do not know to be useful or believe to be beautiful.' The 'or' is significant, a pure functionalist would argue that it should be 'and' instead. It is also intriguing that he contrasts 'knowing' and 'believing'.

Morris's importance for design has been attacked on two fronts: by those who oppose Pevsner's historicism and his interest in figures in the past, such as Morris, for their contribution to the modern movement and the international style; and by those who see design evolving more by necessity – through the anonymous engineers and others who created what was needed – rather than by any conscious desire to change and simplify. But their arguments in no way invalidate Morris's own role as a highly important

and influential designer and teacher. In the early years of the Firm, he was only one of its several designers. But it was he who emerged as the greatest designer of flat patterns of the century.

There was a continual paradox inherent in Morris's career as a businessman. He was not particularly political when he began the Firm, but he was sufficiently Ruskinian to believe that the worker should have joy in his work. While there is no doubt that he enjoyed his own work immensely, it is not clear how much the Firm's hundred or so workers enjoyed theirs. He paid them well, but they were still caught in the commercial system which he abhorred. And though he became more and more radical, he never seems to have felt that he could or should do anything about this situation. Any individual amelioration, he felt, would have no result other than to make his own particular workers more rather than less wedded to the system that should be destroyed. He did not use that as an excuse to treat his workers badly, and he evolved a system of profit-sharing for his senior workers. Quite a few of them followed him politically, although in some cases it might have been from a sort of loyalty similar to that found in other factories. But Morris was more aware than he has been given credit for of the paradoxes of his position, especially after he became a socialist. As he remarked in 1886 in an interview with Emma Lazarus, it was

almost impossible to do more than to ensure the *designer* (mostly myself) some pleasure in his art by getting him to understand the qualities of the materials and the happy chances of processes. Except with a small part of the more artistic side of the work, I could not do anything (or at least but little) to give this pleasure to the workmen, because I should have had to change their method of work so utterly that I should have disqualified them from earning their living elsewhere. You see I have got to understand thoroughly the manner of work under which the art of the Middle Ages was done, and that that is the *only* manner of work which can turn out popular art, only to discover that it is impossible to work in that manner in this profit-grinding society. So on all sides I am driven to revolution as the only hope, and am growing clearer and clearer on the speedy advent of it in a very obvious form, though of course I can't give a date for it.

From the very beginning he believed in the importance of individual craftsmanship. Yet, as Paul Thompson has pointed out,

Morris was no exception to the trend in the industry of his time *away* from individual craftsmanship. For instance, the first wallpaper pattern he designed, 'Daisy', in 1862 was initially produced in his own workshops. But by 1864 that no longer proved possible and from then on it was manufactured with other patterns, by the eminent firm of Jeffrey & Co. Although much of his work continued to be done at the Firm (stained glass, printed fabrics, weaving, and dyeing), Morris used machines for the production of furniture, and produced items in a general and multiple way, not on personal order.

Yet at the same time the work of his Firm was a powerful influence for change: the growth of 'art' furniture; more serious thinking as to how an interior should look. Morris was not unique – design was improving in general – but he became the most influential in the field. Even if his practice sometimes contradicted what he preached, his message brought about something approaching a revolution in interior decoration. A comment by the *Spectator* in 1883 suggests the effect of the Firm:

Morris has become a household word for all who wish their material surroundings to be beautiful yet appropriate for homely use, 'neat not gaudy', English in taste, not French . . . Nearly all the better kind of designs in the shops are, as far as they are good, cribs from Morris.

Though its products were generally costly, the Firm did make some simple furniture as well, most notably the inexpensive traditional Sussex chair and the famous 'Morris' reclining chair, which in fact was a traditional design adapted by Webb. Morris himself remarked in his autobiographical letter to Andreas Scheu:

I have had a considerable success even from a commercial side; I believe that if I had yielded on a few points of principle I might have become a positively rich man . . . Almost all the designs we use for surface decoration, wall papers, textiles, and the like, I design myself. I have had to learn the theory and to some extent the practice of weaving, dyeing, and textile printing, all of which I must admit has given me and still gives me a great deal of enjoyment. (H 187)

He could design well becaue he trained himself thoroughly in the means of production. He had conquered them through his own experience. And his design imagination was prodigious.

The Firm was rapidly successful; as early as 1862 it had a display at the International Exhibition in London. There, the stained glass windows designed by Rossetti were much remarked upon and gained the Firm contracts to provide windows for four new churches built by the architect G. F. Bodley. (Indeed, the windows were so impressive that some thought that they were medieval glass and as such should be disqualified from the exhibition.) The Firm gained its first major secular commissions: to decorate the Green Dining Room for the South Kensington Museum, still in place, and also to do the Armoury and Tapestry rooms in St James's Palace.

Unlike most eminent Victorians, Morris did not appear to worry too much about religion, probably identifying with the paganism of the Germanic tribes; nor were, as far as we know, most of his fellow-designers particularly religious. Yet the backbone of the Firm's work in its early years was stained glass for churches, the result of the great rash of ecclesiastical building in the nineteenth century, the attempt to provide religion for a vastly expanding population, whether it liked it or not. In the early years most of the windows were designed by Rossetti and Brown; later, by Burne-Jones. Morris did 150 designs himself, although he was comparatively weak in creating figures. More than 600 villages, towns and cities in the United Kingdom, as well as a fair number of cities abroad, have stained glass windows by the Firm. Not that all the designs were different. Successful designs were used frequently and the Firm was flexible in dealing with the needs of clients. For instance, for the stained glass window designed for a Unitarian Chapel in Heywood, Lancashire, the figure representing Love is the same as the figure used for Christ in Anglican churches. The commissions were executed through a division of labour in the Firm, with Morris himself being the co-ordinator. Although this ran contrary to Morris's theory of the unity of art, and the ability of all craftsmen to do all work, in fact, as Charles Sewter has pointed out, this was one cause of the great triumph of the Firm's glass, and one reason why its Arts and Crafts successors were less successful. In the figures, most of them designed after 1865 by Burne-Jones, and in the colours, the glass was magnificent.

Sewter has argued that the Firm's glass was the best made since

the sixteenth century. He also makes clear how, contrary to most previous practitioners, the Firm liberated itself from medieval prototypes, and created modern glass in a medium which almost inevitably lent itself to a false medievalism. Morris was mainly interested in the qualities from the medieval past which had modern relevance.

As regards colour, where the credit, of course, belongs to Morris himself, no other stained glass of the nineteenth century, or of the previous two hundred years, can for one moment be compared to the splendour of his work in such churches as Bloxham, King's Walden, Lytham, Meole Brace, Staveley, Sunderland, Tadcaster or Tilehurst (to mention only a few), or in the Chapel of Jesus College, Cambridge . . . In his early windows, such as those at the eastern end of St Michael's, Brighton, Morris's chords of deep green, dull ruby, blue and pale gold have a boldness of contrast and a subtlety of tonal balance which are not only entirely personal, but quite beyond the capacities of any of his competitors . . . [His windows] reveal a feeling for the expressive power of colour which was unique in the nineteenth century, and rare indeed in the whole history of the art . . . At the end of the century a new generation, which owed an enormous debt to Morris's ideas rather than to his example, adopted an attitude which implied some criticism of his practice. The tendency of the Arts and Crafts Movement was to attempt to unite the entire processes of the art, from the manufacture of the glass itself to the completed window, in the hands of a single artist-craftsman . . . The great secret of Morris's success, apart from his own personal gifts as a creative artist, was his respect for the craftsman. 'You whose hands make those things that should be works of art,' he wrote, 'you must be all artists, and good artists too . . . the handicraftsman, left behind by the artist when the arts sundered, must come up with him, must work side by side with him: apart from the difference between a great master and a scholar, apart from the differences of the natural bent of men's minds, which would make one man an imitative, and another an architectural or decorative artist, there should be no difference between those employed on strictly ornamental work; and the body of artists dealing with this should quicken with their art all makers of things into artists also . . .' This is exactly what he had done in Morris & Co.'s stained-glass workshops.

There may have been an inconsistency in the message Morris preached between the claims of the unity of art and the need for a division of labour to achieve the best results. But he was consistent in his respect for the task to be done, and his opposition to a hierarchy among artists. He had equal respect for all labourers who

tried to do an honest job. But he came to see clearly that in an industrialised society the commitment of the labourer to his work was becoming more and more perfunctory, and indeed that tasks necessary to earn a wage were increasingly distasteful – that there was a growing gap between work and life. To infuse production with a commitment to art became his way of bridging this gap. From this thinking, one can see why he is, with Marx, one of the greatest diagnosticians of the alienation of labour.

The divisions of labour might make the work tedious, and at times it seemed that women did the most boring work, embroidery and painting tiles, as did Charles Faulkner's sisters Lucy and Kate. Faulkner himself stopped being particularly active in the Firm after the first five years. Morris did not allow stencilling on tiles, each one had to be outlined and then handpainted. Tiles were not a very active or profitable part of the Firm's activities, although later in its history Morris & Co. acted as the agents for the objects made by a friend of Morris's who was probably the greatest English ceramicist of the period, William De Morgan.

The Firm continued its activities all through Morris's life, and beyond, although in the years after his death the furniture tended to be less imaginative, and more imitative of eighteenth-century styles. Still today his wallpapers and chintzes are available, mostly from Sanderson & Co., and are extremely popular. Most, but not all, of the designs for these were by Morris. For instance, in 'Trellis' of 1864, possibly based on the rose trellises at Red House, Philip Webb collaborated with Morris and designed the animals. These early papers had a less intense sense of pattern than the later ones, which moved towards an increasing complexity and formality. Ultimately in Morris's lifetime the Firm designed 53 papers and 37 chintzes, with several designs used for both.

The aim of textile design, Morris said, was 'to combine clearness of form and firmness of structure with the mystery which comes of abundance and richness of detail'. His patterns drew upon his intense familiarity with nature, and especially with flowers. Later on in his career, his designs became more historical, based on close study of the older textiles acquired by the Victoria and Albert Museum. Morris advised the Museum on purchases, and at times he felt that it existed for his own education and pleasure: 'Perhaps

I have used it as much as any man living.' He believed that the designer needed to study both nature and old examples. Fiona Clark in her useful handbook *William Morris Wallpapers and Chintzes* (1973) remarks:

Morris's patterns from 1876 onwards show that this historic knowledge brought increased formality and conventionalisation, and was thus potentially at war with his naturalism, yet in his most characteristic designs he manages to reconcile them. Within a Gothic-derived net of incredible complexity, he combines from two to five different plants without destroying the natural system of growth peculiar to each. These patterns create a 'bower' or 'garden tangle' effect which was what he meant by representing Nature and not merely flowers. It is a synthesis which only Morris, with his sympathy for nature and his degree of identity with medieval art, could have achieved.

Another development for the Firm was tapestry, an art which had not been practised in England to any significant extent for the past hundred years. Characteristically, Morris made the first tapestry for the Firm himself, in 1879. So enamoured of the process was he that he would get up at 5 a.m. in order to weave while, it is said, at the same time composing poetry, finding both pursuits equally easy and pleasurable (it was probably a better way to weave than to write). The result was 'Vine and Acanthus', a study of the two plants with birds, approximately 6 by 8 feet. The colouring was mostly blue, green and light brown, and it is now to be found in Morris's country home, Kelmscott Manor. From then on Morris did the patterns, and the work was done by the Firm. Similarly, he designed most of the patterns for woven fabrics, but they were mostly made by machine, and frequently by other manufacturers. As Marina Vaizey has said, Morris

singlehandedly revived the art of high-warp tapestry, from May to September 1879, spending more than 500 hours at the loom, weaving 'Vine and Acanthus'. He thought tapestry the noblest of the weaving arts, and was defensive about his workers being thought of simply as 'animated machines', even though their work in carrying out others' designs was in effect mechanical. One of the anomalies is that Morris revived labour-intensive skills, thus pricing much of the Firm's output beyond the range of ordinary people. Yet judicious use of mechanisation ensured that some designs and media had a long life, and repetitions of successful commissions also contributed.

The first major tapestry done by the Firm was *The Adoration of the Magi* for the chapel of Exeter College, Oxford. It was installed in 1890, and became very popular; other versions of it were sold all over England and in Australia, France, Russia and Germany. The compilers of the catalogue of the textile show of Morris work in Birmingham in 1981 state that Morris and Burne-Jones, the two 'old boys' (who had been made Honorary Fellows of the college in 1883) gave the tapestry to Exeter; but correspondence at Exeter reveals some hard bargaining in 1886 between Morris and the Rector, the Revd J. P. Lightfoot, the head of the college. Morris was interested in being co-operative: 'I need hardly say that it would give me much pleasure to do anything for our chapel, and I should be specially pleased to do the piece of tapestry from Burne-Jones designs.' But after that there was some discussion about price. Morris cited 500 guineas as an approximate price; the Rector said the Governing Body had to have a definite figure; Morris guaranteed the price, but reiterated that it was in guineas not pounds – that is, £525. It is an interesting glimpse of Morris, the well-educated businessman, willing to do something for his old Oxford college – very likely it was a generous price he set – but not willing to undervalue the work of his Firm. The college did well, too, for the tapestry is a beautiful one, and is there now for all to see.

In all his design work, Morris believed in trying to be honest to his materials. As he wrote to Emma Lazarus in 1884:

I have tried to produce goods which should be genuine as far as their mere substances are concerned, and should have on that account the primary beauty in them which belongs to naturally treated natural substances; have tried for instance to make woolen substances as woolen as possible, cottons as cottony as possible and so on, have only used the dyes which are natural and simple . . . (MS)

The paradox in Morris's message is that many arts and crafts practitioners followed his theory on the evil of the division of labour and attempted both to design and execute. Morris, after having discovered how to do it, did very little execution himself. He was above all the designer, and his importance as such was recognised in his own time, though he did not call himself a professional, but rather a tradesman.

369

Because of his reputation, but, more to the point, because of their quality, interest in his designs has probably never been higher than at present, nor reproduction of them more widespread. Other aspects of Morris's celebrity have been more volatile. Despite his standing in the decorative arts, Morris in his own time was even more famous as a poet, and eventually more infamous as a political figure.

4 Poetry and early politics

It was in the late 1860s that Morris returned to poetry. His writing would have little to do with the evolving style of his life – in particular, with his efforts to modify contemporary decoration through the activities of the Firm; little, also, to do with the popular Victorian affection for explicit moralising and sentimentality. But it did conform to the Victorian fondness for narrative verse, and it expressed what lay at the bottom of so much of Morris's thinking and creativity: a profound distaste for the age in which he lived.

In 1867 he published *The Life and Death of Jason*, a book-length poem in which the world of ancient Greece provided the setting for a leisurely retelling of the tale of Jason and his quest for the Golden Fleece. This was poetry which did not demand too much of the reader. Its appeal was caught by Henry James, who wrote of it in a review: 'To the jaded intellects of the present moment, distracted with the strife of creeds and the conflict of theories, it opens a glimpse into a world where they will be called upon neither to choose, to criticise, nor to believe, but simply to feel, to look, and to listen.' The book was a considerable success, and it launched the period of Morris's greatest fame within his own lifetime. He had become 'the poet' – so much so that he would be asked to stand in 1877 for the elected position of Professor of Poetry at Oxford, in succession to Matthew Arnold. And in 1892, on the death of Tennyson, only his socialist politics debarred him from being a very strong candidate for Poet Laureate.

A year after *Jason*, in the spring of 1868, he turned from the classical to the medieval world for his most famous poem, *The Earthly Paradise*, which eventually extended itself to four volumes. The structure was simplicity itself. A group of Norse seafarers arrive at an island inhabited by descendants of the ancient Greeks. The two parties are story-tellers in the grand manner, and the poem (or poems) resulting from their exchanges makes up an

anthology of tales drawn from the contrasting cultures, rather than a consecutive narrative. It is an immense work that one easily can take up and put down, which perhaps accounts for its immediate contemporary popularity. Thereafter, to the great Victorian verse-reading public, who enjoyed similar poems by the Brownings, Tennyson and others, Morris was 'the author of *The Earthly Paradise*'. Yet the twenty-four long tales that so pleased his first readers are now probably the least read of his major writings. What Henry James saw as the untaxing nature of this verse may account, ironically enough, for its diminished appeal to readers of our own day. Perhaps it all came a bit too easily to Morris, even though he revised extensively. Writing poetry, in his view, demanded little more than the simple skill of the sort he expected from the Firm: 'That talk of inspiration is sheer nonsense, I may tell you that flat, there is no such thing; it is a mere matter of craftsmanship' (MS). But for modern readers, it is the shorter poems, in his early *The Defence of Guenevere*, and the prologues to the various narratives of *The Earthly Paradise*, which are the most memorable and esteemed. These seem almost certainly the result of moments of inspiration, rather than exercises in the craft of verse-making.

As escapism (for it was written in part to take Morris's mind off his marital difficulties), *The Earthly Paradise* was so successful that the Burne-Joneses tended to fall asleep when Morris read the poem aloud to them, despite Georgiana's attempts to keep herself awake with pin-pricks. Perhaps it was legitimate to use the poems in order to escape into the peace of sleep from

> The heavy trouble, the bewildering care
> That weighs us down who live and earn our bread,
> These idle verses have no power to bear; . . .

> and if indeed
> In some old garden thou and I have wrought
> And made fresh flowers spring from hoarded seed,
> And fragrance of old days and deeds have brought
> Back to folk weary; and all was not for nought.
> – No little part it was for me to play –
> The idle singer of an empty day.

The poems were meant to allow their readers to escape from 'greater' London:

> Forget six counties overhung with smoke,
> Forget the snorting steam and piston stroke,
> Forget the spreading of the hideous town;
> Think rather of the pack-horse on the down,
> And dream of London, small and white and clean . . .

Their popularity suggests that they succeeded.

One of the poems in *The Earthly Paradise* series, 'The Lovers of Gudrun', had been partially inspired by Morris's increasing interest in Iceland, the country and its Sagas. He started to learn the language with Eiríkr Magnússon, and became, in this comparatively small area of his activities, as a modern commentator has pointed out, 'the foremost English translator and interpreter of Old Norse literature in the nineteenth century. Between 1869 and 1876 he published an extraordinary quantity of work based on the Scandinavian.' It proved a continuing interest; in the 1890s, he even embarked on editing a Saga Library. It was almost as if the hard and brutal world of the Sagas was a compensation for the softer less demanding poetry of *The Earthly Paradise*, and the later long poem, *Love is Enough, or The Freeing of Pharamond*.

He made memorable trips to Iceland in 1871 and 1873. These journeys, whatever their stimulus to his poetry, were also partly an attempted solution to the difficulties of his married life. Since 1865 Jane Morris and Rossetti had become increasingly close; she was his constant model, and they were lovers. In 1871 the Morrises and Rossetti rented Kelmscott Manor, a farmhouse which had been enlarged in the seventeenth century. Situated on the banks of the Thames, near its source in Oxfordshire, Kelmscott would prove to be Morris's most beloved home. In the first years of the joint tenancy, Morris was frequently away – these were the years of the Iceland journeys – especially when Rossetti was in residence. The arrangement to take the house had been made for the sake of Rossetti's health, so that he might live in the country; presumably it also represented Morris's way of accommodation to the relationship between Rossetti and Jane. Officially Morris was an understanding husband and friend. There can be little question, however, that the strains within his marriage caused him much personal despair. But his beliefs in general and his love for Jane in particular

were such that he did not want either to leave her or to deny her wishes, whatever they might be. As for Jane, presumably she did not wish to leave her husband and their daughters for the notoriously unstable Rossetti. So the marriage continued. And the Morrises' relations with Rossetti would more or less end when the Firm was reorganised in 1875.

The trips to Iceland served as more than a way of escape from domestic travail. Morris found there a comparatively primitive world that was far more rewarding to the spirit than 'civilised' England, demonstrating how humankind could do without the advances of the nineteenth century. He found there qualities of endurance and heroism: models for his ideal individuals. It had an immediate effect upon his poetry. As George Bernard Shaw remarked: 'Iceland and the Sagas helped, by changing the facile troubadour of love and beauty into the minstrel of strife and guile, of battle, murder, and death.' Or as Morris said himself, the translations of Norse literature were a 'good corrective to the maundering side of medievalism'. The visits to Iceland impressed him with the native 'worship of courage' and also, as he wrote, when looking back in 1883, 'I learned one lesson there, thoroughly I hope, that the most grinding poverty is a trifling evil compared with the inequality of classes' (H 187).

The early 1870s was a period of trying out new directions. He was in his prime. It was then that G. F. Watts did the portrait, now in the National Portrait Gallery, which is the most familiar image we have of Morris, dark and bearded, with serious and compassionate eyes – a portrait that doesn't quite capture those qualities of restless energy and passion that were so much a part of his nature.

One of Morris's new enterprises at this time was his work as a scribe and a calligrapher. He had experimented in the form earlier, but in the period from 1869 on his activity in this area was prodigious: approximately 1,500 manuscript and decorated pages. Sunday was the day he generally devoted to such work. Probably the most considerable accomplishment in this period was *A Book of Verse* – a selection of his own poems – which he did for Georgiana Burne-Jones. A number of close friends worked on the book – Burne-Jones himself, George Wardle and Fairfax Murray – and the sixty-four pages of the manuscript are marked with an

extraordinary freshness and vitality, emphasised by glowing greens.

Morris continued to create manuscript books, of Icelandic Sagas, and several versions of *The Rubaiyat*. As Joseph Dunlap has commented:

The sources of Morris's manuscripts lie in the Middle Ages, the Renaissance, and the fruits of the earth. Whatever he took for his pages – script, decorative motifs, foliage, flowers – he made his own with overflowing originality . . . For half a dozen years he spent long hours of intense artistic creativity with pen and brush which demanded exceptional concentration, clearness of eye, and steadiness of hand.

While he was engaged in this activity, he was very active in translating the Icelandic Sagas. He began in 1870 with his and Eiríkr Magnússon's *The Story of the Volsungs and Niblungs, with Certain Songs from the Elder Edda*, in prose and verse. In 1876, he brought out *Sigurd the Volsung*, which George Bernard Shaw called the greatest epic since Homer, and Paul Thompson in our own time, more cautiously, 'the greatest of all his poems'. *Sigurd* was the Icelandic version of the Nibelungenlied. Wagner had just finished his own operatic version, which Morris disliked intensely. The 1870 publication was a translation – Magnússon probably providing a literal transcription and Morris transforming it into verse, although he himself also knew Icelandic by this time. *Sigurd the Volsung* was Morris's version of the story, his last major long poem before *The Pilgrims of Hope* in 1885. After 1876, he remained active as a writer but, except for the prose romances, his work would now be mostly political and artistic essays, which are among the greatest of his writings.

Morris was deeply opposed to the age, and all that it stood for, even though inevitably he was in many ways a man of his time. But he had not been active in any public sphere; he had devoted himself to being an artist – a designer, a poet. Now that was to change. From 1876 until 1890 the greater part of his energy went into politics.

Morris's entry into the political fray was as one of the crowd. He was swept up, as many were, in Gladstone's great campaign against

the Turks on behalf of the 12,000 Bulgarian Christians massacred from April to August 1876. Gladstone was out of office, having retired as Prime Minister in 1874, but with his combination of superb political timing and genuine moral outrage he had captured the public imagination with his famous pamphlet *The Bulgarian Horrors and the Question of the East*, published in September, with its demand that the Turks clear out of the Balkans 'bag and baggage'. From then on, until he was victorious in the General Election of 1880, Gladstone attacked the policy of the Prime Minister, Disraeli, with its emphasis upon 'realistic' politics, and its belief that Turkey needed to be supported so that access to the Mediterranean would not fall into the hands of a major power such as Russia. Disraeli's policy had its greatest triumph at the Congress of Berlin in 1878, but Gladstone won the populace, convincing enough of the voters that moral considerations did count for something in international politics.

In his vigour and morality Morris had certain affinities with Gladstone, and for some years he admired him intensely. He started in politics as a dedicated Gladstonian and joined with other officers of the National Liberal League in sending him a letter of congratulations on his seventieth birthday in 1879. How far Morris had come from that first enthusiasm is shown in a letter in 1885, in which he referred to him as 'that canting old scoundrel' – not, as was true of many on the right, because of Gladstone's growing commitment to Home Rule in Ireland, but because in Morris's view Gladstone's Irish policy was not nearly radical enough. By this time Morris had become a dedicated socialist. The years from 1876 to 1883 marked that progress.

On 26 October 1876 a long letter from him was published in *The Daily News*, attacking in strong and splendidly polemical language the possibility of England going to war on behalf of the Turks: 'Can history show a greater absurdity than this, or greater fools than the English people will be if they do not make it clear to the Ministry and to the Porte [Turkey] that they will wage no war on behalf of the Turks, no war on behalf of thieves and murderers? (H 83). He threw himself into the agitation with all the considerable energy at his disposal. He was a welcome recruit because of his literary prominence (he had signed the letter

'William Morris, Author of "The Earthly Paradise"'), and also as a successful businessman with some private wealth. He found himself the Treasurer of the Eastern Question Association; some years later he would also be Treasurer of the National Liberal League; later still he would help pay for the publication of *Justice* for the Social Democratic Federation, and then for *Commonweal* for the Socialist League. He turned his poetical skills to the cause, writing in 1878 'Wake, London lads' as a balance to the famous anthem of jingoism 'We don't want to fight, But, by Jingo, if we do . . .'.

Morris's political experience with the Liberals was important in various ways. It acquainted him with politics and political agitation in which he participated vigorously – whatever he did seemed to require of him a maximum of energy. But gradually he began to be disillusioned with traditional politics and started his search for an alternative to the two major parties. This was indicated in a few letters that he wrote to James Bryce, at this time author, academic and young Liberal leader. In March 1877 Morris remarked about the Eastern Question, 'I am disgusted with everyone's conduct in the affair', and then, in another letter,

we are now at the mercy of the Tories: if they want war they will have it, nor shall we be able to say one word to stop them: it will be quite impossible to get the working man to the meeting on the subject again. . . . I am sure they [the Tories] will hold meeting after meeting, and triumph, as they well deserve to do. (MS)

The Eastern Question Association and the National Liberal League served their immediate political purpose. The Liberals replaced the Tories in the election of 1880. Gladstone himself was deeply disturbed at how little he was able to do once back in office; he felt that he could not go against the imperatives of English power, at least until he attempted to bring about Irish Home Rule in 1886. But in the early years of his government he found himself forced to apply coercion in Ireland and to bomb Alexandria on behalf of Empire. These actions repelled Morris and helped move him further to the left. He wrote to Richard Cobden's daughter, Jane, thanking her for a copy of John Morley's life of her father: 'I am downhearted at the whole Liberal party turning jingos in the lump

. . . How strange that the radicals don't see that all this coercion is one for the Irish, and two for them' (MS).

These political excitements were also accompanied by some domestic upheavals. The needs of the Firm – now reorganised – were considerable, particularly because of the vast increase in dyeing activities based on Morris's experience and experiments with the firm of Sir Thomas Wardle's at Leek in Staffordshire. Morris and his family had left Queen's Square in 1872, and for the next six years lived while in London at Horrington House, now destroyed, in Chiswick High Street. In 1878 he was to acquire from George Macdonald, the poet, novelist and fairy-story writer, The Retreat, on the Upper Mall in Hammersmith, on the Thames. He renamed it Kelmscott House, and there he lived for the rest of his life. Now the headquarters of the William Morris Society, it is quite a handsome Georgian house, with a splendid location, although the damp from the river is probably very unhealthy. The Firm moved to Merton Abbey in 1881, and from then on both family and business made no further changes: a sale room and accounting office were established in Oxford Street in London, one of the great shopping streets of the metropolis.

In 1877 Morris emerged into the public world again, in a dramatically different way that was significant for his training as a public person and also had a great effect upon the look of our world, almost as – perhaps more – important in that respect than the work of his Firm. This was through the founding of the Society for the Preservation of Ancient Buildings. It was a product of the increased historicism of the period, a growing interest in origins, a belief in a dynamic connection with the past. Antiquarianism was not a new phenomenon: eighteenth-century Englishmen, for example, had been great collectors. The study of history had a great revival towards the end of the nineteenth century, not, as in the past, picking and choosing in order to select those aspects that were particularly attractive but, as Ranke taught, to try to discover what had actually happened. It was saving that record to which Morris's Society was devoted. Virtually the first preservation society, it is the parent of those that are so common today; and the most important beginning to thinking about the environment and its preservation.

Morris had already signed petitions against the ruthless destruction of ancient buildings, but he began to think about doing something more as early as September 1876, when he saw the church at Burford in the Cotswolds being torn down. It is hardly coincidental that this sense of the need for public action should strike him at the same time as he was embarking upon a public role in connection with the Eastern Question. Earlier in his life he had not been deeply involved with society at large, other than in his private commitment to make war against the age. Before 1876 his warfare had had no public manifestation but had been confined to redesigning Victorian interiors – for those who were better off. Now he was becoming aware of public powers determined to go their own way, to assert the supremacy of a particular conception of English international interests, no matter what the morality of the issues might be. So too economic needs might dictate the destruction of ancient buildings.

There is a political parallel in Morris's attitude towards preservation. When Morris became a socialist, he tended to consider the Liberals more dangerous than the Tories. The latter were easier to fight, for they did not see themselves as attempting to ameliorate the situation. In Morris's view, the preservation movement's real enemies were not those who were out to tear down buildings – although they were bad enough – but those who wished to *restore* buildings, and he drew a crucial distinction between restoration and preservation. The task of the present, Morris felt, was to do the minimum repairs necessary to allow the buildings to survive. Restoration he saw as an arbitrary choice of a particular period in the history of the building – what happened to be fashionable at the moment – and the lavish reproduction and re-creation of the entire building in that style. Whatever was genuine was then practically buried, and much of interest from other periods was likely to be destroyed.

Under the influence of the Cambridge Camden Society, many people believed, for architectural and religious reasons, that as many churches as possible should be restored in the Gothic style. Morris was extremely fond of the Gothic, and adored his master, G. E. Street, one of the 'Great Goths'. But he firmly opposed the re-creation of Gothic architecture which Gilbert Scott seemed to

be attempting all over England. Morris launched the attack, and ultimately his Society, by a letter to the *Athenaeum* in March 1877:

My eye just now caught the word 'restoration' in the morning paper, and, on looking closer, I saw that this time it is nothing less than the minster of Tewkesbury that is to be destroyed by Sir Gilbert Scott. Is it altogether too late to do something to save it – it and whatever else of beautiful or historical is still left us on the sites of the ancient buildings we were once so famous for? Would it not be of some use once for all, and with the least possible delay, to set on foot an association for the purposes of watching over and protecting these relics, which, scanty as they are now become, are still wonderful treasures, all the more priceless in this age of the world, when the newly-invented study of living history is the chief joy of so many of our lives? (H 85)

Having launched this idea, Morris panicked slightly and a few days later wrote to the art critic of the *Athenaeum*, F. G. Stephen, 'But now what can be done? The names I could be sure of for a society are but few: but I think we should begin as soon as may be, if the thing is in anyway feasible: meantime I am unskilled in organising this sort of thing' (MS). A little more than a year before he had written to Eiríkr Magnússon 'I was born *not* to be a chairman of anything.' Yet from now on he hardly looked backward. He was exaggerating somewhat – he had tended to be an organiser before, of the *Oxford and Cambridge Magazine*, of the Firm, when he was the figure about whom others congregated. The same was to be true now. As in the fashion of Victorian organisations, a committee of the great and good was set up; the next month the Society, SPAB, was on its way. It quickly acquired the nickname of 'Anti-Scrape' because of its opposition to the methods of restoration, to scraping away the accumulations, the patina, of the past in the service of imitating a particular historical moment. The Society celebrated its hundredth anniversary in 1978, and is going strong.

Morris became secretary of the organisation, and was its vital force, as he was in almost anything with which he was connected. He found himself in a somewhat paradoxical position, having to lend his support for buildings he did not necessarily like. He had no particular fondness for Christopher Wren, whom he saw as the

English representative of the hated Renaissance, the period which he regarded as having destroyed artisans and healthy human labour. Nevertheless, when Wren's City churches were threatened he led the campaign on their behalf. Many of the buildings with which the Society was concerned were churches, although as a pagan, Morris personally had little interest in their religious function. The Dean of Canterbury responded to the Society's attack on the planned restoration of the Cathedral with: 'Mr. Morris's Society probably looks on our Cathedral as a place for antiquarian research or for budding architects to learn their art in. We need it for the daily worship of God.' Morris retorted sharply:

For my part remembering well the impression that Canterbury Cathedral made on me when I first stood in it as a little boy, I must needs think that a great building which is obviously venerable and weighty with history is fitter for worship than one turned into a scientific demonstration of what the original architects intended to do. (H 92)

For the same reasons, he now decided, at some loss of business, that the Firm would not put new glass into old churches, but only into newly constructed ones.

The number of cases – some won, some lost – which the Society took under its wing was prodigious. It quickly became involved in international preservation. There was a campaign to prevent what Morris regarded as the mindless restoration of St Mark's in Venice, and for the Baptistry in Ravenna and the Bargello in Florence. Concerning the Bargello, the Committee of the Society wrote in 1881, 'The less that can be done to an ancient building the better: the hope that this maxim will soon be widely accepted is the very cause and reason for the existence of the Society'. The campaign for St Mark's became international, and a considerable number of petitions on its behalf are still preserved. There was a meeting at the Sheldonian Theatre in Oxford; the petition was signed by Gladstone and Disraeli among others. In this particular case the work had been stopped before the petition was received by the Italian Minister. Morris was aware that interfering with projects at home and abroad might be considered tactless, but, he wrote, 'for my part such etiquette seems to me to belong [to] the class of good manners, which would forbid us to pull a drowning man out of the

water because we have not been introduced to him' (MS). As he wrote to Ruskin when asking him to chair a SPAB meeting 'it would be worth the trouble, and years of our little Society's life, if we could but save one little grey building in England.' The Society, although it had many defeats, did much more than save one building. Morris himself derived invaluable political experience from the public organisation that the Society required. His annual speeches to the Society became more and more political, more and more prone to analyse the arrangements of society, and its past history, as the cause of the destruction of art that he found in the present. At the end of the year of the founding of SPAB, 1877, he gave his first two public lectures, one on 4 December on the Decorative Arts and the second on 19 December, his first public political speech, on the Eastern Question. They were the first of hundreds he would make during the rest of his life, the great majority before 1890, when his health began to fail. He spoke on art, on politics, and on the connections between the two.

5 The 1880s

When Morris became involved in the Eastern Question and Anti-Scrape, he could hardly know that at the end of the 1880s he would be perhaps the most prominent figure on the far left in England – a figure referred to in one cartoon as 'The Earthly Paradox'. It was the experience of politics that made him a radical, but throughout his life he had a consistent vision of what an ideal world should be like. He wanted a society which consisted of small semi-independent units, not centrally controlled, but co-operating with one another, in which as much as possible would be done through simple labour, with all members able to discharge the necessary tasks. He suggested that in this way, with the destruction of private ownership and a simpler, less mechanical existence, humankind might be able to lead a better life. In his earlier years, he had hoped that such a society could be achieved through art. Now he came to believe that it was only possible through political means – the achievement of socialism.

In his numerous essays on society and in *News from Nowhere*, which described his vision of the future, Morris was rarely specific about details. What he believed in was the 'religion of Socialism'; it became a faith for him. He was not a good follower, as would become clear in the 1880s, and never formed a successful political organisation, though he tried to. Yet he was one of the great inspirers of the Left in England, and perhaps the leading second-generation Labour Party father figure. He came to believe that socialism would have to come out of the working classes: it could not be imposed upon them from above. That is both his relevance for today and a major reason why Engels attacked him for sentimentalism. He is associated with a socialism highly dangerous to those who have stakes in society, even while he presents an idyllic vision to which many can pay lip service without any fear that it might come into being.

In a famous passage in his 1894 article 'How I Became a Socialist' Morris foretold the dangers of capitalism:

Was it all to end in a counting-house on the top of a cinder-heap, with Podsnap's drawing-room in the offing, and a Whig committee dealing out champagne to the rich and margarine to the poor in such convenient proportions as would make all men contented together, though the pleasure of the eyes was gone from the world, and the place of Homer was to be taken by Huxley? (CW XXIII 280)

This was the culmination of the part of his life that started in the late 1870s. It fitted in with the growth of left-wing activities in England in the 1880s. There was an increased agitation for the franchise, given to urban workers in the Second Reform Act of 1867 and to be given, theoretically, to all males over twenty-one in the Third Reform Act of 1884. A great many were still disfranchised for technical reasons even after that date, but there was virtually no longer any theoretical reason why every male should not have the vote – there was also some agitation for votes for women. Morris himself always had somewhat ambivalent feelings about the whole process of traditional politics. His opinion of Parliament is demonstrated in *News from Nowhere*, where the disused Houses of Parliament are a store-house for manure. He felt that the compromises necessary in a parliamentary system might delay the advent of the new society. On the other hand, he recognised the value of the political experience and was unsympathetic to what he regarded as the totally nihilistic attitude and actions of the anarchists. He was humanly inconsistent in that when arguing with parliamentarians, he veered in an anarchist direction, and when disputing with anarchists he tended to be somewhat sympathetic towards traditional political measures.

The economic situation also intensified the politics of the 1880s. Historians have extensively debated the nature of the so-called 'Great Depression' starting in 1876, but even if it were far less serious than has previously been thought, England still felt beleaguered and was aware that Germany and the United States were threatening her dominion, particularly in the industrial sphere. Though it was the centre of the greatest empire the world had ever

known, and, supported by financial capitalism, the most powerful country in the world until the First World War, the poverty of many in the nation became even more evident during this period of economic difficulty. Morris was not the only member of the middle classes who felt that something needed to be done about the situation. There was an outpouring of intellectual talent into movements dedicated to changing English society, of which one of the most prominent was the Fabians, founded in 1884. Although he maintained good relations with the leading Fabian, George Bernard Shaw (who appeared at one point on the verge of marrying Morris's daughter May), Morris disliked their dry unsentimental approach.

The 1880s were the great period of the growth of unionism. The end of the decade saw the Matchgirls' Strike, the Gasworkers' Strike, and finally the great Dock Strike of 1889. Morris himself, although he was firmly convinced of the exploitation of the proletariat, the workforce created by needs of capitalism, and the workers' need to take action, did not appear to be particularly interested in unionism as a means to bring about the changes he wished for society. His style was to be involved in the organisation of demonstrations and personal preaching, which he did every Sunday by Hammersmith Bridge. His hope was to help foment a rising of the workers: 'Educate, Agitate, Organise', as is inscribed on the Social Democratic Federation's membership card, which he designed. The unions of skilled workers were threatened in the worsening economic and political atmosphere of the end of the century; this led to a coming together of political organisations, such as the Democratic Federation, the Fabians and others, with the unions in 1893 to form the Independent Labour Party – the ancestor of the Labour Party. For Morris, such an approach meant too much co-operation with a system which he regarded as corrupt. As Trevor Lloyd has remarked, 'Socialism in England passed from the age of lonely individual genius to that of organisation and compromise.'

The first vehicle for Morris's socialism was the Democratic Federation, founded by H. M. Hyndman, a rich stockbroker, who never gave up his frock coat and top hat. (Morris, in contrast, wore simple clothes, a smock at work and a rough serge suit with a blue

worker's shirt most of the rest of the time.) The Federation became Marxist in 1883 and added 'Social' to its title.

Morris too became a Marxist, though he never called himself one. He accepted Marx's analysis of society, the materialistic interpretation of history and the necessity of eliminating private property. Under the influence of Marx's thought he recognised the necessity of the machine for freeing the workers from 'Useless Toil'; and he came to excuse his failure to provide his workers with enough pleasure by way of his Marxist belief that the individual effort of changing one's own practice would not really hasten the transformation of society. (And a drastic change within the Firm itself would have deprived Morris of the wherewithal to fight the good fight.) Yet he felt that the worker should be neither a slave of the machine nor a machine himself. His was a Marxism infused with his own insights and beliefs, with Engish individualism and a great regard for humane values, consistent with the writing of the young Marx (which of course he did not know). *Das Kapital* was not yet available in English, and Morris did not read German, but in 1883 he was reading it in French. He made a few famous remarks denigrating his ability to understand economics, which have provided evidence for those who wish to see his socialism as not particularly theoretical or Marxist. J. Bruce Glasier, the Scottish socialist and later theosophist and disciple of Morris, who wished to capture Morris firmly for the tradition of English ethical socialism, quotes him as saying,

To speak quite frankly, I do not know what Marx's theory of value is, and I'm damned if I want to know . . . I have tried to understand Marx's theory, but political economy is not my line, and much of it appears to me to be dreary rubbish. But I am, I hope, a Socialist none the less. It is enough political economy for me to know that the idle class is rich and the working class is poor, and that the rich are rich because they rob the poor. That I know because I see it with my eyes. I need read no books to convince me of it.

Undoubtedly, the major impetus behind his socialism, as it generally is, was moral.

Morris was not totally unrealistic about what might be achieved. In famous lines from *The Dream of John Ball* he spoke of 'How men fight and lose the battle, and the thing they fought for comes

about in spite of their defeat, and when it comes turns out not to be what they meant, and other men have to fight for what they meant under another name.' Certainly the welfare states of most of the Western world would have seemed to most of the socialists of the later nineteenth century a very heaven, at least in conception, but we can see how far they are from the spirit of what they – and particularly Morris – had wished.

Morris came to socialism through art, which, Ruskin had argued, seemed to be sickening in nineteenth-century England. He was convinced that art could not flourish in a society of 'commercialism and profit mongering', but there is of course hardly an absolute guarantee that, if human beings turn from thinking only of profits, art will automatically flourish. A series of lectures that he gave on art in the years between 1877 and 1883 charted his progress towards socialism. Morris announced his conversion in his talk on 'Art Under Plutocracy' at Oxford in November 1883, with John Ruskin in the chair, and much to the dismay of the University authorities. He had warned the organisers of the Oxford Liberal Club that he would be taking up Hyndman's position – he had joined the Democratic Federation the previous January – but that had not deterred the sponsors. In 1882 a collection of five of his lectures was published, with the characteristically ambivalent Morrisian title, *Hopes and Fears for Art*. These were the prelude to the public declaration of his socialism. 'I not only admit, but declare, and think it most important to declare, that so long as the system of competition in the production and exchange of the means of life goes on, the degradation of the arts will go on.'

In his first political incarnation he had been a radical, on the left of the Liberal Party, as was evident in a letter he wrote to George Howard, later Earl of Carlisle, a radical political associate, an artist, and a patron of the Firm. Howard had been elected to Parliament by a tiny margin, and Morris wrote to him, 'Here is a scratch of the pen from a somewhat downtrodden radical to congratulate you very heartily on defeating the enemy in East Cumberland. Keep it a-going and before long, please give us radicals something more to rejoice in, that we may be enthusiastic (and numerous) at the poll next General Election' (MS). But he wrote about the Liberal Party some years later:

A nondescript and flaccid creation of bourgeois supremacy, a party without principles or definition, but a thoroughly adequate expression of English middle-class hypocrisy, cowardice, and shortsightedness, engrossed the whole of the political progressive movement in England, and dragged the working-classes along with it, blind as they were to their own interests and solidarity of labour. (CW XXIII 71–2)

Prompted either by Marx or his own rather choleric temper, or by both, he was capable of a certain glorious invective.

As he became more and more politically involved, he also became more and more disillusioned with traditional politics; the logical consequence was to join the one society at the time that professed socialism: the Democratic Federation. He now wrote to William Allingham, the poet:

Yes, I am a rebel and even more of a rebel than some of my coadjutors know perhaps. Certainly in some way or other this present society, or age of shoddy, is doomed to fall: nor can I see anything ahead of it as an organisation save Socialism: meantime as to present parties I say: damn Tweedle-dum and blast Tweedle-dee. (H 170)

He was a considerable recruit to the fledgling party. In May 1883 he became a member of its executive committee. The organisation itself remained small, comprised mostly of Londoners, numbering throughout the 1880s around 600. It persisted, however, and membership reached a total in 1897 of 3,250 members. For a brief period it met his aims.

In June 1883 Morris wrote to C. E. Maurice, a son of the well-known radical theologian, F. D. Maurice:

I so much desire to convert all disinterested people of goodwill to what I should call active and general Socialism ... For my part I used to think that one might further real Socialistic progress by doing what one could on the lines of ordinary middle-class Radicalism ... in fact ... Radicalism is made for and by the middle classes and will always be under the control of rich capitalists: they will have no objection to its *political* development, if they think they can stop it there; but as to real social changes, they will not allow them if they can help it ... I believe that Socialism is advancing, and will advance more and more as education spreads, and so believing, find my duty clear to do my best to further its advance ... A word about the Democratic Federation: as far as I know it is the only active Socialist organisation in England; ... therefore I found myself bound to join it. (H 173–4)

The difficulty for Morris was that he was not an organisation man, and in any case Hyndman was difficult to deal with. The Democratic Federation, though small, was beginning to galvanise socialist feelings in England. It was intended, at least in theory, to build Jerusalem in England's green and pleasant land. Hyndman was ambitious and determined to have things his own way. He was anxious to move the Federation towards participation in politics, to achieve position and power in a traditional English way. Morris was opposed to this, but not as opposed to it as others were. As Paul Thomspon has pointed out, Morris's classic dilemma was that he was torn between purism and practical agitation. As is evident in his attitude to anarchism, he would move in one direction when those he was with tended to move in the other. The official Marxist position as represented by new recruits to the Federation, Marx's daughter, Eleanor, and her lover, the unscrupulous Edward Aveling, was against Hyndman's line. Morris with his supporters – who may have used him as something of a figurehead – acquired a majority on the Council against Hyndman. Rather than staying in the Federation and engaging in further wrangles on tactics, they left the organisation at the end of 1884 and formed a new group: the Socialist League. Morris was to be its leader until 1890. Its membership card, devised by Walter Crane, depicted Morris as a blacksmith at an anvil. Unlike the Federation, it did not try to elect members to Parliament; rather, with varying degrees of success, to educate, organise and agitate.

The Socialist League was in many ways the high point of Morris's political life. It was not big; it had approximately 700 members in 1886, with eighteen branches. There was a sense of comradeship in it. Morris had written in *The Dream of John Ball*: 'Fellowship is heaven, and lack of fellowship is hell: fellowship is life and the lack of fellowship is death'; in many ways he was a lonely man, particularly in his marriage, and despite close friendships with the friends of his youth. There was an unsatisfied yearning within him for a wider community, and the Socialist League for a while satisfied it. For the first few years, he really thought that it would bring about a transformation of society, the creation of an ideal socialist state in England.

Morris hoped that the Socialist League would be capable of a

389

proper course veering neither towards Parliament nor anarchism. He also wanted the League to support not state socialism, which he saw as the aim of the Social Democratic Federation and of the Fabians, but rather revolutionary socialism. The manifesto of the League stated:

The dominant classes are uneasy, anxious, touched in conscience, even, as to the condition of those they govern; the markets of the world are being competed for with an eagerness never before known; every thing points to the fact that the great commercial system is becoming unmanageable, and is slipping from the grasp of the present rulers.

In the report of its 4th annual meeting in 1888 the League offered to provide fifteen lecturers, who would speak without charge in London, and for expenses elsewhere. These included Morris, with talks on such topics as 'Work as it is and it might be' and 'How we live and how we might live'. He was not a particularly good speaker, as he realised himself. He wrote in his diary about a speech he gave on the Paris Commune in 1887, 'I spoke last and, to my great vexation and shame, *very* badly; fortunately I was hoarse, and so I hope they took that for an excuse; though it wasn't the reason; which was that I tried to be literary and original and so paid for my egotism.' He tended not to be able to wander too far away from his notes. At the beginning of *News from Nowhere*, he presents a rather dispirited picture of what the worst sort of meeting must have been like: 'There were six persons present, and consequently six sections of the party were represented.' The League was able to do some effective work for the cause of socialism, but there was much internecine disputing. Morris tried to maintain a position in the middle. It was difficult, although he was able to last it out for five years.

In the first years Morris was full of hope. He felt that the revolution was around the corner; the workers could bring it about. These hopes came to an end on Bloody Sunday, 13 November 1887, when thousands of socialists, radicals and Irish involved in a demonstration were dispersed and beaten back by the police using batons. A radical member of Parliament, R. Cunninghame Graham, and John Burns, a Labour leader, were arrested, and sentenced the following January to six weeks in prison. Others,

who chose to be dealt with immediately, received longer sentences. More than one hundred were wounded, and two died of injuries. Bloody Sunday ended for a long time this sort of action, and the ban on demonstrations was not lifted until 1892.

Originally Morris had felt that a controlled attack by the workers might succeed. On 10 February 1886, he wrote: 'I look at it as a mistake to go in for a policy of riot, all the more as I feel pretty certain that the Socialists will one day have to fight seriously ... [Yet] any opposition to law and order in the streets is of use to us, *if the price of it is not too high* ... An English mob is always brutal at any rate till it rises to heroism'. Bloody Sunday demonstrated to Morris that the revolution would require force, violence and organisation, the people in arms. The powers of repression were not going to give up easily. (In fact, the Commissioner of Police, Sir Charles Warren and the Home Secretary, Matthews, were much criticised on all sides for their mishandling of the event.) On 20 November the funeral took place of Alfred Linnel, one of the two who had died of their injuries; 120,000 participated, and Morris wrote his 'A Death Song', sold as a benefit for Linnel's children:

> Here lies the sign that we shall break out of prison;
> Amidst the storm he won a prisoner's rest:
> But in the cloudy dawn the sun arisen
> Brings us our day of work to win the best.
> Not one, not one, nor thousands must they slay,
> But one and all if they would dusk the day.

The events of Bloody Sunday intensified the splits within the League over the issue of parliamentary participation, and in this instance the official Marxists – Eleanor and Aveling – were in favour of running candidates. Their branch, the Bloomsbury one, disaffiliated. Morris expressed his views in a letter in May 1888, to Glasier:

We should treat Parliament as a representative of the enemy ... We might for some definite purpose be forced to send members to Parliament *as rebels* ... but under no circumstances to help to carry on their Government of the country ... and therefore we ought not to put forward palliative measures to be carried through Parliament, for that would be helping them to govern us.

He saw such activities as working towards state socialism, which he opposed. He planned to leave the League if the resolution to put up a parliamentary candidate was carried.

Despite his growing worry about the course politics were taking, he continued to be active. Although he was not sure when the revolution would take place, he never lost faith that it must. He supported the League and *Commonweal* to the extent of £500 a year – 2,000 copies of the paper were printed – and he continued to edit it weekly. In 1889 he attended the organisation meeting of the 2nd International in Paris and was at the Marxist congress there rather than the more moderate socialist one. The same year he declared himself a communist.

The secession of the parliamentary group from the League left Morris vulnerable to the machinations of the anarchists. Perhaps because of his romanticism, Morris tended at first to find them more attractive as individuals than the parliamentarians. He had written as early as May 1887, 'I distinctly disagree with the Anarchist principle, much as I sympathize with many of the anarchists personally, and although I have an Englishman's wholesome horror of government interference and centralisation which some of our friends who are built on the German pattern are not quite enough afraid of I think.' But by 1889 he was less tolerant, as indicated in a letter to Glasier: 'I believe there will be an attempt to get on the Council a majority of stupid nobbedehays [*sic*] who call themselves anarchists and *are* fools, and to oust Kitz from the secretaryship as he forsooth is not advanced enough for them. If this were to succeed, it would break up the League' (MS). In fact, the anarchists succeeded in taking over the League. Morris put up with it for a brief time, but in November 1890 he withdrew, and converted the Hammersmith branch of the League into the Hammersmith Socialist Society. It continued to meet in a small building next to Kelmscott House and to be active for the rest of Morris's life. The dream of achieving a revolution was still real to him. England would undergo a socialist transformation into a country where classes and private property were abolished, where the worker would enjoy his work and the fruits of his labour, where exploitation would no longer take place, where Morris's moral criticisms of society would be answered – but he no longer

thought that all this would happen in the immediate future. That is far different from saying that he abandoned that vision; it was continually put forth at the many meetings of the Hammersmith Socialist Society.

Alongside his whirlwind political activity, and in spite of its considerable demands on his time, he continued his work with the Firm. He had a growing influence upon an increasing number of individuals coming to the forefront in design. In 1882 the Century Guild was established. Its exciting new designs were a combination of styleless solidity and an anticipation of *art nouveau* whiplash line. In 1884 the Art Workers' Guild was established by young architects and designers, most of whom agreed with Morris that the look of the world about them was not satisfactory. The extent of his influence is testified to by the fact that his bust still has pride of place in the meeting room of the Guild. These were not quite the guilds of medieval times. These Art 'workers', who tended frequently to be from the middle class, were important in helping to redesign the world and in carrying Morris's design influence forward to the modern movement. In 1888, the great year for such organisations, the National Association for the Advancement of Art and Its Application to Industry was established. Although it saw itself as comparable to the British Association for the Advancement of Science, it had a brief life of only three years. The same year, 1888, the Arts & Crafts Exhibition Society was founded, introducing that term – so intimately associated with Morris – to the world. Also in 1888 C. R. Ashbee set up the School and Guild of Handicraft. All these organisations sought Morris's blessing and help, and he gave generously of his time if in a somewhat grudging spirit. He regarded them as palliatives, not getting to the heart of economics and politics. Even so, he felt that they were moving in the right direction: their attention to the 'lesser' arts was undermining what Morris and his disciples regarded as the illegitimate domination of the 'finer' arts. Some of these figures followed Morris politically and agreed with him that art could not be truly liberated, be truly fit and proper, until it functioned in a totally different political system.

As Morris's health began to fail, he became less politically active. Despite his having sometimes advocated what might

almost be called a simple 'machine for living' – one large white-washed room which would serve as bedroom, living-room and study, he continued to live in his comparatively large houses, spending as much time as he could at his beloved Kelmscott Manor, fishing in the Thames.

6 Last years

Morris regarded as the two most beautiful objects in the world a good building and a good book. He had devoted his professional life to making the contents of buildings much more attractive. But in his last years much of Morris's energy went into new bursts of activity: into writing prose romances, into book collecting, and into the Kelmscott Press.

He had never stopped writing. In the mid-1880s he had published a long poem, *The Pilgrim of Hope*, about a romantic triangle (similar to his own with Jane and Rossetti) and the involvement of the three in the Paris Commune, which he saw as a socialist ideal. The poem described a conversion experience to socialism in religious terms, a 'new birth'. It had run as a serial in *Commonweal* from April 1885 to June 1886. His next major work was *A Dream of John Ball*, published in *Commonweal* in 1886 and 1887 and brought out as a book in 1888. In it the narrator is transported back to 1381 to Kent and tells of his meeting with John Ball, the rebel priest, who was one of the leaders in Wat Tyler's rebellion. It had as its frontispiece a wood-engraving by Burne-Jones, who continued working closely with Morris, even though he had little interest in his politics. The picture depicts Adam and Eve and their children, with the remark, attributed to John Ball: 'When Adam delved and Eve span who was then the gentleman?' That slogan summons up so much of Morris's socialism: its intense moral character, its characteristic English tendency to look backwards for a golden age.

Morris's most important writing in this period, and the most important of all his literary works, was *News from Nowhere*, which appeared as instalments in *Commonweal* in 1890 and then in a revised version, published in 1891. It is a summation of all Morris's social values; its vision represents his hopes for England and for the rest of the world.

The book had one of its origins in two boat trips Morris made,

first in August 1880, and then the following summer, from Kelmscott House at Hammersmith in London to Kelmscott Manor. That journey, from urban to rural England, from discontent to content, makes up the last third of the book. It is set in the future, and its earlier part is a description and discussion of what England had become. In the *Commonweal* version of the story, the revolution is supposed to have taken place in the early twentieth century. Only a year later, Morris had become more pessimistic, and in the book version the revolution is placed in 1952. The immediate impetus for the book was the publication of Edward Bellamy's *Looking Backwards*, presenting a utopia of Boston in the year 2000 which Morris found horribly mechanistic; he called it a 'cockney paradise'. Similarly, he was distressed by the *Fabian Essays*, published in 1889 and advocating, he thought, a state where the numerous vices of want, the evils of a capitalistic society, might well be taken care of, but where there would be none of the internal values which a new society needed to provide.

News from Nowhere – 'nowhere' of course translates 'utopia' – uses a common convention for utopias, which is also a variant on the framework of *A Dream of John Ball*. The Dreamer of that book becomes the Guest. Rather than moving back into the past, he wakes up in the future, still in his house, but it has now become a hostel and is next to a Thames that is no longer polluted and is full of salmon. (Salmon, one notes in passing, have begun to return to the Thames, which indicates that perhaps some environmental progress has been made.) The subtitle of the book is *An Epoch of Rest*. The Guest finds a society in which history has stopped. Law courts and prisons have been abolished. A central government has been replaced by direct, participatory democracy, a series of self-governing communes in communication with one another. Small is beautiful, in terms of government and of the economy.

Until fairly recently, such an approach to modern Western society appeared to be hopelessly romantic. But the popularity of Morris's vision has increased since the 1960s, when it became obvious that centralisation, 'big government' and state socialism were not working, that they were failing to provide continued prosperity, not to mention more intellectual and emotional satisfactions. This accounted for the move, in the 1960s and early

1970s, towards communes, whose members – so-called hippies or flower-children – often wore a rather Pre-Raphaelite, semi-medieval sort of dress. The lack of realism in Morris's vision of utopia is not so much in the sort of economy he depicts as in one of his basic premisses: that humans need not be aggressive. The reason why most communes have not been able to survive is that human beings are not sufficiently able to maintain peaceful relations with one another. For Morris, the perversion of human character brought about by capitalism means that humans are alienated from themselves, others, their work and their environment. He may be right, but unfortunately there has not been a society yet, no matter what it may call itself, able to solve the problems of the aggressive manifestations of human nature.

In *News from Nowhere* Morris worked out his conception of how the new society could have come into being. Convinced by this time that peaceful evolution was not possible, he assumed in the book that there had been two years of warfare, brought about by conflict between capitalists – threatened by continual economic crises – and organised labour. He now felt that such a struggle was bound to come. He had written in 1885, 'The class struggle is really the only lever for bringing about the change. Of course you understand that though I would not shrink from a civil war if that be the only necessary means, I would do all I could to avoid it' (MS). As he wrote in a subsequent letter to Comrade Pickles, opposing the sending of representatives to Parliament, 'tis no use prophesying as to the details of the revolution . . . if violence is inevitable, it will be begun by the reactionaries' (MS). The powers that be would not give up their position easily. In the book, once the war was over, society fairly rapidly became peaceful, a world in which all lived in pleasant places – the dream of the English and others of a quiet existence, where sordidness had been eliminated, as well as wealth and poverty. Equality had been achieved. The world is very much as if Morris & Co. had designed everything, and the inhabitants have learned Morris's lesson that pleasure in work results in more beautiful objects. Machines are at a minimum.

Morris recognised that these achievements had a price, though it was one that he was more than willing to pay. The atmosphere

of this new society is non-intellectual, perhaps even anti-intellectual; reading does not appear to be central in most people's lives and they are leading a healthy, outdoor life; yet, as children, they learned how to read early – as Morris did – and picked up Latin and Greek.

There is no formal education. The country, nature, will ensure a happy life. So the trip from the city Kelmscott to the country Kelmscott emphasises the importance of a rural utopia. The book ends in a feast to celebrate the haymaking at the small Kelmscott church, now a banqueting hall; it is at that point at which the narrator fades, perhaps because he had never learned how to wield a scythe, and finds himself returned to 'dingy Hammersmith'. The illustrator, C. M. Gere, in the Kelmscott Press edition of 1892, captured Morris's intense feeling for Kelmscott Manor in his drawing of the house, surrounded by a border designed by Morris, and the legend beneath it: 'This is the picture of the old house by the Thames to which the people of this story went'. (This provides a nice example of life imitating art; in the recent preservation of the Manor, the front door was changed to conform with the illustration.)

The notion of 'an epoch of rest' is applied in some degree to work itself. There is a little cutting of hay; there are people in attendance in shops; other tasks are suggested, but work is somewhat at a minimum. In this, Morris was prophetic of the present emphasis on the importance of leisure – the true values of life may be found in it rather than in work. The last line of the book asserts the potential reality of what he has written: 'If others can see it as I have seen it, then it may be called a vision rather than a dream.'

That he thought his picture of England no mere fantasy is indicated in a recently rediscovered lecture he gave in 1889. There, Morris emphasises his dedication to eliminating the division of labour, and alienation from labour, in a manner consistent with his own and with Marx's analyses:

We may have in appearance to give up a great deal of what we have been used to call material progress, in order that we may be freer, happier and more completely equal ... This would be compensated (a) by our taking pleasurable interest in all the details of life, and (b) by our regaining the pleasure of the eyesight, much of which we have already lost, and more of

which we are losing everyday ... Work ... obviously useful, and also adapted to the capacity of the worker would mostly be a pleasant exercise of the faculties; necessary work that would otherwise be drudgery would be done by machinery or in short spells: no one being condemned to work at unpleasant work all his life ... [we will] do our best to remain men, even if in the struggle we become barbarians; which latter fate I must confess would not seem to me a very dreadful one.

Certainly the book's values – turning away from 'useless toil' to 'useful work', living more with the senses, cherishing nature and the land – mean more to many now than they may have done some years ago.

News from Nowhere shows a world in which life has been simplified. The Thames and its banks have been restored to an earlier beauty. Life has a medieval quality to it without the disadvantages of that hierarchical society. Art has come into what Morris regards as its own. Old Hammond tells Guest about the changes in society:

When men began to settle down after the war, and their labour had pretty much filled up the gap in wealth caused by the destruction of that war, a kind of disappointment seemed coming over us, and the prophecies of some of the reactionists of past times seemed as if they would come true, and a dull level of utilitarian comfort be the end for a while of our aspirations and success ... Probably, from what I have told you before, you will have a guess at the remedy for such a disaster: remembering always that many of the things which used to be produced – slave-wares for the poor and more wealth-wasting wares for the rich – ceased to be made. That remedy was, in short, the production of what used to be called art, but which has no name amongst us now, because it has become a necessary part of the labour of every man who produces ... The art or work-pleasure, as one ought to call it, of which I am now speaking, sprung up almost spontaneously, it seems from a kind of instinct amongst people, no longer driven desperately to painful and terrible overwork, to do the best they could with the work in hand – to make it excellent of its kind; and when they had gone on a little, a craving for beauty seemed to awaken in men's minds, and they began rudely and awkwardly to ornament the wares which they made; and when they had once set to work at that, it soon began to grow. All this was much helped by the abolition of the squalor which our immediate ancestors put up with so coolly; and by the leisurely, but not stupid, country-life which now grew ... to be common amongst us. Thus at last and by slow degrees we got pleasure into our work; then we became conscious of that pleasure and cultivated it, and took care that we had our

fill of it; and then all was gained, and we were happy. So may it be for ages and ages! (Ch. XVIII)

This would seem to sum up what was perhaps the major theme of Morris's life. His ideal was that art and life should be inseparable. Despite his own success and his possible artistic influence, he felt that only with a socialist revolution could there be a permanent improvement in the status of art. As he wrote in 1883, the year he became a socialist, in his long autobiographical letter to Andreas Scheu:

I have not failed to be conscious that the art I have been helping to produce would fall with the death of a few of us who really care about it, that a reform in art which is founded on individualism must perish with the individuals who have set it going. Both my historical studies and my practical conflict with the philistinism of modern society have forced on me the conviction that art cannot have a real life and growth under the present system of commercialism and profit-mongering. I have tried to develop this view, which is in fact Socialism seen through the eyes of an artist, in various lectures, the first of which I delivered in 1878. (H 187)

The connected art and life of his utopian society were both beautiful and useful, without the price paid in medieval times of

violence, superstition, ignorance, slavery; yet I cannot help thinking that sorely as poor folks need a solace, they did not altogether lack one, and that solace was pleasure in their work . . . We must turn this land from the grimy back-yard of a workshop into a garden. If that seems difficult, or rather impossible, to some of you, I cannot help it; I only know that it is necessary. (CW XXIII 163, 173)

Art was to be a democratic commodity, available to and made for all, 'a joy to the maker and the user'. In 'How I Became a Socialist', the essay written in 1894, two years before his death, Morris summed up the impetus behind his vision:

Apart from the desire to produce beautiful things, the leading passion of my life has been and is hatred of modern civilisation . . . What shall I say concerning its mastery of, and its waste of mechanical power, its commonwealth so poor, its enemies of the commonwealth so rich, its stupendous organisation – for the misery of life . . . Its eyeless vulgarity which has destroyed art, the one certain solace of labour? . . . It must be remembered that civilisation has reduced the workman to such a skinny and pitiful existence, that he scarcely knows how to form a desire for any life much

better than that which he now endures perforce. It is the province of art to set the true ideal of a full and reasonable life before him, a life to which the perception and creation of beauty, the enjoyment of real pleasure that is, shall be felt to be as necessary to man as his daily bread. (CW XXIII 279–81)

It was this state that had been achieved in *News from Nowhere*.

That book was undoubtedly Morris's most important publication in these years; but he also had an extraordinary further outburst of writing, mostly prose, but some poetry, in the so-called prose romances, tales of quest and adventure. In some respects *A Dream of John Ball* and *News from Nowhere* were part of this tradition, but they were explicitly political.

Between 1888 and his death in 1896 he published six of these books – *The House of the Wolfings* (1889), *The Roots of the Mountains* (1890), *The Story of the Glittering Plain* (1890), *The Wood beyond the Plain* (1890), *The Wood beyond the World* (1894), *Child Christopher* (1895), *The Well at the World's End* (1896). Two were published after his death, *The Water of the Wondrous Isles* (1897) and *The Story of the Sundering Flood* (1898). These romances were set elsewhere in time, in most cases in a somewhat mythological past. Until recently they tended to be the least regarded of Morris's writings, having dated, it was thought, even more than *The Earthly Paradise*, a similarly fantastic tale. Their utopian elements are furthermore clearly connected with Morris's increased commitment to politics and social change, although he himself vehemently denied that the stories have any political significance. In 1895 a reviewer in the *Spectator* claimed that *The Wood beyond the World* was an allegory concerning Capital and Labour. Morris felt constrained to reply: 'I had not the least intention of thrusting an allegory into *The Wood beyond the World*: it is meant for a tale pure and simple, with nothing didactic about it. If I have to write or speak on social problems, I always try to be as direct as I possibly can be' (H 371). He perhaps did not wish to see that the depiction of another society whose more primitive and non-capitalistic aspects help create a better world does inevitably have political significance.

The writing of these tales – taking place in the world of dreams and fairy tales – gave Morris pleasure, and they have given pleasure

to readers since – probably more so in recent years than in the past. They are now reprinted in popular paperback editions, attracting those who enjoy the stories of Tolkien and C. S. Lewis. In *The House of the Wolfings* and *The Roots of the Mountains* Morris emphasised the importance of the tribe, as opposed to the individual, seeing in it some sort of equivalent – in both its strengths and its weaknesses – of a socialist state. In these two books in particular, Morris dwelt on the virtues of Teutonic direct democracy and the vitality of German barbarism, the qualities of fellowship and community. As they were written when Morris was still at his most active politically, it is not surprising that, whatever he might say, they should be more explicitly political than the later romances. Morris described *The House of the Wolfings* as 'the story of the Gothic tribes on their way through Middle Europe, and their first meeting with the Romans in war. It is meant to illustrate the melting of the individual into the society of the tribes: I mean apart from the artistic side of things that is its moral – if it has one' (H 302). Yet at the same time the stories tell of quests, of fulfilment, of awakening sexuality. As one commentator has remarked, 'All of the later prose romances pose questions of personal behavior and relationships in a background of commitment to some group of friends or some social community or kindred. Only when the personal relationships are resolved within the community can the story come to an end.' In these books, as in *News from Nowhere*, he is projecting an ideal society free of the vices of sordidness, human greed, and corruption. The prose romances were part of his quest for a better world.

The last eight years of Morris's life were dominated by books – those that he wrote, but even more so by those that he printed at the Kelmscott Press. In fact, the two interests sometimes came together, as when he rewrote the end of *Child Christopher* so that it would look better on the printed page. His interest in printing started when he was still intensely active in the political sphere, in 1888. At the time of the first show of the newly founded Arts & Crafts Exhibition Society, Morris was irritated to discover that no books of his own were worthy of being included. *The House of the Wolfings* was just in the process of being printed, and he took

intense interest in that, advised by his artistic and political follower, Emery Walker. *The House of the Wolfings* was done in a special type modelled on an old Basel font, and with a feel for the proportion of the margins, and extra care was taken with the look of the title pages. The second romance – *The Roots of the Mountain* – was printed with changes that heralded the methods of the Kelmscott Press. Morris felt that it was the best-looking book produced since the seventeenth century. As with all that he did, the object was to make life better. He recognised that his activities in the world of design and literature were not really accessible to the ordinary person. He realised that such a person was too downtrodden to worry about the fine things in life. Nevertheless it was essential to set standards: 'To enjoy good houses and good books in self respect and decent comfort, seems to me to be the pleasurable end towards which all societies of human beings ought now to struggle.'

In connection with the first Arts & Crafts Exhibition in 1888, there was a series of lectures by various figures. Morris himself gave one on tapestry and carpet weaving. Emery Walker gave a talk on printing, reflecting some of the concerns which Morris and he had in designing *The House of the Wolfings*. (In the 1893 printing of the lectures in *Arts and Crafts Essays*, an expanded version of the lecture is given as being by them both.) Walker dwelt on the necessity 'to have harmony between the type and the decoration', as Oscar Wilde reported the talk in the *Pall Mall Gazette*. For Morris the most important aspect was the projection of enlarged photographs of Jenson letters from the edition of Pliny on a screen: this inspired him with the possibility of designing type.

Morris has left a vivid account of the occasion in a letter to his daughter, Jenny, which also suggests the extraordinary pace of his activities:

I spoke on four consecutive days: last Saturday in St Paul's Coffee, Sunday Hyde Park, Mondy [*sic*] Store St. Hall, Tuesday Clerkenwell Green. At the latter place there was a bit of a shindy but not till when I had gone away: as a result I had to bail a comrade on Wednesday and spend a couple of hours in that sink of iniquity a Police Court. Thursday I was at the Arts & Crafts at Walker's Lecture on printing: he was very nervous and ought to

have written down his words; but of course he knew his subject thoroughly well: there were some magic-lantern slides of pages of books, and some telling contrasts between the good and the bad. There was a ridiculous Yankee there who was very much 'risen' by Walker's attacks on the ugly American printing; who after the lecture came blustering up to Walker to tell him he was all wrong; so I went for him and gave him some candid speech on the subject of the said American periodicals. (H 303)

From then on one of the central activities in Morris's life was the creation of a Private Press. At the time such enterprises were comparatively rare; the greatest impetus to their rapid increase came from Morris. In December 1889, Morris asked Walker to go into partnership with him. Walker was too modest to accept, but he continued to advise Morris, finding him Joseph Batchelor as his papermaker, Edward Prince as his punch-cutter, Jaenecke of Hanover as the best producer of ink. Walker also produced enlarged photographs of letters which assisted Morris in designing type, the two that were used for most of the Kelmscott books: Golden and Troy.

The very last book published by the Kelmscott Press was *A Note by William Morris on His Aims in Founding the Kelmscott Press*, in 1898, two years after his death. In it, Morris wrote:

I began printing books with the hope of producing some which would have a definite claim to beauty, while at the same time they should be easy to read and should not dazzle the eye, or trouble the intellect of the reader by eccentricity of form in the letters. I have always been a great admirer of the calligraphy of the Middle Ages, of the earlier printing which took its place. As to fifteenth-century books, I had noticed that they were always beautiful by force of the mere typography, even without the added ornament, with which many of them are so lavishly supplied. And it was the essence of my undertaking to produce books which it would be a pleasure to look upon as pieces of printing and arrangement of type. Looking at my adventure from this point of view, then, I found I had to consider chiefly the following things: the paper, the form of the type, the relative spacing of the letters, the words, and the lines; and lastly the position of the printed matter on the page.

Thus began his 'little typographical adventure'. He was still very much interested in calligraphy, and as a dedicated medievalist he regarded it as superior to printing. But he was determined to create the best thought-out and most beautiful books that he could. His

404

interest in printing and the writing of the prose romances have been frequently cited as indications of his disillusion with socialist politics. Clearly, there was some shift of interest and slowing down, although he retained his intense political commitment.

His split with the Socialist League made it financially easier for Morris to launch the Press: the money that he had been using to subsidise *Commonweal* could now be dedicated to his new endeavour. Also, the printer for that paper, Thomas Binning, became his chief pressman. He established the Press in Sussex House, opposite a pub called The Doves which gave its name to the Doves bindery of Thomas Cobden-Sanderson, and ultimately to the great private press established by Cobden-Sanderson and Emery Walker: The Doves Press. The Kelmscott Press issued its first book in the spring of 1891, *The Story of the Glittering Plain*. This version was unillustrated; it was reissued as the twenty-second book of the Press in 1894, with illustrations by Walter Crane. In total the Press published 53 books, three after Morris's death. Several were by Morris or translated by him, including eight volumes of *The Earthly Paradise*, as one title; then there were poems by Rossetti, Keats, Swinburne, Tennyson, Shakespeare, Shelley and Coleridge, More's *Utopia*, seventeen medieval texts, and various other books in which Morris was particularly interested. Here was a summation of many of the concerns of his life.

The masterpiece and most ambitious book of the Press was the folio Kelmscott Chaucer. The collected poems of one of Morris's hero figures, it had 87 woodcut illustrations by Burne-Jones. It took four years to produce. Though listed as the fortieth book for the Press, it was not finished until June 1896. Morris himself designed the decorative aspects of the book, such as initial words and borders. (He had made 644 designs for the Press during its existence.) Four hundred and twenty-five copies were printed on paper and thirteen on vellum. The former sold for £20, the latter for £120. But most of the Kelmscott Press books were quite reasonable in price. Morris attempted to create books which, although new in design, would suggest the quality of older books. The Press was similar to all his other enterprises in providing a sense of what was worth preserving as well as charting a course for the future. The Kelmscott Press was the progenitor of the other

great private presses of the period: not only Doves, but Vale, Eragny, Ashendene, Essex House and others.

Though limited, items made by the Firm and the Press had a profound effect on the look of objects and books in wider production. The man who had considerable doubts about machines in fact was a major influence in improving the quality of what was produced by them. Perhaps there was some aspect of self-indulgence in the Press. Morris himself felt that such activities were merely palliative, considering the general rottenness of society. But as society has not transformed itself as he wished, we should be immensely grateful for the important, innovative and influential work he did through the Firm and the Press. The Press helped create a far greater concern for a beautiful page, and through the Arts & Crafts movement and art and printing schools Morris's influence spread throughout England and the world.

Towards the end of his life Morris renewed an interest which had perhaps an element of legitimate self-indulgence, of luxury. He began to collect books again, a hobby he had more or less abandoned in the early 1880s, although apparently it is not true, as had been believed, that he sold his collection in order to benefit the Democratic Federation. That was not necessary, as his annual income was £1,800 at this time. But in the 1890s he returned to collecting early printed books and medieval illuminated manuscripts. He was particularly fond of Gothic woodcuts. In 1895 he was buying at a great rate – for instance, a thirteenth-century Book of Hours for £450, a fourteenth-century *Roman de la Rose* for £400, a large folio French thirteenth-century Bible for £650. Up until the end, he continued the pursuit – and surrounded himself with beautiful books and manuscripts both from the past and of his own making. It was almost as if he were seeking a return for the beauty that he had attempted to bring into the world.

Morris had been ill for more than a year before his death in October 1896, but a serious decline was brought on by the complications of a cold caught in December 1895. He had been speaking outside Waterloo station as part of the funeral for his old friend, Sergius Stepniak, the Russian revolutionary, who had been run down by a train while absent-mindedly crossing the tracks in Chiswick. Morris went on a cruise to Norway, he worked on

Kelmscott Press books, he continued to write, but he was clearly failing. It was a sad, protracted death. In September, Arnold Dolmetsch, who had done so much to recover older music and instruments, played the virginals for him. Morris died on 3 October at 11:15, and was buried in the village of Kelmscott on 6 October. The funeral was appropriately simple, yet dramatic: a very wet day, a howling wind, the rising waters of the Thames, the coffin carried in an open hay cart, a wreath of bay, a simple service in the church, the mourners being the villagers, friends, workers from Merton Abbey, quite a few members of the Art Workers' Guild. The family remained at Kelmscott Manor, and after May Morris's death the house went first to Oxford University and then to the Society of Antiquaries. Philip Webb built a gravestone for him, raised from the ground on short stone stilts, in the face of the minister's objections to such an unconventional tomb. Even in death, Morris did things differently. As Webb wrote to Jane Morris, 'If I could put a semblance of a roof over him, in mimic show of an Iceland one, it would not vex him if his spirit was alight there under it; like that of one of his old northern heroes in his cairn' (MS).

I hope that the preceding pages have made clear how extensive were Morris's ideas. He influenced so wide an area – in design, as a writer, as a socialist – that it is possible to see his life as hopelessly diffused. But in fact there is, I believe, a strong consistent line in his thought. He wished to reform the world, to simplify life, to make it more rewarding, to make it more beautiful, to make it more just, to make the joy of it available to more and more people, to fight against shoddy, to remove 'mumbo-jumbo' from the world. These conceptions are stronger for us because of his ideas: he was central in changing our vision of the world. He did not accomplish all that he hoped, but it is astounding how much he did.

'Have nothing in your houses that you do not know to be useful, or believe to be beautiful.' Morris's views on the environment, on preserving what is of value in both the natural and the 'built' worlds, on decentralising bloated government, are as significant now as they were in Morris's own time, or even more so. Earlier in

the twentieth century much of his thinking, particularly its political side, was dismissed as sheer romanticism. After the Second World War, it appeared that modernisation, centralisation, industrialism, rationalisation – all the faceless movements of the time – were in control and would take care of the world. Today, when we have a keen sense of the shambles of their efforts, the suggestions which Morris made in his designs, his writings, his actions and his politics have new power and relevance.

Further reading

Writings by Morris

Books by and about William Morris are legion, although they are harder to come by than one might think, as not very much is in print. The standard collection is in twenty-four volumes, *The Collected Works*, edited by his daughter, May (Longmans Green, London, 1910–15), supplemented by two further volumes also edited by her, *William Morris Artist, Writer, Socialist* (Blackwell, Oxford, 1936, reissued, Russell & Russell, New York, 1966). Philip Henderson has edited *The Letters of William Morris to His Family and Friends* (London, 1950).

Various of Morris's works have been available in paperback editions. Geoffrey Grigson, ed., with an introduction, *A Choice of William Morris's Verse* (Faber and Faber, London, 1969); Asa Briggs, ed., *William Morris Selected Writings and Designs* (Penguin Books, Harmondsworth, 1962), A. L. Morton, ed., *Three Works by William Morris: News from Nowhere, The Pilgrims of Hope, A Dream of John Ball* (International Publishers, New York, 1968); A. L. Morton, ed., *Political Writings of William Morris* (International Publishers, New York, 1973); Robert W. Gutman, ed., *Volsunga Saga* (Collier, New York, 1962). The renewed interest in works of fantasy has resulted in paperbacks of some of the prose romances, such as Lin Carter, ed., *The Sundering Flood* and *The Well at the World's End* (Ballantine Books, New York, 1973 and 1975); Tom Shippey, ed., *The Wood Beyond the World* (Oxford University Press, 1980).

Writings about Morris

There are numerous biographies and short studies, of which the authorised biography in two volumes is by Edward Burne-Jones's son-in-law, J. W. Mackail, *The Life of William Morris* (Longmans Green, London, 1899, reissued, Benjamin Blom, New York, 1968). The four major largely biographical studies of recent years are E. P.

Thompson, *William Morris: Romantic to Revolutionary* (Merlin Press, London, 1955, revised edition, 1977); Paul Thompson, *The Work of William Morris* (The Viking Press, New York, 1967, reissued, 1977); Philip Henderson, *William Morris* (McGraw-Hill, New York, 1967); Jack Lindsay, *William Morris* (Constable, London, 1975). Two recent shorter studies are Ian Bradley, *William Morris and His World* (Charles Scribner's Sons, New York, 1978), heavily illustrated, and Peter Faulkner, *Against the Age: An Introduction to William Morris* (George Allen & Unwin, London, 1980).

Design: A general study is Ray Watkinson, *William Morris as Designer* (Reinhold Corporation, New York, 1967, new edition, 1979). Two broad studies put Morris's design work in perspective: Gillian Naylor, *The Arts and Crafts Movement* (Studio Vista, London, 1971), and Nikolaus Pevsner, *Pioneers of Modern Design, From William Morris to Walter Gropius* (Penguin Books, Harmondsworth, 3rd edition, 1970). The interpretation implied by the subtitle is controversial in its argument concerning Morris's role in the creation of modern architecture.

Architecture and Artefacts

Many British museums contain objects manufactured by William Morris, most notably the Victoria and Albert Museum in London which also houses the Green Dining Room done by the Firm, as well as textiles that Morris studied and helped select. There is the William Morris Gallery itself in Walthamstow, London. Three of Morris's houses are open at times to the public: The Red House in Bexleyheath, Kent, privately owned, Kelmscott Manor, Kelmscott, Gloucestershire, belonging to the Society of Antiquaries, and Kelmscott House, Upper Mall, Hammersmith, London, owned by the William Morris Society.

Index

Index

Index

OXFORD

MORE OXFORD PAPERBACKS

This book is just one of nearly 1000 Oxford Paperbacks currently in print. If you would like details of other Oxford Paperbacks, including titles in the World's Classics, Oxford Reference, Oxford Books, OPUS, Past Masters, Oxford Authors, and Oxford Shakespeare series, please write to:

UK and Europe: Oxford Paperbacks Publicity Manager, Arts and Reference Publicity Department, Oxford University Press, Walton Street, Oxford OX2 6DP.

Customers in UK and Europe will find Oxford Paperbacks available in all good bookshops. But in case of difficulty please send orders to the Cash-with-Order Department, Oxford University Press Distribution Services, Saxon Way West, Corby, Northants NN18 9ES. Tel: 0536 741519; Fax: 0536 746337. Please send a cheque for the total cost of the books, plus £1.75 postage and packing for orders under £20; £2.75 for orders over £20. Customers outside the UK should add 10% of the cost of the books for postage and packing.

USA: Oxford Paperbacks Marketing Manager, Oxford University Press, Inc., 200 Madison Avenue, New York, N.Y. 10016.

Canada: Trade Department, Oxford University Press, 70 Wynford Drive, Don Mills, Ontario M3C 1J9.

Australia: Trade Marketing Manager, Oxford University Press, G.P.O. Box 2784Y, Melbourne 3001, Victoria.

South Africa: Oxford University Press, P.O. Box 1141, Cape Town 8000.

PAST MASTERS

General Editor: Keith Thomas

The *Past Masters* series offers students and general readers alike concise introductions to the lives and works of the world's greatest literary figures, composers, philosophers, religious leaders, scientists, and social and political thinkers.

'Put end to end, this series will constitute a noble encyclopaedia of the history of ideas.' Mary Warnock

HOBBES

Richard Tuck

Thomas Hobbes (1588–1679) was the first great English political philosopher, and his book *Leviathan* was one of the first truly modern works of philosophy. He has long had the reputation of being a pessimistic atheist, who saw human nature as inevitably evil, and who proposed a totalitarian state to subdue human failings. In this new study, Richard Tuck shows that while Hobbes may indeed have been an atheist, he was far from pessimistic about human nature, nor did he advocate totalitarianism. By locating him against the context of his age, Dr Tuck reveals Hobbs to have been passionately concerned with the refutation of scepticism in both science and ethics, and to have developed a theory of knowledge which rivalled that of Descartes in its importance for the formation of modern philosophy.

Also available in Past Masters:

Spinoza Roger Scruton
Bach Denis Arnold
Machiavelli Quentin Skinner
Darwin Jonathan Howard

PAST MASTERS

General Editor: Keith Thomas

The people whose ideas have made history . . .

'One begins to wonder whether any intelligent person can afford not to possess the whole series.' *Expository Times*

JESUS

Humphrey Carpenter

Jesus wrote no books, but the influence of his life and teaching has been immeasurable. Humphrey Carpenter's account of Jesus is written from the standpoint of an historian coming fresh to the subject without religious preconceptions. And no previous knowledge of Jesus or the Bible on the reader's part is assumed.

How reliable are the Christian 'Gospels' as an account of what Jesus did or said? How different were his ideas from those of his contemporaries? What did Jesus think of himself? Humphrey Carpenter begins his answer to these questions with a survey and evaluation of the evidence on which our knowledge of Jesus is based. He then examines his teaching in some detail, and reveals the perhaps unexpected way in which his message can be said to be original. In conclusion he asks to what extent Jesus's teaching has been followed by the Christian Churches that have claimed to represent him since his death.

'Carpenter's *Jesus* is about as objective as possible, while giving every justifiable emphasis to the real and persistent forcefulness of the moral teaching of this charismatic personality.' Kathleen Nott, *The Times*

'an excellent, straightforward presentation of up-to-date scholarship' David L. Edwards, *Church Times*

Also available in Past Masters:

OPUS

General Editors: Walter Bodmer, Christopher Butler, Robert Evans, John Skorupski

A HISTORY OF WESTERN PHILOSOPHY

This series of OPUS books offers a comprehensive and up-to-date survey of the history of philosophical ideas from earliest times. Its aim is not only to set those ideas in their immediate cultural context, but also to focus on their value and relevance to twentieth-century thinking.

CLASSICAL THOUGHT

Terence Irwin

Spanning over a thousand years from Homer to Saint Augustine, *Classical Thought* encompasses a vast range of material, in succinct style, while remaining clear and lucid even to those with no philosophical or Classical background.

The major philosophers and philosophical schools are examined—the Presocratics, Socrates, Plato, Aristotle, Stoicism, Epicureanism, Neoplatonism; but other important thinkers, such as Greek tragedians, historians, medical writers, and early Christian writers, are also discussed. The emphasis is naturally on questions of philosophical interest (although the literary and historical background to Classical philosophy is not ignored), and again the scope is broad—ethics, the theory of knowledge, philosophy of mind, philosophical theology. All this is presented in a fully integrated, highly readable text which covers many of the most important areas of ancient thought and in which stress is laid on the variety and continuity of philosophical thinking after Aristotle.

Also available in the History of Western Philosophy series:

RELIGION AND THEOLOGY
IN OXFORD PAPERBACKS

Oxford Paperbacks offers incisive studies of the philo-
sophies and ceremonies of the world's major religions,
including Christianity, Judaism, Islam, Buddhism, and
Hinduism.

A HISTORY OF HERESY
David Christie-Murray

'Heresy, a cynic might say, is the opinion held by a minority of
men which the majority declares unacceptable and is strong
enough to punish.'

What is heresy? Who were the great heretics and what did they
believe? Why might those originally condemned as heretics
come to be regarded as martyrs and cherished as saints?

Heretics, those who dissent from orthodox Christian belief,
have existed at all times since the Christian Church was founded
and the first Christians became themselves heretics within
Judaism. From earliest times too, politics, orthodoxy, and
heresy have been inextricably entwined—to be a heretic was
often to be a traitor and punishable by death at the stake—and
heresy deserves to be placed against the background of political
and social developments which shaped it.

This book is a vivid combination of narrative and comment
which succeeds in both re-creating historical events and elu-
cidating the most important—and most disputed—doctrines
and philosophies.

Also in Oxford Paperbacks:

Christianity in the West 1400–1700 John Bossy
John Henry Newman: A Biography Ian Ker
Islam: The Straight Path John L. Esposito

HISTORY IN OXFORD PAPERBACKS

Oxford Paperbacks offers a comprehensive list of books on British history, ranging from Frank Stenton's *Anglo-Saxon England* to John Guy's *Tudor England*, and from Christopher Hill's *A Turbulent, Seditious, and Factious People* to Kenneth O. Morgan's *Labour in Power: 1945–1951*.

TUDOR ENGLAND
John Guy

Tudor England is a compelling account of political and religious developments from the advent of the Tudors in the 1460s to the death of Elizabeth I in 1603.

Following Henry VII's capture of the Crown at Bosworth in 1485, Tudor England witnessed far-reaching changes in government and the Reformation of the Church under Henry VIII, Edward VI, Mary, and Elizabeth; that story is enriched here with character studies of the monarchs and politicians that bring to life their personalities as well as their policies.

Authoritative, clearly argued, and crisply written, this comprehensive book will be indispensable to anyone interested in the Tudor Age.

'lucid, scholarly, remarkably accomplished . . . an excellent overview' *Sunday Times*

'the first comprehensive history of Tudor England for more than thirty years' Patrick Collinson, *Observer*

Also in Oxford Paperbacks:

John Calvin William J. Bouwsma
Early Modern France 1515–1715 Robin Briggs
The Spanish Armada Felipe Fernández-Armesto
Time in History G. J. Whitrow

WOMEN'S STUDIES FROM
OXFORD PAPERBACKS

Ranging from the *A–Z of Women's Health* to *Wayward Women: A Guide to Women Travellers*, Oxford Paperbacks cover a wide variety of social, medical, historical, and literary topics of particular interest to women.

DESTINED TO BE WIVES
The Sisters of Beatrice Webb
Barbara Caine

Drawing on their letters and diaries, Barbara Caine's fascinating account of the lives of Beatrice Webb and her sisters, the Potters, presents a vivid picture of the extraordinary conflicts and tragedies taking place behind the respectable façade which has traditionally characterized Victorian and Edwardian family life.

The tensions and pressures of family life, particularly for women; the suicide of one sister; the death of another, probably as a result of taking cocaine after a family breakdown; the shock felt by the older sisters at the promiscuity of their younger sister after the death of her husband are all vividly recounted. In all the crises they faced, the sisters formed the main network of support for each other, recognizing that the 'sisterhood' provided the only security in a society which made women subordinate to men, socially, legally, and economically.

Other women's studies titles:

A–Z of Women's Health Derek Llewellyn-Jones
'Victorian Sex Goddess': Lady Colin Campbell and the Sensational Divorce Case of 1886 G. H. Fleming
Wayward Women: A Guide to Women Travellers
Jane Robinson
Catherine the Great: Life and Legend John T. Alexander

OXFORD LIVES

Biography at its best—this acclaimed series offers authoritative accounts of the lives of men and women from the arts, sciences, politics, and many other walks of life.

STANLEY

Volume I: The Making of an African Explorer
Volume II: Sorceror's Apprentice

Frank McLynn

Sir Henry Morton Stanley was one of the most fascinating late-Victorian adventurers. His historic meeting with Livingstone at Ujiji in 1871 was the journalistic scoop of the century. Yet behind the public man lay the complex and deeply disturbed personality who is the subject of Frank McLynn's masterly study.

In his later years, Stanley's achievements exacted a high human cost, both for the man himself and for those who came into contact with him. His foundation of the Congo Free State on behalf of Leopold II of Belgium, and the Emin Pasha Relief Expedition were both dubious enterprises which tarnished his reputation. They also revealed the complex—and often troubling—relationship that Stanley has with Africa.

'excellent . . . entertaining, well researched and scrupulously annotated' *Spectator*

'another biography of Stanley will not only be unnecessary, but almost impossible, for years to come' *Sunday Telegraph*

Also available:

A Prince of Our Disorder: The Life of T. E. Lawrence
John Mack
Carpet Sahib: A Life of Jim Corbett Martin Booth
Bonnie Prince Charlie: Charles Edward Stuart Frank McLynn

OXFORD LETTERS AND MEMOIRS

Letters, memoirs, and journals offer a special insight into the private lives of public figures and vividly recreate the times in which they lived. This popular series makes available the best and most entertaining of these documents, bringing the past to life in a fresh and personal way.

RICHARD HOGGART

A Local Habitation
Life and Times: 1918–1940

With characteristic candour and compassion, Richard Hoggart evokes the Leeds of his boyhood, where as an orphan, he grew up with his grandmother, two aunts, an uncle, and a cousin in a small terraced back-to-back.

'brilliant . . . a joy as well as an education' Roy Hattersley

'a model of scrupulous autobiography' Edward Blishen, *Listener*

A Sort of Clowning
Life and Times: 1940–1950

Opening with his wartime exploits in North Africa and Italy, this sequel to *A Local Habitation* recalls his teaching career in North-East England, and charts his rise in the literary world following the publication of *The Uses of Literacy*.

'one of the classic autobiographies of our time' Anthony Howard, *Independent on Sunday*

'Hoggart [is] the ideal autobiographer' Beryl Bainbridge, *New Statesman and Society*

Also in Oxford Letters and Memoirs:

My Sister and Myself: The Diaries of J. R. Ackerley
The Letters of T. E. Lawrence
A London Family 1870–1900 Molly Hughes

ANTHONY TROLLOPE IN THE WORLD'S CLASSICS

Anthony Trollope (1815–1882), one of the most popular English novelists of the nineteenth century, produced forty-seven novels and several biographies, travel books, and collections of short stories. The World's Classics series offers the best critical editions of his work available.

THE THREE CLERKS

Anthony Trollope
Edited with an Introduction by Graham Handley

The Three Clerks is Trollope's first important and incisive commentary on the contemporary scene. Set in the 1850s, it satirizes the recently instituted Civil Service examinations and financial corruption in dealings on the stock market.

The story of the three clerks and the three sisters who become their wives shows Trollope probing and exposing relationships with natural sympathy and insight before the fuller triumphs of Barchester, the political novels, and *The Way We Live* Now. The novel is imbued with autobiographical warmth and immediacy, the ironic appraisal of politics and society deftly balanced by romantic and domestic pathos and tribulation. The unscrupulous wheeling and dealing of Undy Scott is colourfully offset by the first appearance in Trollope's fiction of the bullying, eccentric, and compelling lawyer Mr Chaffanbrass.

The text is that of the single-volume edition of 1859, and an appendix gives the most important cuts that Trollope made for that edition.

Also in the World's Classics:

The Chronicles of Barsetshire
The Palliser Novels
Ralph the Heir
The Macdermots of Ballycloran